Designer's Guide to
Decorative Accessories

Treena Crochet
Allied Member ASID

Illustrated by David Vleck

PEARSON

Prentice
Hall

Upper Saddle River, New Jersey
Columbus, Ohio

Library of Congress Cataloging-in-Publication Data
Crochet, Treena.
Designer's guide to decorative accessories / Treena M. Crochet.
 p. cm.
ISBN 0-13-233114-4 (978-0-13-233114-2) 1. Interior decoration—History. I. Title.
NK1710.C76 2009
747—dc22 2008010212

Editor in Chief: Vernon R. Anthony
Acquisitions Editor: Jill Jones-Renger
Editorial Assistant: Doug Greive
Production Coordination: Linda Zuk, WordCraft, LLC
Associate Managing Editor: Alexandrina Benedicto Wolf
Project Manager: Kris Roach
Senior Operations Supervisor: Patricia A. Tonneman
Operations Specialist: Deidra Schwartz
Art Director: Diane Ernsberger
Cover Designer: Diane Lorenzo
Cover art: © Judith Miller/Dorling Kindersley/David Rago Auctions
Director, Image Resource Center: Melinda Patelli
Manager, Rights and Permissions: Zina Arabia
Manager, Visual Research: Beth Brenzel
Manager, Cover Visual Research and Permissions: Karen Sanatar
Image Permission Coordinator: Nancy Seise
Director of Marketing: David Gasell
Marketing Manager: Leigh Ann Sims
Marketing Assistant: Les Roberts
Copyeditor: Patsy Fortney

This book was set in Minion by S4Carlisle Publishers and was printed and bound by CJ Krehbiel.
The cover was printed by Phoenix Color Corp/Hagerstown.

Pearson Education Ltd. Pearson Education Australia Pty, Limited
Pearson Education Singapore, Pte. Ltd. Pearson Education North Asia Ltd
Pearson Education, Canada, Ltd. Pearson Educación de Mexico, S.A. de C.V.
Pearson Education–Japan Pearson Education Malaysia, Pte. Ltd.

10 9 8 7 6 5 4 3 2 1
ISBN-13: 978-0-13-233114-2
ISBN: 0-13-233114-4

For my nieces, Stephanie, Bailey, and Kayce,
who always like looking at pretty things.

Contents

PREFACE ix

ACKNOWLEDGMENTS xi

ABOUT THE AUTHOR xiii

INTRODUCTION xv

PART 1 HISTORICAL DEVELOPMENTS 1
CHAPTER 1 THE ANCIENT WORLD 3
NEOLITHIC PERIOD 4
Neolithic Architectural Settings 4
Neolithic Interior Furnishings 5
Neolithic Vessels and Containers 5
Neolithic Weaving and Textiles 7
Comparative Designs 8
ANCIENT EGYPT 10
Egyptian Architectural Settings 10
Egyptian Design Motifs 12
Egyptian Interior Furnishings 18
Egyptian Vessels and Containers 19
Egyptian Metalworking 20
Egyptian Weaving and Textiles 21
ANCIENT AEGEAN CULTURE 22
Comparative Designs 23
Aegean Architectural Settings 23
Aegean Design Motifs 25
Aegean Interior Furnishings 27
Aegean Vessels and Containers 27
Aegean Metalworking 29
Aegean Weaving and Textiles 29
Comparative Designs 30

CHAPTER 2 ANCIENT GREECE AND ROME 31
ANCIENT GREECE 32
Greek Architectural Settings 32
Greek Design Motifs 33
Greek Interior Furnishings 36
Greek Vessels and Containers 37

Greek Metalworking 38

Greek Weaving and Textiles 38

Comparative Designs 40

ANCIENT ROME 41

Roman Architectural Settings 41

Roman Design Motifs 43

Roman Interior Furnishings 45

Roman Vessels and Containers 47

Roman Metalworking 49

Roman Weaving and Textiles 50

Comparative Designs 51

CHAPTER 3 MEDIEVAL EUROPE 53

Architectural Settings 54

Design Motifs 55

Interior Furnishings 61

Decorative Accessories 62

Pottery 62

Glass 63

Metalworking 64

Medieval Room Setting 66

Textiles 68

Comparative Designs 70

PART 2 THE MODERN WORLD 73

CHAPTER 4 THE RENAISSANCE: FIFTEENTH AND SIXTEENTH CENTURIES 75

Architectural Settings 76

Design Motifs 84

Interior Furnishings 90

Decorative Accessories 92

Pottery 92

Glass 93

Mirrors 93

Metalworking 93

Lighting 94

Clocks 94

Textiles 95

Italian Renaissance Room Setting 96

Comparative Designs 98

CHAPTER 5 BAROQUE: SEVENTEENTH CENTURY 99

Architectural Settings 100

Design Motifs 106

Interior Furnishings 108

French Baroque Room Setting 109

Decorative Accessories 111

Pottery 111

Glass 112

 Mirrors 113
 Lighting 114
 Metalworking 114
 Clocks 115
 Textiles 116
 Wallpaper 118
Comparative Designs 120

CHAPTER 6 **ROCOCO: EIGHTEENTH CENTURY 123**
 Architectural Settings 124
 Design Motifs 128
 Interior Furnishings 128
 Decorative Accessories 133
 Pottery 133
American Room Setting 134
 Glass 135
 Mirrors 136
 Lighting 136
 Metalworking 136
 Treenware 140
 Clocks 140
 Textiles 140
 Wallpaper 144
Comparative Designs 144

CHAPTER 7 **NEOCLASSIC: LATE EIGHTEENTH AND EARLY NINETEENTH CENTURIES 147**
 Architectural Settings 149
English Early Neoclassic Room Setting 152
 Design Motifs 153
 Interior Furnishings 156
 Decorative Accessories 161
 Pottery 161
 Decorative Boxes 165
 Glass 166
 Mirrors 167
 Lighting 168
 Metalworking 170
 Clocks 171
 Textiles 171
 Wallpaper 175
Comparative Designs 177

CHAPTER 8 **VICTORIAN, ARTS AND CRAFTS, ART NOUVEAU: NINETEENTH CENTURY 179**
 Architectural Settings 180
Art Nouveau Room Setting 185
American Victorian Room Setting 186

Interior Furnishings 187
Bungalow Room Setting 189
Decorative Accessories 193
Pottery 193
Glass 197
Mirrors 201
Lighting 203
Metalworking 205
Clocks 209
Textiles 210
Wallpaper 213
Comparative Designs 215

CHAPTER 9 **MODERN AND POSTMODERN: TWENTIETH AND TWENTY-FIRST CENTURIES 217**
Early Modernism 219
Glasgow School 220
Wiener Werkstätte 224
Frank Lloyd Wright 224
International Style 228
De Stijl 228
Bauhaus 230
Cranbrook Academy 232
Art Deco And Art Moderne 234
Pottery 238
Plastics 239
Glass 240
Mirrors 243
Lighting 243
Metalworking 244
Clocks 245
Textiles and Wallpaper 247
Scandinavian Design 248
Contemporary Culture and World War II 248
Organic Designs in Home Furnishings 250
Popular Culture of the 1960s 253
Pottery 259
Glass 259
Minimalism 262
Postmodernism 265
The Twenty-First Century 266

GLOSSARY 271

FURTHER READING 275

INDEX 279

As a practicing interior designer, I place great importance on telling my students about the experiences I've encountered in the field with contractors, clients, and vendors. They have heard just about all of it—the good, the bad, and the ugly. I stress to my students that, although they can never know it all, they can acquire a basic knowledge of many things. My goal is for students to learn as much as possible while they are in college, yet know where to go to find answers once they graduate and begin working with clients on their own.

In the Boston area, where I work, the "greatest mistake" is told again and again among designers at conferences and awards ceremonies. A high-profile designer once told a client to get rid of a lamp that he thought was atrocious. It turned out that the lamp dated from the turn of the twentieth century and was an authentic Louis Comfort Tiffany. (In 1985, a Tiffany Magnolia lamp sold at auction for more than $500,000.) Luckily, an employee of the designer recognized the style and the lamp was saved from the junk pile. If designers don't know what is valuable and what isn't in a client's home, how can they make decisions about which items stay and which ones go? Moreover, what kind of service are they offering their clients?

Essentially, this is how the *Designer's Guide* series began: books written for students rather than scholars that are easy to read and informative. This second book in the series covers the history of Western decorative accessories, giving insight into the more common objets d'art used to complete interior schemes in particular styles. Although the selection and specification of interior furnishings and accessories are only one aspect of interior design, these finishing touches often determine the success or failure of the entire job. Like color, interior furnishings create a mood or feeling in the space regardless of style or design. Although there is so much to learn about the decorative arts, I recommend that any student of design begin with the most rigorous art history classes. Completion of a thorough art history course covering the Paleolithic period to the present gives the student of design a firm foundation for further study. It is not the goal of this book to teach students the history of art and architecture.

Designer's Guide to Decorative Accessories presents significant movements in Western decorative arts relative to interior design and architectural settings from the Neolithic age to the current century. This book is intended to augment the study of art and architectural history by discussing the function (often the driving force in development) and aesthetic purpose of pottery, glassware, lighting, textiles, mirrors, metalworking, clocks, and wallcoverings and their integration into interior design. As a pretext to stylistic development, information on political and social events and the technological advances that influenced the design trends of the period are addressed.

Furthermore, comparisons are made between objects from different periods, showing the progression of an idea or concept through the object's stylistic development.

Descriptions of period room settings provide the context of how these decorative accessories complement the architecture and interior design. Finally, the glossary highlights key vocabulary, and bibliographic information inspires further reading. This book is a handy resource for future designers or a refresher for those already in practice.

Treena Crochet

Acknowledgments

First and foremost on my list to thank is Vern Anthony, editor-in-chief at Pearson/Prentice Hall, who continues to offer his support in turning my ideas into books. I am grateful to my editor at Pearson/Prentice Hall, Jill Jones-Renger, and to Linda Zuk at WordCraft LLC, for doing such an amazing job. Also, to my personal editorial assistant, Jean Murphy, and copyeditor Patsy Fortney, thanks!

In addition, I appreciate the guidance provided by Gay McNair, IDEC, and Kellie Wallace, IDEC, at the Art Institute of Dallas for sharing their syllabi, exams, and research assignments. This material helped me focus on what students need to know about the decorative arts without overwhelming them with information.

Finally, I wish to thank the following reviewers, who provided constructive criticism and valuable suggestions for the improvement of this book: Denise Bertoncino, Pittsburgh State University; Peter Dedek, Texas State University, San Marcos; Sarah A. Lichtman, Parsons The New School for Design; LuAnn Nissen, University of Nevada, Reno; and Lisa Tucker, Virginia Tech.

Treena Crochet

About the Author

Award-winning and bestselling author Treena Crochet, Allied Member ASID, is a frequent presenter at national and international conferences, speaking on a variety of interior design issues, including historic preservation, architectural style, and furniture design. She spent more than twenty years in the classroom teaching interior design courses in the United States and the Middle East. Since 1994, she has consulted on residential design projects ranging from new construction to historic renovation and restoration interiors work. Her interior design work has been featured in numerous publications, including *The Boston Globe* and *Yankee Magazine.* For more information, view her website at www.TreenaCrochet.com.

Introduction

At the beginning of civilization, humanity survived the elements by living in cave shelters, by forming weapons to hunt animals for food, and eventually by devising tools used in the planting and harvesting of crops. Objects we take for granted today, such as a warm bed throw, a bright reading lamp, or a cleverly designed cooking pot, were developed out of the most basic needs of survival.

Early humans were unyielding in their attempts to make a more comfortable lifestyle for themselves. Animal skins provided warmth as clothing and bedding material; grass or straw spread on the ground kept the chill and dampness of the earth away from their bodies; and hollowed-out tree branches and logs were used to store food, while dried gourds and animal skin pouches held water. Over the course of time, humans developed these survival items into well-designed objects made from whatever materials were available and perfected their craft with each generation.

Archaeological excavations tell us that as far back as the third millennium BCE interiors were outfitted with drapes, rugs, beautiful pottery, decorative figurines, furniture, lamps, and artwork. Pharaohs, kings, and the nobility found great pleasure in amassing teams of artisans whose sole purpose was to create the most beautiful functional objects, which were then flaunted as symbols of their wealth. As societies advanced into the medieval and Renaissance periods, utilitarian objects became more decorative, even for the emerging merchant classes.

By the mid-eighteenth century, such luxuries as fine porcelains, delicate glassware, superb repoussé metalwork, and elaborate furniture completed the room décor and also served functional purposes. As the Industrial Revolution took hold during the nineteenth century, advanced production methods and techniques along with new materials broke the boundaries of class and wealth by providing the public with inexpensive machine-made objects. By mid-nineteenth century, proponents both for and against the machine were debating the issue of the quality of handmade objects versus mass-produced objects.

The debate over which were better—handmade or machine-made objects—continued into the twentieth century. Enthusiastic designers eager to shed the past developed new styles for a technologically modern age, and often opposed those who chose to preserve the artistry of handmade objects. Because they were more expensive than those made by machine, handmade objects in the early styles of the century, such as Art Nouveau and Art Deco, perpetuated the gap between wealthy and middle-class consumers. By the mid-twentieth century, modern culture proved to be more tolerant of the machine age and newly introduced synthetic materials, such as plastics. Furthermore, innovative designers embraced these synthetic materials and used mechanized processes that enabled them to bring high style to the masses. At the end of the century, clever marketing strategies by big-box department stores brought everyday household objects by world-renowned designers to all classes of society.

Regardless of the label historians use to describe a style, period, or movement for a particular time or culture, by studying the history of the decorative arts, we learn

that humans have an inherent desire to beautify their environment while satisfying the need to perform domestic duties. How a given culture at a given time chose to do so depended on social, economic, and even political factors. Over the centuries, ingenuity overcame limitations and each culture adapted household objects to fit its changing lifestyles.

Who can predict what the new styles of design will be for the twenty-first century? For the first time in history the world is linked through satellite television and the Internet. As globalization continues, styles will merge and evolve as each culture takes what it needs from popular culture and adapts it to meet its own unique lifestyles. Will history books of the future still separate styles by country as we do now? Or will twenty-first-century culture become one global melting pot? After living in the Middle East for three years, I realize that the creative possibilities of blending and merging cultural styles are endless. Perhaps globalization through the Internet and satellite television is our Silk Road in the twenty-first century.

Part 1
Historical Developments

The Ancient World

TIMELINE	

Paleolithic Period

40,000–25,000 BCE		Neanderthal species replaced by Cro-Magnons.
		Nomadic humans find shelter in caves.
	20,000	Small statuaries depict female nude as fertility goddess; *Venus of Willendorf* sculpted.
15,000–10,000 BCE		Prehistoric cave paintings record life of early *Homo sapiens*.
		Cave paintings at Lascaux, France, and Altamira, Spain, created.

Mesolithic Period

8000–7000 BCE		Humans begin cultivating crops and raising animals.
		Permanent settlement at Jericho shows development of architecture.

Neolithic Period

6500–5700 BCE		Humans establish permanent settlement at Catal Huyuk.
		Settlements indicate use of tools and furniture.
		Pottery making and textile weaving develop.
4000–3000 BCE		Advanced settlements develop along the Nile River in Africa.
		Use of mud brick in architecture; post and lintel architectural construction methods evolve.
		Cuneiform writing develops.
		First earthworks project begins on Salisbury Plain in England (remade with stone in 1800 BCE).

Ancient Egyptian Period

3000–2000 BCE		Unification of Upper and Lower provinces by King Narmer.
	2800	Beginning of Old Kingdom.
	2500	Great Pyramids at Giza completed.
		Lavishly decorated furniture appears.
2000–1000 BCE		Middle and New Kingdoms thrive economically.
		Temples, palaces built using post-and-lintel construction methods.
	1417–1397	Temple at Luxor built.
	1333	Pharaoh Tutankhamun rules Egypt.
	1250	Moses leads Israelites out of Egypt.
1000–500 BCE		Ethiopian kings rule Egypt.

Ancient Aegean Period

3000–2000 BCE		Early Minoans settle on the island of Crete.
	2500	Cycladic idols appear.
		Construction begins on the Palace of Knossos.
2000–1000 BCE		Aegean Middle and Late Minoan civilizations thrive.
		Citadels flourish, beehive tombs; cyclopean architecture, keystone arch in use.
	1500	Linear A and Linear B script in use.
	1300	Mycenaean culture occupies mainland Greece.
		Lion Gate created at Mycenae.
	1200	King Agamemnon defeats Trojans.

Neolithic Period

Little is known about the Neanderthal culture that lived during the Paleolithic period dating to around 33,000 years BCE and commonly referred to as the Stone Age. Because recorded history did not exist until around 3100 BCE, archeologists, art historians, and anthropologists have attempted to reconstruct the lives of these Stone Age people by analyzing the artifacts they left behind. Scholars have divided this time into three periods: the Paleolithic, Mesolithic, and Neolithic. The division of Stone Age culture into these periods was determined by particular advancements toward a "civilized," or orderly, existence.

The Neolithic period is marked by the establishment of permanent settlements by formerly nomadic groups of people. Humans discovered that it was much better to cultivate their own crops and raise their own animals than roam the countryside in search of food and prey. Generally, the accepted period for the existence of Neolithic culture ranges from 6500 to 3000 BCE and encompasses those tribes of people living in modern-day Europe, Africa, and Asia.

Scholars who traced the development of Neolithic culture by studying its architecture, painting, and sculptural styles, along with domestic objects such as furniture and pottery, reasoned that early artifacts from prehistoric times fulfilled both spiritual and practical purposes. Moreover, although some objects were highly ornate, others were quite restrained in design and decoration. In studying the development of these artifacts throughout time, historians have concluded that those who owned functional objects of great artisanship and beauty had wealth, high social standing, and a high level of sophistication or taste.

Neolithic Architectural Settings

Jericho, the earliest settlement discovered to date, is located in the Jordan River Valley and dates from around 8000–7000 BCE during the Mesolithic period. Only remnants of the original stone fortifications and mud brick houses remain, with little else besides traces of decorated plaster covering floors and walls. No pottery shards were found in Jericho, or any other forms of household furnishings. Since this period predates recorded history, only the artifacts reclaimed through laborious excavations can tell scholars how members of this ancient culture lived their daily lives. At Jericho, little survives to tell the story of its ancient culture.

The Neolithic period begins with the discovery of more developed villages than those found at Jericho. One of the most telling settlements excavated to date is located in present-day Turkey; the town of Catal Huyuk dates back to 7000–6500 BCE and is used to establish the beginning of the Neolithic period. Living an agrarian lifestyle— farming the land and shepherding animals—the ancient Anatolians put down their roots and developed a vast city structure with private homes and public buildings. The buildings excavated at Catal Huyuk revealed a sophisticated system of architecture consisting of post and lintel construction.

Excavations indicate that the residents of this town made useful objects for themselves and decorated their homes with bright and colorful wall paintings. Catal Huyuk reveals some of the most advanced forms of artwork for the time including drawings of animal and human forms, landscape paintings decorating the walls of homes, and some textile fragments. In addition, woven floor mats, pottery, baskets, and wooden and stone boxes found at the site have geometric designs—a testament to the creation of items for human comfort with consideration of the creative process and aesthetics.

Scholars surmise that the artifacts found at Catal Huyuk served a practical function as well as an aesthetic one. Who knows for sure why the potter began to decorate the surface of the clay? Alternatively, who knows why landscapes were painted on the interior walls of houses? What is certain is that this practice of beautifying living spaces continued throughout history. As societies became more progressive, the utilitarian objects they produced became more decorative and sophisticated in their design. It is in these ancient prehistoric settlements that the humble beginnings of the decorative arts are found.

Neolithic Interior Furnishings

Excavations at Catal Huyuk revealed built-in reclining couches or beds attached to walls and made from plaster. Presumably, these couches were used for lounging or sleeping, yet human skeletal remains were found buried in the floors underneath. This discovery is perplexing and suggests that the couches may also have functioned as family burial shrines. Also found at Catal Huyuk were small statuettes of females—possibly deities—seated on chairs or stools (Figure 1–1). While there may have been other types of furniture in use in Neolithic households, there is no physical evidence.

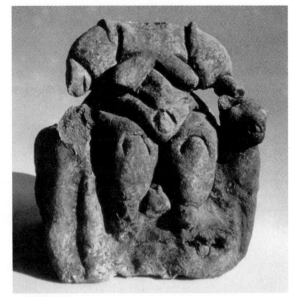

FIGURE 1–1 This small sculpture, believed to represent a fertility goddess by her swollen breasts and protruding belly, was from excavations at Catal Huyuk. The woman is seated on a chair flanked by lions. The lion, which appears in the furniture design of the Egyptians, Greeks, and Romans, is a symbol of power.
© *Dorling Kindersley*

Neolithic Vessels and Containers

The need to collect and store water, grains, and other foods led to the development of a variety of vessels and containers, mostly all of which discovered to date feature a swelling or bulbous form. Early storage vessels were made from woven reeds in the form of baskets or hollowed-out gourds (Figure 1–2). The gourd, with its rounded belly, was the perfect shape for storing liquids, and the gourd's long, tapered neck offered a practical design for pouring.

Containers made from hollowed-out wood and stone carved into a variety of shapes proved more durable and long-lasting than gourds. Well after they discovered pottery making, Neolithic people continued to use wood and stone vessels for food storage, preparation, and serving. Wooden examples are scarce because of the natural decomposition of their organic material, but bowls and jars made from stone have turned up in several excavated sites in Europe, China, and the Americas (Figure 1–3). Pottery was imported and exported freely among neighboring cultures and for millennia became an essential factor in the economy of Neolithic society. Scholars are unsure of how the

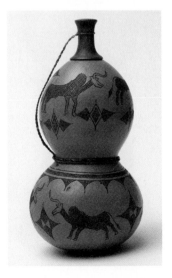

FIGURE 1–2 Taking cues from remote tribes still living by ancient tradition, the creator of this gourd from Madagascar, which dates from the late nineteenth century, featured painted designs of animals among geometric motifs.
© *Dorling Kindersley, Courtesy of the Pitt Rivers Museum, University of Oxford*

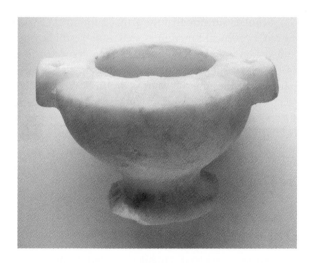

FIGURE 1–3 This bowl carved from calcite, or alabaster, has two handles and a footed base.
Alan Hills and Barbara Winter
© The British Museum

process of pottery making evolved, although ceramic bowls, cups, jars, and vases have been unearthed from prehistoric cities in the Middle and Far East alike—Anatolia, Mesopotamia, and China. In Neolithic culture, women reared the children, and their roles naturally catered to domestic responsibilities including the making of household objects. Scholars agree that pottery making was probably first performed by women to make their domestic lives easier (Figure 1–4).

Early potters used clay-rich soil that they shaped by hand using a coiling method or by pressing the clay into a mold. Many examples excavated so far have embossed patterns indicating that the wet clay was pressed into a woven basket acting as a mold. For the coiling method, clay is rolled into long ropelike coils and then wrapped concentrically one row on top of the other while the vessel is slowly turned to give the pot its rounded shape. Variations in the diameter of these concentric bands give the pot its shape. The surface is then smoothed to mesh the coils together and then covered with a fine slip, a creamy mixture of clay and water. The piece is finally fired at high temperatures making the clay stronger and virtually watertight after the object cooled. More than likely, the first clay vessels were laid in the sun to dry and harden in the same manner as sun-dried bricks were made for building houses.

FIGURE 1–4 This piece of domestic pottery features a practical design; its lid is the shape of a bowl and fits snuggly on top of the two-handled jar.
Alan Hills and Barbara Winter
© The British Museum

While some of the earliest pottery dating back to 6900–6800 BCE excavated to date lacks surface decoration, fragments discovered as early as 6000 BCE show simple geometric designs. Painted decorations were applied with a brush using a slip with natural minerals added for coloring. Once fired, these added minerals changed into brilliant colors (Figure 1–5). Other methods of ornamentation seen on various examples found in Mesopotamia, Africa, and the Mediterranean include both incised and relief designs. Incised designs were created while the clay was still wet; a sharp tool was used to draw designs into the surface of the clay before firing. In relief work, separately formed designs from wet

FIGURE 1–5 A pottery shard excavated in Romania and dating from c. 6000 BCE shows a colorful red and yellow pattern outlined in black.
Dave King © Dorling Kindersley, Courtesy of the University Museum of Archaeology and Anthropology, Cambridge

clay were applied to the pot using a slip for bonding the ornament to the surface of the pot (Figure 1–6).

The shapes and sizes of pottery produced during the Neolithic period were determined by their function. For storage and pouring of wine or other liquids, the vessel usually had a handled base for gripping and a long neck or spigot for easy pouring (Figure 1–7). A drinking cup was often two handled, and its broad basin rested on a footed base to keep the cup from tipping over. Wide-mouthed jars were fitted with tight lids and held grains, whereas other objects were fashioned into bowls and saucers.

Other practical vessels discovered from Neolithic sites included several lamps. Made from hollowed-out stone or pottery, the lamps were shaped into bowls to be filled later with oil or animal fat and a wick for burning the fuel. The wick, made from twisted grass or reed, absorbed the oil and kept the lamp alight. These early lamps were small enough to be carried from place to place, as they were necessary both inside and outside the home. From this simple bowl shape, more practical designs developed, such as those with fold-over tops or lips that kept oil from spilling out when carried, and narrow spouts or funnels to keep the wick in place (Figure 1–8).

Neolithic Weaving and Textiles

During the Paleolithic period, floor coverings consisted of animal skins laid on the floors of caves. With the discovery of ivory or bone needles threaded with animal sinew, animal skins were sewn together to make the earliest form of clothing. The process of weaving is thought to date back to the Stone Age as small sculptures of female figures show tightly braided hair.

Because Neolithic people survived by fishing and corralling livestock, more than likely, nets and ropes developed as a means of survival. Moreover, the roofs of houses during this period were made by interlacing thatch, reeds, or palm fronds together to protect against the weather. The technique

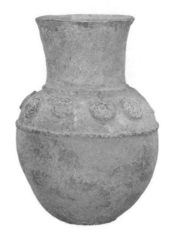

FIGURE 1–6 A Neolithic terra-cotta vessel from Anatolia dating from c. 3000 BCE shows relief work banding and applied lotus flowers.
© Judith Miller/Dorling Kindersley/Sloan's

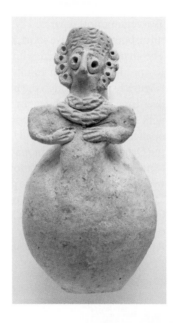

FIGURE 1–7 This interesting flask from the Middle Euphrates region (modern-day Syria) c. 2400–2000 BCE is fashioned into the head, shoulders, and arms of a woman. Her curly hair, eyes, and necklace were created with relief work and digging into the wet clay before firing.
Alan Hills and Barbara Winter © The British Museum

FIGURE 1–8 This terra-cotta oil lamp from Palestine c. 2000 BCE has a shaped spout for holding a wick.
© Judith Miller/Dorling Kindersley/Ancient Art

FIGURE 1–9 This fragment of speckled black cloth found during excavations at Catal Huyuk was woven from woolen yarns.
© Arlette Mellaart

COMPARATIVE DESIGNS

Two ceramic pots separated by four thousand years of history share common design features; both vessels have short, rounded bodies, yet their decorations are vastly different. The first pot, decorated with red and black coloring, dates from 2700–2200 BCE. Its mottled coloration resulted from a chemical reaction during the firing process (Figure 1–10). Although the basic function and shape of pots have not changed much over time, the English teapot from the eighteenth century is meticulously decorated with polychrome floral designs accented in gold (Figure 1–11). As trade routes opened between Europe and China during the eighteenth century, drinking tea from the Orient became a fashionable pasttime for well-to-do Europeans. The decorations featured on the English teapot reflect the wealth and sophisticated taste of its owner, which was meant to impress guests invited for tea.

In the Victorian period of the nineteenth century, statuettes such as that shown in Figure 1–13 were made as knick-knacks that middle-class and affluent consumers collected for their decorative value. The similarities between the ceramic objects in Figures 1–12 and 1–13 are obvious—both sets of sculptures feature the horse. The

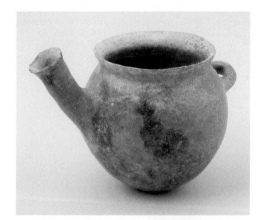

FIGURE 1–10 This early Bronze Age red and black mottled pottery vessel dating from c. 2700–2200 BCE has the characteristics of a modern teapot.
© Judith Miller/Dorling Kindersley/Helios Gallery

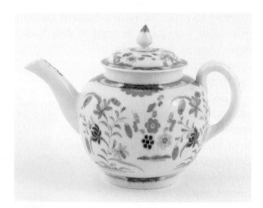

FIGURE 1–11 This Worcester ware teapot from the eighteenth century features polychrome decorations with gilt accents.
© Judith Miller/Dorling Kindersley/Gorringes

of overlapping fibers may have started with hair braiding or the fishing net, but basket weaving became a prolific craft in Neolithic cultures. Baskets made from the over-and-under technique of interlacing reeds and grasses gave someone the idea to take these cellulosic fibers and spin them into yarns for producing textiles. Evidence of flax (linen) and wool yarns in textile fragments was found in several Neolithic sites in central Europe, the Middle East, and China. Excavations at Catal Huyuk also provided scholars with textile clothing fragments believed to date back to 5800 BCE and sections of woven grasses that were used as floor mats (Figure 1–9). Eventually, the process of weaving was made more productive around 5000 BCE with the introduction of the loom.

COMPARATIVE DESIGNS

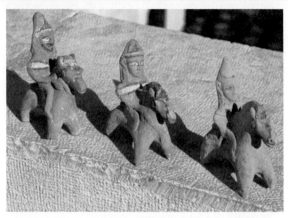

FIGURE 1–12 Small figurines were found in many Neolithic sites, although their original purpose is unclear. These three quaint equestrians immortalized in clay could have been toys for children or made to commemorate a military victory.
Alistair Duncan © Dorling Kindersley

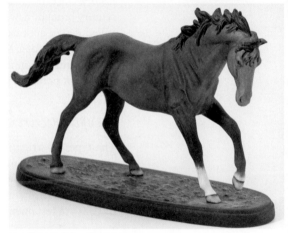

FIGURE 1–13 The Royal Doulton Company in England began making art pottery in 1815. This horse, with its attention to fine detail, was made by pressing hard-paste porcelain into a mold and firing.
© Judith Miller/Dorling Kindersley/Potteries Specialist Auctions

Neolithic example in Figure 1–12 shows both horse and rider, whereas the sculpture dating from the early nineteenth century is a lone horse depicted in a trotting motion.

Stylistically, there are many differences between the sets. The Neolithic equestrians are rendered in a primitive manor; the artist conveyed the features of humans and horses but with the most rudimentary details. The sculpture from the nineteenth century is more realistic. This artist painstakingly captured every detail of the horse in motion from the raised hoof to the wind-blown mane and tail. These varying degrees of complexity reveal the skill levels of their respective artists and reflect the technologies available at the time.

The rough texture of the terra-cotta clay used by the Neolithic artist limited the ability to create precise details. With the introduction of hard-paste porcelain in the eighteenth century, European ceramicists were able to capture the minutest details in clay. In conclusion, these small sculptures reveal much about the respective cultural milieus from which they came.

Ancient Egypt

Perhaps one of the most fascinating Neolithic cultures to develop was that of the Egyptians. As early as 4000 BCE, advanced settlements developed along the Nile River in northeastern Africa. In 3000 BCE, these various tribes united into one cohesive government under the leadership of King Narmer. This unification led to strong economic development and military might and positioned Egypt as one of the great nations bordering the Mediterranean. Divided into three periods, the Old, Middle, and New Kingdoms, Egypt's lengthy history included thirty dynasties and such notorious rulers as Ramses I, Tutankhamun, and Cleopatra. During each period within this history, lavish building projects occurred, many of which survive to this day. The Great Pyramids near Giza, Queen Hatshepsut's Temple outside of Luxor, and the numerous burial tombs in the Valley of the Kings and the Valley of the Queens are only a few of the reminders of the advancements made by the Egyptians. Excavations at these and other sites have yielded thousands of artifacts that tell us much about how the ancient Egyptians lived.

The accomplishments of ancient Egyptian artisans—from architects to tomb painters to furniture makers—influenced and inspired designers throughout modern history. Once the French emperor Napoleon's campaigns into Egypt in the late eighteenth century brought news and drawings of this great culture back to Europe, Egyptian-inspired design appeared in interiors and in furniture styles and related decorative arts throughout Europe. More recently, after the discovery of the Middle Kingdom tomb of King Tutankhamun in 1922, Egyptian designs reemerged in the styles of the Art Deco movement prevalent in Europe and North America throughout the 1920s and 1930s.

Egyptian Architectural Settings

The types of structures built during the Old, Middle, and New Kingdoms include many tombs, monuments, and temples, palaces for the pharaohs, villas for the wealthy, and mud brick houses for skilled laborers and townspeople. Egyptian burial practices ensured that their cultural history would not be forgotten; the Great Pyramids outside of Giza are testament to the immortality of Old Kingdom pharaohs (Figure 1–14).

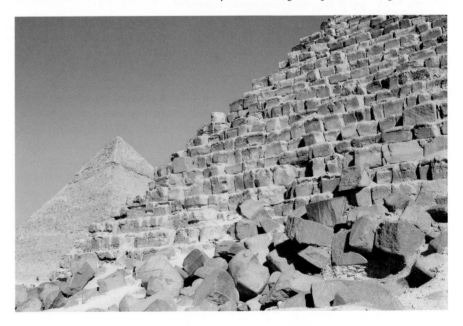

FIGURE 1–14 The Great Pyramids in Giza are over five thousand years old and date back to the Old Kingdom in Egypt. Burial tombs for the pharaohs, both pyramids and rock-cut tombs, held mummies of the deceased, who were entombed with all their worldly possessions.
Treena M. Crochet

The afterlife was so much a part of Egyptian culture that elaborate tombs for the nobility or royalty— whether pyramids or rock cut—were lavishly decorated with scenes of the life of the deceased. Filled with the worldly comforts of home such as food, wine, furniture, perfumes, jewelry, clothing, and sometimes boats and chariots, these tombs ensured that the "ka," or spirit, could enjoy them in the afterlife.

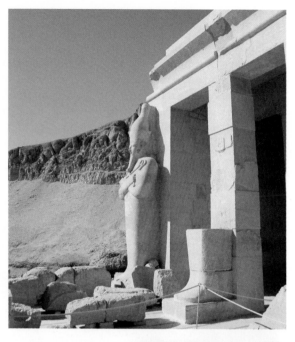

FIGURE 1–15 The entrance to Queen Hatshepsut's funerary temple outside Luxor incorporates a colossal sculpture of Osiris wearing the regalia of a pharaoh: crown, false beard, and scepter. Traces of the original red paint are seen on the statue's left cheek.
Treena M. Crochet

Temples built during the reign of the pharaoh exalted their powers among their compatriots and were the settings for religious ceremonies. Remnants of these many temples still exist in the hot, arid climate of Egypt giving clues to the past and hints at the lavish paintings and colossal statues that once adorned them (Figure 1–15). These tombs and temples were covered with bright and colorful wall paintings illustrating day-to-day life and important religious practices of the ancient Egyptians— including the rites of passage into the afterlife. In addition to these wall paintings, the tombs also had elaborate designs on floors and ceilings (Figure 1–16). The hieroglyphic writing that accompanied these images was undecipherable until the discovery of the Rosetta Stone in 1799. The stone tablet had both Greek and Egyptian hieroglyphs, which allowed scholars to break the code. Archaeologists are now able to read these hieroglyphics and gain insights into ancient Egyptian culture.

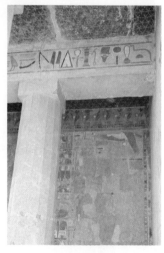

FIGURE 1–16 Brightly colored hieroglyphics and design motifs decorate the entrance hall to a temple near Luxor. The barrel-vaulted ceiling is painted with a dark blue background with stylized gold stars indicating the night sky ruled over by the goddess Nut. Geometric patterns create border designs around wall panels.
Treena M. Crochet

Modestly sized mud brick houses provided shelter for others less noble, who lived in towns or sites around the vast building projects of pyramids and temples. These houses were furnished with the essentials for domestic life (Figure 1–17). Tomb paintings display colorful scenes of workers at their tasks making wine, fishing, herding cattle, and making pottery. These scenes reveal that the Egyptian economy was dependent on a large workforce, as they, too, were immortalized within the tombs.

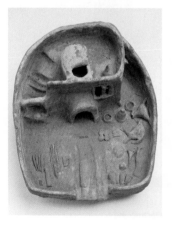

FIGURE 1–17 This terra-cotta model dates from c. 1900 BCE and shows a two-story house surrounded by a high wall with food offerings and household tools laid out in the front yard. "Soul houses" such as this one indicate what houses for working-class Egyptians might have looked like. They were placed in the burial tomb of the deceased for sustenance in the afterlife.
Peter Hayman © The British Museum

Egyptian Design Motifs

Design motifs adorning furniture, lamps, textiles, and the interiors of tombs and temples were inspired by the natural surroundings of Egypt's lifeblood, the Nile River. Lotus and papyrus blossoms, flowering roses, and the river's fluid waters were simplified into stylized renditions for both decorative and symbolic purposes. Separately, lotus and papyrus designs were once the national symbols of Upper and Lower Egypt, respectively (Figures 1–18 through 1–21). Once King Narmer unified Egypt, the lotus and papyrus were paired or intertwined as a symbol of unity (Figures 1–22 through 1–24).

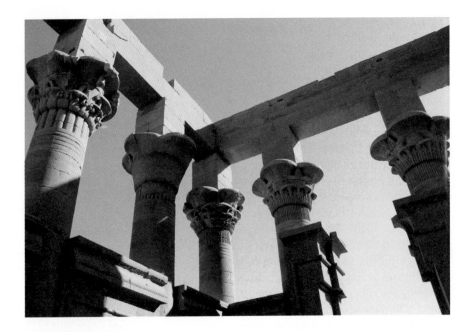

FIGURE 1–18 The columns on this temple from ancient Egypt feature capitals fashioned into the shapes of opening flowers. During ancient times, architectural elements such as these were painted in bright colors to give a more realistic appearance to the flowers and create greater visibility from a distance.
Treena M. Crochet

FIGURE 1–19 Stylized lotus buds were repeated in a linear fashion to create decorative borders on architecture and accessories.

FIGURE 1–20 Alternating lotus buds and blossoms were combined to create a colorful design.

FIGURE 1–22 Papyrus blossoms were repeated in large and small sizes to create brightly colored decorative borders on architecture and decorative accessories.

FIGURE 1–23 The papyrus blossom and lotus bud were repeated to create this colorful border design.

FIGURE 1–21 The vertical arrangement of repeated papyrus flowers suggests that this pattern was used to outline a door opening.

FIGURE 1–24 A relief carving from inside an ancient Egyptian temple shows one example of how artisans used alternating papyrus blossoms and lotus buds for decorating interiors. *Treena M. Crochet*

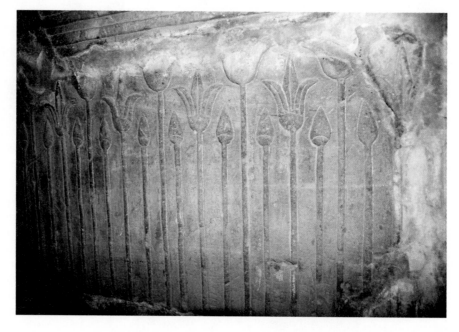

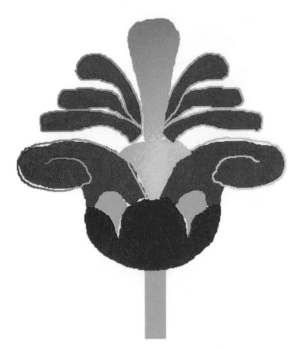

FIGURE 1–25 A palmette flower was rendered as a single design motif.

FIGURE 1–26 Rose blossoms were repeated in this rosette design.

FIGURE 1–27 Spiral wave motifs were geometric interpretations of the swirling currents of the Nile.

FIGURE 1–28 Repetitive rosettes are framed between two rows of stylized wave designs. The interlocking circles, called guilloche, represent the rise and fall of ocean waves.

FIGURE 1–29 The combination of spiral waves and rosettes created this interesting block pattern.

Other floral motifs that evolved in ancient Egypt included palmettes and blossoming roses. Palmettes were stylizations of intertwining lotus and papyrus blossoms fashioned into the shape of palm trees (Figure 1–25). Rosettes featured a simple flower designed with a contrasting center and radiating petals (Figure 1–26). The rosette motif was used repeatedly as border decorations on the walls, floors, and ceilings of tombs and temples, and appeared on the surfaces of decorative accessories. Other stylizations included the spiral wave motif, an abstraction of the swiftly moving water of the Nile rendered as swirling spirals (Figure 1–27). Often, these motifs were combined

FIGURE 1–30 Alternating rosettes and spirals created this block design.

FIGURE 1–31 Fret or Greek key designs meander around rosettes in this block pattern.

FIGURE 1–32 Ancient Egyptians viewed this motif as a representation of the god Re, shown here with the opened wings of a hawk clutching the sun.

FIGURE 1–33 The god Anubis appears here as a jackal-headed man.

and repeated to create lavish patterning for walls, floors, and ceilings (Figures 1–28 through 1–31).

Other motifs had symbolic meanings; Egyptian spirituality was based on a system of gods and goddesses who ruled over the earth and the heavens. The sun god Re was supreme, Anubis was the god over mummification, and Osiris ruled the underworld throughout eternity (Figures 1–32, 1–33, 1–15). These gods were represented as mythical figures; for example, the falcon or hawk was a symbol for the god Horus, who, along with the sphinx, protected the reigning pharaoh (Figures 1–34, 1–35).

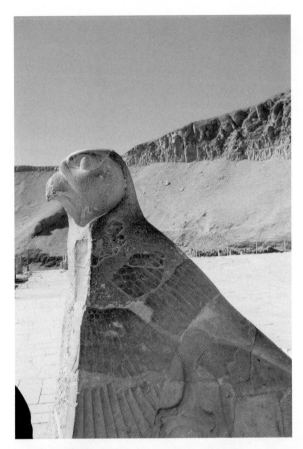

FIGURE 1–34 Symbolizing the Egyptian god Horus, this oversized sculpture guards the entrance walkway to Queen Hatshepsut's Temple. The winged hawk, vulture, and falcon were seen as protectors of the pharaoh in Egyptian iconography.
Treena M. Crochet

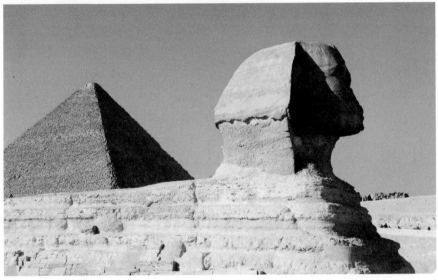

FIGURE 1–35 A colossal figure of the sphinx (half man, half lion) stands guard in front of the Great Pyramids at Giza.
Treena M. Crochet

Like the sphinx, the griffin symbolized protection and appeared in artwork as a winged lion (Figure 1–36). The ankh symbolized life; its design is an abstraction of the womb and birth canal (Figure 1–37).

Geometric designs were plentiful and used extensively inside tombs as border designs or loose abstractions of natural elements (Figure 1–38). The chevron motif

FIGURE 1–36 A protective figure, the griffin is a mythological creature having the body of a lion and the wings of an eagle.

FIGURE 1–37 The Egyptian symbol for life, an ankh represents the womb and connecting birth canal.

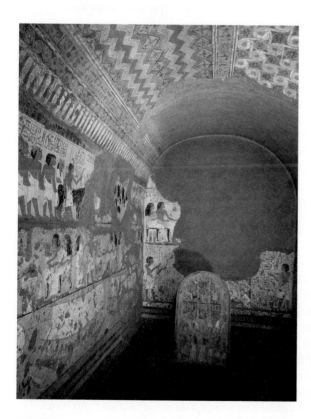

FIGURE 1–38 A modest-sized tomb belonging to the Egyptian artist Maia dates from the New Kingdom c. 1390–1352 BCE and shows ornately decorated walls and ceilings. The barrel-vaulted ceiling has chevron patterns in blues and reds on one side, with a spiral wave pattern on the other. *Picture Desk, Inc./Kobal Collection*

featured rows of zigzags indicating the movement of the Nile's forceful current (Figure 1–39). The fret motif symbolized the cresting waves of the Mediterranean Sea running in succession to the shore (Figure 1–40). Artisans used checkerboard patterns and wide bands of alternating colors to fill in around landscape paintings and scenes of daily life inside the tombs (Figures 1–41, 1–52).

FIGURE 1–39 The chevron motif with rows of zigzags represented the flowing water of the Nile.

FIGURE 1–40 The fret design was a geometric stylization of the cresting waves of the Mediterranean Sea.

FIGURE 1–41 A simple checkerboard design was used as a border on walls and floors inside Egyptian tombs and temples.

Egyptian Interior Furnishings

The discovery of King Tutankhamun's tomb in 1922 by the British archaeologist Howard Carter was one of the most impressive of the twentieth century. Now on display in the Egyptian Museum in Cairo, artifacts taken from the tomb—chairs, beds, tables, lamps, and chests along with a multitude of floor coverings, fabrics, and vases—document the refinement of royal possessions and the skill of the ancient Egyptian artists. Sealed away in the boy-king's tomb since 1325 BCE, and preserved against centuries of decay-causing elements, these artifacts are some of the best examples in existence from the New Kingdom and give a complete picture of the possessions of the pharaohs.

The artifacts found inside King Tutankhamun's tomb were made in royal workshops and show a range in artisanship from the most elegant (for the pharaoh's use) to the most basic (for use by the pharaoh's domestic servants). Those objects made for the pharaoh were carved from wood and incorporated design motifs made more vibrant through gilding, a process of applying gold to the surface of an object (Figure 1–42). Hammered gold and silver were also used to make dazzling coverings over wooden chests and boxes. The creamy white of carved alabaster vessels was contrasted against gold painted designs. Other forms of decoration included inlaid designs of semiprecious stones, bone, ivory, and faience, a glasslike substance made from silica.

Although the tombs yielded many examples of the types of household furnishings the royal court enjoyed, those not belonging to the nobility used simply designed, functional furnishings (Figure 1–43). Hieroglyphic texts that documented extensive

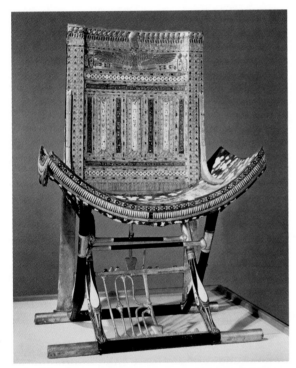

FIGURE 1–42 A highly decorative throne chair found in the tomb of King Tutankhamun features design motifs having spiritual significance; a falcon with its wings spread wide and the solar disk symbolizing the sun god Re appears on the crest rail offering protection to the pharaoh. Other motifs decorating the chair include lotus and papyrus blossoms, rosettes, and checkerboard patterns.
Robert Harding World Imagery

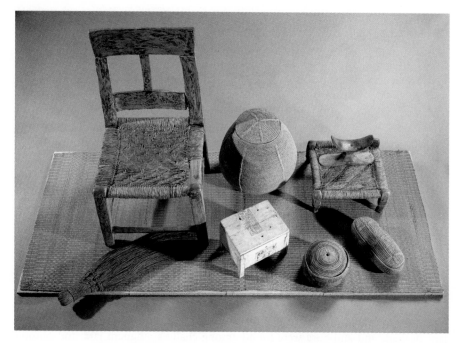

FIGURE 1–43 Household furnishings made of wood, rush, and palm and removed from a tomb dating from the New Kingdom represent the most basic items necessary for domestic life—a chair, stool, table, baskets, and woven rush floor mat. *Picture Desk, Inc./Kobal Collection*

inventories of more modest homes for tax purposes list chairs, tables, beds, lamps, vases, kitchenware, rugs, and cushions as part of the household.

Egyptian Vessels and Containers

As early as the Old Kingdom, Egyptian artists were applying a colorful glaze over earthenware objects ranging from jewelry to amulets. Known as *faience,* the glaze made from a silica-based material gave the appearance of glass when fired. Glass-making techniques traced back to the ancient Egyptians included both the core forming and mosaic methods. Core forming (Figure 1–44) involves the application of molten glass over a core of formed clay and sand, or animal dung. Once the desired colors are applied over the core's surface, the glass is cooled and the inner core dug out with a stick or long tool.

Mosaic glass, produced in Egypt after 1390 BCE, became a leading export to other regions of the Mediterranean, even though these regions had knowledge of glass-making processes. The mosaic glass-making method created multicolored designs on the surfaces of vases and bowls. Glassmakers positioned an assortment of hardened glass rods and beads on a ceramic surface, then placed this ceramic palette into a furnace to soften and fuse the rods and beads together. Working the glass while still soft, glassmakers shaped the malleable glass and created surface patterns by dragging a tool

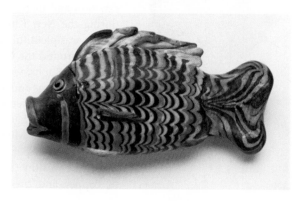

FIGURE 1–44 This whimsical fish made from the core method of glass-making stored scented oils or cosmetics. *Peter Hayman © The British Museum*

across the fused rods and beads, producing swirls of brilliant color. To avoid breakage, the glass was cooled slowly.

Like other ancient cultures, Egypt relied on ceramic production to provide the necessary household vessels for food storage, eating, and drinking. The advent of the potter's wheel at first, a primitive wooden turntable, is traced back to at least 3000 BCE, with evidence verified through potsherds discovered in Mesopotamia. In fact, Egyptian tomb paintings discovered in Beni Hasan dating to around 1900 BCE document the business of manufacturing pottery for both domestic and export markets. Egyptian pottery depicted in tomb paintings is plain and undecorated, yet examples found in excavated sites show some elaboration (Figure 1–45). Geometric designs were painted on the clay's surface with a mineral-enriched slip, and the pieces were then fired to harden the clay and bring out the color of the slip.

Vessels found inside King Tutankhamun's tomb held a variety of goods from foodstuffs to perfumes and kohl—a makeup used to line the eyes. Ordinary ceramic jars, beakers, and amphora were found among chalices, unguent jars, and canopic containers elaborately carved from alabaster. Today, modern artisans in Egypt carve and chisel alabaster into beautiful vases for the tourist industry using methods dating back to these ancient times. Because alabaster has a translucency that allows light to filter through, it is the perfect material for making lamps (Figure 1–46). Animal fat or plant oils kept a wick made from twisted linen cloth or flax reed burning. Alabaster was later used for windows before glass panes become affordable.

Egyptian Metalworking

Leaving the Stone Age behind, people in the Neolithic period made impressive technological advances in metallurgy, and the developing Iron and Bronze Ages supported increased mining for iron, copper, and tin. Ancient Egyptians made weaponry, jewelry, and domestic objects; and their skills as metalworkers are traced to around 4000 BCE. Metalworking developed into a recognized art form as objects were created either by hammering sheets of metal into desired shapes or smoothing thin sheets of metal over wooden forms—a form of gilding. The practice of smelting raw ores and methods of mold casting developed during the New Kingdom. Indigenous to Egypt, copper was plentiful and greatly exported to other regions around the Mediterranean. Gold, reserved for the pharaohs, was used freely on their household furnishings and jewelry.

Domestic objects fashioned from metal included mirrors that reflected images from their polished surfaces. Mirrors were small and handheld and were very expensive; thus they became a luxury of the wealthy (Figure 1–47). Bronze, an alloy of copper and tin, proved suitable for making

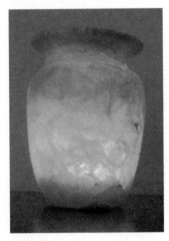

FIGURE 1–45 A tomb painting from the New Kingdom in Egypt shows various pottery jugs, bowls, and vases on tables placed in front of the god Anubis.
Treena M. Crochet

FIGURE 1–46 The translucent qualities of alabaster are shown in this lit candle vase from modern-day Egypt.
Treena M. Crochet

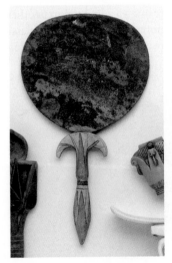

FIGURE 1–47 This bronze mirror is attached to a handle fashioned into a papyrus blossom. Only wealthy Egyptians owned handheld mirrors like this one.
Peter Hayman © The British Museum

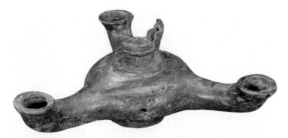

FIGURE 1–48 A bronze lamp fashioned into three arms for holding wicks and a hinged lid encircled with hieroglyphics for holding the oil.

© Judith Miller/Dorling Kindersley/Sloan's

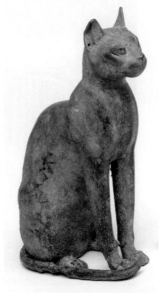

FIGURE 1–49 This bronze statue of a cat represents Bastet, the goddess in Egyptian mythology who protected pregnant women and was the goddess of love, joy, and pleasure.

Peter Hayman © The British Museum

lamps because the metal was more durable than ceramic (Figure 1–48). Amulets, also made from bronze, were fashioned into deities that were believed to bestow protective and spiritual powers on those who owned them (Figure 1–49).

Egyptian Weaving and Textiles

Fiber baskets made using either the coiled, plaited, or braided method were plentiful, allowing households to run efficiently by storing a variety of domestic wares (Figure 1–50). In fact, found inside the tomb of King Tutankhamun were several baskets containing the remains of flowers, fabrics, and grains. Woven floor mats became more common in Egyptian households by the New Kingdom, replacing the earlier practice of scattering straw over the beaten earth floors. Woven from cellulosic fibers such as flax, floor mats ranged from those with simple designs to those embellished with colorful patterns (Figure 1–51).

FIGURE 1–50 This small woven basket found in Deir el Medina has folded cloth inside containing powdered henna. Notice the simple coiling method used in making the basket.

Picture Desk, Inc./Kobal Collection

Textile production during the ancient Egyptian period yielded beautiful linen garments seen worn by men and women in tomb paintings. Egyptian law declared that all garments had to be produced from linen to support the local flax crop. The flax fibers were colored using natural dyes producing bright reds, blues, and yellow ochre. Egyptians used a spindle for twisting the flax fibers into yarns, and textile production was made faster by using a loom. Tomb paintings reveal that there was a booming textile industry in Egypt, with a variety of clothing styles, draperies, and chair cushions. The tombs themselves yielded many still-intact mummy masks and body coverings including those made from wool (Figure 1–52).

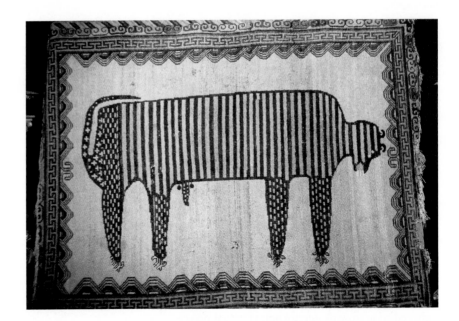

FIGURE 1–51 This 2,300-year-old Egyptian rug depicts an image of a sacred cat.
Linda Whitwam © Dorling Kindersley

Ancient Aegean Cultures

Between the Mediterranean and Aegean seas, a mountainous mainland and cluster of small islands were home to Mycenaean and Minoan settlements. The region's history can be traced back to 3000–2500 BCE at the end of the Neolithic period and the start of the Bronze Age in Europe. The Greek culture evolved from the coalescence of the Mycenaean who lived on the Peloponnesian mainland, the Minoans who lived on the island of Crete, and the tribes who traveled from Neolithic Anatolia and settled in the nearby Cycladic islands.

The evolution of these Aegean settlements into Greek culture took place over several centuries and resulted from a variety of cataclysmic occurrences. Around 1500 BCE, a volcanic eruption on the island of Thera (now Santorini) sent tidal waves throughout the Cycladic islands and into Crete. Many historians believe the location of Plato's description of the lost city of Atlantis is ancient Thera. Earthquakes following the eruption destroyed Minoan settlements and weakened the defenses of the Cretans. The Mycenaeans took advantage of this opportunity; their armies invaded the islands, and the displaced Minoans were assimilated into Mycenaean culture.

The Dorians—a tribe from the north of present-day Greece—invaded the Mycenaean mainland in 1150 BCE. Subsequently, by 1100 BCE, Ionian tribes traveling from the east reestablished the island population. Ultimately, by 776 BCE, the Dorian and Ionian tribes merged to form distinctive city-states extending from mainland Greece and the islands into ancient Mesopotamia, Italy, and eventually Egypt.

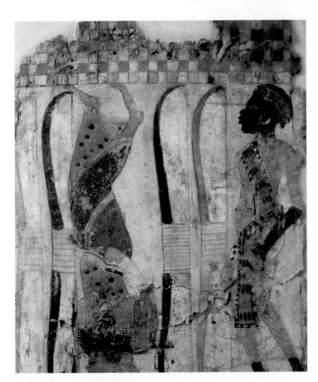

FIGURE 1–52 This painted cloth has human figural patterns that read from both directions, an indication that it was not used as a wall hanging. A painted checkerboard band frames the figures along the top and bottom.
Picture Desk, Inc./Kobal Collection

Canopic jars discovered in ancient Egyptian tombs were integral in the mummification process as receptacles for the deceased's internal organs. Many examples found to date have lids fashioned into either a likeness of the deceased or a rendition of a sacred deity. The canopic jar shown in Figure 1–53 is simple in its design and features colorful geometric bands encircling its bulbous form. A rudimentary likeness of the deceased was fashioned into the lid. When Napoleon's troops invaded Egypt as part of his military campaigns in the eighteenth century, Egyptian-inspired design became fashionable in Europe as his troops brought back souvenirs of their conquests. The jasperware vase made by English potter Josiah Wedgwood (1730–1795) was designed much like the originals discovered in Egypt (Figure 1–54). The lid is fashioned into the image of a pharaoh wearing an official headdress, yet curiously, concentric bands of Egyptian hieroglyphics appear with Greek and Roman mythological figures around the base of the vase in white relief over a blue ground.

These combinations of Egyptian, Greek, and Roman design motifs are indicative of the mood of the Neoclassic period in Europe during Napoleon's reign. The Wedgwood factory produced jasperware sought after by wealthy British patrons. Whether these well-to-do Londoners would have wanted these jars decorating their interiors had they known the originals held mummies' internal organs is questionable.

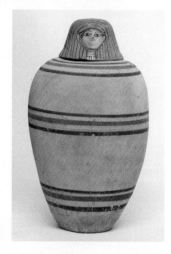

FIGURE 1–53 This canopic jar from ancient Egypt features a stylized head of the deceased.
Peter Hayman © The British Museum

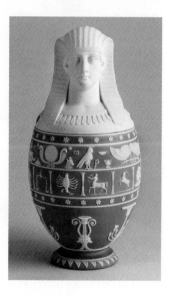

FIGURE 1–54 This Wedgwood jasperware jar dates from the Neoclassic period.
© Judith Miller/Dorling Kindersley/ Woolley and Wallis

Aegean Architectural Settings

Remains of architectural foundations, wall fragments, pottery shards, and funerary and other religious objects excavated from Minoan and Mycenaean sites revealed advanced engineering skills for the period. The most significant discovery of Minoan cultural remains occurred in 1900 with the excavation of the Palace of Knossos on the island of Crete (Figure 1–55). English archaeologist Sir Arthur Evans (1851–1941) accomplished the first successful excavations of the palace after attempts in the nineteenth century had failed. The Palace of Knossos dates to 1600 BCE and was the royal residence of the mythical King Minos. The legend of the labyrinth is thought to have evolved from the palace itself—with 1,500 rooms spread over three stories, it was easy to get lost in its vastness.

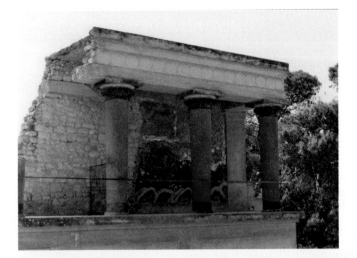

FIGURE 1–55 The Palace of Knossos on the island of Crete, shown in this partial reconstruction interpreted by Sir Arthur Evans, has red painted columns with flared black capitals and circular relief carvings on the frieze.

Treena M. Crochet

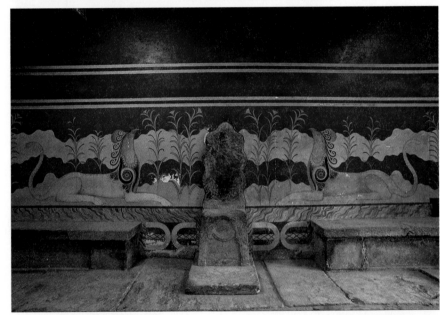

FIGURE 1–56 The throne room in the Palace of Knossos reconstructed to show colorful walls with elaborately painted griffins.

Max Alexander/Dorling Kindersley © Archaeological Receipts Fund (TAP)

The architecturally advanced palace complex had light courts illuminating rooms on all three levels. In addition, sophisticated engineering skills are evident in an elaborate underground plumbing system that brought running water into rooms through a complex network of interlocking clay pipes. Inside the queen's bedchamber are the remains of a bathroom equipped with a flushing toilet system (although primitive by today's standards) and a stone bathtub.

Evans continued to reconstruct the palace based on his findings, although his practice is highly criticized today. He instructed artists to paint murals on the reconstructed walls based on fresco fragments discovered during excavations. Rebuilt sections of the palace were painted in bright red on door frames and windows following examples seen in fresco fragments. Murals depicted scenes from the Aegean—native animals, plants, and sea creatures framed within geometric patterned borders. Little evidence of interior furnishings survived except inside the royal throne room. The walls of the room were covered in bright red frescoes featuring mythical creatures and abundant plant life with built-in benches and a throne chair carved from stone (Figure 1–56).

Another significant ancient Minoan archaeological site was discovered on the island of Santorini and first excavated in 1967. Dating to 2000–1650 BCE, the city of Akrotiri was instrumental in providing scholars with the understanding of what a typical town of the period looked like. Sophisticated city planning with carefully laid out streets and public squares, multiple-storied houses, and shops revealed a highly developed culture. Like the Palace of Knossos, the town of Akrotiri was equipped with underground plumbing furnishing running hot and cold water. Unfortunately, the warm thermal springs feeding into the public water system were an early indicator of an impending volcanic eruption, which eventually destroyed the city in 1500 BCE.

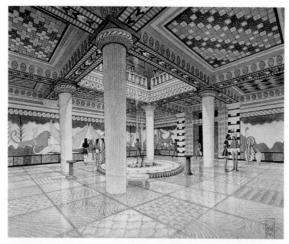

FIGURE 1–57 A reconstruction drawing depicts the throne room of the Megaron at the Mycenaean Palace of Nestor as it might have looked in the thirteenth century BCE. The painting reveals lavish and colorful frescoes of lively animals, stylized plants, and bold geometric patterning on walls, floors, and ceilings.

Piet de Jong, The Throne Room of the Megaron. *Reproduced by permission of the Department of Classics, University of Cincinnati.*

Aegean Design Motifs

Excavations of Mycenaean and Minoan palaces revealed bright and colorful paintings on walls, ceilings, and floors, which were also covered with decorative designs. Excavations began in 1939 in the Peloponnesian town of Pylos, where evidence of a great palace was discovered. Further excavations at this site yielded artifacts from the Palace of Nestor, including several fresco fragments revealing narrative scenes surrounded by geometric borders and marine motifs (Figure 1–57). Minoan and Mycenaean artists celebrated the surrounding marine life, combining playful water creatures such as dolphins, octopuses, and coastal plant life with strong geometric patterning (Figures 1–58, 1–59). Furthermore, economic trade between countries bordering the Mediterranean brought the influences of ancient Egyptian design motifs into Minoan and Mycenaean culture. Motifs included the spiral wave and rosette designs similar to those used by the Egyptians (Figures 1–60, 1–61) as well as more stylized variations (Figures 1–62 through 1–65).

FIGURE 1–58 This medallion incorporates stylized marine plants in its design.

FIGURE 1–59 Fret motifs arranged to create a dizzying maze of line and pattern recall the myth of the labyrinth inside the Palace of Knossos.

FIGURE 1–60 The hypnotic spirals in this pattern represent swirling ocean currents.

FIGURE 1–61 Framed by flat, linear bands of color, rosette designs were further abstracted using simple radiating lines.

FIGURE 1–62 The interlocking circles of the guilloche motif are further abstractions of the spiral wave motif and are shown here framed by blocks of alternating colors.

FIGURE 1–64 This elongated rosette design has a wide band at its center. The motif was seen on Mycenaean frescoes.

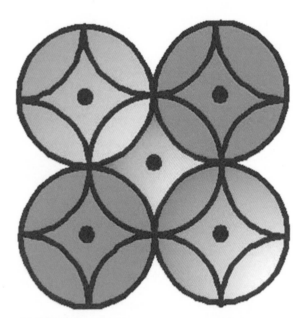

FIGURE 1–63 Circles with a central dot and quadrant sections were repeated to create this allover pattern of abstracted rosettes.

FIGURE 1–65 Taken from a Mycenaean button design, playful swirls and an abstracted octopus create interesting patterns inside this medallion.

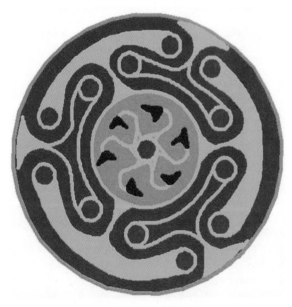

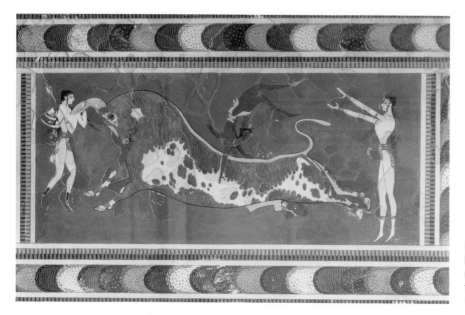

FIGURE 1–66 The leaping of the bulls, an event from Minoan funerary rituals, is represented in this painting from the Palace of Knossos.
Corbis/Bettmann

Similar to the Egyptians, the Aegean cultures favored designs that had symbolic or spiritual meanings. Animals such as griffins and bulls were plentiful; the bull was a precious sacrifice to the gods, and its representation in murals depicting sacrificial rites speaks to the legend of the Minotaur (Figure 1–66). The griffin, introduced to the Mediterranean regions from Persia, was a symbol of strength to the Minoans. The throne room in the Palace of Knossos depicts these winged creatures flanking the throne and protecting the king (Figure 1–56).

Aegean Interior Furnishings

Evidence of furniture from the ancient Aegean cultures is scarce. Unlike the airtight tombs of the Egyptians, the humid climate of the Aegean Sea destroyed artifacts made from wood. Minoans buried their dead but without their worldly possessions. The Mycenaeans practiced inhumation and cremation—placing the personal possessions of the deceased on the funeral pyre or in the tomb. Evans' excavations of the Palace at Knossos yielded few examples of furniture. The remains of a gilt wood box were recovered from a royal Mycenaean tomb (Figure 1–67). Fresco fragments from these ancient sites are the best indicators of the kinds of furniture that existed during the period: chairs, stools, footstools, and tables.

Aegean Vessels and Containers

The development of the potter's wheel on the island of Crete traced to 2300 BCE advanced the Aegean ceramic industry into producing inexpensive containers used by all classes of society for domestic purposes. Ceramic containers were an important part of daily life, storing the food supplies of the household (Figure 1–68). The art of Aegean pottery making

FIGURE 1–67 This wooden box covered with gilt-paneled decorative scenes dates from the sixteenth century BCE and was recovered from a Mycenaean tomb.
Picture Desk, Inc./Kobal Collection

FIGURE 1–68 Found buried beneath the rubble of houses in Akrotiri, these large jars and pots once stored food and grains. Geometric banding, a common form of early Minoan decoration, appears on one of the jars.
Treena M. Crochet

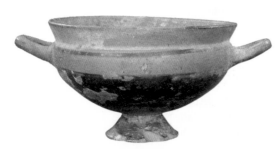

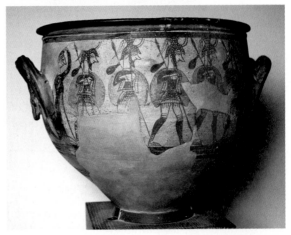

FIGURE 1–69 This Mycenaean buffware footed cup with two handles was used for mixing water and wine; its two-tone coloring is a form of early pottery decoration.
© *Judith Miller/Dorling Kindersley/Sloan's*

FIGURE 1–70 This partially reconstructed two-handled warrior vase from Mycenaean Greece dates from c. fourteenth to twelfth centuries BCE and features a military procession. The rendering of soldiers is crude, although the details of weaponry and armor are clearly represented.
Studio Kontos Photostock

became specialized with one artist forming the clay into a variety of shapes while another applied the decorations. The designs ranged from simple geometric banding to designs inspired by nature in the form of spiral waves and plant and sea life (Figure 1–69).

By the fourteenth century BCE, pictorial scenes like those painted on the palace walls started to appear on the surfaces of ceramicware (Figure 1–70). It is widely accepted that these scenes documented historical and mythological events, including stories about the gods and goddesses and great battles. These ceramicwares were instrumental in the home schooling of children—what better way for children to learn about their heritage than seeing these dramatic narratives on the family milk jug?

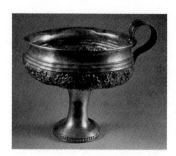

FIGURE 1–71 This gold chalice has hammered rosette designs, a footed base, and a gooseneck handle. Tiny bead patterns are shown on the handle and around its footed base. The chalice was found in the royal burial tombs at Mycenae on mainland Greece.
Picture Desk, Inc./Kobal Collection

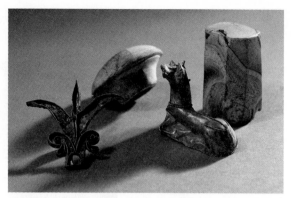

FIGURE 1–72 Found in the treasures of Kadmeion in Thebes, Greece, these small sculptures—one a palmette design and the other a seated bull—are made of gold and date from the second millennium BCE.
Picture Desk, Inc./Kobal Collection

Aegean Metalworking

The Bronze Age of the Aegeans, dating between 3200 and 1050 BCE, is marked by the introduction of smelting copper and tin imported into the region to produce bronze. Artisans used bronze in the production of weaponry, vessels, and jewelry, and their craft was widely exported. Cast and hammered gold cups, rhytons (drinking cups), and plates found inside Aegean royal burial tombs had metalwork designs showing exquisite artisanship like that of objects found in King Tutankhamun's tomb in Egypt (Figure 1–71). Golden artifacts excavated from royal burial tombs in Mycenae and Pylos included jewelry, amulets, and vessels used in offerings to the gods (Figure 1–72).

Aegean Weaving and Textiles

Although small fragments of textiles have been found in gravesite excavations (mostly the remains of funerary shrouds), the best documentation of the Aegean textile industry comes from ancient Minoan and Mycenaean writing tablets. Woolen fibers taken from gravesites and sheering tools found in other excavations show evidence of a woolen textile industry, although most of the fiber fragments found from this period were made from flax. Like the Egyptians, the Aegean cultures grew flax to produce linen textiles. Furthermore, the discovery of loom weights made from stone and ceramic reveals that the looming process was active in these regions. The frescoes unearthed at the Palace of Knossos show figures outfitted in colorful costumes with lively decorations, and written tablets describe the textiles used in the making of clothing and bed linens (Figure 1–73).

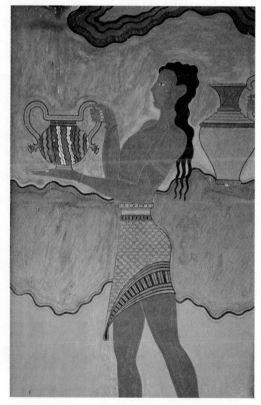

FIGURE 1–73 A fresco from the Palace of Knossos shows a man wearing a colorful loincloth decorated with design motifs. The figure is carrying a ceramic vase with lively geometric designs painted on its surface.
Robert Harding World Imagery

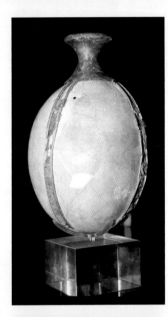

FIGURE 1–74 Made from an ostrich egg bound with gold and bronze settings, this vase was found in Mycenaean Greece and dates from the fourteenth century BCE.
© Ancient Art & Architecture/DanitaDelimont.com

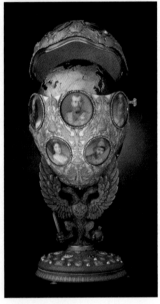

FIGURE 1–75 Peter Carl Faberge began creating his famous eggs in the nineteenth century for the Russian tsar as Easter commemoratives for the royal family.
Aurora & Quanta Productions

A collection of unusual containers made from ostrich eggs was discovered in excavations at Thera, Knossos, Zakros, and Mycenae. The impractical delicacy of the eggshells led scholars to believe these vessels were used in religious ceremonies rather than as domestic objects. Furthermore, examples of ostrich egg vessels also appeared in Egyptian culture and were thought to represent life and creation. The egg motif appears throughout ancient and modern history, incorporated into the design of Greek and Roman temples, Christian churches, and Islamic mosques. Although religious practices have changed throughout history, the symbolic meaning of the egg has remained a part of our modern culture.

The Mycenaean vase shown in Figure 1–74 is one example of twelve ostrich egg vases excavated to date from the Aegean region. The delicate eggshell is protected by metallic bands running from the base to an attached metal neck, and the absence of a footing indicates that the vase was not able to stand on its own. Ostrich egg vases like this one feature a lipped neck, suggesting they were used either as a container for liquids or as rhytons.

The Russian enamelist Peter Carl Faberge (1846–1920) began making his ornate metal eggs in 1884, first for Tsar Alexander III and subsequently for his successor son, Nicholas II. The first eggs were made as gifts to the tsarina in honor of the Christian celebration of Easter. Faberge continued making eggs for the imperial family until the execution of the Russian tsar and his family in 1918. Faberge made the eggs primarily from gold and silver, each featuring lavish decoration in jewels and enameled designs. The Faberge egg shown in Figure 1–75 was made in 1913 to commemorate the three hundredth anniversary of Romanov rule over Russia.

Ancient Greece and Rome

TIMELINE

Ancient Greece

2000–1000 BCE		
	1200	Dorians invade Greece.
1000–500 BCE		Archaic period begins.
		Stone replaces wood as a building material.
		Doric, Ionic, Corinthian orders of architecture introduced.
	850–800	Literature of Homer: *The Iliad* and *The Odyssey.*
	776	First Olympic games held in Olympia.
500–0 BCE		Greek Classical period begins.
	497–479	Persian Wars.
	460	Rule of Pericles.
	447	Construction begins on the Acropolis buildings.
	399	Socrates condemned to death for his philosophical teachings.
	360	Plato publishes his philosophies in *Republic.*
	350	Aristotle writes *The Athenian Constitution.*
	332	Alexander the Great conquers Egypt and Persia.
		Hellenistic period begins.
	190	Sculpture *Nike of Samothrace* created.
	146	Greece becomes a Roman province.

Ancient Rome

1500–500 BCE		Etruscans move into Italy.
		Trabeated architecture develops further with design of Etruscan temples.
	753	Founding of Rome by the mythical Romulus and Remus.
	510	Establishment of Roman Republic period.
	50	Construction begins on the *Pont du Gard* aqueduct.
500–0 BCE		
	30	Crucifixion of Jesus.
	27	Vitruvius completes his *Treatises on Architecture.*
	44	Assassination of Julius Caesar Octavius (Augustus) establishes Roman Imperial period.
	70	Construction begins on the Colosseum in Rome.
	29	Virgil writes *The Aeneid.*
0–500 CE		Composite and Tuscan orders of architecture appear.
	79	Mount Vesuvius erupts.
	118	Construction begins on the Pantheon in Rome.
	235	Late Imperial period begins.
	285	Diocletian divides Empire into East and West.
	313	Constantine legalizes Christianity through the Edict of Milan.
	333	Construction begins on the first St. Peter's Basilica in Rome.
	330	Seat of Roman Empire moved to ancient site of Byzantium in Turkey; city renamed Constantinople.
	410	Sack of Rome.
	476	End of Roman Empire in the West.

Ancient Greece

Four cultural periods shaped Greek history: the Geometric (900–700 BCE), Archaic (700–500 BCE), Classical (500–300 BCE), and Hellenistic (300–100 BCE). During the Archaic period, land was divided among members of a territorial aristocracy who forced workers and merchants to rent property from them or move to the outlying regions of the cities until the organization of city-states around 750 BCE. War plagued Greece, and the region suffered from constant Persian invasions between 500 and 499 BCE.

The Greek ruler Pericles is recognized for establishing a democratic system of government, one that emphasized the individual as a citizen who could own property and compete economically—although women, slaves, and foreigners were excluded from these benefits. Pericles also undertook ambitious building projects including the Acropolis temples in Athens, a main port city with a thriving economy. Greek religious practices were administered by all of the people through festivals, sacrificial offerings, and prayers to their sacred deities. The Acropolis buildings were the site for temples honoring their gods and goddesses. These buildings, designed during the Greek Classical period, became the most influential examples of architecture, providing the standard future cultures would aspire to for their refined proportions.

During the Hellenistic period, Alexander of Macedonia, commonly referred to as Alexander the Great by Western historians, rid the area of Persian dominance through military strength in 331 BCE. By the second century BCE, Alexandria became a key port city on the Mediterranean within the Greek city-states. The power of the Greek Empire was far reaching before the Romans overtook the region in 146 BCE. The Romans adopted much of the Greek way of life including its religious practices, architectural style, and artistic expression. The Greco-Roman style of art and design is considered one of the most enduring of all historical styles and has been assimilated by countless artisans throughout history.

Greek Architectural Settings

Sophisticated town planning occurred in most Greek cities; temples and civic buildings were zoned separately from housing, and economic marketplaces were located near municipal buildings, which attracted the most traffic. Religious buildings were large temples made of stone, primarily marble, whereas public buildings were less monumental and provided spaces for markets, assemblies, and cultural events.

Greek architectural design evolved from that of the Egyptian, Minoan, and Mycenaean cultures and relied on a trabeated system of architecture using post and lintel construction. Large temples had gabled roofs supported by perimeter columns and integral inner columns supporting the beams (Figure 2–1). The Doric, Ionic, and Corinthian orders of architecture prevalent during the Classical period are featured on many Greek temples, with the Corinthian order used inside the structures (Figure 2–2).

The Greeks living at this time did not escape the frequent earthquakes that devastated Minoan culture on the island of ancient Thera. The region is scattered with archaeological sites in various forms of structural decline, as construction techniques at the time did not provide much protection from earthquake damage. Remains of stone foundations give some indication of the layouts of Greek temples and housing. Housing for the working-class populations was made from mud bricks, whereas housing for wealthier citizens was made of stone usually two to four stories in height (Figure 2–3). More upscale homes had interior wall paintings, and floors were covered in either plaster or decorative mosaics. Homer, who lived during the Greek Geometric

FIGURE 2–1 The Parthenon in Athens represents architectural achievements in Greek design with its refined proportions and manipulation of proportional ratios to create a visually perfect structure.
Treena M. Crochet

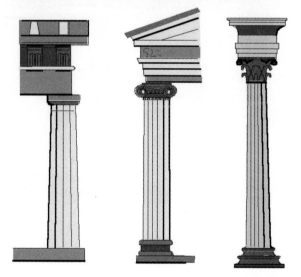

FIGURE 2–2 The three orders of Greek architecture, shown from left to right, are the Doric, Ionic, and Corinthian. The Doric features a broad, flat column, and its shaft rests directly on the floor, or stylobate. A volute capital and column base is used on the Ionic order, and the Corinthian order is recognized by its acanthus leaf capital and flared base.

period, wrote about "lovely dwellings full of precious things," and pottery decorations indicate sophisticated furnishings and architectural details (Figure 2–4).

Greek Design Motifs

Like their Aegean predecessors, the Greeks used design motifs with strong geometric patterning, stylized designs inspired by nature, and animal forms. There is a strong connection between Greek design motifs and those of other cultures in the Mediterranean region; spiral waves, fret borders, and rosettes appear as elaborately carved decorations on Greek buildings, wall paintings, and interior furnishings (Figures 2–5 through 2–7).

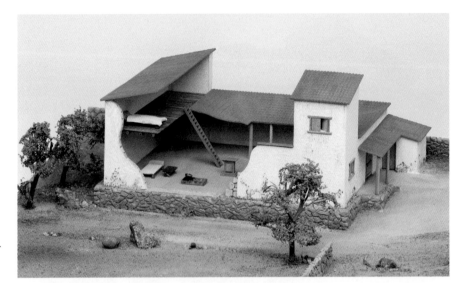

FIGURE 2–3 A cutaway model shows the interior of what a typical Greek farmhouse might have looked like with its vast interior courtyard and upper-level sleeping lofts. The dwelling features a red tile roof, and the exterior walls are covered with stucco.
Bill Gordon © Dorling Kindersley

FIGURE 2–4 This pottery piece shows the front door of a Greek home decorated with circular designs that could represent riveting over heavy metal hinges. Two pottery jars rest on pedestal stands just outside the doors.
Nick Nicholls © The British Museum

FIGURE 2–5 An oil container from ancient Greece is fashioned into the shape of a dolphin, which is shown leaping over waves. The spiral wave was a common design motif used by cultures surrounding the Mediterranean.
Nick Nicholls © The British Museum

FIGURE 2–6 The fret motif, also referred to as a Greek key, appears frequently on artifacts from ancient Greece and Rome.

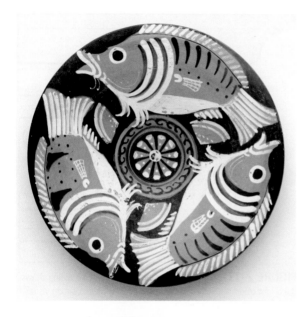

FIGURE 2–7 The inside of a dish shows stylized fish swimming around a central rosette. *Nick Nicholls © The British Museum*

FIGURE 2–8 The antefix is a stylized representation of native Greek flowers and palm fronds.

FIGURE 2–9 Delicate petals grow upward and outward in this stylized rendering of the anthemion.

FIGURE 2–10 Palmette flowers and the anthemion appear in this border design.

FIGURE 2–11 Stylized vine and leaf patterns create a flowing pattern.

Floral designs included the antefix and anthemion, which were Greek variations of the Egyptian palmette flower (Figures 2–8, 2–9). These stylized flowers appeared as finials along the gabled roofs and, along with border designs of honeysuckles and allover floral designs, in the friezes of temples and civic buildings (Figures 2–10, 2–11). Bright, colorful paint—brilliant reds, blues, greens, and gold—further enhanced the motifs on buildings giving these architectural details a stronger presence when viewed at street level (Figures 2–12, 2–13). Artisans incorporated the motifs that appeared on buildings on furniture, pottery, wall hangings, and textiles achieving unified interior and exterior designs.

Additional design motifs based on mythological animals and minor deities included the griffin and those that were half animal and half human, such as the sphinx and triton (Figures 2–14, 2–15). Furthermore, Greek artists incorporated human

FIGURE 2–12 A band of egg and dart details frames borders of palmette and anthemion blooms. Motifs like these were painted to distinguish each part of the design.

FIGURE 2–13 This rendering of a frieze area of a building shows the bright colors applied to design motifs giving them a strong visual presence from the street below.

FIGURE 2–14 The griffin appears as if its wings were made from acanthus leaves.

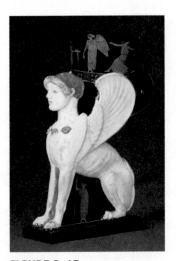

FIGURE 2–15 A black vase with red figure painting is fashioned into the mythical sphinx. Slightly different from Egyptian examples, the Greek and Roman artists depicted the sphinx as a female head on the body of a lion with the wings of an eagle.
Nick Nicholls © The British Museum

representations of the Olympian gods and goddesses into designs that celebrated their existence and power on earth, although these images had lost their spiritual connections when they reappeared as design motifs in later centuries.

Greek Interior Furnishings

Examples of furnishings from ancient Greece are scarce. Because of the humid climate of the region, wood decomposed readily. What remains of Greek furniture are those

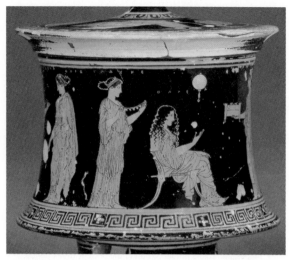

FIGURE 2–16 A woman sits on a klismos chair as servants carrying jewelry and a small chest attend to her dressing. On the wall nearest the seated woman hangs a handheld mirror.
Nick Nicholls © The British Museum

FIGURE 2–17 Drawings show the most fundamental shapes of Greek pottery; from left to right are the kylix, krater, amphora, hydria, and lekythos.

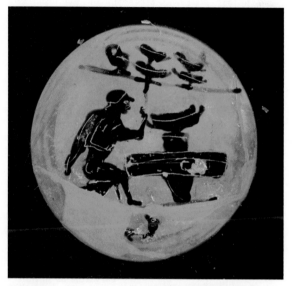

FIGURE 2–18 This scene depicts a man sitting in front of a potter's wheel. An assortment of his wares appears on the shelf behind him.
Nick Nicholls © The British Museum

made from stone or bronze. The decorative paintings on pottery from the period reveal the best examples of what was fashionable for home interiors. Greek furniture design emphasized refined proportions rather than sweeping curves of chair backs and leg forms (Figure 2–16). Working-class homes contained the most basic pieces of furniture necessary to perform domestic functions, such as stools and tables. Most of these items had little or no gilding and limited carving, and rarely used inlay. The affluent households could afford stools, tables, chairs, chests, and reclining couches covered with loose cushions covered in fabric.

Greek Vessels and Containers

Pottery vessels were the most common items found in any home, regardless of the owner's wealth. Various shapes and sizes of containers served many purposes; hydria for water, amphora for wine, and lekythos for oils. The kylix served as a two-handled drinking cup, and the krater was a footed bowl fitted with handles (Figure 2–17). Designs on Greek pottery featured scenes of great historic battles and everyday domestic activities (Figures 2–18, 2–19). The scenes offer information about the life of the ancient culture and were used as teaching tools with young children. Artists who specialized in pottery painting used brushes to paint colored slip on the surface of pots. Firing at high temperatures brought out rich reds and black.

The availability of glass objects in Greece was limited. Vessels made from glass were usually imported from the Phoenicians, who excelled in glass-making techniques. The delicate nature of the material made glass accessories a coveted commodity of the wealthy. Owning glass plates, drinking cups, amphorae, and cosmetic jars in transparent colors with gilt accents was a reflection of great taste and social standing (Figures 2–20, 2–21). Grecian glass was made using mold casting or the coiling method until the end of the Hellenistic period, when glass blowing techniques were introduced.

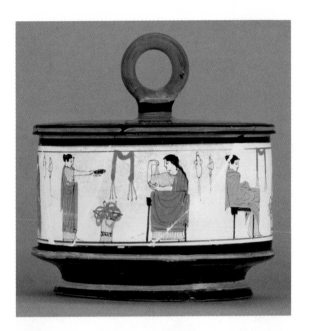

FIGURE 2–19 A cosmetic jar with a removable lid shows scenes of women working in the home. Women are seated on furniture with curtains and other objects hanging on the walls. The white background of the ceramic gives stark contrast to the red and black coloration of figures and decorative details.
Ivor Kerslake © The British Museum

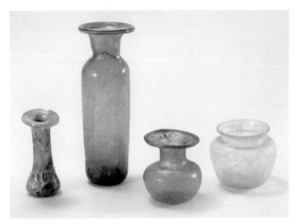

FIGURE 2–20 This collection of glass vases on display in the Thessaloniki Archaeological Museum in Greece shows the variety of sizes, shapes, and colors produced during the ancient Greek period.
Dorling Kindersley © Archaeological Receipts Fund (TAP)

Greek Metalworking

The Greeks were the first to strike metal coins, an inventive form of metalworking that showed great skill in metallurgy. Greek sculptors used a variety of casting methods, including the lost-wax method of casting bronze into life-size statues. Therefore, it is no surprise that bronze was fashioned into a variety of household objects including vessels, lamps, furniture, and small figurines (Figure 2–22). Hand-held mirrors made from polished bronze incorporated mythical creatures into their designs. Several examples dating back to the seventh century BCE feature graceful caryatids as handle supports (Figure 2–23). Small figurines made from solid brass representing deities, athletes, and mythical creatures were made as temple offerings or grave gods (Figure 2–24). Greek lamps were made from metal and ceramic and used a wick to burn the oil for light. Lamps were small and designed with carrying handles so they could be moved around the house and carried outdoors. Placing these small lamps onto tall torchères raised the light source high into the room, shedding more light on the interior (Figure 2–25).

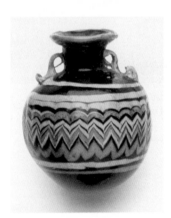

FIGURE 2–21 A faience perfume pot from ancient Greece shows brightly colored chevrons in blue and gold.
Nick Nicholls © The British Museum

Greek Weaving and Textiles

The spinning of woolen and flax fibers into yarns and the efficiency of the loom enabled the Greeks to produce a myriad of textiles for fine clothing and household accessories. Weaving was done by all social classes of women, producing cloth for use inside their households (Figure 2–26). Ancient texts of Greek mythology describe that the goddess Athena wove the cloth for making her tunic. Clothing and fabrics for the home featured on pottery paintings reveal a wide range of seat and bed cushions, wall hangings, and draperies (Figure 2–27). Stripes, polka dots, and Greek key motifs appeared on fabrics as decorations; their bright colors revealed through fresco fragments indicate that bold geometric patterning was preferred to plain cloth.

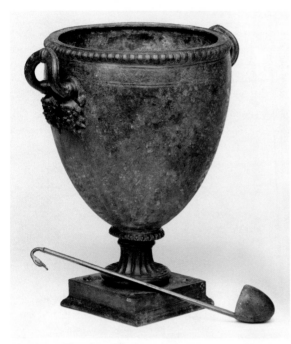

FIGURE 2–22 A bronze wine jar with dipping ladle from ancient Greece features the face of Dionysus, god of wine, beneath its two handles.
Nick Nicholls © The British Museum

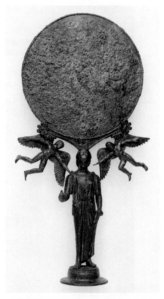

FIGURE 2–23 The handle of this bronze mirror is fashioned into a standing woman flanked by winged gods representing Eros. The copper, added to the tin to produce bronze, has oxidized over the years leaving a green patina.
Nick Nicholls © The British Museum

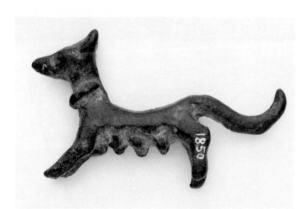

FIGURE 2–24 A Greek statue of a small a dog crafted from bronze.
Alan Hills © The British Museum

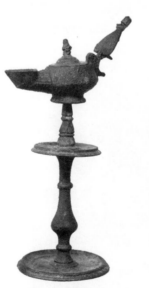

FIGURE 2–25 This bronze candelabrum or torchère from ancient Greece has a lamp at the top supported by a baluster-shaped pedestal base.
Bronze-Lighting Utensils. Lamp and Candelabrum. The Metropolitan Museum of Art, Purchase, 1901. (01.17.1-2)

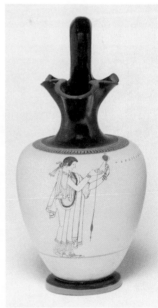

FIGURE 2–26 A vase decorated with an image of a woman spinning yarn onto a spindle.
Nick Nicholls © The British Museum

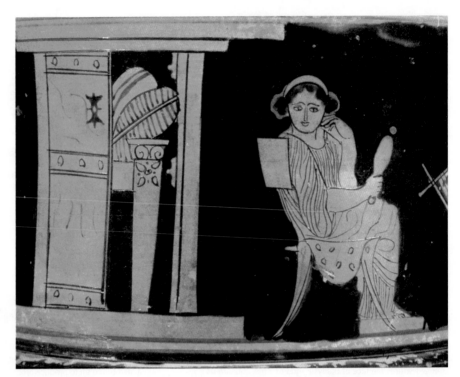

FIGURE 2–27 This red figure pottery scene shows a woman holding a mirror seated on a klismos chair. The chair is made more comfortable with a loose cushion seat shown here covered in a polka dot pattern. A Greek kline, or bed, covered with striped bedding is visible through an open door.

Louvre, Paris, France/The Bridgeman Art Library

COMPARATIVE DESIGNS

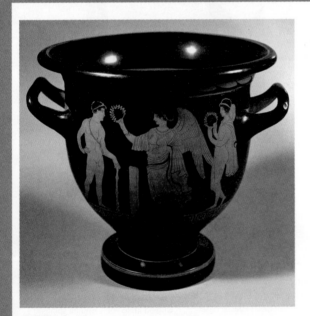

FIGURE 2–28 The scene on this red figure technique vase from the fifth century BCE shows the Greek goddess Nike presenting an athlete with a crown of laurels.

Picture Desk, Inc./Kobal Collection

FIGURE 2–29 A silver trophy cup with footed base is designed to commemorate special occasions or accomplishments.

Steve Gorton © Dorling Kindersley

The first Olympiad was held in Greece in 776 BCE, and it was customary to crown the heads of the winning athletes with laurel wreaths as a symbol of honor. The common expression, "resting on their laurels" originated from this custom. Over time, the significance of the games increased, and a more lasting commemorative gift bestowed on the winning athletes came in the form of a "trophy" cup. These two-handled ceramic cups depicted scenes of athletes receiving their crowns of glory from the mythological goddess of victory, Nike (Figure 2–28). Although silver has replaced ceramic, the symbolic gesture of presenting winners with "trophy" cups is still practiced worldwide (Figure 2–29).

Ancient Rome

By the eighth century BCE, Greek settlements had expanded into southern Italy and the coast of Sicily. In northern Italy, a tribe known as the Etruscans had settled the area between the Tiber and Arno rivers. Originally from Asia Minor, the Etruscans spoke a language unknown to the Greeks, which limited exchanges between the two cultures. In fact, Etruscan writing has evaded translation by scholars to this day, leaving aspects of their culture unknown. The Greeks viewed the Etruscans, along with other cultures to the north, as barbarians—crude people with uncivilized ways, ignorant of the refinement of Greek customs and culture.

The establishment of Rome on the south bank of the Tiber River in a region first called Latium, from which the word *Latin* is derived, dates to 753 BCE. Considered one of the greatest political nations in the Western world, the Roman Empire held political control for nearly a thousand years and ruled geographic regions as far as the British Isles to the north, as well as Egypt, Greece, and parts of Asia Minor. Beginning with the Roman Republic period in 510 BCE, the first laws of the empire were established. Control by the Roman emperor relied on sophisticated highway systems, including roads and waterways, keeping the city of Rome connected to all regions of the empire.

When the Greek city-states fell to Roman rule in 146 BCE, the Romans adopted much of their highly developed Hellenistic culture including mathematics, science, and religion. The rise of the Imperial period in Roman history occurred after the assassination of Julius Caesar in 44 BCE. Caesar's great-nephew Octavius expanded territorial holdings through a vast army and navy at this time. By 27 BCE, the emperor and his consulates maintained autocratic control through a centralized government. All roads led to Rome.

The Late Imperial period lasted from 284 to 395 CE, during which time Rome was under constant threat from advancing forces from the north. The division of the empire into western and eastern regions (the eastern seated in Constantinople, which is present-day Istanbul) divided the imperial army and weakened the control of the emperor in Rome. The city of Rome finally fell in 410 CE to plundering northern Goths, and in 476 CE, the Western Roman Empire collapsed.

Roman Architectural Settings

Roman engineering evolved from Greek architecture and urban planning and further advanced through Roman builders' extensive use of concrete. Concrete made from the rich volcanic ash from the region enabled the Romans to build aqueducts, a highly

developed water system that brought water into towns from local aquifers. A town's water system brought hot and cold running water to the public baths and, for those who could afford it, into private homes. Moreover, the reliance on concrete as a building material enabled the Romans to build taller structures more quickly.

Greek artists, taken into slavery by the invading Romans, created great works of art and architecture for the empire. Furthermore, these Greek artisans also trained Roman workers in the Classical and Hellenistic styles of design. Great building projects from the Imperial period that featured vast temples and civic buildings modeled after Greek prototypes appeared in all regions of the empire (Figure 2–30). Roman architectural designs introduced two new orders to building construction—the Tuscan and Composite (Figure 2–31). Based on the Greek Doric, the Tuscan order featured a fluted column shaft and included a base. The Composite order also featured a fluted column shaft and base, and its capital bore a blend of volutes and acanthus leaves.

In addition to the numerous temples and civic buildings erected throughout the empire, thriving cities included residential districts that included town houses and private villas. Excavations at Pompeii and Herculaneum revealed some of the most impressive archaeological finds, giving insight into the lifestyles of those living in the Roman Imperial period. Located south of Naples along the Mediterranean Sea, these two cities were entombed by volcanic ash when Mount Vesuvius erupted in 79 CE. Within a day, Pompeii and Herculaneum were covered with volcanic ash and debris, creating a time capsule not discovered again until the mid-eighteenth century.

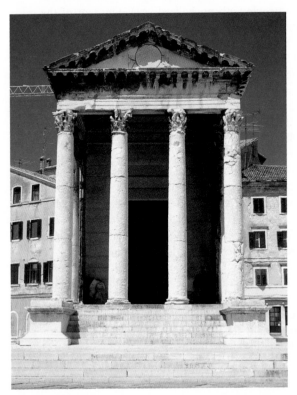

FIGURE 2–30 This Roman temple built c. 2–14 BCE in Croatia shows the far-reaching impact of the empire. The temple features magnificent Corinthian columns on its portico and is well preserved for its age.
Lucio Rossi © Dorling Kindersley

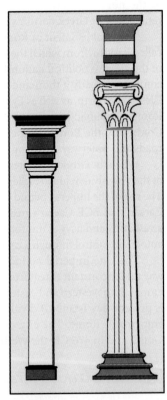

FIGURE 2–31 The Tuscan and Composite orders were added to Roman architectural design.

Eighteenth-century excavations of these first-century towns revealed exquisite examples of architecture, furniture, wall paintings, and mosaics once belonging to their wealthy inhabitants (Figures 2–32 through 2–34).

In addition to wall paintings, colorful wall mosaics depicted scenes from mythology, history, and domestic life. Mosaics made with tesserae (small pieces of colored stone) were inlaid into a cement binder and covered floors and walls (Figure 2–35). Mosaic sidewalks appeared in the ancient Roman city of Ephesus, a tribute to the wealth of the town's inhabitants.

Roman Design Motifs

Roman artists continued to use Greek design motifs to decorate their buildings, interiors, and decorative accessories. Geometric patterning appeared as banding around decorative wall paintings, and on floor mosaics and pottery (Figure 2–36). Motifs inspired by nature included floral patterns depicted in arabesque and rinceau designs. The classical arabesque featured a symmetrically arranged vertical panel of flowers and fauna, often embellished with minor deities (Figure 2–37). Rinceau motifs highlighted

FIGURE 2–32 Villa of the Mysteries, unearthed during the excavations at Pompeii, is a large brick villa with red tile roofing and plenty of windows. Located just outside Pompeii, the villa's interior, with its colorful wall paintings and floor mosaics, reflects the wealth of its owner.
Treena M. Crochet

FIGURE 2–33 Bright and colorful wall paintings line the corridor of the logia inside the Villa of the Mysteries.
Demetrio Carrasco © Dorling Kindersley

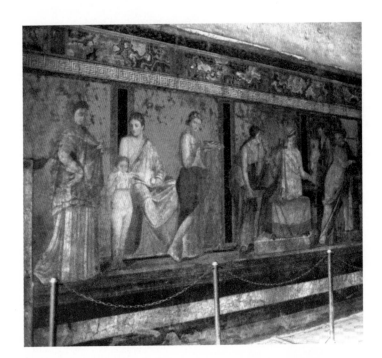

FIGURE 2–34 Inside one of the rooms in the Villa of the Mysteries, a colorful wall painting depicts a scene from Dionysian cult practices.
Treena M. Crochet

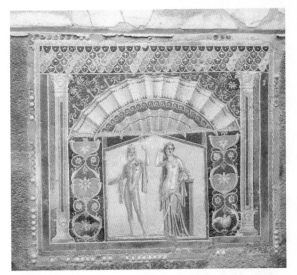

FIGURE 2–35 A colorful wall mosaic taken from a house during excavations at Herculaneum features the mythical King and Queen of the Sea. The scene is framed by an interesting juxtaposition of motifs including a shell design with a spiral wave pattern, Corinthian columns, fluid arabesques, and flat bands of blue and green.
James Stevenson © Dorling Kindersley

FIGURE 2–36 This Roman floor covering made from Grecian marble is laid out with red, black, and gold geometric patterning.
© Dorling Kindersley

asymmetrically arranged flower and vine patterns repeated to create borders in architectural friezes (Figures 2–38, 2–39).

The mythical creatures, gods and goddesses, and minor deities found in Roman design are symbols of Roman religious practices. Grape clusters on meandering vines represented Dionysus and Baccus, the Greek and Roman gods of wine (Figure 2–40). Other motifs with connections to religious deities include representations of cupid

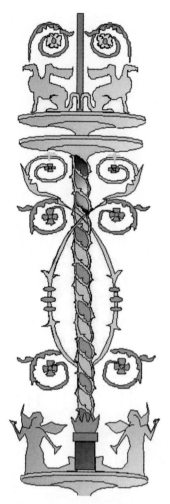

FIGURE 2–37 This arabesque design includes foliate patterns with mythical figures of griffins and cupids.

FIGURE 2–38 Delicate flowers and vines intertwine to create this rinceau motif.

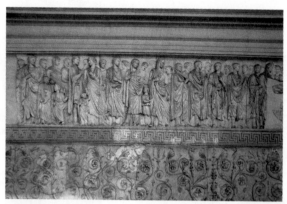

FIGURE 2–39 This relief carving taken from the frieze area of the Altar of Augustan Peace in Rome depicts the family of Marcus Agrippa. The figurative scene rests on a band of Greek key motifs, while the free-flowing vines and flowers of the rinceau pattern appear below.
Mike Dunning © Dorling Kindersley

shown as a winged boy or young man, and Pegasus depicted as a winged horse (Figures 2–41, 2–42). In addition, the sacrificial ram frequently adorned the frieze areas of temples, where these rites were held (Figures 2–43 through 2–45). Like in Greece, frescoes discovered at Pompeii and Herculaneum show that Roman artists accentuated these decorative motifs on buildings with colorful paint.

Roman Interior Furnishings

In ancient Roman times, most households had the usual supply of stools, tables, and reclining couches—furniture necessary to run the household (Figure 2–46). Wall paintings reveal simple designs, often made from turned wood, that have minimal

FIGURE 2–40 This stylized drawing of the grape bunch, leaf, and vine is symbolic of the mythological god of wine.

FIGURE 2–41 Cupids are the featured motif in this border design surrounded by anthemion and rinceau patterns.

FIGURE 2–42 Pegasus leaps over swirling vines and is placed next to a ram symbolizing virility in this rendering of a frieze detail from a Roman temple.

FIGURE 2–43 The skull of the sacrificial ram is often depicted on architectural entablatures.

FIGURE 2–44 The sacrificial ram is featured in this central medallion.

FIGURE 2–45 This architectural border design features a ram's head flanked by acanthus leaves.

FIGURE 2–46 This funerary relief carving from the ancient Roman period shows a variety of furnishings including a high-backed chair, a reclining couch called a lectus, and an X-form folding stool. Furnishings such as these were found in households of all social classes.

© *The British Museum*

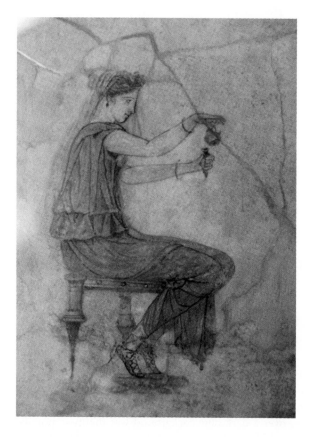

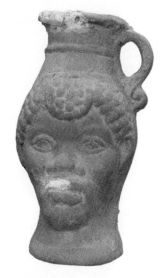

FIGURE 2–47 A wall mural shows a woman sitting on a stool while mixing perfume. The stool has disk-turned legs, and a loose cushion provides comfort to the seat.
Simon James © Dorling Kindersley

FIGURE 2–48 This terra-cotta jug features the face of a mythical satyr.
© Judith Miller/Dorling Kindersley/ Sloan's

decoration (Figure 2–47). Finer examples made from bronze and featuring elaborate designs incorporating griffins and sphinxes were excavated from Pompeii and Herculaneum. A variety of charred wooden examples was also discovered at Herculaneum, preserved from the hot ash that entombed them.

Roman Vessels and Containers

Accessories such as lamps, glassware, pottery, and bronzes coordinated with interior furnishings and were abundant during the Roman period. Pottery, still a main staple of the domestic household, now featured intricate designs created by artists' use of plaster molds. Pressing wet clay into molds was a fast, economical way of manufacturing pottery pieces in a variety of shapes and with a myriad of surface decorations (Figures 2–48, 2–49). The embossed surfaces were covered with monochromatic glazes rather than the red and black figure techniques favored by the Greeks.

New glass-making techniques were introduced during the Roman period, and glass-making became a valued art form. The most intricate glass objects in the possession of wealthy households were made from cameo glass (Figure 2–50). Cameo glass was made by layering different colors of molten glass into a mold, which gave the object its shape.

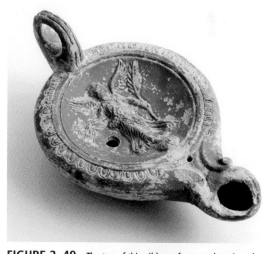

FIGURE 2–49 The top of this oil lamp features the winged goddess of victory standing on a globe. Made by pressing the various parts into molds, the final piece was assembled and its joints smoothed over with slip before firing.
© Judith Miller/Dorling Kindersley/Ancient Art

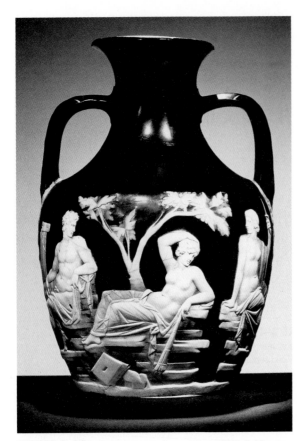

FIGURE 2–50 This cameo cut-glass vase has white relief figures sculpted over a dark blue glass background.

Portland vase, 3rd c. A.D. Cameo-cut glass. British Museum, London

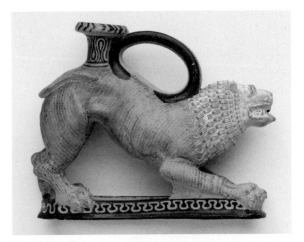

FIGURE 2–51 This small pitcher in the shape of a crouching lion dates to 340–300 BCE in Etruscan Italy. The vase is thought to have stored perfume.

Nick Nicholls © The British Museum

FIGURE 2–52 This glass jar and lid fashioned from mosaic glass features swirls of bright color.

Christi Graham and Nick Nicholls © The British Museum

Once the glass cooled, an artist exposed the different layers of colored glass by cutting the figures or patterns in relief. White figures over a dark blue background was the most popular color combination for the period. Making glass objects from molds yielded a wide range of vessels for domestic use including cups, bowls, and storage jars. More complex perfume bottles, beakers, and vases featuring three-dimensional relief designs were molded in two parts. The parts were then fused together before cooling (Figure 2–51).

Mosaic glass was made by taking different colored pieces of softened glass and pressing them into a mold. The object was then heated to fuse these small pieces of glass together, producing interesting colors and patterns in the final design (Figure 2–52). With the aid of the iron blowpipe developed in the first century BCE, glass production became more economical, and glass began to appear in middle-class households. Molten glass was affixed to the end of a long pipe and air was blown into the pipe by a glassworker at the other end. This inflated the molten glass like a balloon, and the artist could manipulate the shape by spinning the pipe and stretching the glass. Blowing glass into a patterned mold yielded a variety of surface decorations (Figure 2–53). Furthermore, by blowing glass directly into molds, glassworkers could make bottles, vases, and beakers more quickly and in consistent shapes and sizes. In fact, blow-molded glass bottles and beakers were inexpensive enough that shops set up alongside the Coliseum in Rome sold them as souvenirs to spectators.

Roman Metalworking

The casting and forging of metals during the Roman Empire produced a wide range of artifacts now housed in museum collections throughout the world. In addition to the striking of coins, Roman metalworkers kept busy producing weaponry needed for the enforcement of imperial law. So important was the role of metalworkers that in Roman mythology, the god Vulcan protected them. A wide range of household goods including mirrors, cups, baking dishes, vases, small figurines, and lamps were made from bronze, silver, and gold worked by artisans who mastered the skill of repoussé and casting (Figures 2–54, 2–55). Objects made from gold and silver appeared in homes owned by those who could afford such luxuries (Figure 2–56). As Roman artists mastered the casting method, fine and intricate detailing appeared on goods produced for affluent households and on fine jewelry (Figure 2–57).

FIGURE 2–53 This flask in the shape of a bunch of grapes used for serving wine was created by blowing molten glass into a mold.
Christi Graham and Nick Nicholls
© The British Museum

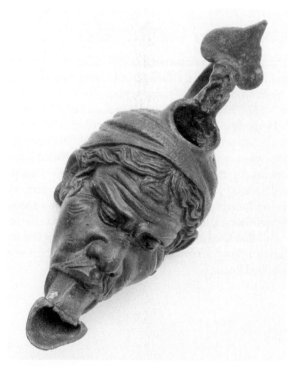

FIGURE 2–54 This curious representation of a human head fashioned into a bronze lamp shows the versatility of a Roman metalworker.
Christi Graham and Nick Nicholls © The British Museum

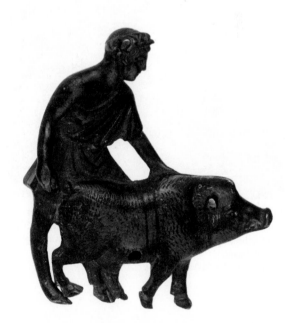

FIGURE 2–55 This small figurine of a toga-clad man leading a wild boar to be sacrificed is made from cast bronze.
Christi Graham and Nick Nicholls © The British Museum

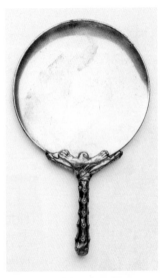

FIGURE 2–56 This silver mirror with a polished flat reflecting disk has an ornately crafted handle. Mirrors were owned by wealthy patrons, a sign of their economic success.
*Christi Graham and Nick Nicholls ©
The British Museum*

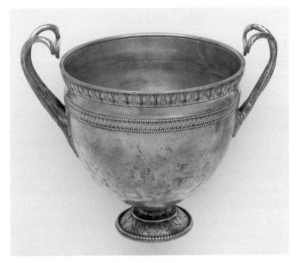

FIGURE 2–57 This silver drinking cup has two long handles with a decorative bead trim around the top rim and footed base.
Philip Nicholls © The British Museum

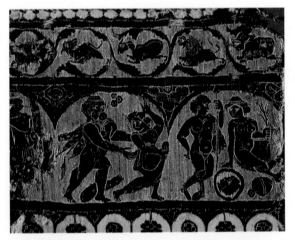

FIGURE 2–58 This fragment of cloth made from linen and wool fibers depicts lively scenes of romantic pursuits between Cupid and Psyche. The fragment is all that remains of what was once a beautiful tunic.
Picture Desk, Inc./Kobal Collection

Roman Weaving and Textiles

The Roman Empire had a thriving textile industry. The main commodity was clothing, although only fragments of cloth made from wool and flax yarns remain from this period (Figure 2–58). The Silk Road from China reached the Roman Empire by the first century CE, and imported silks were coveted by the affluent and influential of Rome, including its emperors. Most could not afford these imported silks, however. Within the empire, slaves produced fabrics on warp-weighted looms, which sped up production. In general, women continued to weave fabrics for various items necessary for their homes, mainly bedding, drapery, and cushions. The legend that Cleopatra delivered herself to Julius Caesar rolled up in a carpet is myth; rather, she wrapped herself in a swathe of bed linens.

Surface decorations appeared on glass objects as far back as the second millennium BCE, but it was the Romans who perfected the art of press molding. The yellow glass beaker shown in Figure 2–59 features a distinctive teardrop pattern created by pressing softened glass into a two-piece mold. Before the glass cooled, the two halves were joined, leaving a visible seam. The two vases dating from the twentieth century were manufactured using the same technique, although modern machinery had replaced the hand-molding process (Figure 2–60).

FIGURE 2–59　A glass beaker from the Roman Empire has a teardrop pattern created by pressing the malleable glass into a two-piece mold. A slight seam is visible where the two halves were fused together.
Christi Graham and Nick Nicholls
© The British Museum

FIGURE 2–60　These milk glass vases (named for the opaque white coloring) made in the 1930s feature an allover hobnail pattern, one of the oldest motifs used as a surface decoration on glass.
© Judith Miller/Dorling Kindersley/Take-A-Boo Emporium

Medieval Europe

TIMELINE

Medieval Period

500–1000 CE

527	Justinian becomes Emperor of the Eastern Roman Empire.
532	Construction begins on the Church of Hagia Sophia.
597	Illustrated manuscript of the New Testament appears in *Gospels of St. Augustine.*
622	Death of the Prophet Muhammad.
711	Moorish invasion of Spain brings Islam to the region.
756	Formation of the Papal States by the Holy Roman Empire.
792	Basilica Church building thrives as construction begins on the Palatine Chapel, Aachen, Germany.
800	Charlemagne, King of the Franks, is crowned Holy Roman Emperor of the West by Pope Leo III.
	Franks develop the feudal system, establishing hierarchy of kings, barons, noblemen, and serfs (peasants).
828	Egbert, King of Wessex, crowned first king of England.

1000–1500 CE

	Growth of townships and establishment of craft guilds.
1002	Leif Ericsson explores the North American continent.
1080	Romanesque architectural style flourishes with construction of St. Sernin Cathedral, Toulouse, France.
1096	First wars of the Crusades begin.
1150	Gothic style of architecture first appears in France.
1209	Cambridge University is established in England.
1271	Marco Polo leaves for China.
1285	Completion of construction on Notre Dame Cathedral in Paris.
1303	Giotto begins painting the Arena Chapel in Padua.
1306	Dante begins writing his epic *Divine Comedy.*
1387	Chaucer writes *Canterbury Tales.*
1300–1400	Black Death plague claims 25 million lives.
1414	Roman architect Vitruvius' architectural treatise, *De Archtitectura,* rediscovered and published.
1453	Eastern Roman Empire is overthrown by the Turks; Hagia Sophia becomes an Islamic mosque.
	Ottoman Empire marks end of medieval period.

The medieval period, also labeled the Middle Ages, is the time between the fall of the Roman Empire in the fifth century CE and the beginning of the European Renaissance in the fifteenth century. One of the most significant cultural changes to occur during this thousand-year period was in the religious practices of the people living in the Roman Empire. Constantine the Great, who ruled the Roman Empire in the early fourth century CE, legalized Christianity and authorized the construction of the first Christian church. Roman law allowed for the continuance of polytheism, which co-existed with Christianity through the early fifth century.

Another important catalyst in prompting cultural change during the medieval period occurred when Constantine divided the empire into eastern and western territories in 330. The eastern empire was seated in Turkey in the ancient city of Byzantium and continued to prosper under the new name, Constantinople, until the fifteenth century. In the west, weakening protection offered by Roman armies at the farthest outreaches of the empire led to constant invasions, making the collapse of the empire inevitable.

After the Roman Empire lost its political stronghold in Western Europe, land was claimed by individuals who established their own laws and forms of government. These "lords and ladies" of the land eventually became kings and queens, ruling over controlled lands protected by paid mercenaries and worked by peasant surfs under feudalistic law. These small kingdoms, which developed into larger countries, were strong unifying forces for the people who lived during the medieval period.

During this time, the Catholic Church gained strength as the spiritual leader of the people. Church doctrine overruled individual thinking and repressed the pagan culture of the fallen Roman Empire. A sequestering of polytheism in church libraries put an end to the classical ideologies of Greece and Rome until the European Renaissance. The church became the source of education for the population, and pious but illiterate individuals followed liturgical teachings made visible through the artwork of the period. Strict church doctrine controlled social mores and the acceptance of what was appropriate in science, literature, and art. Islam was introduced in the early seventh century by the Prophet Muhammad, and the new religion spread into all of the Middle East, parts of Africa, and southern Spain and Portugal by the mid-eighth century.

Architectural Settings

Continuing efforts by the church to eradicate pagan idolatry contributed to the destruction of Roman architecture. Stones from these ancient sites were often recycled as new churches replaced Greek and Roman temples. Moreover, medieval builders abandoned many of the engineering advancements made by previous cultures such as using concrete as a primary building material and planning for indoor plumbing. Arcuated architecture—the method of supporting structures through a series of vaults and arches—enabled the construction of massive churches and cathedrals built from locally quarried stone. Cathedrals built in the Romanesque and Gothic styles of the eleventh through fourteenth centuries featured tall spires, large arched windows with stained glass, and decorative details carved from stone (Figure 3–1).

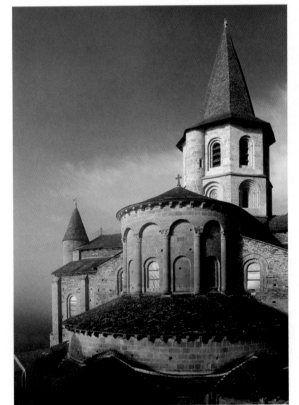

FIGURE 3–1 The Abbey Church of St. Foy built in 1120 in France features Romanesque style architectural details including a stone arcuated support system, tall spires, arched windows, and massive scale. *Alan Williams © Dorling Kindersley*

After the turn of the first millennium CE, population growth in Western Europe led to expanded city centers and local trade flourished. A surge in building construction followed with large castles built for wealthy rulers and gentry, and immense church compounds. Castle compounds were large enough to house the royal family and extended family along with servants and mercenaries (Figure 3–2). Early castles were vast stone and timber buildings with one large room called the great hall. The great hall served as dining room, bedroom, and gathering room for all aspects of medieval life (Figure 3–3). Fires to warm the castle were built in the center of the room on the stone floor, and an open window provided ventilation. Eventually, separate rooms for sleeping and fireplaces with chimneys were introduced to the design of castles. The vastness of these compounds, including surrounding fortifications, reflected the power and wealth of the lords who owned them.

The working classes lived in mud, stone, or timber cottages with thatched roofs and beaten earth floors—modest homes compared to the feudal castles (Figure 3–4). Merchants, who thrived on local trade inside the medieval walled cities, lived in larger town houses made from timber and stucco. Family businesses were located on the street level, with two levels of living quarters above.

FIGURE 3–2 High above terraced walls, this Norman castle typifies the medieval fortification necessary to protect its occupants from marauding invaders. Known as Rochester Keep, this twelfth-century castle features four tall towers, making it the tallest in England for its time.
Geoff Dann © Dorling Kindersley

Design Motifs

Motifs appearing as decorations on interior furnishings and decorative accessories were fashioned after the architectural styles of churches. The decoration of church buildings and cathedrals across Europe was orchestrated by the church fathers, and most of the

FIGURE 3–3 This banquet room features exposed beam ceilings and a patterned tiled floor. The trestle table is a reproduction based on medieval examples.
Geoff Dann © Dorling Kindersley

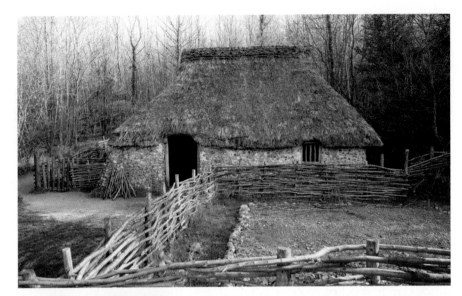

FIGURE 3–4 This stone cottage with a thatched roof and small windows was reconstructed based on thirteenth-century farmhouses. *Geoff Dann/Dorling Kindersley © Weald and Downland Open Air Museum, Chichester*

FIGURE 3–5 A column and capital from inside a twelfth-century church in France depicts the Virgin Mary shrouded in blue among brightly painted decorative carvings that include a band of rosettes. *Philippe Giraud © Dorling Kindersley*

designs had spiritual meanings. Certain animals in Christian iconography represented virtues and vices, and plants and flowers had special meanings assigned to them; for example, clustered grapes on the vine symbolized the Eucharist. The thornless rose represented the Virgin Mary, and a combined white and red rose became the symbol of the Tudor kings of England after a truce ended the War of the Roses in the fifteenth century (Figures 3–5 through 3–8).

Other symbols of the Virgin Mary included a white lily, a testament to her purity; the lily's three petals represented the Holy Trinity. French kings used the *fleur de lis*, or the "flower of the lily," as an emblem of their Christian faith in flags and shields (Figure 3–9). Although the fleur de lis is mostly

FIGURE 3–6 During medieval times, the rose was a symbol for the Virgin Mary and became a commonly used design motif in a variety of abstracted forms.

associated with the French, Elizabeth I of England incorporated the motif into insignias for the Tudor monarchy (Figure 3–10). The integration of fleur de lis motifs into medieval furnishings and interior design showed the owner's strong allegiance to the monarchy and Christian faith (Figure 3–11).

Other motifs seen on Gothic cathedrals appeared in medieval furnishings. Trefoil and quatrefoil patterns fashioned into the design of stained glass windows and carved decorations represented the Holy Trinity and the four evangelists (Figures 3–12, 3–13). The crocket, a motif partly based on the hilt of the medieval sword, appeared as finials

FIGURE 3–7 The Tudor rose combines white and red rose patterns into one unified design showing the unity of England under the rule of Henry VII at the end of the War of the Roses in 1487.

FIGURE 3–8 A stylization of the rose appeared in the design of stained glass windows.

FIGURE 3–9 A symbol of Christianity, the fleur de lis is a special emblem symbolizing the purity of the Virgin Mary. Both France and England used the "flower of the lily" in flags and family crests.

FIGURE 3–10 This architectural carving incorporates the crown of the monarchy with carved fleur de lis motifs around its midsection and a Tudor rose carved with the perceived image of the Virgin Mary.
Rob Reichenfeld © Dorling Kindersley

FIGURE 3–11 The fleur de lis is the central design motif in this tiled floor.

Geoff Dann © Dorling Kindersley, Courtesy of Chateau de Saumur

FIGURE 3–12 Designs such as these trefoil and quatrefoil motifs often appear as decoration on Gothic cathedrals and interior furnishings.

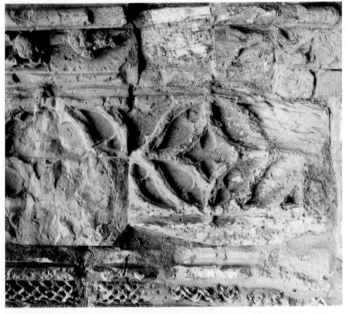

FIGURE 3–13 Quatrefoil motifs like this one were carved on the side of the Cathedral of Seville built in the fifteenth century as the largest Roman Catholic church in Spain.

Treena M. Crochet

FIGURE 3–14 A crocket design fashioned after the hilt of a medieval sword.

FIGURE 3–15 The flowering petals of a crocket resemble a Latin Cross.

lining the roofs of Gothic cathedrals, and their delicate flowers intertwined with strapwork appeared in stone tracery carvings (Figures 3–14 through 3–17).

Wood joiners, who made furniture and wood paneling for church interiors, incorporated similar motifs in their commissions for home furnishings. Panels carved to look like folded linen and oak leaves with acorns were typical in Gothic furniture and architectural wainscoting (Figures 3–18, 3–19). The linenfold motif represented the importance of the cloth-making trades to the medieval economy; cloth guilds were first established in the twelfth century. The ease of carving the linenfold motif onto oak panels made it a favored design for woodworkers (Figure 3–20). The oak leaf and acorn appeared on furnishings in Northern Europe, its origins possibly dating to the Roman Empire (Figures 3–21, 3–22).

With the spread of Islam in the eighth century and the building of mosques, design motifs associated with the Byzantine Empire and those favored by Eastern

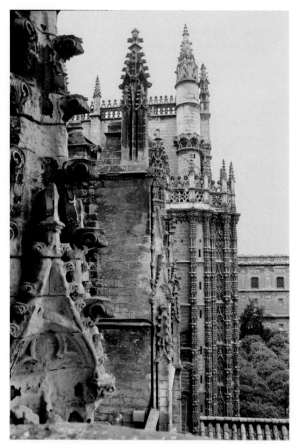

FIGURE 3–16 This view from the top of the Cathedral of Seville shows exquisitely carved crockets lining the slopes of rooflines, spires, and arches.

Treena M. Crochet

FIGURE 3–17 Interlacing crocket finials were a popular motif carved onto furniture, wall paneling, and leatherwork, and drawn as border designs in illuminated manuscripts.

FIGURE 3–18 Carved designs resembling folded linen were a popular motif incorporated into furniture designs and wall paneling.

FIGURE 3–19 A variation of the linenfold motif is shown in contrasting color as painted on examples of furniture.

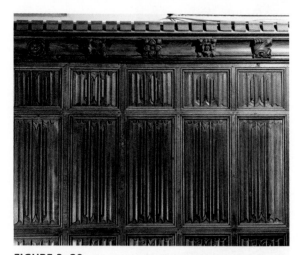

FIGURE 3–20 This section of wall paneling from a castle from the medieval period reveals the fine linear carvings of linenfold panels.

Dave King © Dorling Kindersley, Courtesy of The Brooking Collection of Architectural Detail, University of Greenwich

cultures were reinvented in Western culture as strapwork designs decorating illuminated manuscripts and tooled leathers. Free-flowing arabesques—a term used to describe Islamic ornamentation—featured intertwined vines and flowers as representations of God's creation (Figures 3–23, 3–24).

FIGURE 3–21 The oak leaf and acorn design appears on furniture carvings and wall paneling during the medieval period.

FIGURE 3–22 This earthenware floor tile from the medieval period features a stylized representation of a griffin surrounded by an oak leaf and acorn design in the corners.
© *Judith Miller / Dorling Kindersley / Clevedon Salerooms*

FIGURE 3–23 Interlacing vines are commonly seen in the free-flowing floral pattern of the arabesque motif.

FIGURE 3–24 Sweeping floral patterns painted on a white wall are surrounded by arabesques and a large central rosette.
Dave King / Dorling Kindersley © Weald and Downland Open Air Museum, Chichester

Interior Furnishings

Medieval furnishings and interior design dating from the twelfth through the fifteenth centuries reveal the strong architectural influences of the Gothic cathedral. Larger-scaled furnishings were made to fit into interiors with high ceilings and well-appointed woodwork matched by the fine carving on chairs, case goods, and chests. Interior furnishings were sparse inside the great halls of medieval castles. These multifunctional rooms were furnished with stools, large trestle tables for dining, chests, and bedding. Stools were designed with low backs and carrying handles, which made them easy to move around. Written accounts of banquets tell about guests bringing their own stools so they would have something to sit on when they arrived (Figures 3–25, 3–26). The trestle table was made from a long, narrow board placed on end supports similar to modern sawhorses (Figure 3–3). Long benches and stools were arranged around the table, and when the feast was over, the table was dismantled and all furnishings were placed against the wall.

Chests in a variety of sizes were the most important pieces of furniture inside medieval homes (Figure 3–27). Clothing, tapestries, and linens were stored in larger chests and cabinets, and small caskets stored jewelry, money, gold, and silver. Strength in construction ensured the safety of valuables placed inside, and iron reinforcements including keyed locking devices protected items from theft (Figure 3–28). Decorations on these chests and caskets included linenfold carvings, trefoil and quatrefoil motifs, and carved strapwork detailing.

FIGURE 3–25 This small rectangular stool with trestle-type leg supports has holes cut along the long sides providing a handgrip for carrying the stool from place to place.
Geoff Dann © Dorling Kindersley

FIGURE 3–26 A three-legged chair with a triangular seat is an improvement over the basic stool with the addition of a backrest.
Geoff Dann © Dorling Kindersley

FIGURE 3–27 This medieval chest made from ivory supported on metal legs features carvings of human figures, rosette motifs, and large decorative hinges reinforcing the sides. The locking device on the front side has two keyholes for extra security.
Geoff Dann © The British Museum

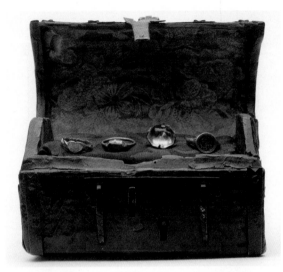

FIGURE 3–28 The view inside this medieval jewelry casket shows a collection of gold rings. The body of the box is made from wood covered with leather while the inside lid is covered with tooled leather featuring floral designs. The locking device and hinges are made from wrought iron.
Liz McAulay © Dorling Kindersley

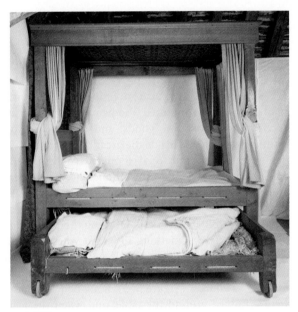

FIGURE 3–29 The ropes on this canopy bed support a mattress stuffed with straw. Periodically, a wooden key was used to tighten the ropes to keep the mattress from sagging. The expression "sleep tight, don't let the bed bugs bite" refers to the tightening of the ropes, and insect-infested straw. Underneath the bed, a small trundle bed on wheels would be pulled out at night for the children to sleep on.
Geoff Dann / Dorling Kindersley © Weald and Downland Open Air Museum, Chichester

An improvement over sleeping on a straw-stuffed mattress on the floor of the great hall, the bedstead was an innovation of the medieval period. Looking like today's modern canopy beds, the medieval tester bed had drapes that closed around the mattress at night for both privacy and warmth (Figure 3–29). The amount of wood needed to construct the frame, headboard, footboard, and canopy, along with the many yardages of fabric, made the tester bed the most expensive piece of furniture listed in household inventories.

Decorative Accessories

Pottery

Medieval potters produced the usual assortment of housewares such as beakers, plates, jars, and bowls. These earthenware vessels were decorated with vibrant glazes in deep ultramarine, gold, crimson, and green—the same bright colors seen in the stained glass windows of Gothic cathedrals. Designs included family crests and colorful coats of arms, crowns, and other symbols of the nobility who owned them (Figures 3–30 through 3–32). Clay tiles were also made to decorate floors, walls, and fireplaces inside more affluent households (Figure 3–33).

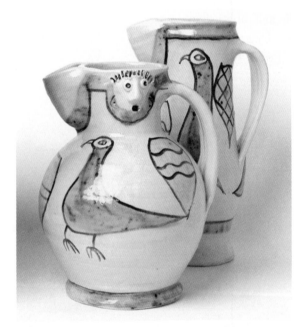

FIGURE 3–30 Glazed jugs show primitively drawn birds with an unusual humanlike head projecting from the rim of the smaller vessel. These ceramic jugs were used for serving wine and ale.
Geoff Dann / Dorling Kindersley © York Archaeological Trust for Excavation and Research Ltd.

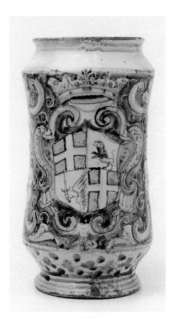

FIGURE 3–31 Dating from around the early 1500s, this jar maintained its brilliant color depicting a family crest.

Geoff Dann © Dorling Kindersley, Courtesy of the Museum of the Order of St John, London

FIGURE 3–32 This plate from the 1400s features a coat of arms with two gold lions and two gold castles on the center shield encircled by spiral wave patterns and arabesque designs.

Geoff Dann © Dorling Kindersley, Courtesy of the Wallace Collection, London

Glass

Glassware was reintroduced into Europe after late twelfth-century crusaders brought back Roman glass-making techniques from the Eastern Empire. Making stained glass for the windows of Gothic cathedrals became a specialized art form; blown glass spheres were flattened by spinning the iron blow-pipe to remove the air, then flattening the glass into a small disk. The artist would then cut and piece together the cooled glass into predetermined shapes and bond them together with lead. Colorful stains were then wiped onto the glass and black ink applied with a brush to refine and enhance the scene (Figure 3–34). Although colorful stained glass was plentiful in Gothic cathedrals, glass windows in the home were reserved for extremely wealthy families (Figures 3–35 through 3–37).

For those who could afford them, glass cups, beakers, and bowls supplemented pewter wares and wooden dishes (Figure 3–38). Owning glassware during the medieval period reflected a refinement of taste and wealth. The most exquisite examples of glass came from Venice. The small village of Murano, an island near Venice, was well known throughout Europe for its glass production and was visited often by wealthy merchants during the Renaissance. Venetian glassmakers experimented with using quartz to produce a clear, colorless glass. This glass known as *cristallo* (crystal) was extremely expensive (Figure 3–39).

FIGURE 3–33 Made in England circa 1320–1330, these tiles were likely applied to a wall and not a floor, judging from their condition. The two scenes, rendered in yellow and red, depict town life during the medieval period. The figures and details of the scene incised into the clay expose the red slip underneath, creating an outline effect. © *The British Museum*

FIGURE 3–34 A scene depicting a horned devil on horseback is rendered in blue and red stained glass. Black ink applied with a brush enlivened facial features, hair, and clothing.
Neil Lukas © Dorling Kindersley

FIGURE 3–35 The stained glass windows of Gothic cathedrals celebrated advancements in glass-making techniques at the time. Small panes of glass were held in place with lead muntins, and the entire glass panel was attached to the window with stone tracery.

FIGURE 3–36 The uppermost section of this window design features a central trefoil motif. The remaining window was made with small pieces of clear glass held together with lead.

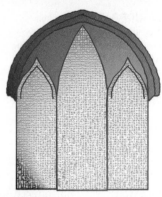

FIGURE 3–37 Glass windows inside affluent households were made from small diamond-shaped pieces of glass held together with lead.

Metalworking

Although the art of enameling can be traced back to ancient Mycenaean culture, the craft became more popular during the medieval period. Since the first millennium, enameling appeared as decoration on church reliquaries throughout Europe. Enameled designs were created by applying a ground glass paste in a variety of colors to the body of either copper or brass. The object was then heated, which fused the glass to the metal and brought out the sheen of the glass. After cooling, the exposed copper or brass was polished, giving the appearance of bright gold.

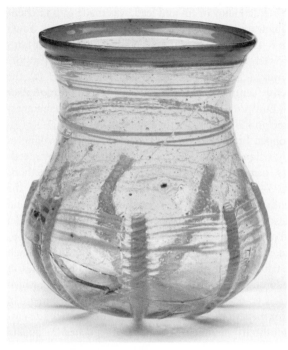

FIGURE 3–38 This blown glass cup has simple blue and yellow lines decorating its surface.
Peter Anderson © Dorling Kindersley, Courtesy of the Statens Historiska Museum, Stockholm

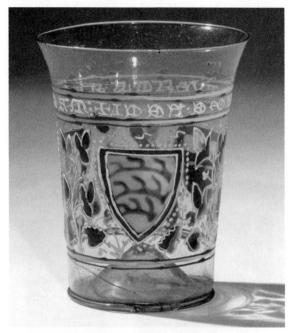

FIGURE 3–39 This Italian beaker has intricate painted designs including the coat of arms identifying its owner. This example of Venetian glass dates from the 1300s.
© The British Museum

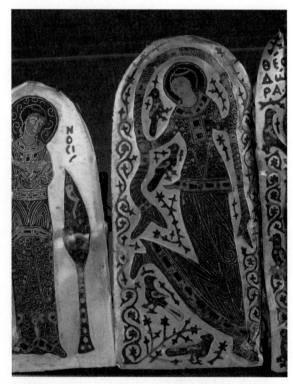

FIGURE 3–40 Cloisonné enamel plaques adorn the crown of Constantine IX.
Magyar Nemzeti Muzeum

A form of enameling, the art of cloisonné was introduced into Europe from Byzantium. Thin, raised bands of copper or brass were adhered to the body of the object to define the decorative patterns. The partitions were then filled with colored enamels and heated, fusing the glass and bringing out its luster. The small partitions, called *cloisons* in French, appeared bright gold after polishing (Figure 3–40). By the fifteenth century, Limoges in central France produced some of the finest cloisonné work in Europe.

Wrought iron goods were produced during the medieval period by blacksmiths, who forged the metal into a variety of usable objects by hammering out shapes on an anvil. Strap hinges and locking devices fortified doors and chests and were held in place with large rivets. Window openings were secured with wrought iron bars. Iron was also used to make light fixtures such as chandeliers, lanterns, and candlesticks. Torchères were held in place by large iron rings that were mortared into the stonework or stucco, and smaller lanterns were carried from room to room (Figure 3–41). Chandeliers featured candleholders that were attached to a large wheel that hung from the ceiling on chains (Figure 3–42). A pulley system raised and lowered the wheel so that the candles could be lit.

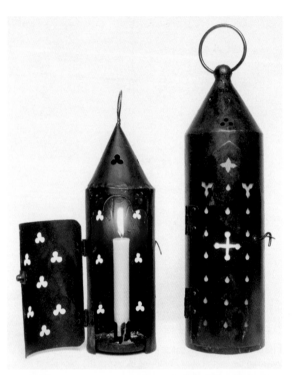

Pewter, an alloy of tin and lead, was made into kitchen- and tableware such as pitchers, cups, plates, and bowls (Figure 3–43). One of the luxuries enjoyed by wealthier families, pewter, with its lackluster finish and thicker proportions, was a less expensive substitute for silver. By the fourteenth century, pewter workshops were commonplace around Europe, and artisans who worked with this metal established guilds to improve their craft.

Copper, brass, and bronze were used in the making of statuary, reliquaries, and candlesticks for the church by metalworkers using both the lost-wax and casting methods (Figure 3–44). Monumental brasses first appeared in the thirteenth century as effigies to deceased nobility, royalty, and papal leaders, capturing the likeness of the deceased in flat relief applied over sarcophagi. Brass was made from an alloy of copper and calamine, a material with zinc compounds. Although bronze figurines and lamps date back to early Roman times, in the medieval period, brass was favored for its coloring, which resembled gold (Figures 3–45, 3–46). The establishment of guilds for metalworkers during the thirteenth century set standards for the artisans and workshops that regulated the quality of these goods.

FIGURE 3–41 These two metal lanterns were decorated with a punched trefoil design that allowed candlelight to filter into the room. The round ring at the top is a handle for carrying the lantern from place to place and served as a hook for hanging.
© Dorling Kindersley

Medieval Room Setting

The great hall was the main gathering place inside the medieval castle or manor house. In this example, structural ceiling beams affixed to the wall with large modillions, or brackets, are left exposed. Stone relief work above the fireplace features the family crest, or coat of arms, and the fireplace opening is shaped by a rounded arch. The stone floor is left bare, and a long bench is placed against the wall beneath a tapestry hung for warmth. Wrought iron accessories include a large chandelier, fireplace tools, and an assortment of weaponry. The room's interior reflects the style of an affluent household of the period.

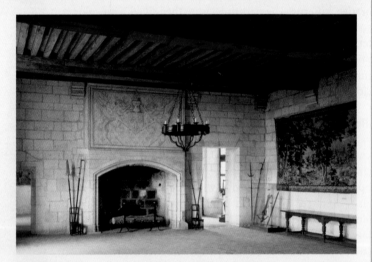

FIGURE 3–42 The great hall in this medieval castle displays an array of wrought iron objects including fireplace tools, weaponry, and a large chandelier.
Geoff Dann © Dorling Kindersley

FIGURE 3–43 A plate and spoon made from pewter date from the medieval period. Men carried knives affixed to their belts and brought them to the dining table. Forks were not widely used until the Renaissance.
Geoff Dann / Dorling Kindersley © York Archaeological Trust for Excavation and Research Ltd.

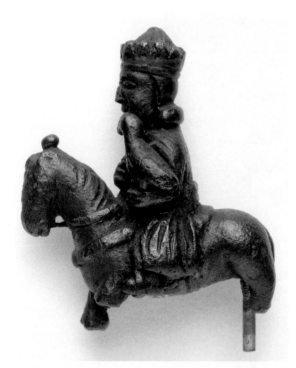

FIGURE 3–44 A cast bronze sculpture of a king on horseback suggests the likeness of Carolingian Charlemagne with its fleur de lis–patterned crown.
© Museum of London

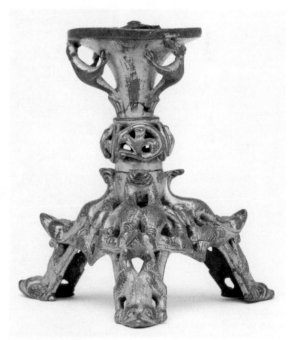

FIGURE 3–45 This ornate tripod-base brass candlestick holder from the medieval period reveals an array of animals cast into its design.
Geoff Dann © The British Museum

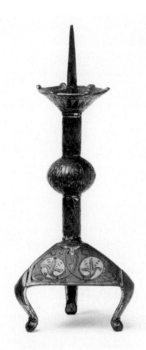

FIGURE 3–46 This ceremonial brass candlestick holder supported on three legs has a tall spike to hold the candle in place. Painted fleur de lis patterns adorn its surface.
Geoff Dann © The British Museum

Textiles

The art of tapestry weaving flourished during the medieval period. Expensive to own, tapestries were hung on the walls of the great hall, insulating the room against drafts and dampness (Figure 3–47). Tapestries made from hand-dyed woolen yarns interspersed with silk threads were commissioned depicting landscapes, Christian scenes, and contemporary subjects in rich colors of crimson, ultramarine, and greens with yellow gold (Figure 3–48). An expensive detail in tapestry weaving were small clusters

FIGURE 3–47 Wall hangings with a crown and rose design that symbolized the Virgin Mary and Christ. A red drape, pulled to one side, covered the door opening.
Geoff Dann/Dorling Kindersley © York Archaeological Trust for Excavation and Research Ltd.

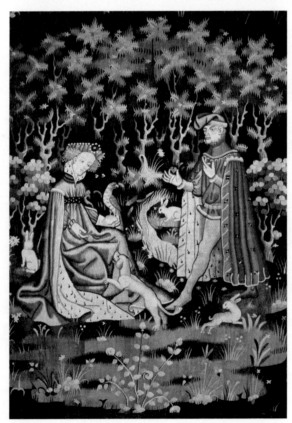

FIGURE 3–48 This colorful tapestry, *The Offering of the Heart*, depicts two well-dressed figures set among a field of millefleurs and animals.
Neil Lukas © Dorling Kindersley, courtesy of Musee National du Moyen-Age Thermes de Cluny

of local flora called *millefleurs*—literally, "thousand flowers"—and the quantity was agreed on in advance between weaver and patron. The art of tapestry weaving thrived during the thirteenth and fourteenth centuries in Europe, with some of the finest examples coming from France and Flanders in Northern Europe.

Unlike woven tapestries, embroideries are designs applied to canvas using needlepoint techniques. Embroidered pillowcases, draperies, tablecloths, and seat cushions appeared in well-appointed interiors belonging to wealthy patrons and the church (Figure 3–49). The most famous embroidery from the medieval period is the Bayeux Tapestry (it was mislabeled a tapestry by early scholars) (Figure 3–50). Commissioned to commemorate the Battle of Hastings, which occurred in 1066 between England and Normandy, the scenes embroidered into the over 230-foot-long cloth document medieval history. Scenes include the battle itself, the construction of Westminster Abbey in London, and the passing of Halley's Comet.

FIGURE 3–49 This gold embroidered pillow finished in gold fringe depicts an enthroned Christ.
Alistair Duncan © Dorling Kindersley

FIGURE 3–50 The famous Bayeux Tapestry is not a tapestry at all; it is embroidery work featuring the Battle of Hastings; it was completed in the eleventh century. In this section, a group of men feasts around a semicircular table.
Detail from the Bayeux Tapestry - 11th Century. By special permission of the City of Bayeux

Medieval tapestries were very expensive to produce, requiring more than a year for a workshop of weavers to complete. Woven with woolen yarns, silk threads, and sometimes gold, tapestries bore colors that were bright and vivid. The dyes used for coloring yarn came from plants, especially woad, which gave the medieval weaver the brilliant blue seen in many tapestries from this period.

The Pre-Raphaelite Brotherhood of artisans, including the legendary William Morris (1834–1896), who worked in the late nineteenth century, sought to re-create the handcrafted quality of medieval guild workers in a time when machine-made crafts were threatening the livelihood of the artist. Morris & Company sold high-quality home furnishings all made by hand using traditional craft methods. Tapestries made for his company depicted images similar to those once popular in the medieval period—Christian subjects, pastoral landscapes, and figures dressed in medieval clothing.

The tapestries shown in Figures 3–51 and 3–52 have similar qualities, although they were woven nearly four hundred years apart. The first tapestry dates from around 1511 and is one of six panels designed by a French artist and woven in Belgium (Figure 3–51). Its subject, *Lady and a Unicorn*, illustrates the five senses (touch, smell, taste, sight, hearing); the meaning of the sixth panel is unclear. Each panel features the

FIGURE 3–51 This French tapestry depicts a well-dressed woman and her attendant in a forest surrounded by a field of millefleurs and animals including the mythological unicorn.
Neil Lukas © Dorling Kindersley, courtesy of Musee National du Moyen-Age Thermes de Cluny

central figures set in a landscape of flora and fauna among a field of millefleurs with Latin inscriptions. The second tapestry, designed by Pre-Raphaelite painter Sir Edward Burne-Jones (1833–1898) in 1892, depicts a landscape set with flora and fauna including deer, fox, and rabbits among trees on a field of millefleurs with inscriptions appearing above (Figure 3–52). Both tapestries were woven by hand on looms using hand-dyed woolen yarns colored with natural pigments.

Although the two tapestries share similarities, their differences reveal the changes in art over the span of nearly four hundred years. The scene in the earlier tapestry shows a flattened, almost bird's-eye perspective; the figures are viewed as if looking at them from straight on, while the background landscape rises up and is forced forward into the scene rather than receding toward any distinctive horizon. These contrasting perspectives are indicative of earlier painting styles of the period. In the later example, Burne-Jones used variations in scale to project a sense of depth into the scene and used millefleurs along the bottom to anchor the figures to a ground plane. Furthermore, the animals and trees depicted in the landscape appear in scale to one another, unlike the disparity between the size of the woman and her maidservant from the *The Lady and the Unicorn.*

FIGURE 3–52 This tapestry woven by John Henry Dearle (1860–1932) for Morris & Company dates from the nineteenth century and was inspired by those from the medieval period with its depiction of animals in a forest surrounded by millefleurs.
© *Judith Miller / Dorling Kindersley / Lyon and Turnbull Ltd.*

Part 2
The Modern World

The Renaissance: Fifteenth and Sixteenth Centuries

TIMELINE

Renaissance Period

1400–1600

1400	Plague breaks out in Europe.
1434	Cosimo de Medici rules Florence.
	Van Eyck paints *The Arnolfini Wedding.*
1436	Brunelleshi completes dome on the cathedral in Florence.
1454	Gutenberg perfects the printing press using movable type.
1473	Astronomer Copernicus reveals theory that planets orbit the sun.
1485	Botticelli paints *The Birth of Venus.*
1492	Christopher Columbus explores the West Indies.
1496	Durer begins woodcut series for *The Apocalypse.*
1498	Leonardo da Vinci completes *The Last Supper.*
1504	Michelangelo sculpts *David.*
1506	Hellenistic sculpture of the *Laocoon* discovered in Rome.
1509–1547	King Henry VII rules England, establishing the Tudor monarchy.
1512	Copernicus writes his treatise on the solar system, *Commentariolus.*
1513	Lorenzo de Medici becomes Pope Leo X.
1519–1520	Portuguese explorer Magellan sails to the Pacific Ocean from Spain.
1515–1547	King François I rules France.
1517	Martin Luther writes his *95 Theses,* launching the Counter-Reformation.
1546	Michelangelo begins designs for the dome on the new St. Peter's Basilica in Rome.
1552	Lavinia Fontana, first woman to paint publicly commissioned art, born.
1556–1598	King Philip II rules Spain.
1558–1603	Queen Elizabeth rules England.
1594	William Shakespeare writes *Romeo and Juliet.*

The word *renaissance* comes from the French *renaire*, meaning "to be born anew." The term describes the European cultural period of the fifteenth and sixteenth centuries that many scholars consider the origin of modernity. Significant cultural changes took place during the last two and a half centuries of the medieval period that lead to a rebirth of classical ideology that we call the European Renaissance. Until the thirteenth century, only a small percentage of people could read and write. The majority of the population received a limited education, mostly through liturgical teachings from the church. Texts predating Christianity that professed polytheistic religions were sequestered by the church, including classical studies and the writings of Plato, Socrates, and Homer.

By the end of the thirteenth century, England, France, and Italy had established the first universities allowing the sons of wealthy landowners to study subjects not covered in liturgical teaching. Over time, education continued to improve. At the end of the fourteenth century, Greek philosophy was taught for the first time since antiquity. The establishment of Greek studies at Florence University prompted curiosity about the beauty of the ancient ruins that lay all around.

Other factors contributing to the demise of the medieval period occurred in the mid-fifteenth century. The seat of the eastern Roman Empire fell to Ottoman Turks in 1453. At this time, members of the clergy fled to Europe, bringing with them ancient classical manuscripts from the libraries held by the Muslims in Alexandria. In 1454, with the invention of movable type and the printing press, these ancient texts were translated into Latin, and multiple copies were printed for distribution around Europe.

Enlightenment soon followed as Western Europeans were introduced to the great philosophers, scientists, and mathematicians of ancient Greece and Rome. Educated readers thirsting for knowledge embraced the classical teaching of humanism, which encouraged free thinking and the right of individuals to determine their own destiny. These events, coupled with greater independence from strict church doctrine, enabled educated classes to experience knowledge at levels unequaled since before the fall of the Roman Empire.

Architectural Settings

The construction of churches and cathedrals continued as a thriving business into the fifteenth century, and more palaces, villas, and chateaus were built during this period, reflecting an increase in individual wealth. With a boosted economy brought on by an increase in international trade, wealthy merchant classes enjoyed a more comfortable lifestyle than the merchants and tradespeople of the medieval period did. In addition, a compilation of writings by the first-century Roman architect Vitruvius was first published in 1486. As contemporary Italian architects experimented with Vitruvian theories, the heaviness of the medieval style gave way to more unified proportions of classicism as expressed through the work of Andrea Palladio (1518–1580). Palladio's Villa Rotunda, built in 1567, is testament to the emerging Italian Renaissance style with its large Ionic porticoes, central domes, and monumental staircases (Figure 4–1).

The architecture of the Italian Renaissance villa resembled that of its Roman counterparts with multiple stories and open courtyards, along with richly decorated interiors (Figure 4–2). Hung against stone or brick walls, intricately woven tapestries provided beautiful decoration and gave some warmth to these cold, drafty interiors. In many homes, skilled artists painted elaborate frescoes onto plaster walls rivaling those from ancient times. Trompe l'oeil scenery expanded the imagination through

FIGURE 4–1 Andrea Palladio designed Villa Rotunda in 1567 after he was inspired by the writings of the first-century CE architect Vitruvius. *Roger Moss © Dorling Kindersley*

FIGURE 4–2 This palace in Naples dating from the sixteenth century features an expansive interior courtyard and marble arched loggias. *Demetrio Carrasco © Dorling Kindersley*

false representations of bookcases, landscapes, and simulated wood panel wainscoting (Figure 4–3).

By the sixteenth century, the Italian Renaissance style had spread to Spain, Scandinavia, the Netherlands, France, and England. Spain, however, was slow in adopting the Renaissance style; because the area was occupied by the Moors from the eighth century until they were driven out in 1492, Islamic design prevailed over European influences. Arabian houses were designed around a central patio and water fountain, common for regions with hot, dry climates (Figure 4–4). Colorful and highly ornate ceramic tiles designed with fluid botanical patterns or strong geometrics—a definitive Moorish influence—covered the patio areas and interior walls and floors. Also, wrought iron grillwork in arabesque patterns of Islamic inspiration were incorporated around the loggia and in the interior, including stairwells, accessories, and furniture (Figure 4–5). Interior furnishings showed refinement of quality and artisanship featuring fine furniture, textiles, and decorative accessories (Figure 4–6).

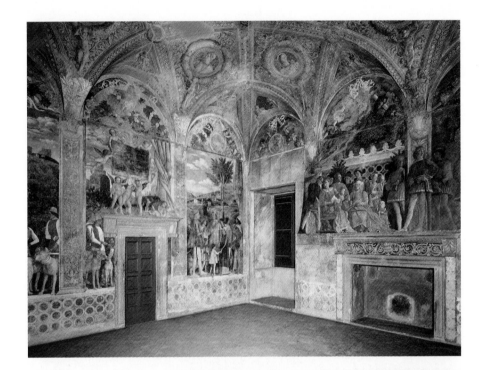

FIGURE 4–3 This room in the Ducal Palace in Italy shows colorful wall paintings depicting expansive landscapes and family portraits painted by Florentine artist Andrea Mantegna (1413–1506).
Getty Images/De Agostini Editore Picture Library

FIGURE 4–4 A central fountain was often the focal point of Spanish courtyards during the fifteenth and sixteenth centuries. The fountain's cascading waterfalls cool the air in the surrounding patio.
Treena M. Crochet

The palace begun in 1563 as the royal palace and mausoleum for the Spanish monarchy, El Escorial, introduced Italian Renaissance design in its attention to symmetry, classical detailing, and ornate frescoes (Figure 4–7). Under the guidance of King Philip II (r. 1556–1598), the complex, which also included a monastery, was first started by Juan Bautista de Toledo. Upon his death in 1567, the project was taken over by Juan de Herrera (1530–1597). The king's chamber exhibits the blending of Moorish and Renaissance designs in the Mudéjar style (Figure 4–8).

FIGURE 4–5 Wrought iron railings surround multiple-storied loggias in this sixteenth-century palace in Seville.
Peter Wilson © Dorling Kindersley

French architectural design remained immersed in the heaviness of the medieval style into the sixteenth century, when Leonardo da Vinci (1452–1519) left Italy in 1516 and traveled there on the invitation of François I. In France, Leonardo became the king's military advisor and offered designs for Chateau du Chambord, François' palatial hunting lodge (Figures 4–9, 4–10). The palace was redesigned to include classical designs mixed with medieval fortification. It was not until François' successor, King Henry II, married Catherine de Medici of Italy in 1533 that the royal residences at Chambord and Fontainebleau were transformed into Italian-inspired palaces. The Italian Mannerist style of design came to France through Catherine's importation of Italian artisans who changed the royal residences from weighty medieval castles into refined Renaissance estates. Fontainebleau, begun in 1528, quickly became a showplace of

FIGURE 4–6 This sixteenth-century Spanish interior in the Mudéjar style has a heavy wooden ceiling, white plaster walls, and hooded fireplace flanked by niches filled with decorative pottery. Placed around the dining table are two armchairs—in Spanish, *sillón de frailero.* One chair has velvet upholstery and the other is covered in leather. A fancy rug with geometric designs in the Islamic tradition covers the floor.
Museo Nacional de Artes Decorativas. Madrid.

FIGURE 4–7 The architects Juan Bautista de Toledo and Juan de Herrera designed El Escorial, palace to King Philip II of Spain. The palace complex dates from 1563 and shows the emerging Renaissance style in Spanish architecture.
Max Alexander © Dorling Kindersley

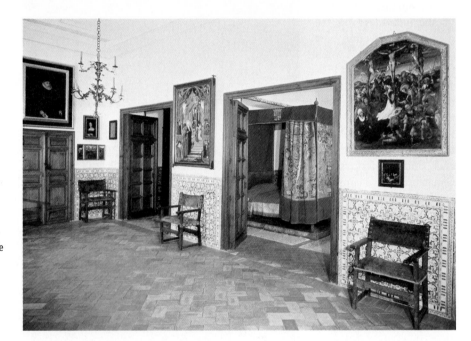

FIGURE 4–8 The interior of El Escorial shows restraint in classical designs in this view of the king's private chamber. Low ceilings, plaster walls with tiled wainscoting, and a tile floor laid in a herringbone pattern provide a simple background for leather chairs. A rather ornate chandelier hangs from the ceiling.
Instituto Amatller d'Art Hispanic. Arxiu Mas

French Renaissance styling with interior designs completed by Italian wood carvers, painters, and plasterers (Figure 4–11).

Geographical location and religious differences separated England from the rest of Europe. As a result, the Renaissance style developed much later in the British Isles than in other countries. Steeped in medieval styling, Hampton Court, home to the English monarchs beginning with King Henry VIII, featured crenellated brick walls and turrets on the exterior and paneled interior walls with

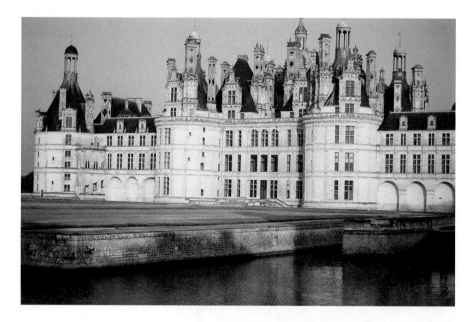

FIGURE 4–9 This view of Chateau du Chambord, built from 1519 to 1547, reveals a classically appointed façade with its Palladian windows, ornate pediments, and pilasters coupled with medieval-style turrets.

John Parker © Dorling Kindersley

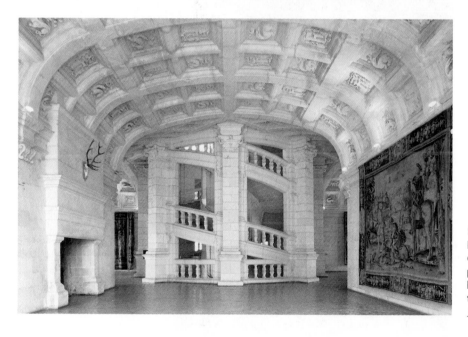

FIGURE 4–10 The reception hall leading to a massive staircase inside Chateau du Chambord features parquet flooring, a coffered ceiling, a hooded fireplace, and a large hanging tapestry.

John Parker © Dorling Kindersley

linenfold motifs, lead and stained glass windows, and Gothic-inspired vaulted ceilings supported by heavy wooden beams (Figure 4–12). Like those of the medieval period beforehand, English castles of the period maintained the great hall as the most impressive room in the house, designed to display the wealth of its owners (Figure 4–13).

English country houses eventually advanced from the large fortified castles, once seats of power for feudal lords, to well-proportioned estate houses. English design characteristics borrowed heavily from other countries, including Holland and Flanders in the Netherlands, and ecclesiastical models. English designers did not adopt a true interpretation of the Renaissance style until the seventeenth century, when the

FIGURE 4–11 A staircase at Fontainebleau combines allegorical paintings in molded plasterwork frames, Mannerist-style female nudes, marble paneling, and a wrought iron banister.
The Bridgeman Art Library International

FIGURE 4–12 An interesting juxtaposition of the various styles of Hampton Court architecture; on the left, the original 1515 castle appears with its crenellated walls. The building on the right, an addition built in 1689 by Sir Christopher Wren, exhibits refined classical detailing with its balustrade roofline and prominent quoins.
Robert Harding World Imagery

architect Inigo Jones (1573–1652) returned from studying in Italy and introduced the style to England's King James I (Figure 4–14). The long gallery in country estates was an adaptation of the medieval church's cloistered walkway; the room was long and narrow with windows running the entire length. Family portraits were hung on the walls opposite the windows, and the long gallery was used as an activity room during foul weather. Oak paneling from floor to ceiling was more common in the English interior, and more elaborate decorations emerged including pargework ceilings and fancy

FIGURE 4–13 This great hall in the Tudor style features a high, fan-vaulted ceiling with hooded fireplace, a refectory table, and wall cupboard.
Joe Cornish © Dorling Kindersley

FIGURE 4–14 Begun in 1616, Inigo Jones's design for Queen's House in Greenwich introduced England to the classical styles of the Italian Renaissance.
Chris Stevens © Dorling Kindersley

plasterwork (Figure 4–15). The in-town residences of the working-class wealthy were built in the Tudor style featuring exposed beams and white stucco walls (Figure 4–16).

Design Motifs

With a renewed interest in the aesthetic qualities of Roman and Greek cultures, Italian Renaissance artisans had only to turn to the ruins of Rome for inspiration. Half buried by centuries of soil, broken entablatures and capitals lay on the ground around the city. As excavations began and the new foundation was laid for the rebuilding of Saint Peter's church in Rome at the beginning of the sixteenth century, a multitude of classical artifacts were unearthed, providing exquisite examples of dentil moldings,

FIGURE 4–15 This large-scale bedroom features an Elizabethan-style tester bed set in an interior finished with a heavy coffered ceiling design of wood, parquet flooring, a large wall tapestry, a brass chandelier, and a frieze design of patterned flowers.
Michal Grychowski © Dorling Kindersley

FIGURE 4–16 This home in Stratford-upon-Avon in England belonged to the physician John Hall, who was the son-in-law of William Shakespeare. Although the home is modest compared to an English manor house, it is an exemplary Tudor-style house with its exposed timber framing and white stucco walls and is typical of the physician's social class.
Rob Reichenfeld © Dorling Kindersley

egg and dart patterns, gadroons, garlands, and guilloche. The motifs from ancient Rome inspired builders and artists during the Renaissance and were incorporated as decorations in lavish interiors and furnishings (Figures 4–17 through 4–20).

The great sculptures of Apollo and Venus, no longer idolized as gods, became sources of inspiration for perfect beauty. Gods and goddesses, including small cupids or putti figures, adorned architectural interiors and furnishings as creatures from mythology, not as the powerful supreme beings once worshipped by the ancient Romans. Lively scenes with frolicking putti figures, classical goddesses, and an assortment of satyrs, griffins, and nymphs were popular subjects of tapestry weavings and fresco designs (Figures 4–21, 4–22).

FIGURE 4–17 This detail of an architectural panel from the fifteenth century shows two putti figures holding a cartouche.
Linda Whitwam © Dorling Kindersley

FIGURE 4–18 This rendering of a cartouche-shaped mirror features the face of a small putti figure on its crest.

FIGURE 4–19 Garlands of asymmetrically arranged flowers tied with ribbons appeared as carved decorations on Italian woodwork and furniture designs during the sixteenth century.

FIGURE 4–20 A symmetrical grouping of flowers tied with ribbons creates this festoon, or garland, motif.

FIGURE 4–21 This classical arabesque motif features a symmetrical arrangement of foliate designs clustered around a ram's skull.

FIGURE 4–22 This trompe l'oeil painting in bright colors features a variety of Renaissance motifs based on classical elements. A central cartouche shows classical nudes on horseback and mythical griffins and satyrs connected by garlands of beads. A guilloche band runs along the top, and an acanthus leaf design appears on the base of the spandrel.

Piccolomini Library, Duomo, Siena, Italy/The Bridgeman Art Library

Spanish, French, and English artists adopted classical motifs in their own unique manners, with most still clinging to patterns that were more conventional from the medieval period. It was not until the start of the seventeenth century in England that Inigo Jones emphasized Renaissance designs in his architecture; interior designs incorporated acanthus leaves, triangular pediments, and volutes. French designs included classical arabesques and geometrical lozenge patterns, with more extensive use of classic details introduced after the royal marriage between King Henry II and Catherine de Medici (Figures 4–23 through 4–26).

FIGURE 4–23 This guilloche border has an alternating oak leaf and rosette pattern.

FIGURE 4–24 A band of laurel leaves appeared in decorative carvings on Italian wall paneling and furniture designs during the Renaissance.

FIGURE 4–25 The diamond shaped lozenge motif often appears with simple geometric designs or embellished with fancy carvings.

FIGURE 4–26 The fleur de lis motif appeared frequently during the Renaissance as a symbol of the monarchies in France and England.

Spanish designs incorporated moderate classical ornamentation, emphasizing Moorish-based geometrical designs. Furthermore, the Mudéjar style, popular in Southern Spain since the medieval period, was a Western interpretation of Moorish, or Islamic, designs. Many of the motifs in the Mudéjar style were featured in fancy tile work used on walls and floors (Figures 4–27, 4–28). These motifs are geometric

FIGURE 4–27 Emblems of the fleur de lis and rosettes appear on these Spanish-made tiles. Queen Elizabeth I of England used the fleur de lis in her official coat of arms, and the motif was adopted by the French monarchs as early as the twelfth century.
Linda Whitwam © Dorling Kindersley

FIGURE 4–28 Colorful tiles feature eight-pointed star designs, strapwork motifs, bunnies, and birds on this patio floor from Grenada, Spain.
Treena M. Crochet

in spirit as Islamic beliefs prohibited the depiction of graven images (Figure 4–29). Other geometric motifs include the octogram, or eight-pointed star pattern, which was adopted by Moslem designers in the building of eighth-century mosques (Figures 4–30 through 4–33).

FIGURE 4–29 Simple geometric panels used in Moorish architecture often appeared on pieces of furniture and wall paneling during the Renaissance period.

FIGURE 4–30 This motif features the eight-pointed star that was frequently used as a symbol of Islam.

FIGURE 4–31 Geometric designs and the eight-pointed star design radiating from the center are featured on this Moorish medallion.

FIGURE 4–32 This medallion features an eight-pointed star at its center encircled by decorative rosettes and simple bands of color.

Interior Furnishings

During the sixteenth century, an established middle-class economy enabled more people to own finer household goods than before. However, a disparity in construction quality and styling remained between furniture used by the middle class and that used by wealthier merchants. More types and designs of furniture, including chair designs, emerged during the fifteenth and sixteenth centuries, and a greater emphasis was placed on luxury and comfort with the introduction of upholstered furniture (Figures 4–34 through 4–36). Upholstered furniture became more common as the cloth trade flourished during the Renaissance period.

Chests and small caskets were an integral part of household inventories. Like those of the medieval period, these trunks contained household valuables that were kept under lock and key (Figures 4–37 through 4–39). In addition to chests and caskets, cupboards and cabinets appeared in greater numbers. The design of these case goods incorporated numerous architectural elements; engaged columns supported entablatures with carved moldings, and elaborate classical motifs appeared in the frieze area. Cupboards were used in the dining hall, and writing cabinets were owned by the literate wealthy (Figure 4–40).

FIGURE 4–33 This doorway from a palace in Southern Spain features a heavy wooden door carved with geometric designs and eight-pointed stars beneath a pediment of Arabic calligraphy.
Treena M. Crochet

FIGURE 4–34 This sixteenth-century Spanish chair, or *sillón de frailero,* was upholstered in leather with prominent nail heads to keep it in place. The leather was tooled with geometric banding.
© Judith Miller/Dorling Kindersley/ Sloans & Kenyon

FIGURE 4–35 This nineteenth-century reproduction of a sixteenth-century Italian chair has a needlepoint-patterned fabric trimmed in fringe. The volute arms, oversized but decorative front and back stretchers, and inlaid ivory are typical features of Renaissance furniture styling.
© Judith Miller/Dorling Kindersley/ Lyon and Turnbull Ltd.

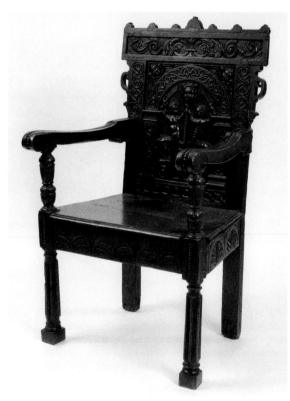

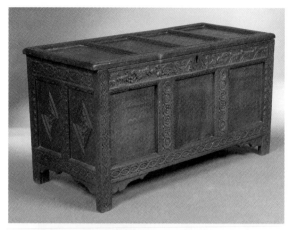

FIGURE 4–37 This early-seventeenth-century English oak chest has guilloche carvings along the front with lozenge motifs on its side.
© *Judith Miller/Dorling Kindersley/Wallis and Wallis*

FIGURE 4–36 This English wainscot chair has acanthus leaf carvings, classical putti figures, gadrooned arms, and columnar legs. Although upholstered chairs appeared in England during the sixteenth century, this wainscot chair would have had a loose cushion seat. Its position against a wainscoted wall gives it its name.
© *Judith Miller/Dorling Kindersley / Hamptons*

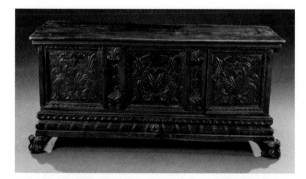

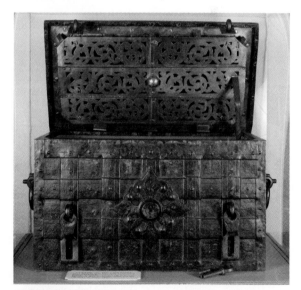

FIGURE 4–38 This Italian cassone carved from walnut features an array of classical motifs including acanthus leaves, gadroons, arabesques, and laurel leaves.
© *Judith Miller/Dorling Kindersley/Sloans & Kenyon*

FIGURE 4–39 This French traveling chest was made from carved walnut reinforced with metal strapping on the exterior and inside the lid. A central rosette decorates the front surface.
© *Dorling Kindersley, Courtesy of the Musee de Saint-Malo, France*

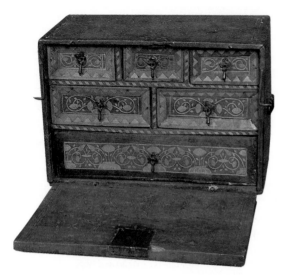

FIGURE 4–40 This seventeenth-century Spanish walnut and marquetry *vargueño,* or writing cabinet, has a hinged fall front surface for writing and compact drawers for storing writing implements and papers. The inlaid arabesque patterns along with the cabinet's portability are influences of Moorish design.
© Judith Miller/Dorling Kindersley/Sloan's

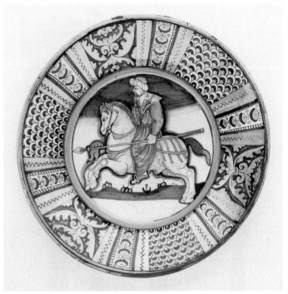

FIGURE 4–41 This Italian majolica dish from the sixteenth century features a Turkish warrior riding on a horse with colorful design motifs in blue and yellow surrounding the outer rim. Tin-glazed earthenware originated in the Middle East.
Geoff Dann © Dorling Kindersley, Courtesy of the Wallace Collection, London

FIGURE 4–42 These two hand-painted storage pots date from the Italian Renaissance and feature Latin inscriptions. The vessel on the left has delicate acanthus leaf designs.
Andy Crawford © Dorling Kindersley

Decorative Accessories

Pottery

Ceramic production on the Spanish island of Mallorca introduced Western Europe to the bright colors and Moorish designs of tin-glazed earthenware. The tin glazes that gave these ceramics their distinctive appearance relied on a lead-based glaze—brought to Spain from the Middle East—that gave the pottery an opaque white finish. Colorful patterns and designs were painted on the vessels, which were fired at high temperatures to make them impermeable. Mallorca exported many of its pieces to Italy, and the designs quickly became the model for Italian ceramics, spreading throughout Western Europe during the late Renaissance period. In fact, maiolica (majolica) production took place in the cities of Urbino in northern Italy and Venice to the south, and these ceramics were traded across Europe (Figures 4–41 through 4–43).

Glass

Venetian glass, and specifically examples from the island of Murano, was coveted by those who could afford it (Figure 4–44). Crystal goblets, beakers, and vases featured patterned designs enhanced with bright colors or gold leaf. During the fifteenth century, Murano glassmakers reintroduced the process of making mosaic glass called *Rosetta* that dated back to Hellenistic and Roman times. Slender rods of glass were made from concentric bands of color giving the appearance of small flowers once the rods were cooled and cut (Figure 4–45). The cross-sectioned pieces with intricate floral designs, or rosettes, at their center were then fused together to create a variety of objects with these *millefiori,* or thousand flowers, patterns.

Mirrors

In addition to glass-making, mirror-making flourished during the Renaissance. Adding to the stock of handheld mirrors, wall-hung looking glasses were made by applying a coating of tin and lead to the backside of either convex or flat glass. Elaborate frames held the mirrors, and themes varied from religious and classical figures to simple geometric designs (Figure 4–46). Convex mirrors reflected small and distorted images, whereas flat mirrors were more accurate in their reflection. Large-scale mirrors were scarce and very expensive because making large panes of glass was a difficult task.

Metalworking

Silversmiths and goldsmiths working during the Renaissance made a range of goods for the wealthy patrons who could afford these precious metals—the

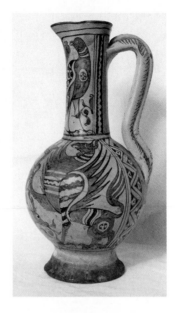

FIGURE 4–43 This ceramic ewer from the sixteenth century has mythical griffins and the phoenix painted on its surface.
Andy Crawford © Dorling Kindersley

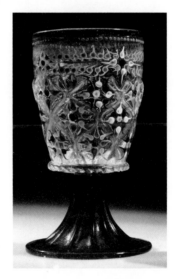

FIGURE 4–44 This cristallo glass goblet dates from around 1475–1525 and features colorful designs in blue, yellow, and green.
Art Resource, N.Y.

FIGURE 4–45 Shown are modern examples of the processes involved in making *millefiori* bead designs; tiny *millefiori* beads attached to a core bead are fused together and then given shape.
© Dorling Kindersley

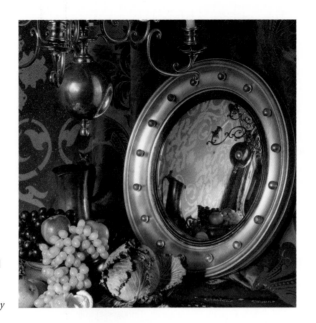

FIGURE 4–46 In this painting a framed convex mirror gives a distorted view of the room's interior including a fancy brass chandelier.
Michael Crockett © Dorling Kindersley

FIGURE 4–47 This elaborately carved silver chalice designed with a wide, ornate base with floral engravings, a long stem with a decorative ball, and a gadrooned cup with gold rim shows the exquisite skills of Renaissance silversmiths.
Geoff Dann © Dorling Kindersley, Courtesy of the Museum of the Order of St John, London

church and the nobility. Ecclesiastical objects for the Eucharist such as chalices, basins, and platters were hand crafted for these special purposes (Figure 4–47). Domestic wares for the nobility included drinking cups, spoons, salvers or serving trays, and the newly introduced fork.

Lighting

Only wealthy households or the church could afford candles. Made from tallow, or animal fat, by the fifteenth century, cotton had replaced grass or rush as a wick. The wick would be dipped several times in tallow, coating the wick and building up the candle to the desired size. Oil lamps were used by those who could not afford the luxury of candles. Lighting an interior was relegated to carefully placed chandeliers, candlesticks, and lanterns that were fashioned from bronze, brass, or wrought iron (Figure 4–48).

Clocks

First introduced in the fourteenth century, the mechanical clock—too expensive for most middle-class households—became a status symbol of the rich. Improvements in clock making in the early fifteenth century resulted in the introduction of spring-coil pocket watches. By midcentury, clocks with minute hands were introduced. The cases designed to hold the clock's mechanical workings became highly elaborate, embellished with designs

FIGURE 4–48 This lantern made from gilt bronze with leaded glass insets is from Seville and dates from the sixteenth century.
Neil Lukas © Dorling Kindersley

FIGURE 4–49 In this portrait painting by Rogier van der Weyden, an early example of a wall clock can be seen in the background just to the left of the man's face.
Koninklijk Museum voor Schone Kunsten, Antwerp, Belgium/The Bridgeman Art Library

popular during the Renaissance period. By the end of the century, table clocks, pocket clocks, and wall clocks adorned many interiors, and by the seventeenth century, the invention of the swinging pendulum made them more accurate (Figure 4–49).

Textiles

Merchants who dealt in cloth, like those who lived in the medieval period before them, had wealth and status in the community. Cloth used for clothing, upholstery, and bed drapes reflected the wealth of its owner in its refined quality and quantity (Figure 4–50). Expensive Italian cut velvets, which hung on the walls of the finest palazzos, were highly prized throughout Europe. The introduction of flocked wallpapers in the seventeenth century offered an inexpensive substitute.

The tapestry weaving industry continued to prosper in Brussels, Flanders, and France throughout the Renaissance (Figures 4–51, 4–52). Aubusson, a small town in France, earned a reputation for producing the finest designs in Europe. By the seventeenth century, Aubusson was declared the royal manufacturing center for textiles for King Louis XIV. The carpets and wall hangings from these workshops were made with a flat weaving process and had no pile. Tapestry designs of the Renaissance period emphasized more pictorial representations as many painters created the cartoons for their weaving.

The Palazzo Davanzati in Florence was built in the fourteenth century as a palace for a wealthy wool merchant and his family, a testament to the prosperity of the cloth trade. Now a museum, the palace is furnished with sixteenth-century furniture including a canopy bed, *predeux*, baby cradle, and chair. The massive scale of the room and its elaborate decorations are an indication of the family's great wealth. A high ceiling is supported by wooden beams that are painted in alternating bands of color, and brightly colored frescoes feature the narrative, *Lady of Vergi*, a French romantic tale about a noblewoman and a medieval knight. The remainder of the room is painted with contrasting geometric designs set against a plain terra-cotta-tiled floor. A corner fireplace keeps the room warm, and heavy wooden shutters close out drafts and filter the light.

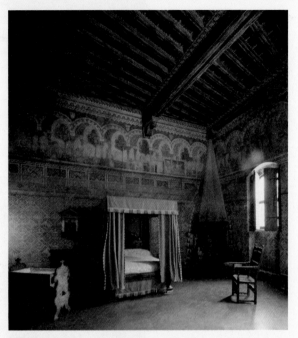

FIGURE 4–50 This bedroom in the Italian Palazzo Davanzati features elaborate interior design with its beamed and painted ceiling, tester bed, cradle, corner fireplace, frescoes, and armchair. The palace, with its well-appointed interior, was the home of a successful cloth merchant. *Art Resource, N.Y.*

FIGURE 4–51 A Flemish tapestry from the fifteenth century depicts the signs of the zodiac. The emphasis on astrology indicates the loosening power of the Catholic Church. *Max Alexander © Dorling Kindersley*

FIGURE 4–52 This French tapestry depicts peasants making wine among a field of millefleurs. *Ranald MacKechnie © Dorling Kindersley, Courtesy of the Musee des Thermes et de l'Hotel de Cluny, Paris*

Embroidered cushions, wall hangings, table and bed linens, and clothing were more plentiful in merchant-class households, with some of the finest needlework coming from Italy (Figure 4–53). Fine handmade lace also showed the wealth of those who could afford its delicate luxury. An offshoot of embroidery, lace became fashionable in the mid-sixteenth century with the establishment of a lace-making industry in England (Figure 4–54). Handmade lace, called needle lace, was very expensive; only royalty could afford it. Bobbin lace, developed in the latter half of the sixteenth century, was constructed using a weaving process. It was used as edging on table linens, garments, and bed linens.

FIGURE 4–53 Queen Jeanne d'Albret of Navarre, mother of King Henry IV of France, is depicted as the mythological goddess Venus in this sixteenth-century silk embroidery.
Picture Desk, Inc./Kobal Collection

FIGURE 4–54 Queen Elizabeth of England is dressed in the finest costume of the sixteenth century. Her collar, bodice, sleeve, and veil are trimmed in handmade lace, launching the domestic fashion for lace on bedding and cushion covers.
Private Collection/The Bridgeman Art Library

To commemorate a special event, person, or accomplishment, wall plaques made from metal, wood, or ceramic were popular throughout the Renaissance. Memorial plaques featured historic and religious figures, events in history, and events with meanings important to the families who commissioned them. The example shown in Figure 4–55 is from Northern Europe and dates from around 1600. Made from silver, the plaque depicts a hunting scene rendered in detail; a dog handler reins in his hounds to the left while a man on horseback on the right rides with a falcon on his wrist. Finely dressed women in the background are observing the hunt from inside a carriage, and castles and other buildings faintly appear in the distance.

The pewter wall plaque from 1905 shows the bust of a woman with long flowing hair wrapping around her torso (Figure 4–56). Poppies connected by sinuous vines encircle the rim, and the entire scene is anchored at the bottom with an acanthus leaf. The design and subject matter of this plaque are typical of the Art Nouveau style that was popular from 1895 to about 1905 in Europe. The plaque was designed for decoration rather than commemoration and was purchased for its aesthetic value.

FIGURE 4–55 A hunting scene appears in this silver wall plaque dating from 1600.
Geoff Dann © Dorling Kindersley, Courtesy of the Wallace Collection, London

FIGURE 4–56 This pewter wall plaque from 1905 features of a woman with flowing hair surrounded by vines and poppies.
© Judith Miller/Dorling Kindersley/Titus Omega

Baroque: Seventeenth Century

TIMELINE	

Baroque Period

1600–1700

1601	Caravaggio paints *Conversion of St. Paul.*
1604	British East India Trading Company established.
1605	Miguel De Cervantes writes *Don Quixote.*
	Sir Francis Bacon writes *The Advancement of Learning,* introducing theory of inductive reasoning.
1607	Jamestown, Virginia, established as first North American colony by the British.
1610–1643	King Louis XIII rules France.
1620	Second North American British colony established in Plymouth, Massachusetts.
1625–1649	King Charles I rules England.
1629	Giovanni Branca invents the steam turbine.
1642	Dutch painter Rembrandt completes *The Nightwatch.*
1643–1715	King Louis XIV rules France.
1649–1660	The Commonwealth rules England under leadership of Oliver Cromwell.
1656	Bernini begins the colonnade at St. Peter's in Rome.
1660–1685	King Charles II rules England.
1665	Vermeer paints *Girl with a Pearl Earring.*
1666	Great Fire razes parts of London.
1667	Milton writes *Paradise Lost*
1669	Construction begins on the Palace at Versailles.
1680	Pachelbel composes *Canon in D.*
1685–1689	King James II rules England.
1687	Sir Isaac Newton introduces new theories on gravity.
1689–1702	King William and Queen Mary rule England.
1692	Witchcraft trials begin in Salem, Massachusetts.

The first use of the term *Baroque* appeared in late-eighteenth-century texts as writers attempted to categorize the significant cultural changes that took place in the period following the Renaissance. The term *Baroque* literally translates from the French as "irregular." The term was used to describe a change in artistic style that emphasized lively patterns, superfluous ornamentation, and contrasting textures.

By the mid-sixteenth century considerable changes were occurring in religion and politics. Prompted by the writings and actions of Martin Luther and John Calvin, a new Protestant faith formed seeking religious reform and freedom from the papacy of the Roman Catholic Church. The ensuing wars, instigated by the Reformation movement in 1517 and the Counter-Reformation in 1560, finally ended around 1650. Furthermore, the Thirty Years Wars fought among the major powers of Europe lasted from 1618 to 1648. By then, European countries were divided by religious alliances, either Protestant or Catholic.

Although Italy was the seat of the Papal States, France became a leading political force in Europe when five-year-old Louis XIV (r. 1643–1715) ascended the throne. Much too young to actually rule, Louis XIV's mother acted as regent until 1661, when he took control of the affairs of state. By this time, France was already the wealthiest and most populated country in Europe. As king, Louis XIV made many progressive reforms including the implementation of a standardized money system and a consistent method of determining weights and measures.

Trade was encouraged within the French borders, and Louis XIV viewed this as a means of building a greater tax revenue base. An increase in local trade supported the growth of a wealthy middle class, the bourgeoisie, who outnumbered the aristocrats.

Throughout the religious wars, Europeans saw merciless battles among fellow compatriots. Compensating for these internal religious insurrections, respective monarchies attempted to create a profound sense of nationalism, promoting an allegiance to country rather than faith. The ruling monarchs strengthened absolutist control and took precautionary measures to reinforce their political power. Absolutism and internal trading resulted in greater economic opportunities for individuals, and the merchant classes rose to the ranks of upper society.

Other important results of the religious wars and the quest for absolutism were rising imperialism and the first permanent English colonies established in North America. In 1607, John Smith and a small group of English adventurers seeking gold and religious freedom settled Jamestown, Virginia. Thirteen years later, in 1620, the *Mayflower* set sail from Plymouth, England, and established the second settlement in Plymouth, Massachusetts.

Architectural Settings

Although the political power of the Catholic Church diminished significantly during the Barogue period, its religious strengths brought on by the victory of the Counter-Reformation and the endurance of the Papal States (Italy, Spain, Portugal, and France) was reflected in the construction of new churches. In Italy, the Baroque period emerged as a more passionate and expressive extension of the sixteenth-century Italian High Renaissance style. Designs for new Catholic churches emphasized magnificent size and scale, and exaggerated ostentatious decorative details replaced the simplicity of classical elegance employed by Renaissance architects. Baroque architectural style was, in essence, a highly articulated extension of Renaissance classicism. Columns, pediments, pilasters, and rounded arches balanced energetic sculptures influenced by the Italian artist Gian Lorenzo Bernini (1598–1680) (Figure 5–1). Throughout the Baroque period, architects and designers worked together to coordinate the architectural structure, paintings, and

sculptures into a single cohesive unit with fresco paintings and plaster relief serving as backgrounds for exquisitely crafted furnishings.

Louis XIV took the initiative to develop art and culture in France, contributing greatly to its advancement. With an increase in revenue, he funded public works projects in an attempt to create a French national style. In 1667, Louis XIV organized the workshops at the *manufacture des Gobelins* (established in 1633 by the Minister of Finance, Jean-Baptiste Colbert [1619–1683]) to provide furnishings for the royal palaces) under the leadership of Charles LeBrun (1619–1690). The following year, LeBrun found himself in charge of his most celebrated achievement—the interior decoration of a new palace for the French monarchy located outside of Paris in Versailles (Figure 5–2). An existing 1624 chateau built for King Louis XIII (r. 1610–1643) was to be transformed into the new royal palace. In addition to LeBrun, Louis XIV assembled under his patronage the leading architects of the period—Louis Le Vau (1612–1670), Jules Hardouin-Mansart (1646–1708), and André Le Nôtre (1613–1700)—to design the palatial residence and gardens. A garden façade setback designed by Le Vau and

FIGURE 5–1 Bernini drew the original sketch for the Trevi Fountain in Rome in the seventeenth century, yet work was not begun until after his death. Taking over the project in 1732, Nicola Salvi (1697–1751) maintained the spirit of Bernini's original design, completing the fountain in 1762. The fountain is positioned in front of the façade of the Palazzo Poli, with its oversized cartouche and Corinthian columns.
Demetrio Carrasco © Dorling Kindersley

FIGURE 5–2 The façade of the Palace of Versailles, designed by Jules Hardouin-Mansart, reveals Baroque styling with its projecting bays, Ionic columns, pilasters, and monumental sculptures running along the roofline.
Max Alexander © Dorling Kindersley, Courtesy of l'Etablissement Public du Musee et du Domaine National de Versailles. Reunion des Musees Nationaux/Art Resource, NY.

FIGURE 5–3 Sun shadows appear on the parquet floor of the Hall of Mirrors from the Palace of Versailles. Coordinating interior furnishings, including crystal chandeliers, gilt furniture, classical figures supporting elaborate candelabra, and ceiling paintings, were orchestrated by Charles LeBrun. *Max Alexander © Dorling Kindersley, Courtesy of l'Etablissement Public du Musée et du Domaine National de Versailles. Reunion des Musees Nationaux/Art Resource, NY.*

enclosed by Hardouin-Mansart held the most impressive room within the palace, the Galerie des Glaces, or the Hall of Mirrors.

The Hall of Mirrors, designed with seventeen lunette windows overlooking the garden, featured equally sized mirrors hung opposite each window (Figure 5–3). This created a room bathed in sunlight. Each morning, the room served as the site of Louis XIV's morning processional as his royal apartments connected to this hallway. Just as the sun is at the center of the universe, Louis XIV considered himself to be at the center of the French state. He viewed himself as the "Sun King," and, unequivocally, Mansart's design had complemented the king's perception of himself (Figure 5–15).

LeBrun attended to the interior details of Versailles. He directed teams of artisans in the design and execution of paintings, tapestries, furniture, and decorative accessories, achieving complete unity within the palace. Along with tapestries, fine embroideries, and velvets, gold and silver gilt furniture played an integral part of the interior scheme at Versailles (Figures 5–4, 5–35). Ultimately, Versailles became the envy of Europe for its beauty and lavish social events. Celebrations and festivals lasted for days, while ballets and performances entertained numerous guests. Court life was poetic for everyone; it was carefree and leisurely. The completion of Versailles established France as the cultural leader in Europe during the seventeenth century. French was the fashionable language to speak, and French court fashion provided a model for aristocrats and the middle-class bourgeoisie alike.

England and the rest of the predominantly Protestant countries were not immediately influenced by the Baroque style of the Papal States. Inigo Jones's contributions toward bringing the High Renaissance style to England during the early part of the seventeenth century led the way for the Baroque style later in the century. After the Great Fire in 1666 destroyed most of London, King Charles II set out to rebuild London in grand style and appointed Christopher Wren (1632–1723) as surveyor to his court. St. Paul's Cathedral in London, begun in 1667, was Wren's first royal commission (Figure 5–5).

Wren had traveled to Paris in 1665 and returned to England with countless engravings depicting the ornate French Baroque style. The grandiose nature of the

FIGURE 5–4 This luxurious bedroom designed for King Louis XIV at the Palace of Versailles features gilt plasterwork, a crystal chandelier, a parquet floor, and a majestic bed with gold-embroidered drapery.
Picture Desk, Inc./Kobal Collection

FIGURE 5–5 Sir Christopher Wren's design for St. Paul's Cathedral, begun in 1675, reflects strong allegiance to Michelangelo's dome of St. Peter's in Rome, built during the Italian Renaissance period. Wren's façade and dome reflect the English Baroque in style, which never fully embraced the energetic sense of movement seen in Italian Baroque architecture.
Dorling Kindersley © Sean Hunter

French Baroque style had impressed the king; however, it was too flamboyant for London. An English national style developed through Wren's achievements, and he was knighted for his architectural accomplishments. Wren's interpretation of the high Baroque style supplanted excessive Baroque ornamentation with classic Palladianism. In 1689, the new Stuart monarchs, William and Mary, commissioned Wren to expand Hampton Court Palace with a wing designed in this new style (Figures 5–6, 5–7, 4–12).

The style of seventeenth-century American architecture was quite different from the Baroque style expressed in European churches and country houses. English ships

FIGURE 5–6 Sir Christopher Wren designed the massive south front of the Palace at Hampton Court for the reigning monarchs, William and Mary of England. The façade features references to the classical elements of symmetry and proportion with its carefully placed windows, balustrade, and festoons.
Robert Harding World Imagery

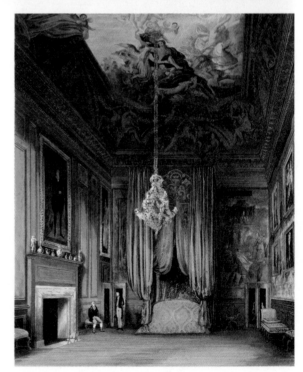

FIGURE 5–7 A colored print showing the bedchamber of Queen Mary at Hampton Court reveals a painted ceiling surrounded by gilt plasterwork, a marble mantel, wall paintings, and a lavishly draped bed.
Picture Desk, Inc./Kobal Collection

sailed for America with a wide range of passengers aboard but with little provisions. Upon their arrival, the first settlers' primary concerns were to build sufficient shelter from the weather and to cultivate the land and prepare for the winter. Small but accommodating houses were made from the abundant supply of trees, and the most basic methods of construction were employed (Figure 5–8). These early settlements resembled European country villages rather than sophisticated cities such as London or Paris.

Homes in America had one or two rooms with loft spaces used for storage. Beaten earth floors and wattle and daub walls provided shelter from the elements but lacked aesthetic detailing. The interiors were furnished with utilitarian items, most of which were made by local joiners or expensively shipped over from England (Figure 5–9).

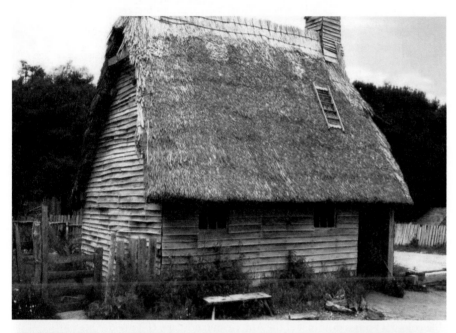

FIGURE 5–8 Modest wooden houses with thatched roofs shown here are recreations based on the original ones at Plimoth Plantation in Plymouth, Massachusetts.
Treena M. Crochet

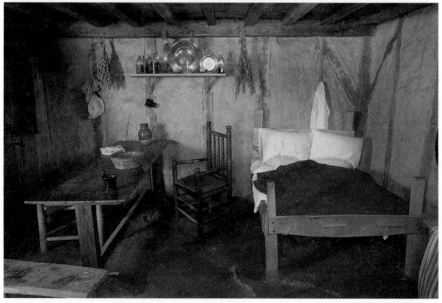

FIGURE 5–9 This re-created interior of the Stephen Hopkins House from Plimoth Plantation shows a low-beamed ceiling, wattle and daub walls, a beaten earth floor, and sparse furnishings. A collection of pewter ware sits on the "cup board" attached to timber posts on a wall beyond the table.
David Lyons © Dorling Kindersley, Courtesy of the Plimoth Plantation, Plymouth, Massachusetts

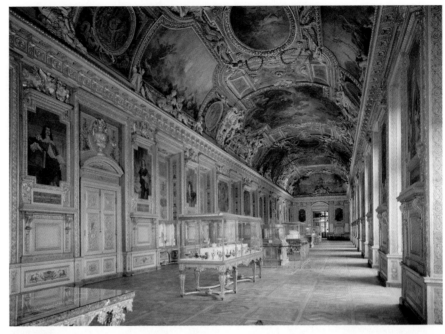

FIGURE 5–10 Baroque design motifs featured in the Galerie'd Apollon in the Louvre include elaborate classical figures seen in the richly carved and gilt architectural moldings and ceiling panels. *Louvre, Paris, France/The Bridgeman Art Library*

FIGURE 5–11 The griffin motif appeared in various forms throughout the Baroque period, including legs on furniture consoles and tables.

Shortly after the establishment of the Jamestown and Plymouth settlements, the Dutch, Spanish, and French also came to the New World. By 1630, towns sprang up all along the eastern seaboard. A developing economy dependent on tobacco and rice exported to Europe brought wealth to the American colonists, and towns continued to grow and prosper. By the end of the seventeenth century, larger and more comfortable colonial homes dominated the American landscape (Figure 6–7).

##

Key design elements consistently found in architectural interiors and subsequently incorporated into furniture designs reflect the Baroque adherence to classic inspiration. These classically based designs were more elaborate during the Baroque period, when interiors were filled with rich decorations (Figure 5–10). Acanthus leaves, shell motifs, griffins, pilasters, classical arabesques, garlands, and cupidlike figures appeared in design details along with lively botanicals (Figures 5–11 through 5–13). As in the Renaissance period beforehand, putti figures were popular; they appeared on furniture, in wall paneling, on textiles, and on decorative accessories (Figure 5–14). Localized to the French decorative arts, the symbolic emblem of the Sun King, featuring a masklike face with radiating rays behind it, appeared throughout the palace of Versailles (Figures 5–15, 5–34).

Botanical designs, especially the iris, lily, and tulip, appeared in plaster relief work and wood carvings. These intricate and ornate floral designs were brought to France by the Dutch during the religious crusades and were made popular in England after the royal marriage of William of Orange to Mary Stuart. Moreover, these floral patterns appeared in marquetry designs on furniture tabletops, drawer and door fronts,

FIGURE 5–12 A classic arabesque frequently adorned wall paneling designs, embroideries and tapestries, and marquetry patterns throughout the seventeenth century.

FIGURE 5–13 A rinceau of delicate flowers was a popular design motif in the Baroque period.

FIGURE 5–14 This red silk and gold embroidery altar cloth from the seventeenth century shows delicate rinceau patterns surrounded by flowers, a Christian cross, and a cherub as the central motif.
Picture Desk, Inc./Kobal Collection

FIGURE 5–15 This face superimposed on a burst of the sun's rays was adopted as the symbol of King Louis XIV of France, who was called the Sun King after the Roman god Apollo. The sun mask motifs along with sculptures fashioned to represent Apollo are a common element in the interior design of the Palace of Versailles.

Nick Hewetson © Dorling Kindersley

FIGURE 5–16 Marquetry patterns in delicate arabesque foliate designs appear on the body of a tall clock case dating from the seventeenth century.

The Bridgeman Art Library International

FIGURE 5–17 A lacquered low table in the William and Mary style features gilt chinoiserie designs on its door panels and drawers. *Chinoiserie* is the name given to describe design motifs fashioned after Chinese landscapes and teahouse scenes.

Steve Gorton © Dorling Kindersley

and long clock cases (Figure 5–16). Influenced by an increase in trade with China, chinoiserie motifs—those that depict Chinese landscapes and figures—became popular in England by the end of the seventeenth century (Figure 5–17).

Interior Furnishings

The wealth and social status of individuals in seventeenth-century Europe were measured by the size of the estate and the quantity and quality of the furnishings within it. The large and lavishly decorated and furnished chateaux, country houses, and villas were filled with matching suites of furniture produced for comfort and function mastered with great aesthetic appeal, the best tapestries and carpets, and crystal chandeliers (Figure 5–18). Each country adapted the Baroque style of architecture to suit its regional preferences; the furniture was also modified in style. The celebrated furniture designs of André-Charles Boulle (1642–1732) for the completion of Versailles established France as the new trendsetter for interior furnishings (Figure 5–19).

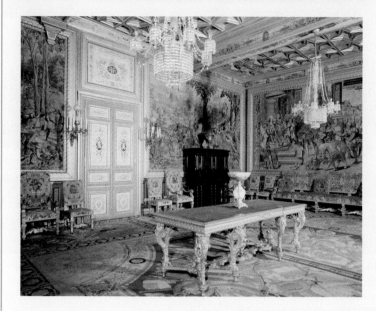

FIGURE 5–18 The salon of Francois I at Fontainebleau has seventeenth-century Flemish tapestries, Louis XIV–style furniture, and crystal chandeliers. The central table has classically inspired carvings featuring acanthus leaves, term figures, and animal feet.
Picture Desk, Inc./Kobal Collection

The Italian influence in France during the Baroque period continued with the marriage of Henry IV (r. 1589–1610) to Marie de Medici of Italy. The chateau at Fontainebleau, built in 1528, underwent a number of renovations as monarchs changed. Various rooms feature the emerging styles popular between the sixteenth and eighteenth centuries. The Salon of Francois I features Renaissance architectural details, Baroque furniture, and Neoclassic chandeliers and carpet designs. The gilt-coffered ceiling, doors, and wall panels date from the Renaissance period and prominently feature the emblem for Henry II, a cartouche with a gold crown above the initial *H.*

Baroque furnishings in the Louis XIV style include a heavily carved ebony cabinet with spiral turned legs, fauteuils or armchairs, side chairs, and a long settee. The carved and gilt chairs and settee are upholstered in fine petit point needlework featuring bouquets of flowers. Common to the era, these furnishings line the walls except for the prominent positioning of a center table. The heavily carved and gilt center table has legs in the shape of term-figures, and the stretcher features a robust putti-shaped finial. On top of the table and above the ebony cabinets are Sèvres porcelain vases with ormolu and gilding.

A large Savonnerie carpet almost covers the room from wall to wall. Its design features classical motifs including the lyre, Roman soldiers, and laurel leaves and dates from the Neoclassic period. Crystal chandeliers in the Empire style hang from the ceiling accompanied by Baroque-period wall sconces. Lastly, Flemish tapestries from the seventeenth century dominate the interior décor.

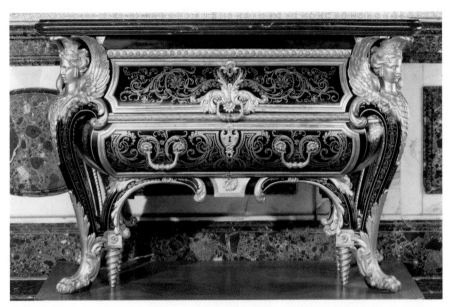

FIGURE 5–19 A French Louis XIV–style commode created by André-Charles Boulle between 1708 and 1709 for Versailles features ebony veneer on walnut with marquetries of engraved brass over a tortoiseshell ground. Classical elements appear on the commode in the form of gilt bronze Roman sphinx term figures, guilloche-patterned ormolu, and a green marble top.
Boulle, Andre Chares (1642–1732). "Mazarine" commode. Tortoiseshell and copper marquetry on ebony, engraved and gilded bronze, top of marble griotte. Executed c. 1708–1709 for the bedroom of Louis XIV in the Grand Trianon, Salon de Mercure. V 901;VMB 14

Attesting to the skill of the cabinetmaker, exuberant carvings and delicate inlay patterns decorated furniture made during the Baroque period (Figure 5–20). Inlay of intricate marquetry patterns became a popular surface treatment for cabinet doors, tabletops, and drawer fronts (Figure 5–21). The variety of fruitwoods, imported ebony, mother-of-pearl, and ivory used for these inlays underscored the wealth of the owner. By the 1680s, the Chinese export trade flourished, bringing Turkish and other Middle Eastern goods to Europe including exquisite enamels, lacquered cabinets with chinoiserie patterns, and fine Oriental porcelains. These imported treasures were enjoyed by the wealthy, who could afford such extravagances.

In the American colonies, furniture was first created for function rather than comfort or luxury. Most pilgrim homes had stools or benches and perhaps a chair, table, and chest (Figures 5–22, 5–9). Beds were mattresses stuffed with straw placed on either a platform or bedstead supported by ropes (Figure 5–9). Colonial furniture was made by local joiners and was fashioned after popular designs from colonists' native countries.

FIGURE 5–20 This English William and Mary style periwig chair features exuberantly carved walnut, a high back, and a cane seat.
© *Judith Miller/Dorling Kindersley/ Lyon and Turnbull Ltd.*

FIGURE 5–21 This William and Mary–style bureau dating from c. 1700 features elaborate marquetry work in mulberry, kingwood, and pewter inlay. *William and Mary bureau in the manner of Coxed & Woster, c. 1700 (mulberry with pewter inlay and kingwood banding). Width: 65 cm. Bonhams, London, UK.*

Decorative Accessories

Pottery

Prior to the seventeenth century, the Portuguese capitalized on trade routes between the western coast of Europe and parts of North Africa and India. By 1600, the British East India Company, chartered by Queen Elizabeth I, and the Dutch East India Company in 1602 imported exotic goods from the Far East. Goods coveted by Europeans from the East Indies included spices such as salt and cinnamon, cotton, and indigo for making blue dye. From China, trading companies brought back exquisite examples of porcelain—a type of pottery with a translucent, creamy white appearance achieved by techniques that were unknown to Europeans at that time (Figure 5–23). Chinese export porcelain had an opaque white background with bright blue designs decorating its surface.

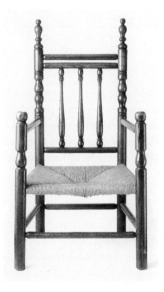

FIGURE 5–22 A late-seventeenth-century Carver armchair from Connecticut; turning ash and hickory on a lathe gave the chair its distinctive shape. *© Judith Miller/Dorling Kindersley/Wallis and Wallis*

The Dutch, in an attempt to copy Chinese porcelains, introduced Delftware in 1605 named for the location of the factory in Holland (Figure 5–24). Although

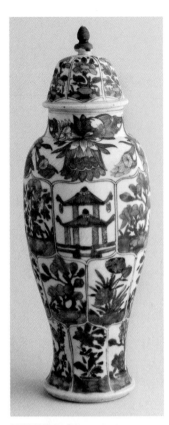

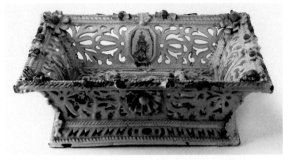

FIGURE 5–24 This Delft blue basket has pierced floral designs finished with gold. Landscape designs appear in blue accents along the inner panels of the basket.

© *Judith Miller/Dorling Kindersley/Woolley and Wallis*

FIGURE 5–23 This beautiful domed lid vase from the Vung Tau cargo for the Dutch market indicates a flourishing trade market catering to middle- and upper-class households. The scene depicts the canal houses typical in the Netherlands, although styled with overtly Chinese pagoda rooftops. The vase dates from between 1690 and 1700.

© *Judith Miller/Dorling Kindersley/ R & G McPherson Antiques*

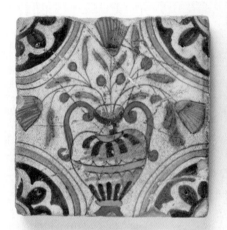

FIGURE 5–25 These Dutch Delft tiles show the trademark blue designs on a white, opaque background.
Steve Gorton © Dorling Kindersley

Delftware had the same bright blue designs over a white background, it lacked the translucency of real porcelain. The Delft trademark blue-on-white and polychrome decorative designs appeared on a variety of vases, pots, beakers, and bowls, and on tiles applied to walls and fireplaces (Figures 5–25, 5–26). By the mid-seventeenth century, England was producing its own version of Delftware.

Glass

Venetian glass continued to be popular in the early seventeenth century. Only the richest could afford the luxury of drinking from a crystal goblet with gold filigree. The glassmakers in Murano introduced colored glass into their filigree work, and the stunning combination of red glass and gold filigree increased the desirability of Venetian glass throughout Europe (Figure 5–27). Although Venetian glass maintained its popularity in the European market during the Baroque period, political upheavals in 1797 brought about its decline. By the end of the eighteenth century, Bohemia and Moravia had taken over as leading producers of fine glass.

FIGURE 5–26 This fireplace from an eighteenth-century farmhouse features Delftware tiles in blue and white.
Paul Kenward © Dorling Kindersley

FIGURE 5–27 A large Venetian ruby glass goblet and matching dish decorated with wide gilt bands of Cupid and Psyche amid scrolling foliage in a scene based on the Baroque paintings by Giovanni da San Giovanni (1592–1636).
© Judith Miller/Dorling Kindersley/Woolley and Wallis

Mirrors

Larger wall mirrors were produced during the seventeenth century, and owning one was a sign of great wealth (Figure 5–28). Venetian glassmakers manufactured these mirrors by casting molten glass onto flat tables to produce larger sheets of glass, which were then coated with a mixture of tin and mercury. The largest Venetian mirror made at that time measured forty-five by twenty-five inches. Wall mirrors were imported throughout Europe, and local artisans made elaborate frames in the current styles of the Baroque period. For the Hall of Mirrors at the Palace of Versailles, Colbert authorized the establishment of a glass factory in France to produce the 357 mirrors necessary to line the 340-foot-long gallery. The mirrors were the largest ever made when the gallery was completed in 1685, and the most expensive for the period (Figure 5–3).

FIGURE 5–28 Mirrors from the Baroque period line the walls in this Viennese museum.
Peter Wilson © Dorling Kindersley

FIGURE 5–29 This view into the Hall of Mirrors at the Palace of Versailles highlights a series of glass chandeliers with small prisms.
Picture Desk, Inc./Kobal Collection

Lighting

In 1676, Englishman George Ravenscroft (1632/3–1683) added lead to his glass-making techniques and developed a type of glass called lead crystal. Lead added to glass made this type of crystal much stronger than the cristallo produced by the Venetians. By the eighteenth century, the lead crystal industry thrived throughout Europe, with factories established at Baccarat (France), Waterford (Ireland), and Bohemia. Lead crystal's highly reflective qualities and sparkle were beneficial to the design of light fixtures. Small lead crystal prisms were attached to chandeliers, candelabras, and wall sconces to refract the light from candles and provide greater illumination to interiors (Figure 5–29).

Metalworking

The skill of the metalsmith in detail and precision is evident in metalwork from the Baroque period. Repoussé work and chasing were the two most popular methods employed by silversmiths for creating domestic objects. Repoussé work is made by hammering a soft metal from the reverse side, giving shape and pattern to the object's outer surface (Figure 5–30). Chasing was a technique applied to the surface of the

preformed object; a sharp tool creased, incised, or indented the metal, giving the object design and pattern. Baroque designs ranged from simple classical motifs to more complex landscapes, figural groupings, and foliate patterns.

Clocks

Clocks were increasingly popular in the seventeenth century, although expensive, and came in a wide variety of models. With the invention of the pendulum clock in 1656 by Christiaan Huygens, clocks were more accurate in keeping time. Clockmakers teamed with cabinetmakers to create casings to house the intricate mechanical workings. The casing designs for tabletop clocks, mantel clocks, and longcase clocks incorporated popular motifs seen in Baroque interiors including classical figures, ornate marquetry designs, and chased metalwork (Figures 5–31, 5–32).

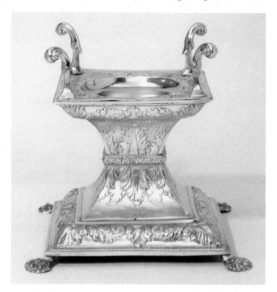

FIGURE 5–30 This salt cellar, hallmarked in 1664 by the Swiss goldsmith Wolfgang Howzer working in London, features repoussé work and chasing detailing scrolled branches and acanthus leaves.
Wolfgang Howzer (1652–1688) "The Moody Salt" (1664–1665). Silver with repoussé work and chasing. Height: 18.8 cm. Width: 19 cm. V & A Images/Victoria and Albert Museum

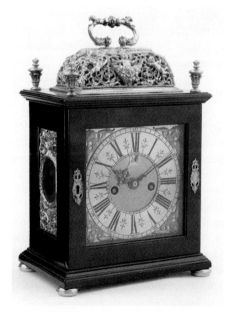

FIGURE 5–31 A small late-seventeenth-century ebonized bracket clock by Richard Colston of London has a fine repoussé basket top surmounted by a decorative carrying handle surrounded by four finials in the emerging Rococo style. Brass bun feet and an engraved back plate are decorated with chased tulip designs.
© Judith Miller/Dorling Kindersley/Wallis and Wallis

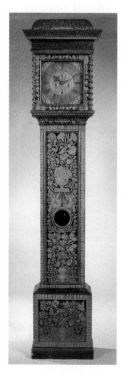

FIGURE 5–32 This late-seventeenth-century longcase clock has Baroque styling with a floral marquetry case and barley sugar twist motifs framing the face of the clock.
© Judith Miller/Dorling Kindersley/Lyon and Turnbull Ltd.

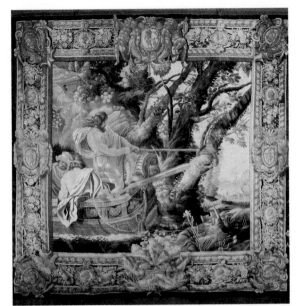

FIGURE 5–33 This tapestry from Amiens, France, after cartoons by Simon Vouet, dates from the seventeenth century and reveals the increasingly popular style of weaving revealing a painterly approach to modeling color and form. The scene has a woven "frame" like a painting.
Picture Desk, Inc./Kobal Collection

Textiles

Jean Gobelins established the *manufacture des Gobelins* when he came to France from Flanders in the 1400s. The factory became known for its rich dyes and intricate tapestry weavings. In 1667, the manufacture des Gobelins was acquired by Minister Colbert for King Louis XIV to provide tapestries for the royal palaces. Other fine quality tapestries came from Amiens in France, Flanders, and Brussels. Tapestry designs included scenes from history and mythological subject matter. These tapestries appeared more like paintings with finer details and subtle color changes, and the new style was to include borders woven to look like ornately carved and gilt picture frames (Figure 5–33).

A former soap factory building called the Savonnerie (French for soap) was converted into a weaving shop to produce the carpets for rooms in the Palace of Versailles. Savonnerie carpets were made with a tight weave, a knotted pile measuring ninety knots per square inch (Figure 5–34). Designs for the Palace of Versailles featured classical motifs including acanthus leaves, scrolls, and botanicals, befitting the rooms that were named after Roman gods and goddesses, such as the Salon of Venus and the Salon of Apollo (Figure 5–35). French Huguenots, fleeing to England to escape religious persecution, set up weaving shops in Wilton, where they began producing cut pile carpets at the end of the seventeenth century. Wilton carpets featured a low-looped pile and were woven from woolen yarns.

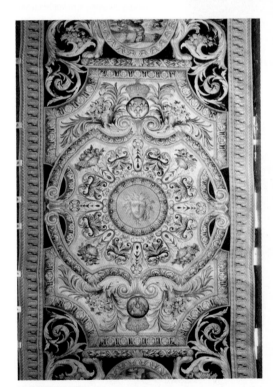

FIGURE 5–34 This detail of a Savonnerie carpet made for the Grande Gallery of the Louvre in 1680 features the emblematic Sun King in its center surrounded by foliate patterns.
Detail of a Savonnerie carpet made for the Grande Galerie of the Louvre, ca. 1680 (wool); French School (17th century). Mobilier National, Paris, France/Bridgeman Art Library.

As early as the sixteenth century and continuing into the seventeenth, embroideries, brocades, and damasks were fashionable textiles used for upholstery, draperies, and bedding (Figure 5–36). Woven from silk on a loom, brocaded fabrics have the appearance of fine embroideries with raised foliate patterns in gold or silver threads enhancing the decorations (Figure 5–37). Damask features flatly woven floral designs, fruits, and animal forms in silk, gold, and silver yarns (Figure 5–38).

The lace-making industry prospered during the seventeenth century with a variety of designs and patterns produced all over Europe. Each country created its own unique patterns. To protect the industry, many regions imposed bans on the importation of lace from other countries. Almost all laces featured flowers—some flatly woven, some raised, and others padded to create a three-dimensional look. Names

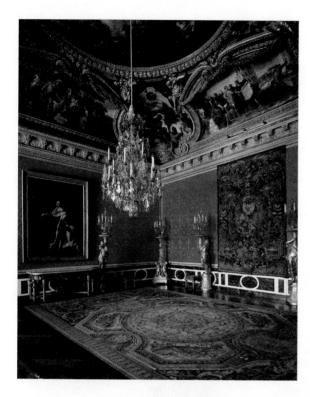

FIGURE 5–35 The Salon of Apollo inside the Palace of Versailles features a dramatically painted ceiling depicting the mythological god. A Gobelins tapestry and Savonnerie carpet are included in the interior scheme along with a crystal chandelier, gilt gueridons, and a portrait of the king.
Picture Desk, Inc./Kobal Collection

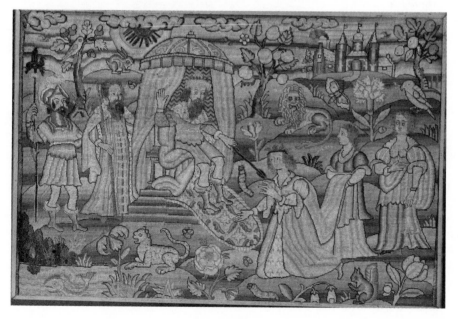

FIGURE 5–36 This English needlework from the late seventeenth century depicts a king seated in a tent surrounded by courtiers and animals in a landscape with a castle in the background. The embroidery in silk needlepoint has metal overlay and seed pearl highlights on a linen ground.
© Judith Miller/Dorling Kindersley/Sloan's

associated with specific regions and designs include *gros point* and *rose point* from Venice, *point de France* named by King Louis XIV, and *point d'Angleterre* from the Netherlands (Figure 5–39). Lace adorned the edges of bedding and table coverings, as well as clothing, and was very expensive.

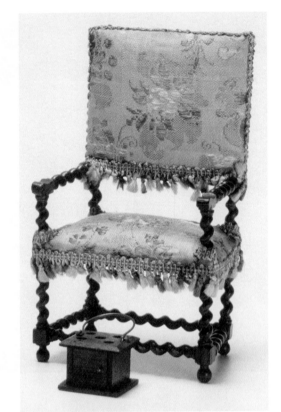

FIGURE 5–37 The brocaded upholstery fabric on this seventeenth-century chair is woven from silk.
Matthew Ward © Dorling Kindersley, Courtesy of the Central Museum Utrecht

FIGURE 5–38 Woven from yellow silk and gold threads, this damask stool cover dates from the end of the sixteenth century.
Picture Desk, Inc./Kobal Collection

Wallpaper

Before the seventeenth century, wallpaper was either hand painted or printed using wooden blocks onto small sheets of paper; it was a costly and time-consuming process. The French sanctioned the first paper-hanging guild in 1599; workers were trained to affix these decorative papers to the wall using paste. Wallpaper production

FIGURE 5–39 This lappet from the seventeenth century shows a scalloped edge and a small and slightly raised flower design of point de France lace. The lace was a popular trim on linens as well as clothing.
© Judith Miller/Dorling Kindersley/ Mendes Antique Lace and Textiles

FIGURE 5–40 Built in 1610, Ham House went through an interior remodel between 1637 and 1639 and was enlarged in the 1670s. This view of the sitting room features exuberant wall paintings, gilt plasterwork moldings, and flocked wall covering.
© Massimo Listri/CORBIS All Rights Reserved

increased during the seventeenth century after a French engraver, Jean Michel Papillon, used wooden blocks carved with repetitive patterns to print continuous rolls of paper. In an attempt to create the look of Italian velvet wall hangings, in 1680, the English invented a flocked paper as a less expensive substitute (Figure 5–40).

Evidence of marquetry work dates back to ancient Egypt with hieroglyphic texts documenting the process of applying or inlaying wood veneers, ivory or bone, and shell—such as mother-of-pearl—to create decorative patterns on furniture, chests, and small boxes. Intarsia, certosina, and taracea are the Latin, Italian, and Spanish equivalences of inlay. Taracea and certosina work was inspired by the traditional inlay patterns found on furnishings and boxes from the Middle and Near East (Figure 5–41).

The popularity of marquetry work peaked during the Baroque period. Wealthy patrons commissioned objects designed with elaborate patterns created by contrasting woods, ivory, metal, shell, and colorful stones (Figure 5–42). In France, André-Charles Boulle popularized marquetry work using tortoiseshell, brass, and ebony in the furnishings he created for the Palace of Versailles (Figure 5–19). William of Orange brought the Dutch and Flemish fashions for fine marquetry work to England from his native Holland. In addition, the Medici family brought the Flemish master Leonard van der Vinne (d. 1713) to their Italian patronage in 1659 (Figure 5–42). By the end of the century, the production of fine marquetry work was increased and made more affordable with the invention of the jigsaw,

FIGURE 5–41 This late-seventeenth-century cabinet on a stand made from teak and rosewood in India for the European market features inlaid ebony and ivory.
© *Judith Miller/Dorling Kindersley/ Wallis and Wallis*

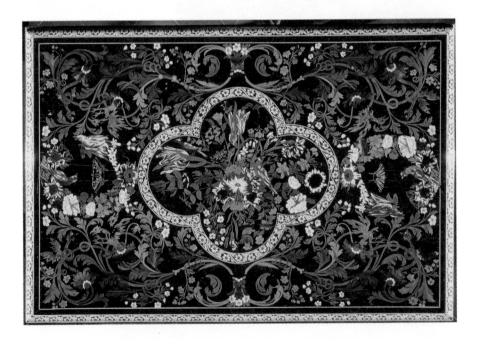

FIGURE 5–42 A marquetry tabletop from 1664 features inlaid floral designs in a variety of stained woods, ivory, and shell.
AKG-Images

which enabled multiple layers of veneers to be cut at one time. A revival of fine marquetry work occurred during the late nineteenth century reintroduced by Arts and Crafts and Art Nouveau designers seeking to bring back handcrafted decorative accessories (Figure 5–43).

FIGURE 5–43 This Arts and Crafts–style cabinet features rose, leaf, and vine marquetry designs in light oak.
© *Judith Miller/Dorling Kindersley/ Lyon and Turnbull Ltd.*

Rococo: Eighteenth Century

TIMELINE		

Rococo Period,

1700–1750	1702–1714	Queen Anne rules England and Scotland, united as Great Britain.
	1712	Atmospheric steam engine patented by Thomas Newcomen.
	1714–1727	King George I rules Great Britain and Ireland.
	1715–1722	Regent Philippe d'Orleans rules France.
	1722–1774	King Louis XV rules France.
	1725	Vivaldi composes *Four Seasons.*
		Construction begins on Chiswick House.
	1726	Jonathan Swift writes *Gulliver's Travels.*
	1727–1760	King George II rules England.
	1733	John Key invents the flying shuttle, improving speed in textile production.
	1738	Excavations begin at Herculaneum.
	1741	Anders Celsius develops thermometer scale.
	1742	Handel performs the *Messiah.*
	1743	William Hogarth paints series *Marriage à la Mode.*
	1748	John Cleland writes *Fanny Hill,* an erotic epic banned by the King of England.
	1779	First bridge constructed in iron.
	1793	Eli Whitney invents the cotton gin.

Political upheavals dominated the eighteenth century with wars and revolutions in Europe and in America. In England, Queen Anne (r. 1702–1714), the last reigning Stuart, took the throne in 1702 after the death of William III. In 1707, an Act of Union between Scotland and England formed Great Britain, combining the two parliaments into one unified government. Queen Anne was succeeded by George I (r. 1714–1727), elector of Hanover (Germany), followed by George II (r. 1727–1760) and then George III (r. 1760–1820) at the time of the American Revolution.

After the death of Louis XIV in 1715, the Regent Duke of Orleans (r. 1715–1723) managed the affairs of state for five-year-old Louis XV, who was a great-grandchild of the king. By 1723, Louis XV (r. 1715–1774) had assumed power and militarily engaged France in the Polish succession of 1733 and the Austrian succession of 1740. In addition, France entered into war with England in 1756 over control of territories in North America and India. Also involved in the conflict were Austria, Russia, Sweden, Hanover, and Prussia. This struggle, referred to as the Seven Years' War by Europeans (called the French and Indian War by Americans, and the Intercolonial War by Canadians) finally ended with the signing of the Peace of Paris in 1763 (also called the Treaty of Paris). This treaty settled the disputes among the countries and reorganized imperial control in North America.

FIGURE 6–1 Architect Pierre-Alexis Delamair (1676–1745), in a formal design based on the classical symmetry of the Baroque, designed the Hôtel de Soubise in Paris in 1704. Further expansion and the interior design were carried out by Germain Boffrand (1667–1754) from 1735 to 1740. Boffrand worked on the interiors creating oval *salons,* or reception rooms, designed in the new Rococo style that included curvilinear decoration, a light color palette, and asymmetrically arranged design motifs.
Max Alexander © Dorling Kindersley

Architectural Settings

The first half of the eighteenth century ushered in a new style of design replacing heavy Baroque features with a lighter fare. Gentle curves and ornamentation based on organic forms led to the use of the term *rococo*—derived from the French *rocaille,* meaning "shell." This new style of design remained fashionable in architecture and the decorative arts until around 1750. Styles in the second half of the eighteenth century reverted to an interest in classicism after the rediscovery of the ancient Roman cities of Herculaneum (1738) and Pompeii (1748). The numerous artifacts excavated from these ancient sites fueled the inspiration for the Neoclassic period.

The earliest expression of a Rococo period style appeared in France as early as the last decade of the seventeenth century with a transitional style incorporating pilasters and columns in classical formality with more expressive façades (Figure 6–1). Although the exterior of buildings remained connected to classical detailing, as the eighteenth century progressed, the new modern taste in interior design replaced rectangular classical symmetry with more organic, asymmetrical curves based on nature. Smaller-scale Parisian town houses, or *hôtels* to the French, had sophisticated interiors designed for comfort and intimacy instead of grandiose Baroque-style rooms designed to impress.

After Louis XIV's death, the regent took five-year-old Louis XV away from Versailles to live in Paris. Aristocrats wanting to stay connected to the court followed and commissioned the building of town houses in Paris for their leisure. The regimented formality and opulence of Versailles were

replaced by smaller, more intimate quarters, resulting in a style of décor taking on a lighter appearance in both ornamentation and color palette (Figure 6–2).

When Louis XV returned to Versailles in 1722, he gave Ange-Jacques Gabriel (1698–1782) the responsibility of creating more buildings on the palace grounds. Rooms replicating the smaller, more intimate rooms of *hôtels* featured exquisite ceiling frescoes depicting mythological figures, wainscot walls painted in creamy white and embellished with gilt accents, rocaille shell motifs, scrolls, and delicate bouquets tied up with ribbons carved into molding designs (Figure 6–3).

FIGURE 6–2 This room setting from the French Rococo period shows restrained elegance with its needlepoint upholstered chairs, carved and pastel painted woodwork, and glass chandelier. Wall panel details feature sinuous vine patterns with subtle asymmetrical arrangements. Carpets of varying sizes cover a parquet floor, and overhead hangs a glass chandelier with its drop centered in front of the pier glass mirror above the fireplace.
Max Alexander © Dorling Kindersley, courtesy of Musee Carnavalet

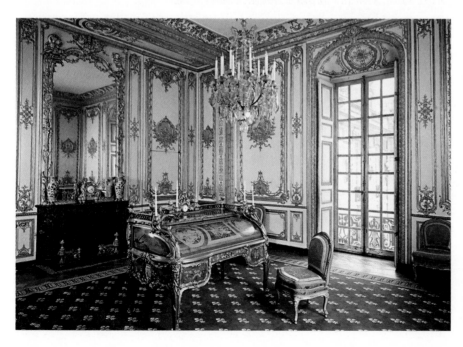

FIGURE 6–3 Louis XV's private study at Versailles, designed between 1753 and 1760, features gilt paneling in the Rococo manner, a large carpet with fleur de lis motifs, and a crystal chandelier positioned in front of an overmantel mirror above the fireplace.
Chateau de Versailles, France/The Bridgeman Art Library

Several variations of style existed in England during the latter part of the seventeenth century and into the early part of the eighteenth century. Following Sir Christopher Wren in pursuit of a national style, English designers vacillated between the Italian Baroque style, an emerging Rococo style, and the influence of Palladianism. Noted is Wren's design for St. Paul's Cathedral in London, which exhibits more classicism than Baroque characteristics (Figure 5–5). James Gibbs (1682–1754) left his native Scotland for London in 1710 to design houses and interiors for wealthy clients. In 1728, his portfolio of work, *Book of Architecture,* was published in London. These drawings established the Rococo style in Great Britain, which was more restrained than the trends favored by French aristocrats (Figure 6–4). For the most part, English architects rejected the inherent French Rococo for Palladianism, which had its beginnings in the work of Inigo Jones during the seventeenth century (Figure 6–5).

Furthermore, translations of Andrea Palladio's *Four Books of Architecture,* which appeared in England in 1715, reinforced the popularity of Palladianism. Thereafter, interior design followed the classical program in every detail; columns, pilasters, and

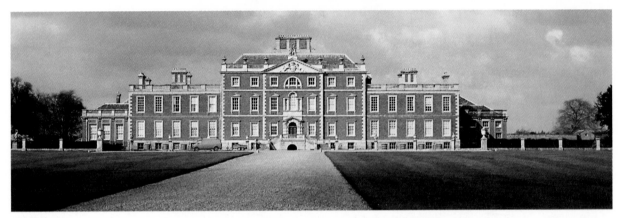

FIGURE 6–4 Wimpole Hall in England was first built in 1643 and was expanded and changed throughout its history. James Gibbs worked on the expansion from 1713 to 1730, incorporating Rococo features illustrated in his *Book of Architecture* into its façade.
Emily Andersen © Dorling Kindersley

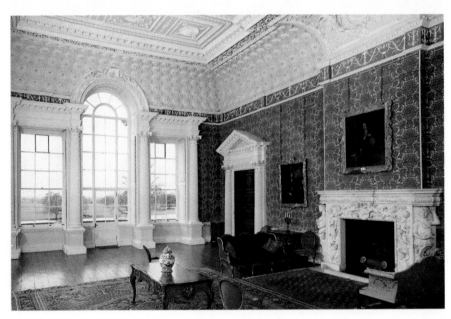

FIGURE 6–5 The salon inside Claydon House in Buckinghamshire features elaborate stucco ceiling designs. Dating from the English Rococo period, these designs incorporate many Baroque features with attention closely paid to classical elements seen here on the fireplace, door header, and windows.
National Trust Photo Library

niches adorned rooms recalling ancient Roman basilicas. Chiswick House, built in 1725 and designed by owner Lord Burlington (1694–1753), reflected characteristics used in Palladio's Villa Rotunda built in the sixteenth century under the direction of William Kent (1685–1748). The interior design of Chiswick combined architectural symmetry with an elaboration of Baroque influences rather than contemporary rococo styling. Kent's furniture designs featured heavy carving and massive proportions in direct opposition to the curvilinear designs of the French Rococo. His furnishings for the Double Cube room at Wilton House are more Baroque in character than Rococo (Figure 6–6).

American architectural styles developed rapidly as economic prosperity in the colonies led to a better lifestyle than those of the early pilgrims. By the end of the seventeenth century, tobacco, rice, and sugar, among other commodities exported to England, created a boom in the American port-trade business. The Georgian style of architecture emerged at the beginning of the eighteenth century in America, a reflection of newfound colonial wealth. Although these colonial houses were modest in size by European standards, they reflected a refinement of detail and quality based on understated classical details. Most homes were two stories, had symmetrical façades, and featured classical lintels over doors and windows. Front doors were usually flanked by classical pilasters and topped by triangular pediments (Figure 6–7).

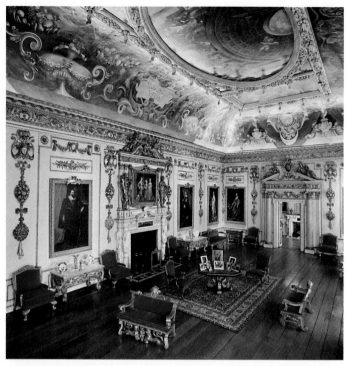

FIGURE 6–6 First begun in 1653, Inigo Jones's interior design for the Double Cube room at Wilton House features the furniture designs of William Kent. Kent's mix of Baroque and Neo-Palladian details reflected the desire to establish a national style in England. The settees and console tables adorning the room feature ornate giltwood classical carvings. © *Wilton House, Wilton, Salisbury*

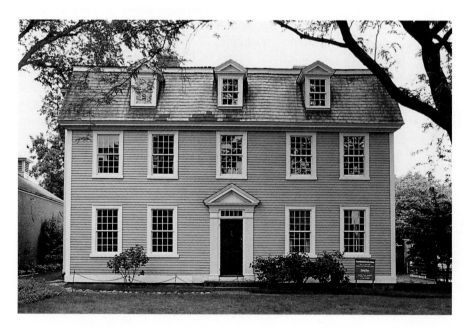

FIGURE 6–7 The Crowninshield Bentley House, built in 1727, reflects the American Georgian architectural style with its symmetrical façade and front door flanked by classical pilasters capped by a triangular pediment. *David Lyons © Dorling Kindersley*

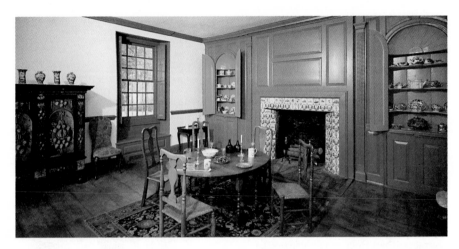

FIGURE 6–8 This interior from the Cortlandt House in New York features common characteristics of Georgian period design and furniture—blue painted woodwork and wall paneling, modest built-in cupboards flanking a fireplace set with blue and white Delft tiles, and an inlaid cabinet with Chinese export porcelains on display. The American Late Colonial style imitated England's popular Queen Anne style.
Dave King © Dorling Kindersley, Courtesy of the Van Cortlandt House Museum, New York

Georgian home interiors had small rooms with low ceilings, and painted wood paneling was a prominent element of the interior architectural scheme (Figure 6–8). During the first half of the eighteenth century, furnishings reflected English tastes, although the American colonies lagged about twenty years behind current English style. Furthermore, wealthier families had the means to afford Chinese porcelains and, on occasion, Oriental rugs.

Design Motifs

Although France and England differed in their interpretations of Rococo design elements, recurring motifs such as chinoiserie and rocaille shells united the decorative arts of these two countries. Chinese exports flooded Europe, and Oriental designs depicting dragons, bonsai landscapes, and pagoda teahouses occupied by kimono-clad figures appeared in all of the decorative arts and on interior architecture (Figure 6–9). The English adopted the use of Chinese frets, a more ornate version of the Greek key, especially in furniture design and interior millwork. There are several variations of the Chinese fret motif; essentially all follow a strict geometric patterning resembling fine latticework (Figures 6–10, 6–21).

Idealized images of Roman gods and goddesses were replaced by *singerie*—frolicsome monkeys dressed in fine French fashion. Classical motifs were reduced to shells, festoons, and an occasional putti (Figures 6–11 through 6–13). Instead, the free-flowing asymmetrical forms seen in nature, such as flowing vine patterns and foliate designs, dominated fine marquetry work, ormolu, and interior wall paneling (Figure 6–14).

Interior Furnishings

French aristocrats living in *hôtels* in Paris furnished their apartments with smaller-scaled furnishings than those found in the larger country chateaus. Chairs with shorter backs were more proportionate to lower ceilings in these diminutive living quarters, and arm pads and thicker seat cushions

FIGURE 6–9 Chinoiserie motifs are a prominent feature on this piece of furniture from the Rococo period created with ivory and wood veneers.
Picture Desk, Inc./Kobal Collection

FIGURE 6–10 Fretwork designs like these were a prominent feature of Chinese Chippendale furnishings, taking inspiration from Chinese export furniture popular in England in the mid-eighteenth century.

FIGURE 6–11 The crest rail on this American Late Colonial–style chair features a delicately carved shell motif referencing the rocaille shell design of the French Rococo period.
© Judith Miller/Dorling Kindersley/Pook and Pook

FIGURE 6–13 Stucco work appearing in this staircase from the Rococo period combines foliate and shell designs with a classical putti and acanthus leaves.
Joe Cornish © Dorling Kindersley

FIGURE 6–12 An elaborately carved cherub (putti) wrapped in gilt laurel leaves appears in this architectural molding design by Grinling Gibbons (1648–1721). Gibbons's career was launched by his work for Sir Christopher Wren on St. Paul's Cathedral in London before he was brought to the attention of King George I and named "master carver."
Stephen Oliver © Dorling Kindersley

FIGURE 6–14 The Rococo period's subtle use of asymmetry in design is seen in this detail photo of a cartouche-shaped escutcheon on a Chippendale chest.
© *Judith Miller/Dorling Kindersley/Pook and Pook*

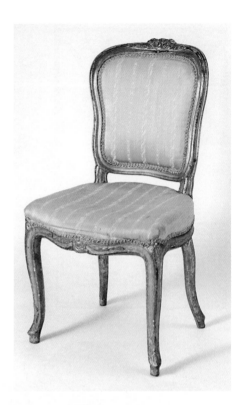

FIGURE 6–15 This Louis XV–style French chair is smaller in scale, features a short back, and is carved from giltwood in the shape of a cartouche. Delicately shaped cabriole legs give the chair a more feminine appearance.

© *Judith Miller/Dorling Kindersley/Caroline de Kerangal*

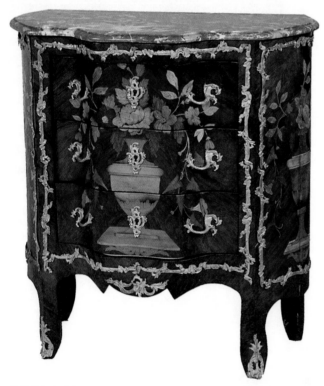

FIGURE 6–16 This transitional-style Louis XV commode has a marble top with kingwood marquetry patterns featuring floral designs in a classical urn. Brass ormolu mounts appear as growing vine patterns over the front and sides of the piece.
© *Judith Miller/Dorling Kindersley/Sloan's*

made chairs more comfortable (Figure 6–15). Upholstery fabrics featured singerie motifs or were foliated brocades or damasks in pastel colors. Moreover, English chintz, French toile de Jouy, petit point, silk, and taffeta replaced the heavier needlepoint and tapestry upholstery fabrics from the Baroque period.

A variety of woods including walnut, oak, and elm appeared in the construction of furniture during the eighteenth century with carving and marquetry patterns supplying most of the decoration. Marquetry and veneer work featured the lighter colors of fruitwoods for inlaid floral designs and chinoiserie (Figure 6–16). Chinese lacquerwork, imitated by the French and English by applying varnish over a painted surface, also became a fashionable furniture treatment during the Rococo period.

Decorations on furniture matched the more feminine architectural moldings; they featured sinuous curvilinear forms, delicate floral designs with graceful proportions, and light pastel colors. Tables, desks, and *ensuite* chairs matched with settees were designed with serpentine curves on seat rails and delicately shaped cabriole legs (Figure 6–17).

English Rococo furniture was named after ruling monarch of the time, Queen Anne, and adopted a more restrained interpretation of the current French

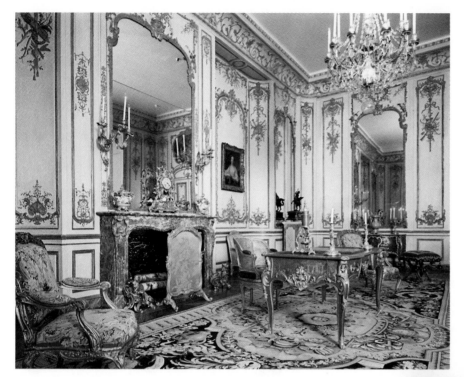

fashion (Figure 6–18). Rooms added onto Hampton Court and those redecorated during her reign maintained influences of the Baroque and Neo-Palladian styles from the previous century. Other than an occasional shell or acanthus leaf motif, most Queen Anne–style furniture had little carving or applied ornamentation but maintained the current fashion for cabriole legs. Natural walnut or mahogany finishes were common, although the English court contained a few items that were either gilt or japanned.

Increased trading with the Far East during the eighteenth century fostered British fascination with Oriental design, which influenced the style and tastes in England into the later Georgian period. Furniture imported from China including chairs, tea tables, and cabinets featuring lacquered chinoiserie details and claw and ball feet (Figure 6–19). English furniture makers imitated the look of Chinese lacquerwork in a technique called japanning, essentially a red or black painted surface sealed with a high-sheen varnish (Figure 6–20). These increasingly popular Chinese characteristics dominated English furniture design by 1760.

In England, Thomas Chippendale (1718–1779) published *The Gentleman and Cabinetmaker's Director* in 1754 cataloging the current Georgian styles of interior furnishings including those with strong Chinese and Gothic influences. Interior furnishings featured in this portfolio incorporated distinctive Oriental designs such as pagodas, dragons, and fretwork. The style was referred to as Chinese Chippendale (Figure 6–21). Moreover, the *Director* featured updated but romanticized interpretations of the Gothic style with tracery, trefoil motifs, and pointed arches

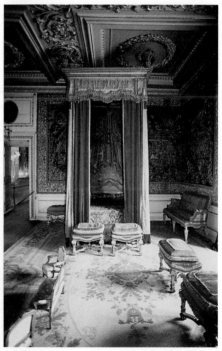

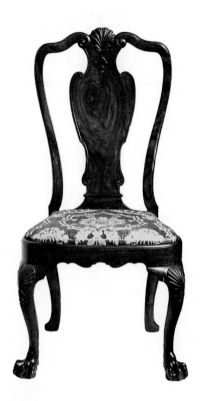

FIGURE 6–19 This early China Trade side chair brought to England from Canton, China, in 1730 is made from rosewood. The chair features Oriental details adopted by English cabinetmakers—a shaped splat and cabriole legs with claw and ball feet.
© *Judith Miller/Dorling Kindersley/ Wallis and Wallis*

FIGURE 6–20 This English Queen Anne–style crimson lacquer bureau bookcase features gilt-chinoiserie figural landscapes, double-hooded cabinet doors, and bun feet.
© *Judith Miller/Dorling Kindersley/ Sloan's*

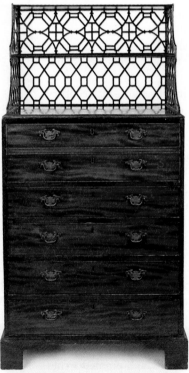

FIGURE 6–21 An eighteenth-century Chinese Chippendale secretaire bookcase features upper shelving in fretwork designs typical of the period.
© *Judith Miller/Dorling Kindersley/ Hamptons*

prominently appearing on chairs, china cabinets, secretaries, and armoires (Figure 6–22).

In America, more grandiose Georgian-style homes demanded finer furnishings for prosperous colonists as these homes revealed a new level of sophistication for the eighteenth century (Figure 6–23). Furniture makers in Philadelphia, Baltimore, Boston, Virginia, and Newport copied Rococo motifs and furniture designs, imitating the English Queen Anne style. American colonial furniture lagged over twenty years behind its fashionable introduction in England until Chippendale's pattern books, brought to the American colonies in 1766, enabled cabinetmakers to keep current with the prevalent English styles.

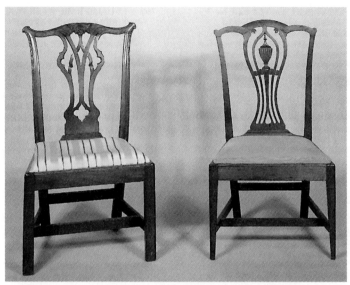

FIGURE 6–22 Chippendale-style mahogany side chairs capture current Rococo fashions; the chair on the left features strapwork carving and a quatrefoil motif on its central splat; the splat on the chair on the right features a classical urn in the Neo-Palladian style.

© Judith Miller/Dorling Kindersley/Freeman's

Decorative Accessories

Pottery

Perhaps the most significant contributor to the development and refinement of a new French style was the mistress of King Louis XV, Madame de Pompadour (1721–1764). Like King Louis XIV before her, Pompadour took an active role in promoting artistic advancement at Versailles in France. A porcelain factory at Sèvres that she patronized supplied soft-paste plaques for furniture and dinnerware, among other objets d'art (Figure 6–24). Soft-paste porcelain, created in Europe, imitated true or hard-paste porcelain available only in Asia. Rose Pompadour, the most popular color of porcelain created at Sèvres, was unique to this factory and influenced the lighter color palettes adopted by Rococo designers.

Locally made ceramics such as bone china and creamware were less expensive substitutes for Chinese export porcelain, which was very popular in Europe. In fact, the word *china* originated at this time to describe a type of ceramic meant to imitate the appearance of fine Chinese porcelain. The drawback of soft-paste ceramicware was that, when subjected to high temperatures inside the kiln, the shape did not hold up well. This limited the design from anything too intricate (Figure 6–25). Transfer-ware ceramics, such as those produced at the factory in Staffordshire, were widely distributed in England and exported to the American colonies as a middle-class substitute for fine Chinese porcelains (Figure 6–26).

At last, the Bavarian alchemist to the king of Poland uncovered the secret of making hard-paste porcelain by identifying the key ingredient, kaolin, in 1709. Soon after, factories set up in Dresden, Nymphenburg, and Meissen produced a variety of decorative objects for wealthy patrons. The modeling capabilities of hard-paste porcelain led to the design of various animal and bird forms, along with figurines brought to life with brightly colored glazes (Figure 6–27).

American Room Setting

This is a parlor of a well-to-do colonist in use between 1760 and the start of the American Revolution. The architecture of the room includes classical-style moldings featuring a deep dentil crown and triangular pediment framed by fluted pilasters over the fireplace. Drapery made from yellow damask has classical swag valances, and gathered panels are held open with tasseled tiebacks. Chippendale-style furniture is upholstered in matching fabric and is typical for the Late Colonial period in America. Along with English porcelains lining the mantel and on tables, a crystal chandelier hangs from the ceiling. Lighting is augmented with an array of candlesticks. A large carpet anchors the arrangement of furniture around the hearth.

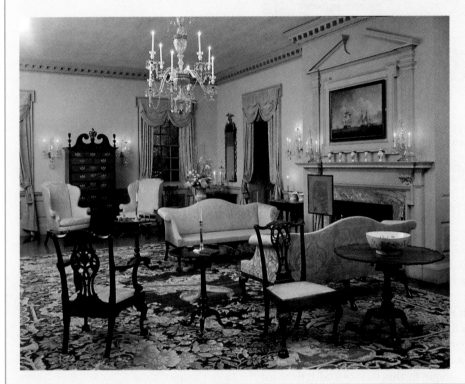

FIGURE 6–23 The Port Royal Room, now located in the Henry Francis DuPont Winterthur Museum, reveals elegant Chippendale furniture from the Late Colonial period, an ornate chandelier, sconces and candelabra, a beautifully woven floral carpet, and cascading window treatments.
Courtesy, Winterthur Museum

FIGURE 6–24 This Sèvres flower vase with panels of painted flowers and fruit surrounded by gilt laurel leaves on a green ground dates from 1770.
© Judith Miller/Dorling Kindersley/Woolley and Wallis

FIGURE 6–25 Delftware, a tin-glazed earthenware ceramic, still found favor with eighteenth-century Europeans evidenced by this example of a lady's slipper designed for the sole purpose of bric-a-brac.
© Judith Miller/Dorling Kindersley/Woolley and Wallis

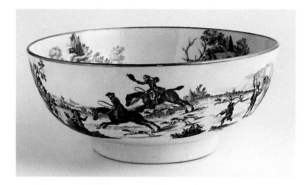

FIGURE 6–26 This Staffordshire porcelain bowl from the eighteenth century features a transfer pattern of an elaborate hunting scene both inside and out. A thin gold band crowns the rim.
© *Judith Miller/Dorling Kindersley/Clevedon Salerooms*

FIGURE 6–28 This Chelsea-made peony dish dates from 1755; its significance in the home relates to the Chinese belief that the peony is a symbol of prosperity and happiness.
© *Judith Miller/Dorling Kindersley/Woolley and Wallis*

FIGURE 6–27 A Meissen figure of a monkey singing as it clutches a sheet of music. Dating from 1760, the colorfully outfitted monkey in contemporary clothing is a reminder of the popular singerie motifs of monkeys at play found in Rococo interior design.
© *Judith Miller/Dorling Kindersley/ Gorringes*

By 1710, porcelain factories were appearing all over Europe and the British Isles seeking to corner the market on hard-paste porcelain. Molds were made to cast the hard paste, and hand-finishing work smoothed out the seams before painting and firing. Figurines depicting aristocratic men and women dressed for a *fête galante* were popular along with birds, animals, tableware and tea sets, and vases (Figures 6–28 through 6–30). By midcentury, factories in Chelsea, Derby, Staffordshire, and Worcester in England capitalized on the purchasing power of well-to-do collectors.

Glass

New glass factories of noteworthy importance came about in the eighteenth century, specifically in Bohemia, Waterford in Ireland, and Baccarat in France. Glassmakers in these regions produced fine cut lead crystal with the aid of wheel engraving. Water-powered cutting wheels allowed the glassworker to etch or cut designs into the surface of the glass, which was then polished to eliminate rough edges (Figure 6–31). With this somewhat mechanized method of decorating glass, a range of glassware featuring finely detailed designs found its way into more homes than ever before. Molded or blown clear glass decorated with painted designs was produced for middle-class patrons (Figure 6–32).

FIGURE 6–29 From the eighteenth century, this Derby figure of a shepherd girl wearing a pink dress stands on a Rococo-style gilt base.
© *Judith Miller/Dorling Kindersley/Gorringes*

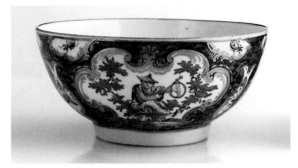

FIGURE 6–30 This Worcester bowl decorated in colored enamels with chinoiserie figures, butterflies, and insects framed within a gilt cartouche on a blue ground dates from 1770.
© *Judith Miller/Dorling Kindersley/Albert Amor*

Mirrors

Mirrors played an even greater role in completing the scheme of fashionable interiors and were more abundant in the eighteenth century than even before. To reiterate the importance of mirrors in room design, oversized mirrors enhanced candlelight from chandeliers by reflecting light back into the room. In addition, frame styles adopted the prevalent Rococo designs found in the room décor, usually matching the features of the furniture (Figure 6–33). Shell motifs, scrolls, and vine patterns appeared on elaborately carved and gilt frames, while English mirror frames reflected the delicate curves found on Queen Anne and Chippendale furnishings (Figure 6–34). Moreover, the same wheel engraving technique used on glassware was used to etch decorative designs such as leaves and flowers onto the surfaces of mirrors.

Lighting

Lighting interiors during the eighteenth century required numerous candles placed in crystal chandeliers, brass and silver candlesticks, and wall sconces (Figures 6–35, 6–36). Beeswax was favored over tallow (animal fat) because of its clean burn and pleasant smell; however, hand dipping candles was time consuming. Because beeswax candles were expensive, they were found in more upscale households. Middle-class households had pewter, wrought iron, or turned wood candlesticks fit with tallow candles (Figure 6–37).

Metalworking

In 1738, brass metallurgy improved when William Champion of England patented a method of producing

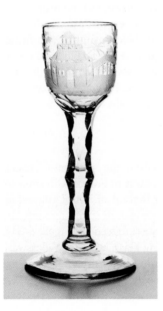

FIGURE 6–31 The chinoiserie engraved designs on this wine glass from 1780 were made using the wheel cut method.
© *Judith Miller/Dorling Kindersley/ Somervale Antiques*

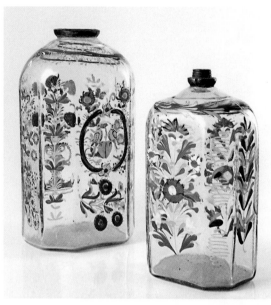

FIGURE 6–32 These two eighteenth-century glass decanter flasks feature painted designs rather than engravings, a less expensive form of decoration.
© *Judith Miller/Dorling Kindersley/Woolley and Wallis*

FIGURE 6–33 This George II mahogany and giltwood mirror from 1750 features cascading vine patterns down its sides and acanthus leaf carvings at the bottom.
© *Judith Miller/Dorling Kindersley/ Wallis and Wallis*

FIGURE 6–34 This late-eighteenth-century mahogany Chippendale-style framed mirror from England has a scrolled pediment crest with corresponding pendant scroll below in curvilinear Rococo fashion. The glass mirror plate is a modern replacement.
© *Judith Miller/Dorling Kindersley/ Freeman's*

zinc from calamine and charcoal. Brass objects made from copper, tin, and zinc were easier to form into elaborate shapes than those without the zinc alloy. Adding zinc to brass also made it less corrosive. Moreover, brass gave off the appearance of gold, but was not as expensive. Brass ormolu mounts appeared on French furniture and accessories as an integral design characteristic of the Louis XV style (Figure 6–38).

Fine dining in wealthy homes featured an elaborately laid out table full of exquisite silver including candlesticks, flatware, and hollowware (Figure 6–39). Silversmiths (who often worked in both silver and gold) produced accoutrements for the table reflecting the sinuous foliate and vine patterns of stylish Rococo interiors. Highly detailed designs were created through chasing or repoussé; parts of lesser importance, such as handles, were sand cast. Chased designs were created by cutting away at the metal. Repoussé is a relief design created by hammering the metal from the opposite side, or inside, of the object.

Pewter ware was used on tables in more modest homes until it fell out of fashion in the nineteenth century. In the sand-cast method, molten pewter was poured into molds made from sand and clay. After cooling, the piece was removed from the mold

FIGURE 6–35 This pair of eighteenth-century fancy brass candlesticks, each with a ridged, lobed base, shaped stems, and cylindrical nozzle with a flared drip pan with a wavy edge, shows the attention to detail and skill of the metalworker.
© Judith Miller/Dorling Kindersley/Freeman's

FIGURE 6–36 This simply designed brass candlestick, with a square base and a baluster-shaped stem, dates from the early eighteenth century.
Steve Gorton © Dorling Kindersley

FIGURE 6–37 This American folding iron candle lantern, with six arched ribs ending in baluster-shaped feet, is fixed with a carrying ring at the top. The basic form and material reflect the skill of a local blacksmith, who designed it for function rather than aesthetic appeal.
© Judith Miller/Dorling Kindersley/ Sloan's

and any visible seams were polished out before the piece was finally buffed to a silvery sheen. Designs from the mold left impressions in the metal. Pewter was not malleable enough to be used with the chase method (Figure 6–40). Hollowware pitchers, mugs, bowls, and porringers completed the set of pewter flatware for day-to-day use.

Other household objects made from an enameled metal called tole included beautifully designed boxes, platters, plates, and pitchers in painted and varnished metals (Figure 6–41). One of the first factories to produce tole was set up in Bilston, England, in 1756 (Figure 6–42). Tole painting became a folk art craft in America, but the designs were not limited to metal; the characteristic polychrome flower designs on a black background also appeared on wood.

FIGURE 6–38 This pair of brass andirons with putti figures and decorative swags reflects the spirit of French Rococo interior fashion.
© *Judith Miller/Dorling Kindersley/Sloans & Kenyon*

FIGURE 6–39 This pair of candlesticks made by John Carter in London in 1770 reveals exquisite silversmith skills as seen in the sweeping gadroons that accentuate the stems and bases.
© *Judith Miller/Dorling Kindersley/John Bull Silver*

FIGURE 6–40 This rare eighteenth-century brazier features a pierced pewter work frame holding a copper bowl (for the hot coals) and copper feet.
© *Judith Miller/Dorling Kindersley/ Bucks County Antiques Center*

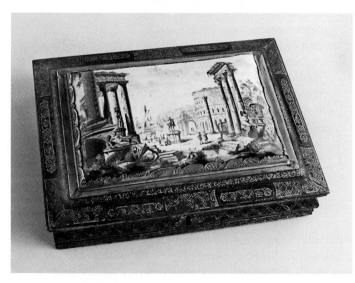

FIGURE 6–41 This tole box features an enameled plaque inset on the lid with a scene of ancient Roman ruins. The box has gilt arabesque designs over a japanned ground. Japanning is a process of painting, then varnishing the surface to give the appearance of true Chinese and Japanese lacquerwork.
© *Judith Miller/Dorling Kindersley/ Halcyon Days*

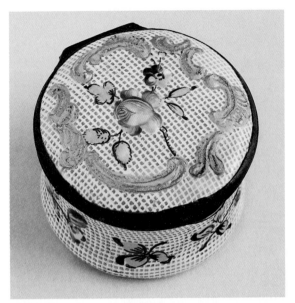

FIGURE 6–42 This circular Bilston enamel patch-box decorated with embossed flowers and raised gilt Rococo scrolls against a pink gingham ground dates from 1775. The inside lid is fitted with a mirror. The box contained small patches that, when applied to the face, gave the appearance of a mole or beauty mark.
© *Judith Miller/Dorling Kindersley/Halcyon Days*

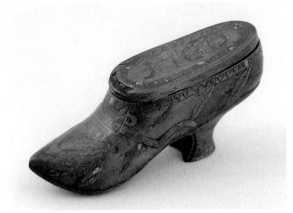

FIGURE 6–43 A treen snuffbox in the shape of a woman's shoe features pewter inlay with the date, 1760, appearing on its removable lid.
© *Judith Miller/Dorling Kindersley/Gorringes*

Treenware

Household objects not made from pewter or other metals were fashioned from wood (Figure 6–43). Called treenware, objects were made by local woodworkers, who carved and hollowed out tight-grained woods to create a variety of shapes. These goods (cups, bowls, canisters, and boxes) appeared in the kitchens of households from all classes. Decorations varied from plain and unadorned to painted, inlaid, and veneered designs (Figure 6–44).

Clocks

In many European villages and American colonial towns, the passing of time was announced by a striking bell clock positioned on a church or on the town hall for all to see. By the end of the eighteenth century, clock-making techniques had improved to the point at which clocks were no longer an exclusive status symbol for affluent families. The inner workings of clocks became more reliable and accurate with the introduction of the new noncorrosive brass, a result of Champion's process for obtaining purer zinc. Specialized clock makers made the inner workings, while cabinetmakers made the cases (Figure 6–45). Longcase clocks became fashionable with the invention of the pendulum clock in the seventeenth century, and these case designs continued to follow the style of the furniture designs (Figures 6–46, 6–47). England banned the exportation of clockworks to the American colonies, so only entire clocks were imported until after the Revolutionary War.

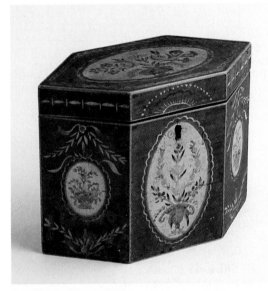

FIGURE 6–44 This treenware tea caddy made from veneered harewood and dating from the late eighteenth century has painted decorations of bouquets tied with ribbons imitating tole work.
© *Judith Miller/Dorling Kindersley/Woolley and Wallis*

Textiles

During the eighteenth century, improvements in spinning and weaving included the flying shuttle, the spinning jenny, the water-powered spinning frame, and by the end of the eighteenth century, the steam-powered loom. With these inventions, spinning and

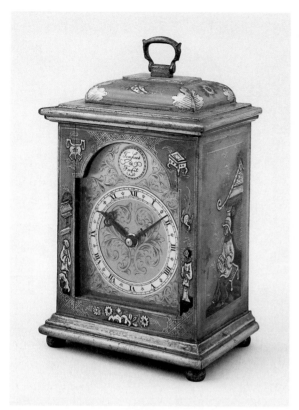

FIGURE 6–45 This early Georgian-style red lacquered mantel clock features chinoiserie decorations on its casing and a brass dial.
© *Judith Miller/Dorling Kindersley/Gorringes*

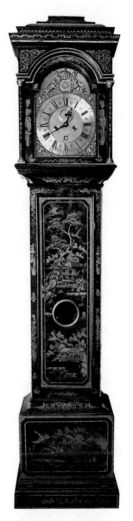

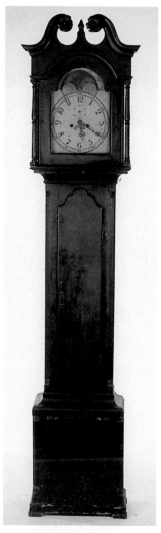

weaving went much faster and required fewer workers to run the machines, resulting in textiles produced at lower costs. Furthermore, printed cotton fabrics were being imported from India. England and France initiated bans against these foreign products to protect their own textile industries (Figure 6–48). England sent imported cotton from India to the American colonies to protect its own textile industry. Cotton gained in popularity over heavier wools, and woodblocks were used to print designs onto bolts of fabric. In addition, with the introduction of roller printing in the last quarter of the seventeenth century, lightweight cottons were produced quickly and economically.

FIGURE 6–46 This longcase clock dating from 1730 has tortoiseshell-inlay chinoiserie designs on its casing and a brass Roman numeral face dial with cherubs, or putti figures, at the crest.

© *Judith Miller/Dorling Kindersley/ Pendulum of Mayfair*

FIGURE 6–47 This late-eighteenth-century Chippendale tall case clock from Pennsylvania features a broken swan neck pediment with rosettes over an arched glazed door flanked by turned columns. The faceplate features a dial with the phases of the moon painted on its surface.

© *Judith Miller/Dorling Kindersley/ Freeman's*

Brocade, damasks, and needlework were fashionable textiles used inside eighteenth-century homes, and along with velvets, were used for upholstery, bedding, drapes, table covers, and fire screens. Full drapes over windows proved effective in controlling light and providing privacy and thermal protection in more elaborate homes; these drapes gained popularity by the second half of the century (Figures 6–49, 6–23). Needlework designs appeared in carpets, on upholstery, on framed pictures, and as decoration on wall paneling and fire screens. Most common were gros point and petit point needlework made from wool and silk threads. The names refer to the size of the stitches over the canvas background; petit point is the smallest stitch and

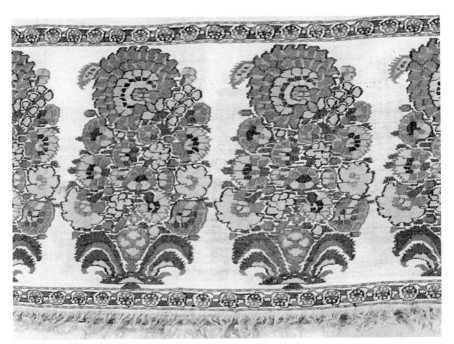

FIGURE 6–48 This textile from the eighteenth century, imported from India, features brightly colored floral patterns.

Picture Desk, Inc./Kobal Collection

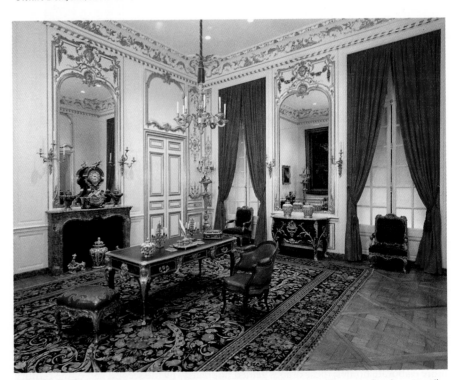

FIGURE 6–49 This French room dates from 1725 to 1726 and features a wide range of exuberant textiles including brocaded upholstery on chairs and a stool, a large carpet, and gathered drapery panels.

The J. Paul Getty Museum, Los Angeles. Paneled Room. Jacques Gaultier (French (Paris), active first half of the 18th c.) and after designs of Armand-Claude Mollet (designer) (French, 1650–1742). 1725–1726; 20th century additions. H: 13ft.; W: 26 ft. 9 in.

FIGURE 6–50 This fire screen from the George II period, covered with a silk needlework panel depicting floral arabesque designs, urns, and birds, dates from 1750.

Treena M. Crochet

FIGURE 6–51 A modern example of how bobbin lace was made.

Anthony Cassidy © Rough Guides

FIGURE 6–52 This early-eighteenth-century example of lacework features a field of whitework—threads removed from a woven cloth to give pattern or openwork designs—and threadwork flower edging. Cloths like this increased in popularity over the next century and appeared as table covers.

© Judith Miller/Dorling Kindersley/ Mendes Antique Lace and Textiles

is used for fine detailing (Figure 6–50). Needlework bobbin lace made in Chantilly, France, was traded throughout Europe and prized for its silk threads. Silk threads were wound around wooden bobbins to keep them from tangling while the worker used pins to hold the needlework in place on top of a pillow (Figure 6–51). Whitework lace was made by weaving openwork fabric on a loom. It resembled handmade laces and, because it was woven, it was less costly (Figure 6–52).

Wallpaper

It the first half of the eighteenth century, European wallpapers were either hand painted or hand blocked, and owning them declared the great wealth of the homeowner (Figure 6–53). In the American colonies, the first wallpaper-producing shop was set up in Philadelphia in 1739; before that time, all papers were imported. Improvements in wallpaper production occurred in 1785 with the invention of the roller-printing machine. By the end of the eighteenth century, wallpapers were featured in entrance halls, dining rooms, and parlors.

COMPARATIVE DESIGNS

Reviving styles from past cultures was common throughout the history of the decorative arts, as artisans often studied the past for inspiration. Influences from the classical past re-emerged during the Renaissance and the latter half of the eighteenth century after excavations began at Herculaneum and Pompeii. The Victorian era, named after Queen Victoria, who ruled the United Kingdom from 1837 to 1901, witnessed more revival styles than any other period. The revivalist styles of the Victorian period were more than "inspired" by the past; rather, architects and designers re-created the past in their works, often imitating monuments seen on their "grand tours" through Europe. Greek Revival, Gothic Revival, Elizabethan Revival, and Rococo Revival were a few of the most popular styles appearing in architecture and interior design throughout the century.

However, in 1890, the Art Nouveau style emerged based on the organic forms found in nature—free-flowing vine patterns and asymmetrical arrangements—the same qualities found in designs from the Rococo period. Art Nouveau, or "new art," was created as an attempt by late-nineteenth-century designers to introduce a new style, one classified as "universal," or not belonging to a particular place or genre.

The mirrors in Figures 6–54 and 6–55 share similar characteristics; the one in Figure 6–54 dates from the mid-eighteenth century and features a carved and gilt frame. Characteristic Rococo motifs appear on the cartouche-shaped mirror including its prominent rocaille cresting and frame fashioned out of vine patterns and floral sprays. The mirror in Figure 6–55 dates from 1905 and reflects the Art Nouveau style. The mirror's frame forms a cartouche, although it is more misshapen than the mirror from the Rococo period. Furthermore, the mirror's frame is asymmetrical and is fashioned from carved and gilt vine motifs that rise up to form the crest and flow downward to create the feet. Although the Art Nouveau style was not considered a revivalist style of the late Victorian period, designers working in this style were interested in capturing the essence of organic forms found in nature, as were those working during the Rococo period.

FIGURE 6–53 This painted wallpaper with a chinoiserie design of bamboo and birds dates from 1760 and was found inside the Chateau de Maintenon in France, the former residence of King Louis XIV's second wife.

Picture Desk, Inc./Kobal Collection

COMPARATIVE DESIGNS

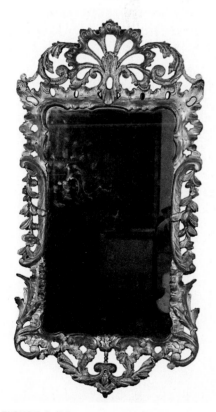

FIGURE 6–55 This mirror in the Art Nouveau style dates from 1905 and features an energetic vine-patterned framework. The highly charged vines appear in whiplash curves asymmetrically fashioned into the mirror's frame and feet.

© Judith Miller/Dorling Kindersley/The Design Gallery

FIGURE 6–54 This gilt pier looking glass from the mid-eighteenth century has a pierced rocaille crest carved with floral sprays. Its design is balanced with pierced work on the apron skirting along the bottom and sides.

© Judith Miller/Dorling Kindersley/Sloan's

Neoclassic: Late Eighteenth and Early Nineteenth Centuries

TIMELINE

Early and Late Neoclassic Periods

1750–1820

1751	Diderot publishes his *Encyclopedie* in France.
1752	Benjamin Franklin discovers electricity.
1755	Elisabeth Vigée-Lebrun, royal painter to Marie Antoinette, born.
1759	Voltaire writes *Candide*.
1760	Industrial Revolution begins, launching mechanization and mass production.
1760–1820	King George III rules Great Britain, Ireland.
1764	Mechanization of textile industry begins.
1767	Fragonard paints *The Swing*.
1770	Gainsborough paints *The Blue Boy*.
1774–1792	King Louis XVI rules France.
1775–1783	American Revolution.
1775	James Watt perfects the steam engine.
1779	First iron bridge constructed.
1785	First crossing over the English Channel in air balloon.
1786	Mozart composes *The Marriage of Figaro*.
1789	French Revolution begins. George Washington named first president of the United States of America.
1792–1795	Reign of Terror begins in France under direction of Maximilien Robespierre.
1793	David paints *The Death of Marat*.
1804–1814	Napoleon rules as emperor of France.
1811	Jane Austen publishes *Sense and Sensibility*. Riots erupt in England over mechanization of the textile industry.
1814	Jean-Auguste Dominique Ingres paints *Grande Odalisque*.

The last quarter of the eighteenth century was overshadowed by a war between the American colonists and England and a brutal civil war in France. In England, the reigning King George III (r. 1760–1820) succeeded in uniting England and Ireland but was unable to maintain rule over the thirteen American colonies. American colonists' disgruntlment about the British Crown's restrictions on imports and increased taxation without representation in Parliament was the impetus for revolution. Such events as the Boston Massacre in 1770, involving colonists and British troops, and the Boston Tea Party of 1773 led the English Parliament to repress American colonists even more by closing the harbor in Boston and rescinding the charter of the Massachusetts Bay Colony.

In 1774, the First Continental Congress met in Philadelphia to organize a protest. With increased tensions between the Crown and the colonists, King George III used British troops to enforce colonial law and secure absolutism. The following year, American patriots fought against the British at Lexington, Massachusetts. There, on April 19, 1775, the first battle of the American Revolution took place. France, by order of the new reigning monarch, King Louis XVI (r. 1774–1792), aided the Americans in their war against the British in 1778. Finally, in 1781, the British surrendered at Yorktown, Virginia, and the American Revolution ended with the signing of the Treaty of Paris in 1783. By the end of the decade, France would be involved in its own gruesome revolution.

By the time Louis XVI inherited the throne in 1774, problems leading to the French Revolution were irreparable. The new monarch's attempts at reform were unsuccessful. The extravagant spending of the previous two monarchs at the Palace of Versailles coupled with costly military campaigns left France near bankruptcy. Heavily in debt, French aristocrats and the monarchy lived on borrowed time. The decadent and extravagant lifestyles of an aristocratic society along with constant controversies involving King Louis XVI's queen, Marie Antoinette, resulted in the monarchy becoming a target of blame. In the eyes of the commoner, these select few lived frivolously while peasants, who comprised the majority of the population, struggled to feed their families.

Increased taxation placed on the already overburdened commoners and peasants contributed to a growing resentment of aristocratic society; the populace eventually reacted with violence and revolution. Seeking political, social, and economic reform, on July 15, 1789, crowds of peasants stormed the Bastille, a prison for political dissidents. The mob killed the commander and his guards, parading their heads on pikes through the streets of Paris. The capture of the Bastille stood for the fall of absolutism in the eyes of the French people.

The National Assembly, composed of French bourgeois representatives, quickly passed reform laws abolishing feudalism, but the fervor of revolution could not be stopped. Even with the aid of Austria and Prussia, Louis XVI failed to maintain control and save the monarchy. Captured trying to flee France in 1791, both Louis XVI and Marie Antoinette were imprisoned, tried for treason against French citizens, and executed in 1793.

In 1794, the Reign of Terror ended with the execution of Maximilien Robespierre, a leader of the opposition against the monarchy. Political order was restored in 1795 under a new constitution enforced by a directoire of five men. However, economic conditions worsened as reforms lacked cohesive leadership under the new directoire. In a coup d'état, a zealous Napoleon Bonaparte (1769–1821) overthrew the directoire and claimed power as consulate in 1799. By 1804, Napoleon had seized absolute control as emperor of France. For fifteen years, Napoleon established peace within French borders, administered economic prosperity through progressive reforms, and maintained political order.

In an attempt to imperialize the rest of Europe and establish France as the New World Order, Napoleon led numerous military campaigns against Austria, Prussia, Naples, Egypt, Sweden, Spain, and Portugal. Defeated by the Russians, Napoleon abdicated and was exiled in 1812. In 1815, he returned to France, deposed the restored Bourbon monarch King Louis XVIII (the eldest brother of King Louis XVI), and raised an army against the British. Defeated in the Battle of Waterloo, Napoleon was exiled once again to the isle of St. Helena, where he died.

Architectural Settings

The term *Neoclassic*, or *Neoclassicism*, first used in the 1880s, refers to the cultural period between 1750 and 1830. Significant changes in stylistic development had occurred as a result of the rediscovery of Herculaneum and Pompeii; clothing and hairstyles, and art and architecture, reflected Roman inspiration. After excavations began in 1738 at Herculaneum and in 1748 at Pompeii, people from all over Europe traveled to southern Italy to witness and record the event. Artifacts removed from these sites were documented in widely published treatises on ancient Roman life.

Artists, architects, and scholars witnessed with great awe the removal of furnishings, household objects, and architectural elements that had been buried beneath tons of volcanic ash and debris for nearly 1,800 years (Figure 7–1). What seemed apparent in the discovery of these ancient Roman cities was that, previously, the European idea of classicism had been based on the still-standing structures of the Italian Renaissance and the writings of Palladio. Now, classicism in its purest form could be studied, modified, and incorporated into eighteenth-century living. Books published at this time featured precise line drawings of the artifacts removed from the excavations.

Early manifestations of the Neoclassic movement first appeared in France as architects and designers grew tired of the exaggerated intricacies of the Rococo-based styles. In the beginning, Neoclassic elements were introduced in the design of interiors but quickly spread outward to all aspects of the structural space. A revival of the three orders of architecture—Doric, Ionic, and Corinthian—appeared in simplistic purity of use and form, singularly arranged across vast porticoes and

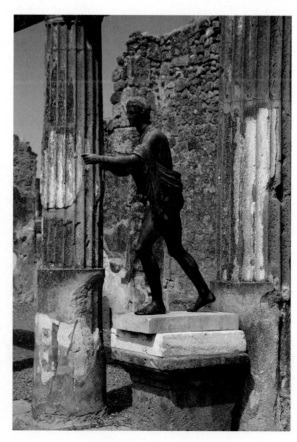

FIGURE 7–1 A view into the excavated site of Pompeii shows the remains of the Temple of Apollo with a bronze statue of the god in situ. *Christopher and Sally Gable © Dorling Kindersley*

inside large salons. Neoclassicism marked a return to rectangular forms, defiantly rejecting the serpentine curves and undulations typical of the Rococo period preceding it.

The Neoclassic period is divided into two parts; the early Neoclassic period, which coincides with the reign of Louis XVI in France; and the late Neoclassic period, lasting from 1792 to 1814. The Petit Trianon, built by Ange-Jacques Gabriel (1698–1782) between 1762 and 1768, exemplifies the synthesizing of Neoclassic elements in both interior and exterior architectural details (Figure 7–2). Constructed on the grounds of Versailles and built as a personal retreat for Madame de Pompadour, the Petit Trianon's main façade is articulated by a central projection created by the symmetrical arrangement of four engaged columns.

In 1775, Louis XVI gave the Petit Trianon to his queen, Marie Antoinette, and she began remodeling the interior in the new style. Interiors were designed with purely geometrical shapes; arcs, rectangles, and circles were incorporated into wall panels, mirror frames, and floor patterns in strict symmetrical arrangements. Ceilings, door frames, and mantelpiece moldings duplicated Roman prototypes taken from the excavations; gilt swags, urns, laurel wreaths, and egg and dart motifs were superimposed over white, gray, or softly tinted walls.

The luxurious home of Napoleon and wife Josephine, Château de Malmaison, remodeled by architects Charles Percier (1764–1838) and Pierre François Léonard Fontaine (1762–1853), is a fine example of interior design from the late Neoclassic period. Having traveled to Rome, the two architects combined Egyptian, Greek, and Roman influences in decoration reflective of the Roman Empire with as much historical accuracy as convenient, creating dramatic interior spaces (Figure 7–3). The intermingling of Egyptian ornament and design into Neoclassicism reflected Napoleon's conquests in Egypt. Interior walls were painted with Pompeian details, adorned with scenic wallpapers, or draped with fabric. Pilasters and engaged columns enclosed fireplace mantels, while cornices encapsulated doors and windows. At Malmaison, the pastel colors of the Rococo period were replaced with rich gold, vibrant crimson, deep blue, and dark green.

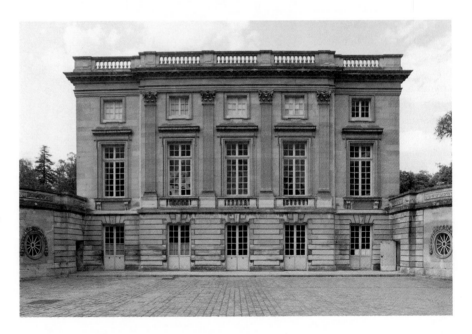

FIGURE 7–2 The Petit Trianon by architect Gabriel was designed in classic symmetry featuring fluted pilasters with Corinthian capitals, a balustrade along the roofline, and lintels with oversized keystones.
Neil Lukas © Dorling Kindersley, Courtesy of CNHMS, Paris

Although several English architects and designers moved swiftly from Palladianism into the Neoclassical style, perhaps the most recognized was interior designer Robert Adam (1728–1792). Adam spent time in Rome studying architectural ruins, visited Diocletian's palace in Split, and traveled to France. A few years after his return to London, Adam published a portfolio in 1764 of his engravings titled *Ruins of the Palace of the Emperor Diocletian*. This work established Adam as one of the leading "antiquarians" of the day, helping to set the standard for classic revival styles in England.

Along with his brother James and other family members, Robert Adam established a successful business as a designer and architect for wealthy British eager to renovate their country estates. Hallmarks of the Adam style were ornately patterned floors balanced by walls decorated in plaster relief and rooms compressed by highly decorative ceilings. His most commonly used motifs—paterae, urns and swags, palmettes, and classical figures—dominated the overall interior scheme.

Robert Adam received the commission to remodel and modernize a sixteenth-century Elizabethan house acquired by a wealthy banking family in London. Work began at Osterley Park in 1761 as he transformed the exterior façade by adding a vast portico supported by Ionic columns. Over the next twenty years, Adam carefully designed every detail for rooms inside the house, turning them into expressions of the Neoclassic aesthetic (Figure 7–4). Wall paneling, ceiling designs, marble flooring, and carpets featured his signature paterae; urn and swag motifs and clocks, textiles, mirrors,

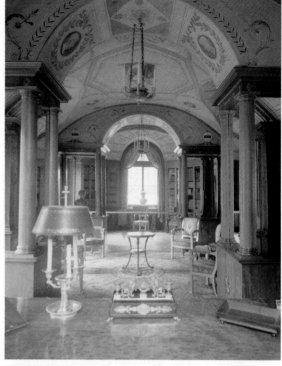

FIGURE 7–3 The library at Chateau de Malmaison showcases the Empire style of interior design in the late Neoclassic period with Tuscan columns, painted ceiling designs, and furnishings. *Picture Desk, Inc./Kobal Collection*

and lighting fixtures coordinated with Adam's furniture designs. While defining the Neoclassic style, Adam captured the essence of the artifacts discovered at Pompeii and Herculaneum.

In America, through the influence of Thomas Jefferson (1743–1826), Neoclassicism was adopted as the national architectural style of the newly formed United States. Jefferson, a self-taught architect and public official, spent five years in Paris from 1784 to 1789 as the United States' minister to France. In Paris, he was surrounded by the Neoclassic architectural design prevalent in France at the time. He was also exposed to the ruins of the ancient Roman Empire.

Monticello, Jefferson's home in Charlottesville, Virginia, reflects his exploration of classical elements (Figure 7–5). In 1796, he remodeled Monticello in a true Palladian sense; the home's dome, centered above a classical portico, is reminiscent of Villa Rotunda and Chiswick House (Figures 7–6, 4–1). Jefferson's interest in Roman and Greek classicism is seen in his designs for the state capitol building in Richmond, built in 1789, and the University of Virginia, completed in 1826. Jefferson's architectural achievements influenced the emerging American Federal style adopted by other notable American architects such as Charles Bullfinch (1763–1844) and Samuel McIntire (1757–1811).

At the turn of the nineteenth century, architects and designers turned toward more romanticized visions of the past, bringing about a number of revivalist styles including Greek, Gothic, Elizabethan, and Italianate. This eclectic combination of styles became the hallmark of the Victorian era and the Second Empire in France.

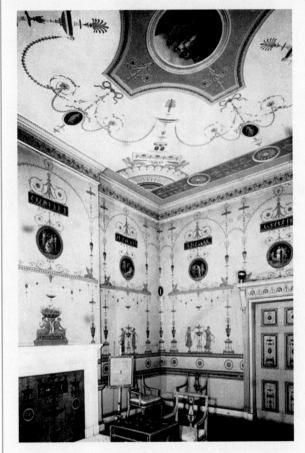

The Etruscan room at Osterley Park was designed by Robert Adam in 1775. The room served as a dressing room, and its decoration was inspired by scenes on ancient Etruscan and Greek pottery vases. The ceiling is painted with a central blue medallion surrounded by classical urns draped with thin swags and tied with ribbons in gold and brown. The walls feature painted scenes of classical goddesses among similar urn and swag motifs on the ceiling. These paintings are vertically arranged above a painted chair rail of rosette bands set above a blue painted wainscot. Door panels and the fire screen replicate the arabesque designs of figures and urns. Adam also designed a set of furniture to match the room décor. A set of painted armchairs with urn-shaped backs and gilt bellflower motifs running along the arms, legs, and back are arranged around the perimeter of the room, along with an assortment of japanned tables.

FIGURE 7–4 Featuring the work of Robert Adam, this dressing room at Osterley Park in England reveals Pompeian-style wall paintings and classically inspired furnishings.
National Trust Photo Library

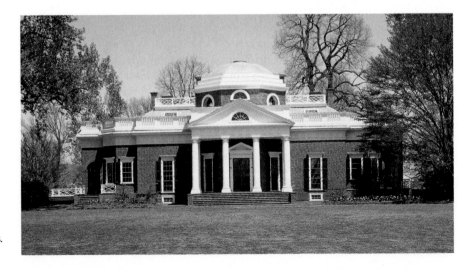

FIGURE 7–5 Monticello, the home of Thomas Jefferson, shows his interest in Neoclassical and Palladian architecture. Emphasizing symmetry, the central dome and large portico anchor the balanced, projecting wings.
Library of Congress

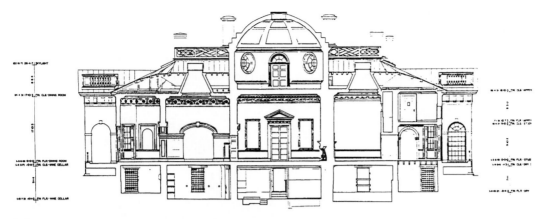

FIGURE 7–6 A section drawing of Jefferson's Monticello shows classically inspired interior pediments, arches, and moldings.
Courtesy of the Library of Congress

FIGURE 7–7 The wall paneling in this room from the early Neoclassic period features a guilloche border framing a field of palmette and acanthus leaves in inlaid woods.
Kim Sayer © Dorling Kindersley

FIGURE 7–8 Concentric circles create the medallion design used as a motif in early Neoclassic furnishings and architectural details.

Design Motifs

Rosettes and medallions intertwined with Vitruvian scrolls, guilloche decorations, paterae, and foliate patterns appeared as carved or inlaid decorations on architecture and furniture during the Neoclassic period. The style was inspired by the design motifs seen on the architectural elements, furniture, wall frescoes, and floor mosaics excavated from Pompeii and Herculaneum (Figures 7–7 through 7–11).

Reinterpreted by the designers of the Neoclassic period, these motifs appeared on clocks, in textile designs, on furniture, and in architectural details such as wall paneling and moldings.

Designers during the early and late Neoclassic periods were inspired by Robert Adam's combinations of Greek and Egyptian motifs in interior fashions. The early

FIGURE 7–9 The rosette motif often appears as an ormolu mount or carved detail on furniture, in plasterwork designs, on wall paneling, and as a textile pattern during the early Neoclassic period.

FIGURE 7–10 A foliate design rendered with perfect symmetry is often seen as ormolu mounts on furniture and also appears in plaster designs during the late Neoclassic period.

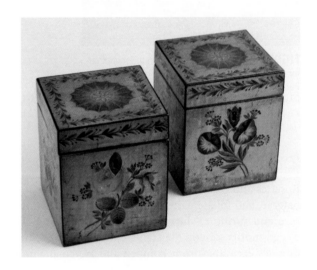

FIGURE 7–11 Two tea caddies veneered in satinwood have painted foliate designs on their fronts and paterae motifs surrounded by laurel branches on the lids.
© *Judith Miller/Dorling Kindersley/Woolley and Wallis*

Neoclassic designs appearing in Adamesque interiors included classical putti, arabesques, and paterae patterns (Figures 7–12, 7–13). Characteristic thin swags of bellflowers tied up with delicate ribbons, urns, and vases were common motifs featured on interior plasterwork (Figures 7–14 through 7–16). In addition, more specific to England, the Prince of Wales plume featured three ostrich feathers arranged in a similar fashion to the fleur de lis (Figure 7–17).

Cornucopia and wheat motifs, which appeared often in the Neoclassic period, were associated with the abundance of the earth, dating back to ancient cult practices (Figures 7–18, 7–19). Moreover, from the last quarter of the eighteenth century and continuing through 1840, essentially all design motifs imitated those used by the ancient Romans. Decorative accessories incorporated caryatid figures, lyre forms, cornucopia, sphinxes, and representations of pharaohs into their shapes and forms (Figure 7–20).

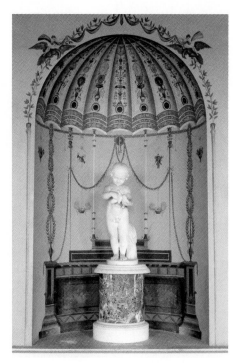

FIGURE 7–12 A putti stands on a pedestal inside this wall niche painted with Neoclassic motifs including arabesque designs, laurel branches, ribbon swags, and trompe l'oeil architectural elements in vivid red, gold, green, and blue.
Joe Cornish © Dorling Kindersley

FIGURE 7–13 (A–C) Three variations of the paterae motif show the oval flattening of the rosette favored by designers from the early Neoclassic period.

FIGURE 7–14 Small bellflowers tied up with ribbons were a recurring motif favored by Robert Adam and regularly appeared on his designs for ceilings, wall paintings, paneling, and furniture.

FIGURE 7–16 Elaborate plasterwork featuring bellflowers tied with ribbons, acanthus leaves and shell carvings, and foliates frame an eighteenth-century seascape painting in this early Neoclassic interior. *Joe Cornish © Dorling Kindersley*

FIGURE 7–15 Hepplewhite-style furniture in the early Neoclassic period features inlaid patterns of bellflowers, a motif based on the small flowers of lily of the valley.

FIGURE 7–18 The horn of plenty, or cornucopia, dates back to the ancient Roman period and was a symbol for the abundance of the earth. The motif was prominently featured on Empire-style furniture in France and America.

FIGURE 7–17 A stylization of the Prince of Wales plume frequently appeared on early Neoclassic furniture in the Hepplewhite style.

Interior Furnishings

As a whole, furniture designed in both the early and late Neoclassic periods did not change in proportion or scale from that of the Rococo period. Furnishings remained on a small scale, and the designs moved away from organically inspired curves toward geometric shapes and symmetry. In both France and England, furniture designed during the second half of the eighteenth century reflected strong Greek and Roman influences. However, toward the turn of the nineteenth century, designs began to include Egyptian characteristics as well. The introduction of Egyptian motifs into design

FIGURE 7–19 A sprig of wheat is a favored design seen on English early Neoclassic furniture, appearing as both carved ornamentation and inlay designs.

FIGURE 7–20 The lyre, an ancient Roman musical instrument similar to a modern harp, was commonly used as a motif on furniture during the early and late Neoclassic periods and was a favorite of both Duncan Phyfe and Robert Adam.

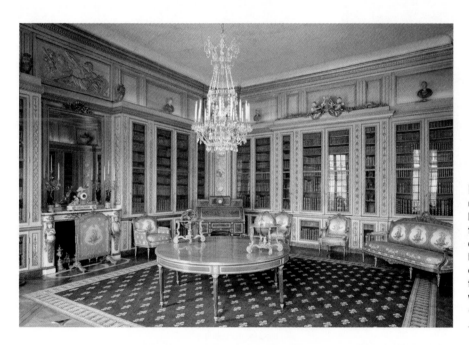

FIGURE 7–21 Decorated in 1781 under the direction of Gabriele, the library of Louis XVI at Versailles features early Neoclassic furnishings designed in 1781 by Jean Simeon Rousseau (1747–1820), including crystal chandeliers, gilt ensuite furniture, and a large wool carpet woven in a fleur de lis design. *Chateau de Versailles, France/The Bridgement Art Library*

during the late Neoclassic period was a result of Napoleon's campaigns into Egypt in 1798. In France this style of furniture is labeled Empire; in England it is labeled Regency.

French furniture in the early Neoclassic Louis XVI style featured straight lines and legs fashioned into fluted or reeded columns. Chair backs were oval, circular, or rectangular, sometimes with a slight arc at the top of the crest rail. Seats and arms also featured smooth arcs, as geometrical shapes prevailed over the sinuous curves of the Rococo (Figure 7–21). Needlework upholstery fell out of fashion during the Neoclassic period; instead, soft pastel-colored upholstery fabrics in brocade, damask, and silk

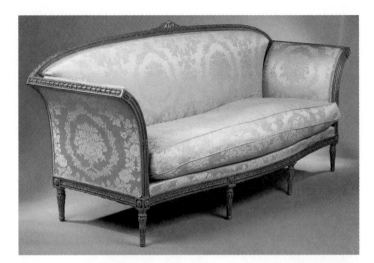

FIGURE 7–22 This giltwood settee in the Louis XVI style features tapered legs with carved acanthus leaf motifs and rosette blocks and is upholstered in pink damask with patterns of tied bouquets framed by foliate medallions.

© Judith Miller/Dorling Kindersley/ Lyon and Turnbull Ltd.

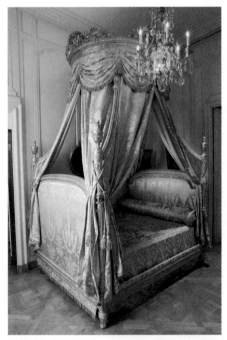

FIGURE 7–23 This elegant canopy bed from the eighteenth century was made by François Honore Georges Jacob-Desmalter (1770–1841) for a bedroom at Versailles. The design includes urn finial bedposts and elaborate carvings featuring festoons, medallions, and foliate motifs.

Peter Wilson © Dorling Kindersley, Courtesy of the Musee Cognacq-Jay, Paris

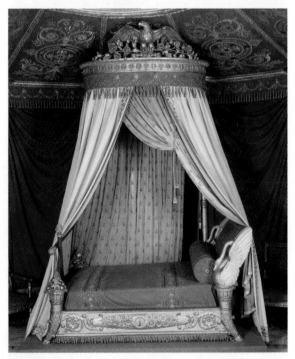

FIGURE 7–24 The bedroom at Malmaison for Empress Josephine features a giltwood canopy bed with elaborately carved swans and cornucopia legs reminiscent of an ancient Roman lectus. Crimson fabric embroidered in gold hangs from the ceiling in tentlike fashion and is also used for the bedding.

Max Alexander © Dorling Kindersley, courtesy of Chateau de Malmaison

covered chairs and settees (Figure 7–22). Furniture in the Louis XVI style was constructed from beechwood and painted in light colors, and those made for the Palace of Versailles were fully or parcel gilt (Figure 7–23).

As the new aristocracy of a prosperous France was eager to put the trepidation of the revolution behind them, Napoleon set the direction for a return to luxurious living with the redesign of Malmaison (Figure 7–24). Furnishings at Malmaison

recaptured the opulence of those at Versailles; they were gilt and lavishly carved (Figure 7–25). For the aristocracy, late Neoclassic furniture in the Empire style featured straight lines. Carved details were minimized; ormolu mounts were used instead. References to Egyptian motifs appeared as ormolu mounts fashioned into the images of pharaohs or sphinxes on furniture and decorative accessories. Less attention was given to painted or gilt surfaces featuring the dark graining and deep red coloring of mahogany and rosewood.

English furniture designed during the reign of George III appears in character with the early Neoclassic period emphasizing geometrical shapes of squared and rounded chair backs and straight legs. The popularity of Thomas Chippendale's *The Gentleman and Cabinet-Maker's Director* encouraged others to produce pattern books capturing the latest styles in England. *Cabinet Maker and Upholsterer's Guide* by George Hepplewhite (unknown–1786) and *The Cabinet Maker and Upholsterer's Drawing Book* by Thomas Sheraton (1751–1806), containing drawings representative of furniture styles in vogue during the early Neoclassic period, perpetuated the popularity of classical designs. Furnishings in the Hepplewhite style featured chairs, cabinets, and tables with small proportions and little carving; decorations were either painted or inlaid (Figure 7–26). Many of the examples in the Hepplewhite and Sheraton drawing books overlapped in design, although Sheraton-style chairs often featured squared chair backs and tables included hidden mechanical devices (Figure 7–27).

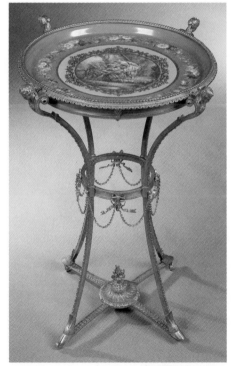

FIGURE 7–25 This gilt brass and Sèvres porcelain gueridon table incorporates many Neoclassic features including swags tied up with ribbons, term figures that support the porcelain basin, and hoof-shaped animal feet.

© *Judith Miller/Dorling Kindersley/Lyon and Turnbull Ltd.*

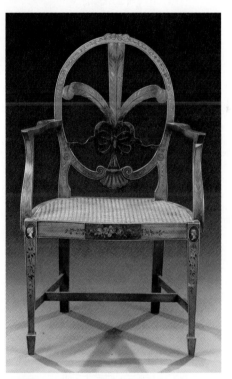

FIGURE 7–26 This Hepplewhite-style chair made from satinwood features the Prince of Wales plume on its oval-shaped back, painted foliate designs on the front seat rail, and bellflower motifs on the tapered front legs. The chair is a reproduction dating from 1900.

© *Judith Miller/Dorling Kindersley/Sloan's*

The Regency style of the late Neoclassic period in England followed on the heels of the Empire style introduced in France by Percier and Fontaine working at Malmaison. In England, this second phase of Neoclassicism identified more closely with the classical past, incorporating many of the characteristics found on furniture items excavated from Pompeii. Thomas Hope (1770–1831) was instrumental in presenting a collection of designs based on the assimilation of Egyptian, Greek, and Roman cultures in his 1807 publication, *Household Furniture and Interior Decoration* (Figures 7–28, 7–29). Inspired by his grand tour through Europe, Africa, and Asia, and his penchant for collecting ancient antiquities, Hope revived the styles of ancient Rome including cornucopia leg forms, volute armrests, and animal legs (Figure 7–30).

The preeminence of the Neoclassic period reached the colonies soon after the end of the American Revolution. Although the colonies were now free from England's rule, the furniture of the American Federal period closely followed the Hepplewhite and Sheraton styles. American cabinetmakers captured the simplicity of Neoclassic styling in graceful, well-proportioned chairs, settees, and cabinets. Through the work of New York cabinetmaker Duncan Phyfe (1768–1854), who combined Sheraton-influenced designs with French Empire styling, American Empire furnishings took on a distinctive Grecian appearance (Figure 7–31). The style was well received by the American elite and middle classes and fit into the currently popular Greek Revival style of architecture introduced by Thomas Jefferson with his buildings in Virginia.

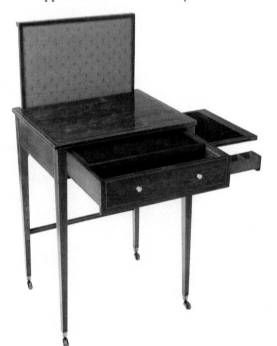

FIGURE 7–27 This rosewood ladies writing table in the Sheraton style has a mechanically rising screen and spring-action pen and ink drawer to the side of the writing drawers. It dates from around 1795, was made from boxwood and satinwood, and features purple heartwood inlays on the top.
© *Judith Miller/Dorling Kindersley/Richard Gardner Antiques*

FIGURE 7–28 This Regency-style chair designed by Thomas Hope and fashioned after the Greek klismos chair has a concave crest rail, saber front and back legs, and winged lion arm supports.
Dover Publications, Inc.

FIGURE 7–29 This drawing for a Roman-inspired tripod table featuring table legs in the form of mythical griffins decorated with acanthus leaf and palmette designs was taken from Thomas Hope's *Household Furniture and Interior Decoration*, published in 1807. *Dover Publications, Inc.*

FIGURE 7–30 An English Regency-style sofa has a reeded and scrolled back rail, scrolled arms, and cornucopia-shaped legs. © *Judith Miller/Dorling Kindersley/Lyon and Turnbull Ltd.*

Decorative Accessories

Pottery

The discovery of kaolin in 1768 near Limoges, France, prompted new factories to make fine porcelain. By 1774, factories in Limoges were supplementing the output from the royal porcelain factory in Sèvres. Because of its ties to the French monarchy, the porcelain factory at Sèvres was on the verge of bankruptcy during the French

FIGURE 7–32 This two-handled Sèvres porcelain vase painted with landscape designs dates from 1793 and features extensive gilding; it reflects aristocratic taste and prosperity.
© *Judith Miller/Dorling Kindersley/T.C.S. Brooke*

Revolution. After Napoleon became emperor of France, the revitalized factory began creating pieces in the new Empire style (Figure 7–32).

Included in Sheraton's *The Cabinet Maker and Upholsterer's Drawing Book* were numerous furniture items incorporating porcelain plaques into English designs. This fashion had been popular in France since the early Rococo period, but it was not adopted by the English until the success of Josiah Wedgwood (1730–1795). Wedgwood's factory was known in the late eighteenth century for producing fine jasperware pottery that he modeled after ancient Roman cameo designs. Classical figures in white relief appear over a soft blue ground of unglazed ceramic (Figure 7–33). The much-recognized blue jasperware was most common, but green, black, and lilac backgrounds also appeared on Wedgwood pottery to coordinate with Neoclassic interior color schemes (Figure 7–34).

A porcelain factory in Derby, England, produced high-quality bone chinaware that so impressed King George III that the factory earned the Crown's endorsement. Royal Crown Derby was the only British factory authorized to use the insignia of the royal crown in its hallmark strike. In 1769, the factory in Derby acquired molds from a factory in Chelsea, and Derby-Chelsea porcelains were produced until 1784 (Figure 7–35). The factory's hard-paste and soft-paste

FIGURE 7–33 A rare Wedgwood solid blue jasperware vase has a lift-out lid with three laurel leaf tulip holders. The white classical figures represent Apollo and the nine Muses standing above a band of trophy and lyre forms. The vase dates from between 1785 and 1795.
© Judith Miller/Dorling Kindersley/ Woolley and Wallis

FIGURE 7–34 This niche from an eighteenth-century interior features trompe l'oeil ceiling designs painted to imitate Wedgwood jasperware.
Tim Daly © Dorling Kindersley

FIGURE 7–35 This pair of Derby-Chelsea figurines of children dressed in eighteenth-century costume at a *fête gallant* dates from around 1790.

© *Judith Miller/Dorling Kindersley/T.C.S. Brooke*

FIGURE 7–36 This creamware ewer and basin from 1780 was made by Leeds pottery.

© *Judith Miller/Dorling Kindersley/John Howard-Heritage*

FIGURE 7–37 This Staffordshire platter designed for the American export market features a black transfer-printed view of the Hudson River in New York among a scene of pastoral birds and flowers. It has molded and scalloped edge framing.

© *Judith Miller/Dorling Kindersley/Sloan's*

porcelain figurines, candlesticks, and dinnerware featured polychrome details with accents in 22-karat gold to compete with Sèvres porcelain.

Creamware, an opaque white glaze applied over earthenware, gave the appearance of fine porcelain, although it lacked the translucency (Figure 7–36). Middle-class households found both creamware and ironstone less costly substitutes for porcelain and bone china. Most popular was creamware, which was made in a factory in Staffordshire, England. Engraved copper plates were used to transfer intricately detailed designs onto plates, cups, saucers, and vases (Figure 7–37). An engraved

copper plate coated with a special ink was printed onto a thin sheet of paper. The paper was used to transfer the pattern onto the ceramic, which was then glazed and fired at low temperatures. Transferware decorated in bright blues closely resembled porcelains imported from China. Although blue was the most popular color of transferware, red on white, brown on white, and black on white were also featured. Flow blue is the name given to ironstone transferware that has a blurred pattern caused by a bleeding of the ink.

Decorative Boxes

Small decorative boxes made from a variety of materials were designed to contain a range of domestic and personal items including snuff, tea, wine, and face powder. Boxes in all shapes, colors, and sizes adorned tabletops, sideboards, and dressing tables and were designed to coordinate with other interior accessories (Figure 7–38). Enameled boxes and glassware were painted to look like fine porcelain for less affluent buyers, whereas boxes made from silver, tortoiseshell, and porcelain appealed to the wealthy (Figures 7–39, 7–40). Separate rooms designated just for dining developed during the last quarter of the eighteenth century, and locking knife boxes and tea caddies made from mahogany or rosewood matched the suites of dining room furniture (Figure 7–41).

Inlaid boxes featured fine marquetry work in wood, shell, and piqué, which was inlaid silver or gold into either a tortoiseshell or ivory ground (Figure 7–42). Tortoiseshell was known for its malleability and rich reddish brown color with dark veining. Fine materials such as tortoiseshell and ivory were popular among the more elite classes who could afford such luxurious items (Figure 7–43). Ivory boxes made from the bone or tusk of animals were increasing in popularity because of a

FIGURE 7–38 This gilt and enamel tole box features a transfer pattern of figures in an eighteenth-century pastoral setting.
© Judith Miller/Dorling Kindersley/Gorringes

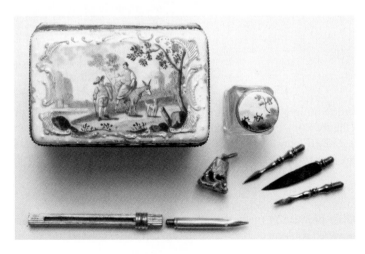

FIGURE 7–39 This eighteenth-century glass box features a pastoral scene painted on its cover.
John Chase © The Museum of London

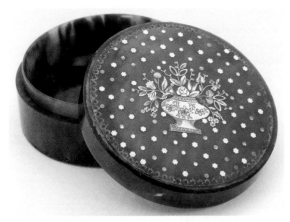

FIGURE 7–40 This silver and gilt metal inlaid snuffbox was made from tortoiseshell and dates from the late eighteenth century.
© *Judith Miller/Dorling Kindersley/Wallis and Wallis*

FIGURE 7–41 This Regency-style mahogany cellaret features fluted pilasters, gadrooned feet, and inlay patterns. A cellaret was used in the dining room for storing accoutrements for serving wine.
© *Judith Miller/Dorling Kindersley/Richard Gardner Antiques*

FIGURE 7–42 This oval box with piqué silver and agate designs dates from 1780.
© *Judith Miller/Dorling Kindersley/Rogers de Rin*

FIGURE 7–43 This ivory box from 1820 includes a portrait of the prince regent, son of George III of England.
© *Judith Miller/Dorling Kindersley/Rogers de Rin*

burgeoning whaling industry that developed in the early nineteenth century (Figure 7–44). Scrimshaw, made from whale ivory, became fashionable in America especially (Figure 7–45). Today, it is unlawful to use ivory and tortoiseshell as the animals are now protected as endangered species.

Glass

Glass production methods improved during the eighteenth century with new steam-powered equipment, high-temperature furnaces, and mechanized processes. In addition

to these cost-saving production methods, wheel-cut and engraved designs and later press-molded glass objects made glass more affordable. The clarity and durability of the glass determined its quality, and owning lead crystal indicated wealth (Figure 7–46). Colored glass came into fashion by early 1800 to try to compete with porcelain accessories that currently dominated the market. In fact, opaque white glass was often painted with designs imitating those found on fine porcelains. Cobalt blue glass was a featured product of glass factories in Bristol, England (Figure 7–47). The factory, first established in the seventeenth century, began producing blue glass in 1780 for affluent patrons. The city became known for producing other colors such as green and purple and exporting wares throughout Europe and the Americas.

Mirrors

Large sheets of glass suitable for making mirrors were made by pouring molten glass onto a frame-fitted table, which was then cooled and polished by hand to give it an even surface. Wall-hung or free-standing mirrors could now be made from one sheet of glass instead of several smaller ones (Figure 7–48). Further enhancements occurred in 1835 when a German chemist developed a process of using silver to coat a plate of glass in less than a

FIGURE 7–44 This snuff rasp from the eighteenth century was made from an ivory animal tusk and features carved designs of a female figure wearing classical drapery and holding a tablet.
© *Judith Miller/Dorling Kindersley/ Dreweatt Neate*

FIGURE 7–45 These scrimshaw teeth have inked etchings of women dressed in early-nineteenth-century costume.
© *State Library of Tasmania*

FIGURE 7–46 These French Empire glass vases from the early nineteenth century are decorated with deep-cut diamond shapes and accented with gilt palmette borders.
© *Judith Miller/Dorling Kindersley/Sloan's*

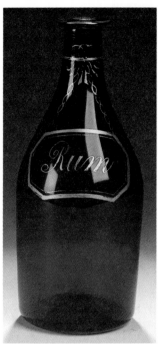

FIGURE 7–47 This rare Bristol blue glass decanter dating from 1800 has gilt accents and label.
© *Judith Miller/Dorling Kindersley/ Bonhams*

minute, replacing the formerly toxic practice of coating the glass with mercury and tin. Coating the glass with silver produced a mirror with more reflective clarity. Frames made to hold the larger panels of glass were designed to match current Neoclassic fashions (Figure 7–49). In the early nineteenth century, mirrors featured a new technique called reverse painting, in which colorful scenes painted on the reverse side of the glass gave a glossy appearance from the front face of the mirror (Figure 7–50).

Lighting

In 1780, Aimé Argand (1750/55–1803) patented a new type of oil lamp that burned more efficiently and provided stronger lighting (Figure 7–51). The lamp relied on a glass tube or shade that helped direct airflow to keep the wick burning evenly. These lamps were more expensive than other types and were out of the financial reach of the middle-class consumer. As before, the style of candleholders

FIGURE 7–48 A Regency-style giltwood and gesso frame features engaged columns with Corinthian capitals. This large looking glass is made of eleven individual panes of glass.
© *Judith Miller/Dorling Kindersley/Lyon and Turnbull Ltd.*

FIGURE 7–49 This George III–style cheval mirror holds a large mirror within its baluster-shaped frame.
© *Judith Miller/Dorling Kindersley/ Lyon and Turnbull Ltd.*

followed the leading interior fashions of the period; crystallized whale oil substituted for tallow in the making of candles (Figures 7–52, 7–53). Candlepower was still prevalent in middle-class households until the invention of kerosene lamps in the mid-nineteenth century.

FIGURE 7–50 This Empire-style mahogany looking glass features a reverse-painted upper panel featuring three pheasants.
© *Judith Miller/Dorling Kindersley/Freeman's*

FIGURE 7–51 An oil lamp invented in 1784 by Aimé Argand and made with a hollow, circular wick, glass cover, and oil tank produced a brighter flame, bringing more efficient lighting to interiors.
Dave King © Dorling Kindersley, Courtesy of The Science Museum, London

FIGURE 7–52 This pair of eighteenth-century gilt wrought iron wall sconce candleholders features classical cupids and rosette designs.
© *Judith Miller/Dorling Kindersley/Lyon and Turnbull Ltd.*

FIGURE 7–53 This pair of bronze and gilt table candelabra, each with scrolling branch and anthemion designs and eagles, reflects the English Regency style of the late eighteenth and early nineteenth centuries. The hanging crystals helped reflect more light into the interior.
© Judith Miller/Dorling Kindersley/Lyon and Turnbull Ltd.

FIGURE 7–54 This George III silver tea caddy with an ivory knop finial features engraved foliate designs, laurel wreath medallions, and a keyed lock. Tea, like sugar, was an expensive luxury kept under lock and key.
© Judith Miller/Dorling Kindersley/Woolley and Wallis

Metalworking

During the Neoclassic period, silversmiths worked the metal in a variety of ways creating an assortment of tableware and decorative accessories for upper-class clients (Figure 7–54). The quality of silver was determined by its purity, with fine silver being 95.84 percent pure, and sterling silver being made of 92.5 percent silver and 7.5 percent copper. When Thomas Bolsover of Sheffield, England, tried to repair the handle of a knife made from copper and silver, he noticed that the two metals fused when heated. His discovery in the early 1740s led to further experimentation of fusing silver sheets over copper sheets to produce silver plate. The invention of silver plate allowed middle-class households to own tea and coffee service, tableware, and ornamental boxes made with the same designs and in the same styles as those made from sterling (Figure 7–55). Over time, the silver plate wears off edges and detailed relief patterns, revealing the copper-formed body.

Before the American Revolution, most silver work made in the colonies came from melted coins to avoid paying a tax to the British Crown. Coin silver is an alloy of 90 percent silver and 10 percent copper. The colonial silversmith Paul Revere, who gained notoriety for his infamous participation in the American Revolution, is equally known for his fine metalwork. Learning the craft from his father, the younger Revere made objects in fine silver for wealthy Bostonians (Figure 7–56). After the war, Revere began to design a variety of objects priced for the middle-class market. In 1801, he established Revere Copper Products, a company still in business today (Figure 7–57).

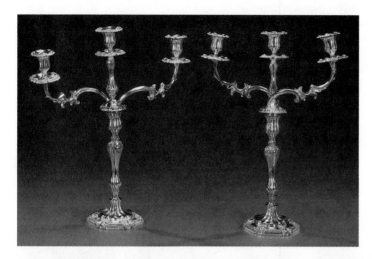

FIGURE 7–55 This pair of early-nineteenth-century silver on copper (silver plate) three-light candelabra features gentle foliate designs.
© Judith Miller/Dorling Kindersley/Sloan's

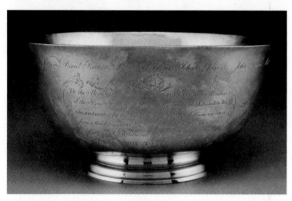

FIGURE 7–56 This Sons of Liberty Bowl, crafted in silver by Paul Revere in 1768, commemorated those who opposed British taxation in the Massachusetts assembly.
Sons of Liberty Bowl. 1768. Object Place: Boston, Massachusetts. Paul Revere, Jr., American, 1734–1818. Silver. Overall: 14 x 27.9 cm (5 1/2 x 11 in.) Other (Base): 14.8 cm (5 13/16 in.) Museum of Fine Arts, Boston. Museum purchase with funds donated

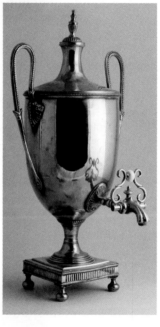

FIGURE 7–57 This George III–style copper tea urn has a domed cover with an urn-shaped knop finial and a vase-shaped body fitted with a brass tap and oversized handles. It stands on a pierced copper base. Copperwares conducted heat more evenly and were less expensive than items made from silver.
© Judith Miller/Dorling Kindersley/Clevedon Salerooms

Clocks

In 1783, Benjamin Hanks (1755–1824) patented a self-winding clock. Until this time, clocks could run for only eight days at a time before needing winding. The clock Thomas Jefferson owned at Monticello operated with two 18-pound weights. Holes had to be cut into the floor for the weights to drop into the cellar to keep it running for a week at a time. Alarm clocks set to chime at predetermined times appeared during the eighteenth century; Napoleon used one at Malmaison. Like all clocks made throughout the periods, clock makers made the inner workings, and cabinetmakers designed cases to coordinate with the popular styles of the period (Figures 7–58 through 7–60).

Textiles

The popularity of imported printed cottons from India led to an increased production of European cottons during the second half of the eighteenth century. Toile de Jouy is a type of printed cotton with a distinctive pattern imitating the scenes found

on popular transferware china of the period. The origin of the design came from a small town in France, Jouy en Josas—hence, the name *toile* means "cloth." The first printed cottons from this factory date to 1760 and were made using woodblocks. Later, copper plates and then copper cylinders were used to transfer the patterns to

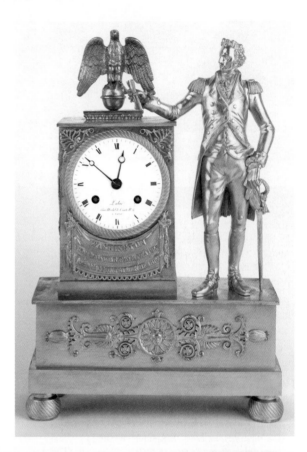

FIGURE 7–58 This cast brass and ormolu mantel clock made for the American market by French clock maker Jean Baptiste Dubac features a youthful George Washington in military dress. Apart from Neoclassic design motifs, a finial in the form of an eagle was added later as a symbol of American independence.
© *Judith Miller/Dorling Kindersley/Pook and Pook*

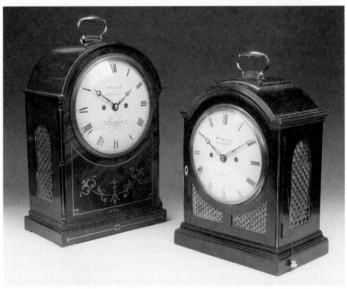

FIGURE 7–59 These two Regency-style bracket clocks feature Roman numeral dials and brass inlay designs. The clock on the left has gilt foliate design on its front case and arched, diaper-patterned sides. The clock on the right features brass fretted front and side panels. Both have brass carrying handles.
© *Judith Miller/Dorling Kindersley/Lyon and Turnbull Ltd.*

the cloth. Pastoral scenes were etched onto the copper, then inked and printed onto rolls of cotton. Colors included black on white, blue on white, and red on white, although greens and dark purple were also in fashion (Figure 7–61). These toile fabrics dominated clothing styles, and the fabric was used for upholstery, drapes, and bedding.

In 1801, Joseph Marie Jacquard (1752–1834) made improvements to the first automated loom (developed in 1745). His invention used a punch card system of weaving to bring speed and consistency to the weaving process (Figure 7–62). As mechanization replaced labor-intensive hand weaving, owning textiles was no longer reserved for the elite.

Once associated with great wealth, needlework pictures became increasingly popular. These embroideries were framed as artwork in homes. The education of young girls included mastering the skill of needlework, and the small pieces of cloth they embroidered showed the dexterity of their hands. These practice pieces, called samplers, showed a variety of stitching techniques applied to ornamental motifs, the alphabet, and numbers (Figure 7–63). Needlework embroideries of the early nineteenth century became more pictorial, often imitating scenes from fine paintings (Figure 7–64).

Improvements in the design and making of carpets occurred during the last quarter of the eighteenth century. The former method of designing a pattern or preparing a cartoon for the weavers to follow was replaced by the Jacquard punch card mechanized loom (Figure 7–65). Moquette carpeting was made by sewing woven strips of carpet together in large enough pieces to cover the entire floor surface of a room (Figure 7–66). This form of wall-to-wall carpeting was introduced in the late eighteenth century, although only the wealthy could afford it.

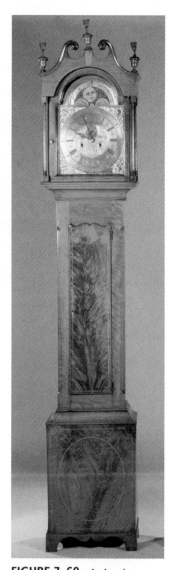

FIGURE 7–60 An American Federal-style inlaid tall case clock features a swan neck pediment surmounted by urn and flame finials (commonly used by Philadelphia cabinetmakers). Turned columnar supports flank a moon phase dial. The clock dates from 1800.
© Judith Miller/Dorling Kindersley/ Freeman's

FIGURE 7–61 This toile de Jouy textile dating from 1797 depicts a pastoral scene of contemporary eighteenth-century figures.
Design Library

FIGURE 7–62 This Jacquard weave bed coverlet designed by Archibald Davidson from the Ithaca Carpet Factory in New York features a field of flowers bordered by deer and trees, American eagles, and buildings. The coverlet dates from 1840.
© *Judith Miller/Dorling Kindersley/Sloan's.*

FIGURE 7–63 This silk-on-linen sampler is decorated with the alphabet, potted flowers, and birds. It was framed as artwork to display the skill of its embroiderer.
© *Judith Miller/Dorling Kindersley/ Wallis and Wallis*

FIGURE 7–64 This early-nineteenth-century Philadelphian silk needlework picture depicting a garden scene includes painted designs on the reverse side of the glass.
© *Judith Miller/Dorling Kindersley/Pook and Pook*

FIGURE 7–65 This original carpet designed for the earl of Coventry in the late eighteenth century depicts guilloche and rosette patterns rendered in four color schemes. Like wallpaper, carpet designs were first created as watercolor renderings as the artist worked out color combinations, size, and pattern repeats.
Courtesy of Trustees of Sir John Soane's Museum, London/The Bridgeman Art Library

Wallpaper

French printer Christophe-Philippe Oberkampf (1738–1815), who produced hand-blocked toile de Jouy fabrics as early as 1760, used his knowledge of printing to invent a wallpaper-printing machine in 1785. Using cylindrical engraved copper plates, he printed patterns on continuous rolls of fabric and paper, which was less expensive

FIGURE 7–66 This watercolor painting from 1815 depicts two women sitting at a table in a room with wall-to-wall carpeting.
Fennimore Art Museum, Cooperstown, New York

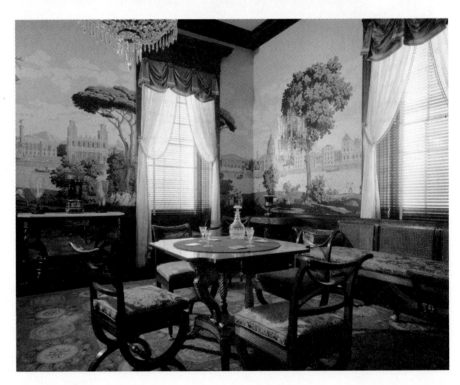

FIGURE 7–67 This formal parlor from a Richmond, Virginia, house built in 1810 includes scenic wallpaper imported from France, unassuming draperies, a large carpet, and furniture by Duncan Phyfe and Charles-Honore Lannuier (1779–1819).
With respect to 68.137, Richmond Room, 1810 American. The Metropolitan Museum of Art, Gift of Joe Kindig, Jr., 1968. (68.137). Photograph © 1995 The Metropolitan Museum of Art.

than hand blocking. Winning the Legion of Honor by Napoleon, Oberkampf's technique enabled upper-middle-class households to afford to wallpaper their homes. Although machine-printed papers were available, hand-blocked papers were still popular among the wealthy. Scenic papers came into fashion in the late Neoclassic period in America, France, and England (Figure 7–67). These hand-printed papers were more expensive than machine-printed papers and were featured in the public areas of houses, such as the front entry hall and sitting room, to impress guests.

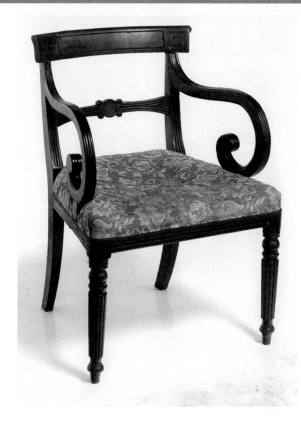

FIGURE 7–68 This English Regency-style armchair with curved and fluted legs features elaborate volute scrolled arms. The shape of the back with its slightly concave crest rail offers comfort without padding or upholstery.
© *Judith Miller/Dorling Kindersley/Gorringes*

History repeats itself in curious ways. The two armchairs featured in Figures 7–68 and 7–69 were designed two hundred years apart and share many features. The more obvious are leg forms, scrolled armrests, and shaped backs, but they share an "attitude," too. By observation alone, the two chairs appear very similar. However, researching further into their histories reveals the differences between the cultural attitudes of the people who used them.

The chair in Figure 7–68 dates from the late eighteenth century and captures the renewed interest in ancient Roman culture brought on by the artifacts removed from excavations at Pompeii and Herculaneum. The saber back legs and fluted and tapering front legs emulate furniture designs from this ancient Roman period. Exaggerated scrolls on the chair's arms were inventions of the eighteenth-century designer, who was inspired by the volute capitals seen on Roman buildings. An upholstered seat replaced the loose cushions that would have been used by the Romans and is a testament to advances in design for comfort. Although the back lacks upholstery, the slight curvature of the crest rail offers some comfort. However, the social attitudes of the time were that ladies and gentlemen needed to keep their heads high and backs straight when seated.

The Bodleian Chair designed by Robert A. M. Stern in the last decades of the twentieth century (Figure 7–69) features similar leg forms, scrolled arms, and a shaped back, but its design captures the idealistic notion of the Postmodern movement

(continued)

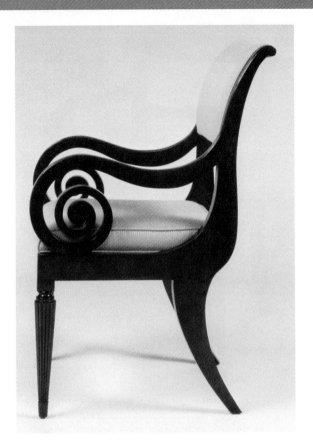

FIGURE 7–69 This chair designed by Robert A. M. Stern in the late twentieth century was inspired by the late Neoclassic Regency style.
Courtesy HBF

popular at the fin de siecle. Designers of the Postmodern movement sought to abandon the modernistic style set by the International style and the Bauhaus from the 1920s and turned toward the classical past in fresh and inspiring ways. Stern's chair reflects this shift toward modern design with its beautifully inspired late Neoclassical features. The seat is upholstered in a thick cushion, and the ergonomically shaped back is padded too. Armrests incorporate soft curves offering a more casual pose. In the twentieth century, social attitudes were more relaxed and less formal; no longer were people required to sit upright in perfectly stiff postures to impress upon their peers that they were well-heeled and refined individuals.

Victorian, Arts and Crafts, Art Nouveau: Nineteenth Century

TIMELINE

Nineteenth Century

1801	United Kingdom is formed.
1815	John Nash begins renovation on the Royal Pavilion in Brighton.
1824	Beethoven composes *Ninth Symphony.*
1825	First steam railroads operate in England.
1835	Talbot develops methods for producing photographic images.
1837–1901	Queen Victoria rules the United Kingdom.
1843	Charles Dickens writes *A Christmas Carol.*
1847	Charlotte Brontë publishes *Jane Eyre.*
1848	Karl Marx writes *Communist Manifesto* with Friedrich Engels.
1851	Great Exhibition opens in London at the Crystal Palace.
1854	The principle of fiberoptic technology is introduced.
1858–1866	First transatlantic telegraph cable.
1859	Charles Darwin publishes *Origin of the Species.*
1860	William Morris initiates Arts and Crafts style in England.
1861–1865	United States engages in Civil War.
1862	Victor Hugo writes *Les Misérables.*
1863	Manet paints *Luncheon on the Grass.*
1865	Lewis Carroll writes *Alice's Adventures in Wonderland.*
1865	Tolstoy writes *War and Peace.*
1871	Giuseppe Verdi composes *Aida.*
1872	Whistler paints portrait of his mother.
1876	Alexander Graham Bell invents first successful telephone.
1888	First gasoline-powered automobile introduced.
1889	Dutch painter Vincent Van Gogh finishes *Starry Night.*
1891	Thomas Edison patents motion picture camera.
1895	Art Nouveau style first appears in Belgium.
1898	H. G. Wells writes *War of the Worlds.*

At the close of the eighteenth century, Western culture faced enormous change as the Industrial Revolution replaced political revolution, giving power to those capitalizing on manufacturing. Industrialization brought wealth to inventive entrepreneurs who earned substantial profits off the mechanization and distribution of consumer products. Self-made millionaires such as Cornelius Vanderbilt (1794–1877), who made his fortune in shipping and railroads, and Andrew Carnegie (1835–1919), who supplied the steel needed for machinery and buildings, became the new aristocrats of an industrial age.

Industrialization displaced tenant farmers as urbanism encroached on agrarian society. People left the hard labor of the fields to work in factories running machinery for mostly low wages. Moreover, industrialization brought new employment opportunities to educated middle-class workers who could handle the quantity of paperwork necessary to fill customer orders, direct shipments, and supervise the labor force. These white-collar, middle-class workers sought a better standard of living for their families.

The urban environment changed as more people left farms and moved to industrial cities. Town houses replaced country villas, offering middle-class families comfortable homes appropriately scaled to fit on narrow plots of land. Lower-cost machine-made goods appealed to the new white-collar working class people who wanted nice things for their homes.

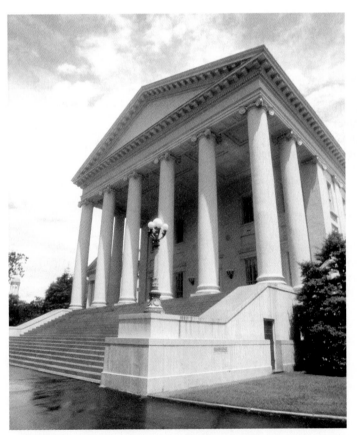

FIGURE 8–1 The state capitol building in Richmond, Virginia, designed by Thomas Jefferson in 1788 led the way for the Greek Revival style in America.
PhotoEdit Inc.

Architectural Settings

As a result of a renewed interest in classicism brought on by the eighteenth-century rediscovery and excavations of Pompeii and Herculaneum, architecture reflected inventive and eclectic interpretations of the past. In France and England, the late Neoclassic period included many examples of Greek Revival–style buildings. Thomas Jefferson's influence in creating a national style of architecture brought the Greek Revival style to the forefront of American design, and the style was chosen for the many government buildings of the newly formed United States of America (Figure 8–1). The Greek Revival style was popular from the last quarter of the eighteenth century until around 1830.

Diversity and eclecticism in architecture developed as the mood shifted toward a nostalgic reinterpretation of traditional styles. Architectural design projects completed throughout the century produced a wide range of revivalist styles synthesizing key elements of the past—Greek, Gothic, Italianate, Elizabethan, and Romanesque influences, although redesigned for the modern era. Architects and designers of the early nineteenth century made many visual references to the past in an attempt to create new buildings that looked "old," or as if they were from far-away places.

Between 1815 and 1823, English architect John Nash expanded the Royal Pavilion in Brighton for King George IV (r. 1820–1830). Nash placed an iron structural framework over

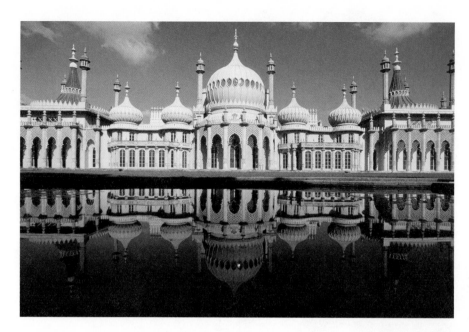

FIGURE 8–2 The Royal Pavilion in Brighton, England, by John Nash, features exotic Oriental designs from India.
Rob Reichenfeld © Dorling Kindersley

the existing classically styled palace to create a pavilion capturing the essence of the Indian Taj Mahal (Figure 8–2). The Pavilion's Hindu-Islamic design reflected the romanticism of nineteenth-century eclecticism. In storybook fashion, the interior furnishings featured Asian-inspired designs including a blending of Indian and Chinese motifs and designs reminiscent of Chinese Chippendale (Figures 8–3, 8–4).

In 1749, Horace Walpole (1717–1797) began construction on his country villa designed to resemble a medieval castle. At that time, architects thought the Gothic style was most suitable for the English landscape. Over the next few decades, work at Strawberry Hill outside London featured a collection of buildings in the Gothic style (Figure 8–5). Furthermore, Chippendale's *Director,* published in 1754, included many Gothic-inspired furnishings and architectural details, documenting England's growing interest in the style. The interiors at Strawberry Hill captured the essence of Gothic design with plentiful tracery; pargework ceilings; and pointed, arched doorways and windows (Figure 8–6).

The rebuilding of the Houses of Parliament in England by Augustus Welby Pugin (1812–1852) and Sir Charles Barry (1795–1860) in 1835 further perpetuated the interest in Gothic styling (Figure 8–7). Rebuilding the Houses of Parliament in the Gothic style seemed appropriate because they were situated next to the medieval cathedral of Westminster Abbey. The monumental structure blends into the context of the site with its tall spires, Gothic arches, and stained glass windows.

The 1851 Great Exhibition held in the Crystal Palace in London marked the turning point for architectural design during the second half of the nineteenth century (Figure 8–8). With

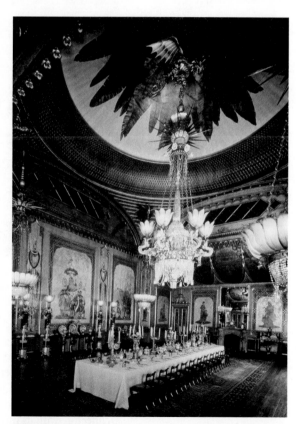

FIGURE 8–3 The banquet room in the Royal Pavilion in Brighton features a silver dragon holding an immense chandelier above a long dinner table with Regency-style chairs. Hand-painted wallpaper reveals Indian-inspired landscape designs.
Royal Pavilion Libraries and Museums, Brighton, England, U.K.

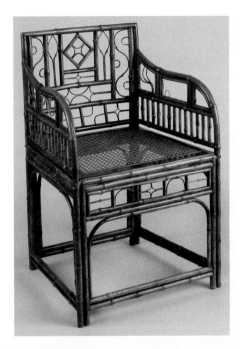

FIGURE 8–4 This Regency-style bamboo chair featuring Chinese fret motifs was made for the Royal Pavilion in Brighton.
© *Judith Miller/Dorling Kindersley/ Woolley and Wallis*

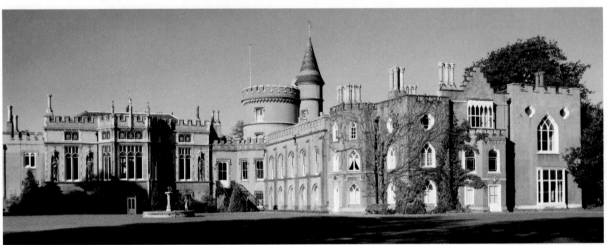

FIGURE 8–5 The buildings comprising Strawberry Hill in Middlesex, London, built from 1749 to 1777 attest to the renewed interest in medieval Gothic styling.
© *Crown copyright. NMR*

nine hundred thousand square feet of exhibition space, the building reflected structural engineering advancements and new building materials. Built exclusively of iron and plate glass, the Crystal Palace became an icon of the Industrial Revolution bringing notoriety to its architect, Sir Joseph Paxton (1803–1865). Paxton was a landscape designer who built greenhouses for Queen Victoria. The Crystal Palace, which combined the strength of iron with the delicacy of glass, set the stage for the development of twentieth-century architecture with its modern glass and steel-framed buildings.

The construction of the Crystal Palace opened up the possibility of using iron to build structures that were taller and more daring in their engineering than structures of the past. The technological advances achieved by using a structural iron framework culminated in the building of the Eiffel Tower for the Paris Exhibition of 1889–1890.

FIGURE 8–6 A room in Strawberry Hill is decorated with wallpaper, pargework, and Gothic-inspired woodwork.
The Bridgeman Art Library, London/New York

FIGURE 8–7 The Houses of Parliament, with their prominent clock tower, rise above the river Thames in London. Begun in 1835 by Pugin and Barry, the complex perpetuated the renewed interest in the High Gothic style.
Dorling Kindersley © Sean Hunter

FIGURE 8–8 The interior of the Crystal Palace features daring architectural and engineering feats for the time with its barrel-vaulted glass ceiling and iron frame mezzanine. *Guildhall Library, Corporation of London, UK/The Bridgeman Art Library*

FIGURE 8–9 One of the entrances of the Paris Metro designed by Hector Guimard from 1899 to 1905 features the whiplash curves of the Art Nouveau style. *Neil Lukas © Dorling Kindersley*

Furthermore, in 1899, Hector Guimard (1867–1942) combined glass and iron in his designs for the entrances to the Paris Metro stations (Figure 8–9). The curvilinear shapes of the support columns and petal-like lobes of the glass canopy captured the essence of the Art Nouveau style. From as early as 1895, the Art Nouveau style abstracted the beauty inherent in nature, capturing characteristic traits of nature by introducing sweeping lines and whiplash curves through organic forms and free-flowing botanicals (Figure 8–10).

The Victorian period, named after the sixty-four-year reign of Queen Victoria (r. 1837–1901), is noted for its literal references to historical styles and an emphasis on superfluous decoration. In England and America, Victorian period houses were designed in the Gothic, Italianate, Second Empire, and Queen Anne styles that followed the current fashions for revivalist designs. In America, Andrew Jackson Downing (1815–1852) published two pattern books, *Victorian Cottage Residences* in 1842 and *The Architecture of Country Houses* in 1850. His books were instrumental in establishing the Gothic Revival style in America. Downing's books featured small cottages designed for the middle class in a style known as Carpenter Gothic. The houses were made from wood, not stone or brick like those in England, and were decorated with intricate millwork designs, charmingly called "gingerbread."

The quaint designs of Downing's cottages inspired the later Queen Anne homes of the Victorian period (Figure 8–11). Queen Anne designs emulated the fancy millwork seen on

Art Nouveau Room Setting

The early work of architect Victor Horta (1861–1947) featured typical revivalist styles until a visit to the Great Exhibition in Paris (for which the Eiffel Tower was built) in 1889 influenced him to change to a "modern" style. Horta's home in Brussels, built in 1898, highlighted the emergence of the Art Nouveau style of design in Europe. His interior architectural scheme included rounded shapes over angular ones, and moldings, stairwells, and railings were fashioned into the sweeping movements of growing vines. In contrast to dark Victorian interiors, woodwork was minimized and paint colors lightened to create a freshness for the "new art." Motifs including whiplash curves, growing vines, and flowering botanicals appeared on floor patterns, wall paintings and wallpaper, light fixtures, and furniture designs.

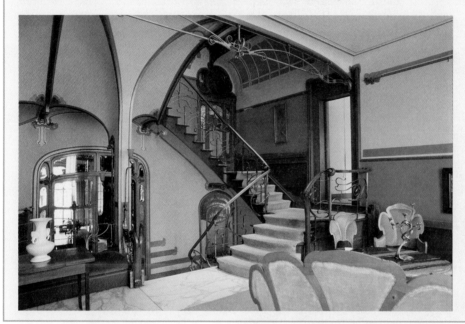

FIGURE 8–10 The home of Victor Horta in Brussels features his Art Nouveau interior design and furnishings.
Demetrio Carrasco © Dorling Kindersley © DACS

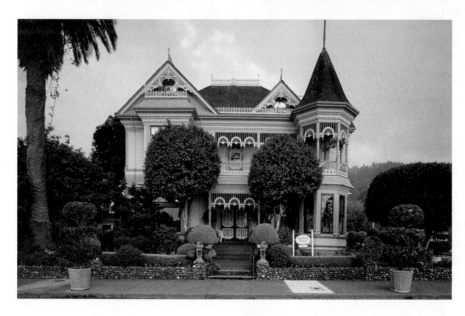

FIGURE 8–11 This Victorian Queen Anne–style house features colorful paint combinations accenting decorative bargeboard detailing.
John Heseltine © Dorling Kindersley

Carpenter Gothic houses, and in fairy-tale-like fashion, these homes sported at least one large turret, a throwback to medieval castles. Paint combinations pushed the visual senses with their bright and contrasting colors accentuating millwork details like icing on a wedding cake.

Influenced by both the Arts and Crafts movement led by William Morris (1834–1896) and the Aesthetic movement, shingle-style homes were introduced to England and America during the last decades of the nineteenth century. These

American Victorian Room Setting

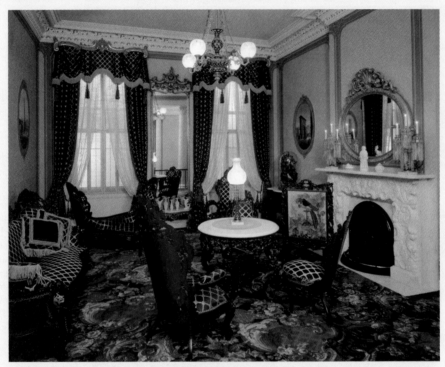

FIGURE 8–12 This parlor from a home in New York features interior decoration in the Rococo Revival style. The room is fitted with heavy drapes designed with scallop valances and tassels, wall-to-wall carpeting, and a gaslit chandelier.

With respect to Inst.65.4, American, New York, Astoria, The Richard and Gloria Manney, John Henry Belter Rococo Revival Parlor. Architectural elements from a villa that stood at 4-17 Twenty-seventh Avenue, Astoria, Queens. Rosewood parlor suite attributed to John Henry Belter (American, 1804–1863), 19th Century, ca. 1852. View #1: window and fireplace walls: "The Metropolitan Museum of Art, Gift of Sirio D. Molteni and Rita M. Pooler, 1965. (INST.65.4) Photograph © 1995 The Metropolitan Museum of Art"

The formal parlor shown in Figure 8–12 dates from around 1850–1860 and is decorated in the Rococo Revival style. The furniture is machine made and incorporates the cabriole legs, cartouche shapes, and delicate curves reminiscent of Louis XV–style furniture. A wide range of decorative accessories including a gaslit chandelier, rocaille-shell gilt mirror, bric-a-brac, and bold patterned wall-to-wall carpeting fill the space in the Victorian fashion of superfluous décor. Pierced plaster crown molding and gilt wall panels surround the room and complement the ornate carving of a marble mantelpiece. Lastly, the oversized windows are corniced with gold-fringed valances and heavy, cascading drapery.

homes were large—often two and three stories tall—and featured eyebrow dormers on multiple-gabled roofs (Figure 8–13). Shingle-style homes made rich use of simple, organic materials in design and construction, featuring wood-shake exterior cladding and wood wainscoting, moldings, and flooring throughout the interiors. Interior furnishings maintained the characteristics of the Aesthetic movement, imitating what Morris and Philip Webb (1831–1915) had designed for Red House in Sussex, England—sparse furnishings, wallpapers and stenciling featuring bird and animal motifs, and Japanese-inspired lacquered furniture (Figure 8–14).

In America, by the end of the century, smaller homes designed with a sense of economy were being built for the working middle class. The American bungalow was a more modest version of the shingle-style home, incorporating natural materials reminiscent of those used by the English Arts and Crafts designers. Bungalow homes were offered to working-class Americans through mail order catalogs such as those from Sears and Roebuck. Gustav Stickley (1858–1942) perpetuated the popularity of bungalow-styled homes through the publication of his magazine, *The Craftsman*, in 1900 (Figure 8–15). Stickely's magazine offered color renderings of interiors showing rich woodwork, art glass windows, ceramic tile, sparse furnishings, and hand-forged metalwork scaled appropriately for these smaller houses (Figure 8–16).

Interior Furnishings

Interiors of Victorian Queen Anne homes featured an abundance of furnishings and ornament. Textiles, wallpapers, carpets, and table coverings featured floral patterns, animals, and landscapes. This overabundance of pattern created a sense of dramatic excitement that was a counterpoint to the often dark interiors. Heavily draped windows concealed the inner sanctum of the home from passersby, offering privacy and

FIGURE 8–13 A shingle-style home from the last decades of the nineteenth century incorporates natural materials such as wood shakes made popular by the Arts and Crafts movement.
Treena M. Crochet

FIGURE 8–14 William Morris designed this dining room in 1867; it captures the characteristics of the Aesthetic movement in its sparse furnishings, Japanese-inspired wallcoverings, and painted wall panels by Pre-Raphaelite artists.

Art Resource, NY

FIGURE 8–15 A Sears and Roebuck advertisement selling an American bungalow kit home, which was shipped via railroad car and assembled on site.

Courtesy Sears Archives

Bungalow Room Setting

The interior design for the modest-sized American bungalow home borrowed heavily from the Arts and Crafts movement popular in England during the second half of the nineteenth century. American-born Gustav Stickley traveled to Europe, where he was introduced to the works of William Morris. On his return to America, he became a proponent for the movement in his design of houses and interior furnishings. Stickley's color renderings of his bungalow interiors revealed built-in furniture such as window seats, cabinets, and bookcases; finely crafted wainscoting; exposed beamed ceilings; and hardwood floors covered with botanical patterned carpets. Colors were harmonious and inspired by nature—soft fern green, yellow ochre, terra-cotta red, and peacock blue. Decorative accessories fashioned from hammered copper and stained glass, as well as matte-glazed pottery, emphasized a return to nature.

FIGURE 8–16 This color sketch by Gustav Stickley features a bungalow interior with harmonious colors, built-in furniture, and Arts and Crafts–style accessories.
© *Judith Miller/Dorling Kindersley/Gallery 532*

solitude from the pressures of living in a rapidly changing and increasingly industrialized world. Rooms were filled to capacity with bric-a-brac scattered about on whatnot shelves and in curio cabinets—bouquets, birds, and small animals fashioned from molded glass and ceramic conveyed the presence of nature while an accumulation of these objects showed off the economic achievements of owners (Figures 8–17, 8–18).

Adding heaviness to the already visually cluttered interiors, rooms were filled with large-scale furniture upholstered in richly colored velvets skirted with fringe. These furnishings expressed the essential character of the Victorian period—heavy, cumbersome, and overstuffed (Figure 8–19). Machine-tufting technology replaced hand-tufting methods, making it more affordable to feature buttoned upholstery on sofas, chairs, and ottomans. Increased mechanization and inventive new processes in furniture making allowed middle-class consumers to purchase inexpensive imitations

of superior-quality goods. As new processes were developed in furniture making, designers were quick to file patents claiming exclusivity of production rights.

Interior furnishings imitated the revivalist styles of architecture with a curious blending of historical motifs and modern interpretations. In fact, the Great Exhibition at the Crystal Palace featured furnishings manufactured in a variety of styles;

FIGURE 8–17 This Victorian walnut whatnot shelf has a pierced gallery, barley sugar twist supports, and movable castors.

© *Judith Miller/Dorling Kindersley/Woolley and Wallis*

FIGURE 8–18 This pair of pottery Dalmatians on cobalt blue bases with gilt designs dates from 1855.

© *Judith Miller/Dorling Kindersley/John Howard - Heritage*

FIGURE 8–19 A pair of late Victorian carpet chairs reveals Turkish-style carpet upholstery and gold fringe.

© *Judith Miller/Dorling Kindersley/Lyon and Turnbull Ltd.*

Elizabethan Revival, Gothic Revival, Renaissance Revival, and Rococo Revival chairs, settees, and tables were among the new designs manufactured with cutting-edge machine technology (Figure 8–20). The Thonet Brothers of Austria, also exhibiting at the Crystal Palace, advanced the capabilities of furniture manufacturing by using steam and pressure to form beechwood into curvilinear forms (Figure 8–21). Moreover, German-born John Henry Belter (1804–1863), working in America, introduced laminated and machine-carved furniture to middle-class clients in the Rococo Revival style (Figure 8–22).

During the second half of the nineteenth century, the tension between industrialization and artisanship heightened as proponents for machine-made goods challenged those artisans who still made things by hand. Concerned with maintaining handmade goods, William Morris supported quality over quantity, rebuking machine-made household furnishings (Figure 8–23). The resulting Arts and Crafts movement was founded on maintaining the spirit of medieval craft guilds that ensured the quality of handcrafted items. Morris and his circle of artisans sold quality designed and produced wallpapers and fabrics, furniture, tiles, and carpets under the firm name Morris & Company (Figure 8–24). Working for Morris & Company, architect Philip Webb and the Pre-Raphaelite Brotherhood of artists—Dante Gabriel Rossetti (1828–1882), Edward Burne-Jones (1833–1898), and Ford Madox Brown (1821–1893)—created coordinating decorative accessories for Victorian homes. The Arts and Crafts movement, supported by social critic John Ruskin (1819–1900) in England, caught on in America under the auspices of the Mission style made popular by the Stickley Brothers and the Roycroft Campus (Figure 8–25).

One last effort to freshen the atmosphere of cultural change from Victorian taste occurred during the last decade of the nineteenth century with the introduction of the Art Nouveau style. The movement attempted to revive ornate beauty while bridging the gap between handicraft and

FIGURE 8–20 One of a set of six Gothic Revival dining chairs from 1880 features crocket finials, a quatrefoil motif back, and pointed arches.
© *Judith Miller/Dorling Kindersley/The Design Gallery*

FIGURE 8–21 A bentwood table and chairs in miniature were designed and made by the Thonet Brothers furniture company.
© *Judith Miller/Dorling Kindersley/Chiswick Auctions*

FIGURE 8–22 This American Renaissance Revival laminated walnut sofa with Rococo-inspired cabriole legs and cartouche-shaped backs features tufted upholstery. Carved details appearing on the laminated back were machine cut using processes patented by John Henry Belter.
© *Judith Miller/Dorling Kindersley/Wallis and Wallis*

FIGURE 8–23 A Morris & Company woven wool upholstery fabric features a peacock and dragon pattern.
© *Judith Miller/Dorling Kindersley/Lyon and Turnbull Ltd.*

FIGURE 8–24 This folding screen produced by Morris & Company features silk panels inside an elaborately pierced frame and dates from 1890.
© *Judith Miller/Dorling Kindersley/Lyon and Turnbull Ltd.*

machine fabrication (Figure 8–26). As William Morris discovered earlier, however, handmade goods were beyond the economic reach of the middle class. The Art Nouveau style suffered the same fate as Morris's Arts and Crafts movement: demise through elitism. By the early twentieth century, designers began to focus on how to design for machine production as handcrafted household items were too expensive for the average consumer.

FIGURE 8–25 This slat back rocking chair by Gustav Stickley in the Mission style was made from quarter-sawn oak and features leather upholstery.

© *Judith Miller/Dorling Kindersley/Wallis and Wallis*

FIGURE 8–26 This Art Nouveau–style desk by Louis Majorelle features nature-inspired marquetry designs.

© *Judith Miller/Dorling Kindersley/Sloan's*

Decorative Accessories

Pottery

Quimper pottery made from tin-glazed earthenware featuring colorful polychrome scenes of French Breton country life became popular in nineteenth-century households (Figure 8–27). The pottery had been produced since 1690, but the advent of train routes from Paris to Brittany brought about a renewed interest. The pottery's rustic charm and pastoral scenes appealed to middle-class collectors, and the popularity of tin-glazed earthenware continued through mid-century.

Further developments in pottery making, including mechanized processes, new mold-making equipment, gas-fired kilns, and steam-powered potter's wheels and lathes, made ownership of fine

FIGURE 8–27 This Quimper fan vase dating from 1875 features polychrome painted designs of farmers.

© *Judith Miller/Dorling Kindersley/Chiswick Auctions*

ceramicware more affordable. The Mason family pottery business in London made strong stoneware for the domestic market and in 1813 patented the name ironstone (Figure 8–28). Decorations varied from revivalist designs and motifs to plain and undecorated white versions simulating the look of bone china. Stoneware pottery, named for its stonelike strength, was made into the most basic kitchen jars, jugs, and saltcellars sturdy enough to handle rough and tough daily use (Figure 8–29).

FIGURE 8–28 This ironstone vase decorated with red and blue foliate designs dates from 1810.
© *Judith Miller/Dorling Kindersley/Woolley and Wallis*

FIGURE 8–29 A mid-nineteenth-century American stoneware crock with stenciled letters and hand-painted foliate designs in blue.
© *Judith Miller/Dorling Kindersley/Pook and Pook*

First brought to Europe from the Middle East during the medieval period, luster-ware became increasingly popular in the nineteenth century. Glazes made with metal oxides gave off an iridescent sheen on ceramics once fired (Figure 8–30). Pink, blue, and copper lusters were among the favorite colors of avid collectors and were produced by several English factories including Wedgwood and Staffordshire. The English potter Herbert Minton (1793–1858) displayed an assortment of pottery wares at the Great Exhibition in 1851 that imitated the look of fine Italian majolica. These brightly painted pottery pieces were molded into the shapes of animals, plants, and flowers and used on vases, tableware, and knickknacks (Figure 8–31).

Factories such as Sèvres, Staffordshire, Minton, and Worcester continued to produce fine porcelain wares throughout the nineteenth century (Figure 8–32). Minton developed a process for building up layers of white slip on a porcelain body, then carving away layers to expose the white ground, which created a cameo effect called pâte-sur-pâte (Figure 8–33). Worcester and Wedgwood in England produced a range of Parian ceramics made from porcelain. Parian ceramics were left in an unglazed finish—white bisque—so the finished piece looked as though it were carved from marble (Figure 8–34). Fine Irish Belleek porcelain was recognized by its luminous white coloring with gilt accents; it was made in America by the Ceramic Art Company in Trenton, New Jersey, owned by Walter Scot Lenox (Figure 8–35). In 1906, the company changed its name to Lenox and began producing white creamware under its new name.

The impact of William Morris's Arts and Crafts movement dominated design trends from its inception in the 1860s through the first quarter of the twentieth century.

FIGURE 8–30 A pair of nineteenth-century pink lusterware rectangular plaques each decorated with warships.
© Judith Miller/Dorling Kindersley/Woolley and Wallis

FIGURE 8–31 This Victorian majolica jardinière and stand features brightly painted sunflowers.
© Judith Miller/Dorling Kindersley/Gorringes

FIGURE 8–32 One of a pair of Sèvres vases exhibited at the 1851 Great Exhibition at the Crystal Palace by the French government features a portrait of Queen Victoria.
© Judith Miller/Dorling Kindersley/Hope and Glory

Much of the applied arts were influenced by the Arts and Crafts notion of producing quality hand-crafted goods. Artists working in this style sought to recapture the quality of handmade goods, before the crafts were degenerated by the industrial age. In effect, these artisans returned to the medieval craft guilds for their inspiration. Rather than fine porcelains, they created earthenware pottery with iridescent glazes featuring designs inspired by the natural surroundings; birds and insects set against fields of flowers appeared in relief or were painted on pottery (Figure 8–36).

In 1880, Maria Longworth Nichol established a ceramic factory in Cincinnati, Ohio, producing matte glaze pottery with botanical motifs in earth tone colors. In 1902, her company, Rookwood Pottery, created an architectural department supplying tile for various building projects throughout America. Predominantly, her tiles were embossed with flora and fauna designs with matte glazes in green, dark brown, orange, yellow, and pink (Figure 8–37). Following the success of Rookwood, the Roseville Pottery Company began producing art pottery in 1890, Newcomb in 1895, and Grueby in 1897. These Arts and Crafts–inspired designs remained popular until World War I (Figure 8–38).

FIGURE 8–33 A nineteenth-century Minton pâte-sur-pâte vase; the pink ground is accentuated with bellflower designs tied with ribbons and a central medallion featuring a classical figure.
© *Judith Miller/Dorling Kindersley/Freeman's*

FIGURE 8–34 This Parian ware bust of Queen Victoria wearing her coronation robes was made to resemble fine porcelain.
© *Judith Miller/Dorling Kindersley/Thos. Wm. Gaze & Son*

FIGURE 8–35 This lotus ware vase with gilt floral decorations was made by an American company in 1892 to imitate Irish Belleek porcelain.
© *Judith Miller/Dorling Kindersley/Jill Fenichell*

FIGURE 8–36 This art pottery vase attributed to John Ruskin is inlaid with engraved silver foliage against an iridescent greenish-brown ground.
© *Judith Miller/Dorling Kindersley/Gorringes*

FIGURE 8–37 A green candlestick made by Sarah Sax for Rookwood Pottery.
© *Judith Miller/Dorling Kindersley/Freeman's*

FIGURE 8–38 This Roseville Grey Gardenia cornucopia vase has soft pink accents.
© *Judith Miller/Dorling Kindersley/333 Auctions LLC*

Art Nouveau pottery designs emulated the free-flowing floral patterns and whiplash curves found in architecture and interiors (Figure 8–39). Many examples of Art Nouveau pottery prominently featured young women with long hair blowing in the breeze and wearing flowing gowns (Figure 8–40). These young maidens were essentially ancient classical goddesses re-created for a new era.

Glass

The advent of industrialization in the glass-making business brought the price down to manageable levels. Middle-class consumers could not get enough of the wide range of tableware, vases, and figurines that flooded the market during the Victorian period. Colored glass became increasingly popular after the blue cobalt designs introduced by Bristol, and experimentation with adding metallic oxides to glass yielded a variety of colors for modern glassmakers. Adding gold chloride created rich ruby colors for what was called

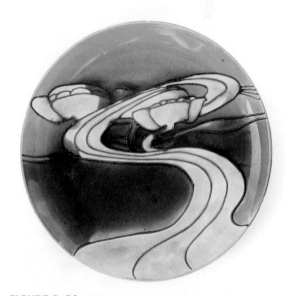

FIGURE 8–39 This charger plate made by Minton features Art Nouveau whiplash designs and stylized water lilies.
© *Judith Miller/Dorling Kindersley/Woolley and Wallis*

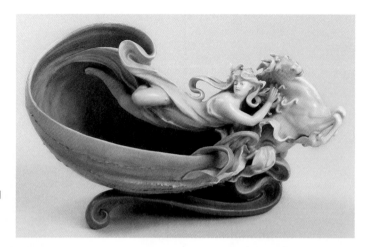

FIGURE 8–40 This Art Nouveau porcelain compote features a female figure in repose with flowing gown and hair.

© Judith Miller/Dorling Kindersley/Lyon and Turnbull Ltd.

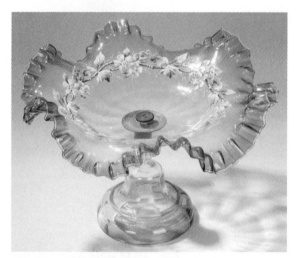

FIGURE 8–41 This Victorian ruffled-edge cranberry glass compote has enameled floral designs and a footed base.

© Judith Miller/Dorling Kindersley/Chiswick Auctions

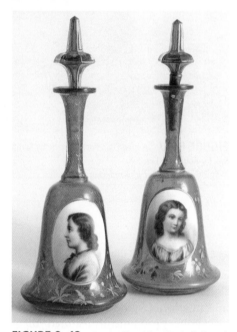

FIGURE 8–42 A pair of late Victorian bell-shaped red glass decanters with hand-painted oval cameos and gilt borders.

© Judith Miller/Dorling Kindersley/Andrew Smith & Son Auctions

cranberry glass (Figure 8–41). Vaseline glass, named for its transparent, yellow-green coloring, was made by adding uranium dioxide to molten glass (Figure 8–42). Adding manganese resulted in deep amethyst colors.

The quality of glassware depended on how the pieces were made. Inexpensive glass items were made from molds, which allowed the soft glass to take on any shape, form, or pattern. Cylindrical pieces such as goblets, vases, and pitchers were molded in two pieces and then fused together leaving a visible seam. Designs once etched by hand or engraved on the wheel were more economically produced by using acid to scratch

FIGURE 8–43 This nineteenth-century vaseline glass epergne for holding flowers has three spiraling clear glass trumpet-shaped canes with crimped edges and base.
© *Judith Miller/Dorling Kindersley/Woolley and Wallis*

FIGURE 8–44 A Victorian molded glass celery vase from 1870 with an etched swan design and visible seams on the footed base.
© *Judith Miller/Dorling Kindersley/Otford Antiques and Collectors Centre*

away at the surface of the glass (Figure 8–44). By 1907, molded glass was so inexpensive that American glassmaker Frank Leslie Fenton's iridescent glass became known as carnival glass because it was given away as free prizes at carnivals (Figure 8–45).

Followers of the Arts and Crafts movement detested the inexpensive knickknacks, candy dishes, vases, and goblets made from molded glass. For these artists working in the nineteenth century, making hand-crafted glass was another fine art form like painting or sculpture (Figure 8–46). Considered works of art, highly decorative glass vases featured scenes from nature and captured the design motifs popular with both the Arts and Crafts and Art Nouveau movements including botanicals, small animals, and the abstracted blossom of a single rose (Figure 8–47). The intricacies of these styles and the fine quality of artistry precluded mass production and so the decorative accessories proved too expensive for middle-class society (Figure 8–48).

FIGURE 8–45 A Fenton blue carnival glass bowl from 1907 produced in numerous other colors, this popular design features a dragon and lotus pattern.
© *Judith Miller/Dorling Kindersley/Branksome Antiques*

Nineteenth-century improvements in glass-making celebrated by the construction of the Crystal Palace in 1851 brought about a renewed interest in window glass whether it was stained, cut, painted, or etched. England repealed a tax on window

FIGURE 8–46 This Loetz iridescent vase from Austria features a feather design; it dates from around 1898 to 1904.
© *Judith Miller/Dorling Kindersley/Andrew Lineham Fine Glass*

FIGURE 8–48 This amber vase by the French Art Nouveau designer Emile Galle is decorated with tree branches, flowers, and stems made with colored glass threads.
© *Judith Miller/Dorling Kindersley/David Rago Auctions*

FIGURE 8–47 This Baccarat crystal vase from 1900 has etched flowers and branch designs highlighted with gilding on the ruby cameo designs.
© *Judith Miller/Dorling Kindersley/Lyon and Turnbull Ltd.*

glass in the second half of the century, and stained glass windows became featured items in newly built Victorian houses. In 1879, American artist and glassmaker John LaFarge (1835–1910) patented a process for making opalescent glass, by fusing small pieces of colored glass to create a milky effect. His window designs followed the prevalent themes of the period, featuring scenes from literature and the Bible surrounded by an abundance of nature (Figure 8–49). LaFarge's work appeared in churches, libraries, and private homes in and around New England and rivaled the work coming out of Tiffany Studios.

Louis Comfort Tiffany (1848–1933), the son of jewelry designer Charles Lewis Tiffany (1812–1902), patented his method of making opalescent glass in 1885. Tiffany's glass, called Favrile, was influenced by the designs of the Art Nouveau movement and featured highly stylized flowers, dragonflies, and other motifs inspired by nature. His company,

FIGURE 8–49 Peacocks and Peonies, a stained glass window by John LaFarge, dates from 1882.
John La Farge, "Peacocks and Peonies I," 1882. Stained glass, 105 3/4 x 45 Inches. (268.6 x 114.3 cm). Gift of Henry A. La Farge. National Museum of American Art, Washington, DC, USA./Art Resource, NY

FIGURE 8–50 Tiffany Studios produced this stained glass window design featuring a landscape with flowering magnolia trees in 1905.
"Memorial Window: Landscape scene with iris and flowering magnolia." Maker: Tiffany Studios, New York City. Glass-Stained, American, New York, 20th Century, c. 1905. H. 60-1/4 in. W. 42 in. (153 x 106.6 cm). The Metropolitan Museum of Art, Anonymous Gift

Tiffany Studios, sold lamps, vases, and stained glass window designs along with rugs and textiles (Figure 8–50).

Mirrors

Cylinder glass, inflated with compressed air, could be made in larger sizes because machines could blow more air than humans could. In addition, steam engines powered polishing and grinding machines, relieving workers of the laborious task of hand polishing. These technological advances made the production of mirrors more economical, so they were available to all classes of society. Mirrors were soon appearing on whatnot shelves and inside china cabinets to reflect the glistening surfaces of cut-glass and ceramic knickknacks (Figure 8–51). Hall tables and coat racks featured low mirrors just above the floor so women could make sure no petticoat ruffles were showing before they left the house. Freestanding floor mirrors called *chevals* became a standard feature of bedrooms, allowing women to see their entire figures and make sure petticoats were covered (Figure 8–52). Frames were designed in revivalist styles to coordinate with furniture and room décor (Figures 8–53, 8–54). And, in

FIGURE 8–51 A pair of Victorian painted and gilt-bow-fronted *encoignures*, or corner cabinets, with scrolling mirror backs and marble tops fashioned in the Rococo Revival style.

© *Judith Miller/Dorling Kindersley/Lyon and Turnbull Ltd.*

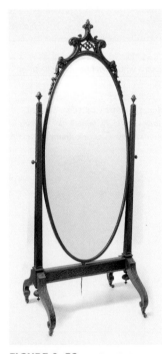

FIGURE 8–52 A cheval mirror with a beveled edge in a decorative mahogany frame carved with Chinese fret designs, acanthus leaves, and pierced and fretted cresting.

© *Judith Miller/Dorling Kindersley/ Clevedon Salerooms*

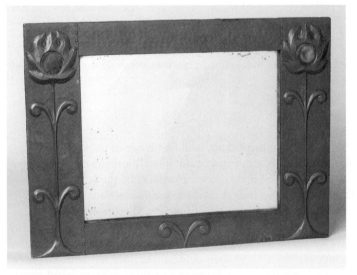

FIGURE 8–53 This copper-framed wall mirror available through the department store Liberty & Company features two flowering plants with blue-glazed circular plaques.

© *Judith Miller/Dorling Kindersley/Puritan Values*

spite of the advent of gas and electric lighting in Victorian interiors, the overmantel mirror remained a focal point in the formal sitting room.

Lighting

Considerable improvements in interior lighting came about in the nineteenth century. The invention of a candle-making machine in 1834 resulted in candles being produced much faster than by hand. Candles were now considerably cheaper. Candleholders were fashioned into the popular styles of the period, designed to coordinate with the interior furnishings (Figures 8–55, 8–56). By midcentury, cleaner-burning and odorless paraffin wax was replacing tallow and crystallized whale oil in the making of candles.

Furthermore, lighting interiors with candles became less desirable after improved oil-burning and kerosene lamps, along with the Argand lamp, proved more efficient (Figures 8–58, 8–59). After that time candles were used to create atmosphere rather than provide the primary source of light.

Lighting changed dramatically when, in 1792, William Murdock (1754–1839) devised a way to light his home using gas as a fuel. Slow to reach the domestic market, gaslights began appearing on the streets of London by 1807, in

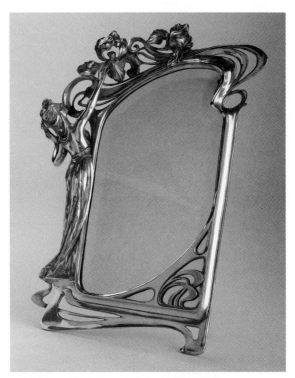

FIGURE 8–54 This Art Nouveau mirror features an asymmetrically arranged frame of whiplash curves.
© *Judith Miller/Dorling Kindersley/Lyon and Turnbull Ltd.*

FIGURE 8–55 A pair of Victorian pink overlay glass lusters painted with flowers and leaves in lavender and gilt. Prism-cut drops hang just above a footed stem.
© *Judith Miller/Dorling Kindersley/Bonhams*

FIGURE 8–56 A pair of Arts and Crafts–style copper candlesticks designed by Christopher Dresser in 1900.
© *Judith Miller/Dorling Kindersley/The Design Gallery*

FIGURE 8–57 A bronze Art Nouveau–style candlestick from 1905 features a slender maiden holding iris-shaped candleholders.
© *Judith Miller/Dorling Kindersley/The Design Gallery*

FIGURE 8–58 This Victorian oil lamp with cylindrical hurricane glass and green shade features a clear glass oil reservoir supported by a reeded columnar base.
© *Judith Miller/Dorling Kindersley/ Otford Antiques and Collectors Centre*

FIGURE 8–59 This pair of gilt and cast bronze and cut-glass Argand lamps with bobeche prisms dates from 1825.
© *Judith Miller/Dorling Kindersley/Sloan's*

Baltimore by 1816, and in Paris by 1820. Gas lighting was not available to households and businesses until 1858 and did not become widespread until 1865 (Figure 8–60).

Following on the heels of gas lighting, the incandescent lightbulb, perfected in 1879 by Thomas Edison (1847–1931), opened up the possibility of lighting interiors with electricity. The design of electrical lighting fixtures varied from a simple exposed bulb hanging by a wire to ceiling-mounted pendants leaving the bulbs exposed to show off their novelty. Later, shades were added to cover the bulb and reduce glare, which created softer, more diffused lighting. Because electricity was expensive at first, not everyone rushed to have their homes wired. New homes built in the late 1800s were some of the first to feature electric lighting.

Designers working in the late nineteenth century were quick to design table and floor lamps, chandeliers, and wall sconces in styles coordinating with interior furnishings. Arts and Crafts–styled lamps featured bases made from hammered copper, shaped wood, or matte glaze pottery with shades made from mica (Figure 8–61). Tiffany Studios began producing electric lamps with stained glass shades in a variety of designs and patterns in the Art Nouveau style. The women in the glass-cutting department at Tiffany's under the leadership of Clara Driscoll (1861–1944) were in charge of fashioning the small pieces of colored glass to make lamp shades, mosaics, and stained glass windows. New research shows that Driscoll was the designer of several important creations formerly thought to be the work of Louis Comfort Tiffany. Her credited lamp shade designs included Poppy, Wisteria, and the Dragonfly—which won Tiffany a prize at the Paris International Exposition in 1900 (Figure 8–62).

Metalworking

The name Towle is often incorrectly used to describe silver work in general (Figure 8–63). The misconception was the result of the Moulton family's silversmith shop set up in Newburyport, Massachusetts. The Moulton family of silversmiths had produced fine silver from prerevolutionary times until 1857, when one of the sons sold the company to Towle Silversmiths. After the sale, *Towle* erroneously became the catch-all term to describe silver work, regardless of maker.

One of the leading silversmiths of the nineteenth century was Charles Lewis Tiffany. In 1837, Charles Lewis Tiffany and John B. Young opened their doors in New York City selling fine stationery and accessories. In a few short

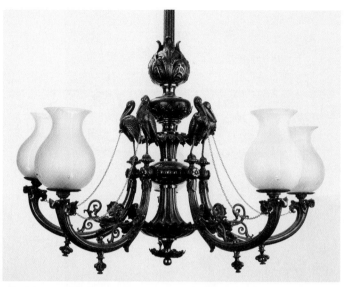

FIGURE 8–60 This gas chandelier features brass pelicans with curved leaf motifs and white glass shades.
Steve Gorton © Dorling Kindersley

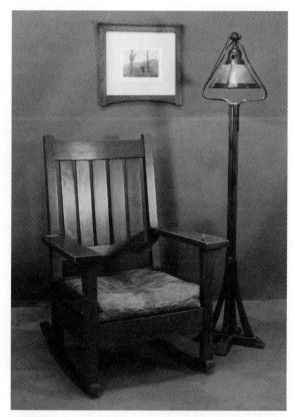

FIGURE 8–61 An Arts and Crafts rocker by Gustav Stickley sits under the light of a Mission-style floor lamp with oak base and mica shade.
The Mission Oak Shop, Putnam, CT

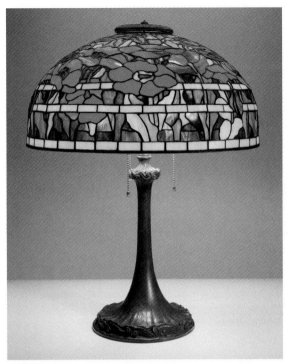

FIGURE 8–62 The Poppy Lamp by Tiffany Studios in an Art Nouveau design features the stained glass and design work of Clara Driscoll.
© Peter Harholdt/CORBIS

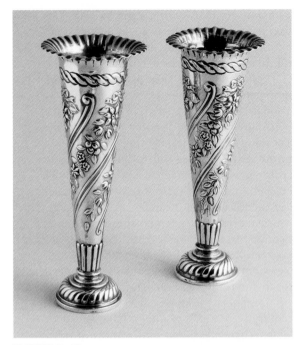

FIGURE 8–63 Victorian repoussé vases feature delicate flowers and leaf designs.
© Judith Miller/Dorling Kindersley/Law Fine Art Ltd.

FIGURE 8–64 An antique American silver candy dish with repoussé flowers and scroll designs made by Tiffany & Company, New York, around 1875–1891.
© Judith Miller/Dorling Kindersley/Sloan's

years, Tiffany & Company had earned a reputation for offering high-quality sterling silver tableware, dresser jars, and jewelry to upscale clients (Figure 8–64). Tiffany took full control of the company in 1853 and expanded into the retailing of clocks, picture frames, and by the end of the century, fine china and crystal. The Tiffany name became synonymous with refinement and good taste. Tiffany's retailing of sterling silver through his Blue Book catalog enabled him to compete in European markets. The company still operates today, and its silverwares are packaged in their infamous light blue box.

Christopher Dresser (1834–1904) earned a place in history as a botanist, a designer, and a sort of Renaissance man living in Victorian England. The author of three books on botany, Dresser left his post as a college lecturer to work as a designer of household objects. The Design Museum in London named Dresser the "first independent industrial designer," recognizing the importance of his designs in textiles, glassware, wallpaper, metalwork, furniture, and ceramics. In 1862, Dresser published *The Art of Decorative Design*, in which he made connections between

FIGURE 8–65 This Victorian cloisonné vase made by Minton in the style of Christopher Dresser features butterflies and stylized foliage against a blue ground.
© *Judith Miller/Dorling Kindersley/Gorringes*

FIGURE 8–66 Designed by Archibald Knox for Liberty & Company, this enameled silver photo frame features storybook styling of an Arts and Crafts door.
© *Judith Miller/Dorling Kindersley/Geoffrey Diner Gallery*

nature and design. His interest in botany and his nature-inspired designs aligned him with the emerging Arts and Crafts movement in England.

Unlike William Morris and his followers, Dresser became a proponent for mass production by creating designs in consideration of how they would be manufactured. Before managing his own retail business in 1880, Dresser consulted and designed for established companies such as Wedgwood, Minton, and Hukin and Heath, which produced silver plate and new electroplate tableware (Figure 8–65). After a visit to Japan in 1877, Dresser's designs became less aligned with Victorian taste; instead he began opting for a streamlined approach to ordinary household accessories. The Art Furnishers Alliance, a group of designers Dresser worked with, was short lived and sold off in 1883 to Liberty & Company of London. Liberty & Company opened its doors in 1875 offering imported goods from Japan to curious clients wishing to purchase exotic carpets, fabrics, and household accessories. Archibald Knox (1864–1933), who worked with Dresser, became a leading designer for Liberty & Company in 1897 (Figure 8–66).

In 1895, Elbert Hubbard (1856–1915) started a small publishing company in East Aurora, New York, as a way of printing works under his authorship. He called it Roycroft after seventeenth-century book publishers Samuel and Thomas Roycroft. Hubbard saw an opportunity to expand his business when construction started on a local inn and he organized workers to create the interior furnishings for the project (Figure 8–67). Dard Hunter (1883–1966) arrived at Roycroft in 1904 and became the primary designer of stained glass windows for the Roycroft Inn. Sculptor and metalworker Jerome Conner (1874–1943) began designing and making copper items in

FIGURE 8–67 A hammered copper vase and brass letter holder bears the hallmark of Roycroft.
© *Judith Miller/Dorling Kindersley/Freeman's*

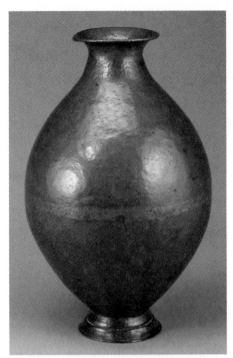

FIGURE 8–68 This copper vase made by the Stickley Brothers features hammered copper pitting, a typical metalworking technique of Arts and Crafts–style artisans.
© *Judith Miller/Dorling Kindersley/Freeman's*

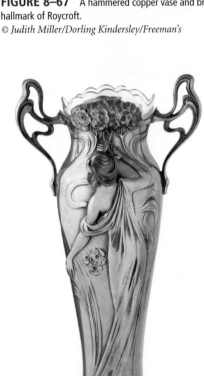

FIGURE 8–69 This pewter vase features the ornate whiplash curves of the Art Nouveau style for handles and the fluid form of young maidens.
© *Judith Miller/Dorling Kindersley/Style Gallery*

1906. He remained at Roycroft for four years, later returning to his native Ireland to work. The Roycroft Campus quickly became a consortium of artisans working in the Arts and Crafts style made popular by the work of Gustav Stickley, and they supported their craft by selling household copperware to the public (Figure 8–68).

From as early as 1890, characteristic traits of the Art Nouveau movement developed throughout Europe with each country interpreting the "new art" in its own regional manner. These regional components (*Jugendstil* in Germany, *Modernismo* in Spain, *Secession* in Austria, and *Stile Floreale* in Italy) shared a connecting thread of design inspired by nature (Figure 8–69). Samuel Bing (also known as Siegfried, 1838–1905) opened his innovative Salon de l'art Nouveau in Paris in 1895. Motivated by his trip to America, where he saw the work of Tiffany Studios, Bing established a gallery featuring the work of designers from Europe and America. His gallery of unified and cohesive interior furnishings and decorative accessories set the stage for the Paris Exhibition of 1900, which brought worldwide recognition to the Art Nouveau style (Figure 8–70). Art Nouveau–styled architecture, furniture, and decorative accessories prevalent in the last decade of the nineteenth century appeared old-fashioned and outdated at the turn of the twentieth century. As a new century unfolded, designers sought to shed the historicism of the past and create new works that evoked the modern age.

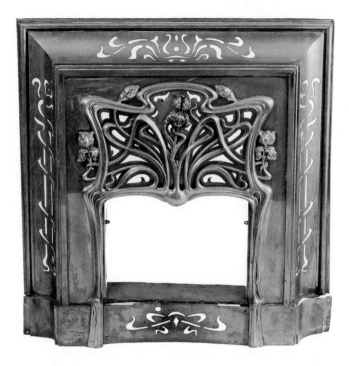

FIGURE 8–70 A French Art Nouveau brass fireplace surrounded with pierced floral designs and whiplash vine patterns.
© *Judith Miller/Dorling Kindersley/Mary Ann's Collectibles*

Clocks

Even before the clock tower was erected outside the Houses of Parliament in London in 1859, civic buildings and churches proudly featured large clocks chiming on the hour and sometimes the half hour. With the increasingly present railroad transporting people from city to city and running tight schedules, the measurement of time became much more important during the nineteenth century than in times past. The Industrial Revolution gave rise to the mass production of clocks so that nearly every household could afford one. In America, Seth Thomas (1785–1859) began mass-producing clock movements in wood by making up to five hundred at a time (Figure 8–71). Another American, Eli Terry (1772–1852), relied on mechanical means to mass-produce die-cut and stamped clock dials, hands, and gears so that the parts were interchangeable with a variety of clockworks.

The clock shifted from being a status symbol of the wealthy to a commonplace item found in most middle-class households. Victorian superstition instigated the practice of stopping the movements of a hall or mantel clock when someone died in the home; it was supposed to ward off bad luck for the surviving family members. Furthermore, in 1875, Henry Clay Work (1832–1884) wrote a popular song, "Grandfather's Clock."

My grandfather's clock
Was too large for the shelf,
So it stood ninety years on the floor;
It was taller by half
Than the old man himself,
Though it weighed not a pennyweight more.

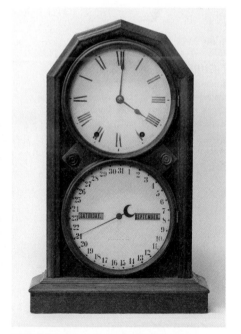

FIGURE 8–71 A late-nineteenth-century American clock with a perpetual calendar, by Seth Thomas, patented in 1876, features white enamel dials in a mahogany case with a plinth base.
© *Judith Miller/Dorling Kindersley/Jacobs and Hunt Fine Art Auctioneers*

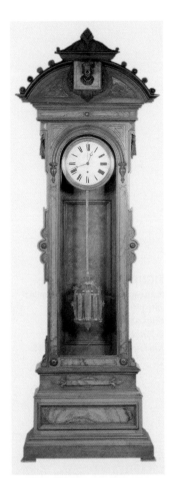

It was bought on the morn
Of the day that he was born,
And was always his treasure and pride;
But it stopped short
Never to go again,
When the old man died.

From that time on, Americans adoringly called the longcase clock a grandfather clock (Figure 8–72).

The advent of standardization in clock making coupled with the establishment of uniform time zones throughout the world in 1884 revolutionized timekeeping. Furthermore, with clock movements now being mass-produced, clock sales were ensured by designing the cases to coordinate with the room décor of the period (Figures 8–73, 8–74).

Textiles

The invention of the steam engine and Jacquard loom spurred competition among factories seeking to offer quality fabrics for clothing and furnishings at reasonable prices. The Great Exhibition at the Crystal Palace was the launching pad for competition among countries to corner the market on the textile industry. Exhibits featured not only the beautiful textiles manufactured by various factories but also some of the mechanisms for producing them, inspiring creative inventors to come up with new and more advanced methods of production. Synthetic aniline dyes, first developed in 1856 by W. H. Perkin from England, were incorporated into textile manufacturing by 1862.

FIGURE 8–72 This Victorian Renaissance Revival tall case clock made from walnut with burr walnut panels emphasizes the inner pendulum workings contained behind a glass door.
© Judith Miller/Dorling Kindersley/Freeman's

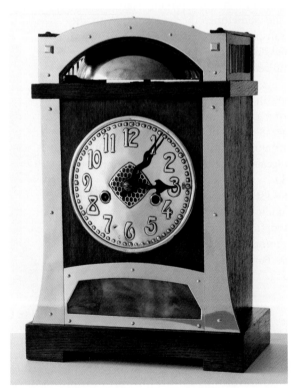

FIGURE 8–73 This Arts and Crafts–style mantel clock features oak and brass details with exaggerated riveted designs.
© Judith Miller/Dorling Kindersley/The Design Gallery

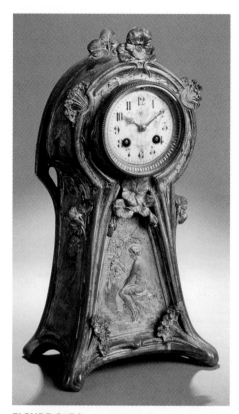

FIGURE 8–74 This French Art Nouveau mantel clock with cast and gilt metal frame featuring maidens and poppies has a porcelain dial.
© *Judith Miller/Dorling Kindersley/Lyon and Turnbull Ltd.*

FIGURE 8–75 This framed wall hanging made from printed cotton panels depicts George Washington and the shield of the United States.
© *Judith Miller/Dorling Kindersley/Sloan's*

Furthermore, roller-printing machines could print up to eight colors at a time by 1860 and twenty colors at a time before the end of the century (Figure 8–75).

Apart from technological advancements, textile fashions for home furnishings followed the popularity of eclecticism of the nineteenth century. England remained fixated on styles reminiscent of the past; Gothic Revival and Renaissance Revival were still in fashion at the time of the Great Exhibition. However, France maintained a strong connection to the Neoclassic styles of the previous century. Although in England and America, pictorial tapestries were no longer fashionable, France maintained its production of Aubusson and Savonnerie carpets (Figure 8–76). The French Revolution had interrupted advancements in textile production in France, but the industry soon recovered during the Second Empire under the reign of Napoleon III (r. 1848–1870).

William Morris prided himself as a weaver, mixing his own dyes from organic pigments to create woolen cloth for curtain panels, bedding coverlets, and tapestries (Figure 8–77). Using hand-carved wooden blocks, he printed cotton fabrics and wallpapers one color at a time (Figure 8–78). His favorite motifs incorporated organic forms based on flowers, birds, and vine patterns, which he printed in vivid colors on his woven textiles, wallpaper, and fabric.

FIGURE 8–76 This Aubusson carpet from the late nineteenth century features acanthus leaves and scrolls in a Rococo Revival style.
© *Judith Miller/Dorling Kindersley/Sloan's*

FIGURE 8–77 Morris & Company's Honeysuckle patterned textile panel in printed and embroidered wool features honeysuckle, bellflower, poppies, and sinuous vine patterns and dates from 1876.
© *Judith Miller/Dorling Kindersley/Lyon and Turnbull Ltd.*

FIGURE 8–78 The Compton pattern by William Morris is a printed cotton with red, cream, and green flower and vine designs and was copyrighted and registered in 1896.
© *Judith Miller/Dorling Kindersley/Lyon and Turnbull Ltd.*

Not all of Morris's British contemporaries supported his anti-industrial philosophies. Charles F. A. Voysey (1857–1941) believed the machine was an integral part of modern society and therefore should be used to its fullest potential. In fact, Voysey saw industrialization as the driver of future development. His furniture, textile, and wallpaper designs had the organic focus of the emerging Art Nouveau style; flowers and foliage intertwined in curvilinear forms (Figure 8–79).

Wallpaper

Mechanical methods of producing wallpapers led to two new types of wallcoverings during the last quarter of the nineteenth century—lincrusta and anaglypta. Lincrusta was invented in 1877 by Frederick Walton (1833–1928), who took the idea from his already successful product, linoleum. He used mechanized roller machines to engrave relief designs on linseed and resin pulp paper to emulate fancy plasterwork (Figure 8–80). In 1887, one of Walton's former employees, Thomas Palmer, had the idea to lower costs by using the same mechanized process on rolls of built-up paper pulp and cotton. The resulting anaglypta was lighter and more flexible than the heavier lincrusta, and both wallcoverings could be painted. Mass production contributed to the overabundance of wallpapers in homes built in the mid-nineteenth century onward (Figure 8–81).

Hand-blocked wallpaper was made by artists working in the Arts and Crafts and Art Nouveau styles. Morris & Company sold hand-blocked wallpapers designed by William Morris and his team of designers to upper-class English households (Figure 8–82). Handmade wallpapers were also made by Art Nouveau designers for an affluent clientele seeking one-of-a-kind designs.

FIGURE 8–79 This Wilton woolen carpet designed by Charles F. A. Voysey retailed through Liberty & Company features scrolling foliate motifs against a deep blue ground.
© Judith Miller/Dorling Kindersley/Lyon and Turnbull Ltd.

FIGURE 8–80 The entrance to the Gibson House in Boston features Victorian lincrusta wallpaper in the Italianate style. Embossed designs of vines, fruits, and flowers are enhanced with gold paint over a slate blue ground.
Linda Whitwam © Dorling Kindersley.
Courtesy of the Gibson House, Boston

FIGURE 8–81 This roller-printed Victorian wallpaper features a pineapple design.
Michael Crockett © Dorling Kindersley

FIGURE 8–82 An original watercolor design for William Morris's Blackthorn patterned wallpaper produced by Morris & Company in 1892.
© Judith Miller/Dorling Kindersley/Lyon and Turnbull Ltd.

The three clocks in Figures 8–83 through 8–85 represent a variety of styles that were popular at the time they were made, although they are most telling about the social standing of women during their respective periods. The women depicted in these clocks embody the image of the classical goddess through hairstyles, nudity, or diaphanous clothing, and the presence of Greek and Roman design motifs such as festoons, the urn, and the lyre make reference to ancient traditions.

Figure 8–83 shows a Parian clock from the late nineteenth century and features three nude maidens with hair piled in knots on the tops of their heads standing around a column supported by an urn that doubles as the clock's dial (Figure 8–83). The maidens appear to be draping a floral garland around both the column and urn in poses reminiscent of statues of classical Greek goddesses.

The second clock, in the Art Nouveau style, features a maiden leaning over the face of the clock, which is shaped like a monument and covered with vines, leaves, and dragonflies (Figure 8–84). The maiden's long, flowing hair cinched with a clip cascades down her back, exposing a bare shoulder. Her dress clings to her body, hinting at nudity in the same manner as artists in classical Greece used wet drapery styles to reveal the female form in a more demure manner.

FIGURE 8–83 This late-nineteenth-century Parian figural clock features classical nude maidens.
© *Judith Miller/Dorling Kindersley/Sloan's*

The third clock, in the Art Deco style, features a maiden playing a lyre as she stands on a marble base that holds the dial (Figure 8–85). Her costume reflects the new styles in women's fashions in the 1920s: short skirt, rolled stockings, and short hair.

Although the depictions of women varies in each clock, they are linked by the representation of women throughout the history of the decorative arts as modern goddesses. These three clocks reflect the social structures and attitudes toward the women of their time: nudity exposes the feminine vulnerability of late-nineteenth century women; the youthful maiden in seductive pose and clothing represents man's temptation; and the inspiring muse offers strength and support.

(continued)

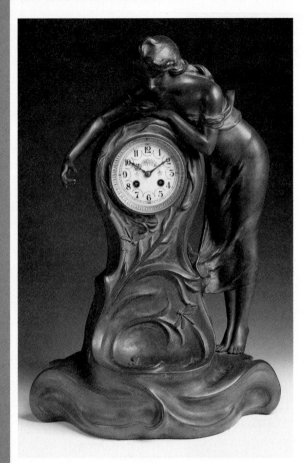

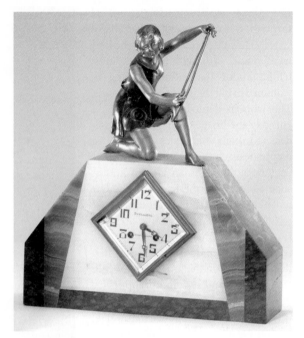

FIGURE 8–85 A maiden plays a lyre on top of this mantel clock in the Art Deco style.
© Judith Miller/Dorling Kindersley/Freeman's

FIGURE 8–84 This Art Nouveau metal mantel clock with circular enameled dial features a willowy maiden among swirling vines.
© Judith Miller/Dorling Kindersley/Lyon and Turnbull Ltd.

Modern and Postmodern: Twentieth and Twenty-First Centuries

TIMELINE

Twentieth Century

1900	World's Fair held in Paris.
1903	Orville and Wilbur Wright conduct the first controlled airplane flight.
1904	Giacomo Puccini composes *Madame Butterfly*.
1905	Matisse and other Fauve painters exhibit in Paris.
1905	Albert Einstein presents his *Theory of Relativity*.
1907	Picasso paints *Les Demoiselles d'Avignon*, introducing Cubism.
1908	First skyscraper built in Manhattan; it rises 47 stories.
1909	First newsreels shown in movie theaters in Paris.
1911	Marie Curie wins Noble Prize for chemistry.
1914	World War I begins, ending in 1918.
1919	Robert Weine debuts his film *Cabinet of Dr. Caligari*.
1925	F. Scott Fitzgerald publishes *The Great Gatsby*.
1929	The Great Depression begins.
1931	Empire State Building completed as world's tallest building.
1939	World War II begins, ending in 1945.
1940	Hemmingway writes *For Whom the Bell Tolls*.
1951	John Cage composes *Music of Changes*.
1951	Color television introduced.
1957	Russians launch the first satellite, *Sputnik,* into space.
1962	Andy Warhol paints *Campbell's Soup Cans*.
1964	IBM introduces System 366 computer.
1969	Man lands on the moon.
1971	Greenpeace movement is established.
1980	Michael Graves's postmodern Portland building constructed.
1981	IBM introduces the world's first personal computer.
1989	Tim Berners-Lee creates the World Wide Web.
1991	Launch of the World Wide Web.
1997	Pathfinder unmanned spacecraft lands on Mars, sends photographs back to Earth.

When Queen Victoria died in 1901 and her son, Edward VII, succeeded her, a new century began, and the Victorian period ended. The new technologies that emerged near the turn of the twentieth century were the underlying force behind the modern cultural movement. Modern culture embraced the development of electricity, telephone and telegraph communication, and rapid transportation made possible by railroads, automobiles, and eventually airplanes. This new century of technological progress marked the beginning of worldwide pragmatic political issues that resulted in two world wars before midcentury.

The First World War, as it was known in Britain, or World War I, began in 1914 as increasing tensions caused by European imperialism culminated in war. Ultimately, thirty-two countries would become involved in the war with the Central powers of Germany, Austria-Hungary, Bulgaria, and the Ottoman Empire fighting against the Allied powers of the British Empire, Russia, and France. Italy joined the Allied powers in 1915, and the United States joined in 1917. In 1917, Russia withdrew from the war under the pressure of increasing civil war at home and the rising Bolshevik-led revolt.

The war, which claimed an estimated ten million lives, caused the demise of imperialism in Germany and Austria-Hungary and the collapse of the Ottoman government. The signing of the Treaty of Versailles in 1919 brought an official end to the war and redistributed political boundaries across Europe. World War I was the first war to embrace modern technological advances such as airplanes and wireless telegraphy. As a result of Thomas Edison's contributions to the motion picture camera, millions sitting in movie theaters throughout developed nations watched newsreel images of the progress and subsequent end of the war.

World War II began with Germany's invasion of Poland in 1939; by 1941, twenty-six Allied countries were fighting against German-led Axis powers. With all the major powers of the world involved in the conflict, the devastating war lasted through 1945. Postwar conferences among the United States, Great Britain, and the Soviet Union held at Yalta and in Potsdam in 1945 accelerated a Cold War between the United States and Russia over divergent political ideologies in post–World War II Europe.

During World War I, manufacturing shifted toward producing only those items relevant to fighting the war—tanks, artillery, ships, submarines, and airplanes. The halt in the manufacturing of domestic goods and, more important, the exportation of the nations' gross national product—whether industrially based or agriculturally based—resulted in high inflation worldwide after World War I ended. Further destabilizing the economic situation were inconsistencies in the gold standard currency markets. Finally, when the United States stock market crashed in 1929, the effects were felt all over North America and Europe, upsetting international trade and increasing unemployment. For the next decade, the Great Depression affected the world economy. President Franklin Roosevelt's New Deal in America and an increase in the manufacturing of military goods during World War II brought economic stability.

In addition to the two world wars, many social reforms took place during the first half of the twentieth century, including labor reform and women's suffrage. The industrialists of the late nineteenth century, who had exploited factory workers, were now faced with labor laws and unions established to curtail the abuse of human rights. Women's rights movements occurred throughout the world as women who had kept the economy going during World War I by performing jobs previously held by men demanded equality. Countries such as India, Great Britain, Canada, Norway, and Denmark gave women the right to vote before the war ended in 1919. Moreover, the Treaty of Versailles of 1919 included a clause ensuring that women would be given equal pay to men when performing the same jobs (although this condition of the treaty was ignored by most countries). Women everywhere

were exerting their independence in male-dominated societies. Fashions changed drastically from the Edwardian styles popular before the first war as women cut their hair (long hair was hazardous in operating machinery), shortened their hemlines, and publicly wore trousers.

Early Modernism

Architects working toward progressive changes in design discovered that the Neoclassic, Neo-Gothic, and Victorian styles popularized throughout most of the nineteenth century no longer fit into the twentieth century brimming with technological advancements. The styles of the nineteenth century were considered too old-fashioned and out of place within the context of this new contemporary culture. Instead, designers chose to strip away historicism and nationalism from their work, which led the way for a new "International" style.

For the first time, modern architects put materials such as steel, glass, and reinforced concrete to innovative uses in commercial, industrial, and residential design projects. Architects expressed form using these new materials without regard to historical context. The Viennese architect Adolf Loos (1870–1933) wrote: "To find beauty in form instead of making it depend on ornament is the goal towards which humanity is aspiring." His statement typifies the efforts of early modern architects, whose exclusionism introduced unadorned, minimalist structures (Figure 9–1). The events of World War I led designers to develop a style of architecture apart from location or culture. People started thinking globally after watching newsreels in local theaters on the war.

The need to furnish the interior with styles equally reflective of the new architecture led to the design of modern furniture. In the beginning, modern furniture styles followed geometric formulas that mimicked the cubist form of architecture. At the same time, the designs also accommodated machine fabrication. By the start of World War I, machine aesthetics prevailed over the distinctive curvilinear styles of the Art Nouveau movement and replaced the excessive scrolls and curlicues seen in Victorian designs.

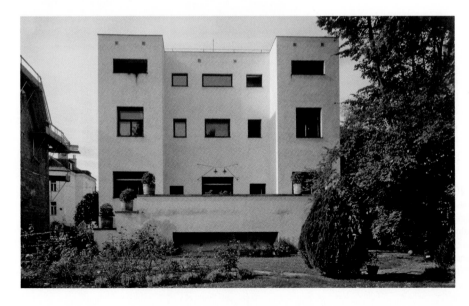

FIGURE 9–1 Adolf Loos designed the Steiner House in Vienna. Built in 1910, the house exemplifies the modern architectural movement by shedding historicism and focusing on form, structure, and materials.
Gerald Zugmann Fotographie KEG

Glasgow School

Students at the progressive Glasgow School of Art in Scotland were exploring stylistic changes in the currently popular Arts and Crafts and Art Nouveau styles. The school's most celebrated student at that time was Charles Rennie Mackintosh (1868–1928). Mackintosh took classes at night and worked in an architectural office in the daytime, first with John Hutchinson and later in the practice of Honeyman and Keppie. Both firms worked in the contemporary Art Nouveau style of the times. Mackintosh formed a friendship with J. Herbert MacNair (1868–1955), who worked with him and studied at the school in the evenings. A teacher at the Glasgow School of Art introduced the two men to artist Margaret MacDonald (1864–1933) and her sister, Frances (1873–1921), who were day students at the school.

Ultimately, Charles and Margaret married, as did Herbert and Frances. Joining creative talents, they were known as the Glasgow Four, first exhibiting their art and furniture designs in the 1896 Arts and Crafts Society Exhibition held in London (Figure 9–2). In a manner that embodied the spirit of an uncomplicated, simplified interior, The Four designed china and tableware, textiles, carpets, and murals with the popular whiplash curves and organically inspired motifs of the Art Nouveau style, which appeared as delicate counterpoint to the rectilinear architecture and furniture designs.

In 1897, Mackintosh won a design competition for the expansion of the Glasgow School of Art (Figure 9–3). The exterior only hinted at Art Nouveau decoration; the mass of the building was lightened by oversized glass windows. Mackintosh and MacDonald collaboratively worked on designs for the interior, which featured large open spaces and double volume ceilings. The expansive geometry of their interiors illuminated by the oversized industrial windows and massive skylights earned the two a reputation for innovative modernism in design.

In 1901, Mackintosh and wife Margaret entered a competition to design a "House for an art lover" sponsored by a German design magazine (Figure 9–4). The house was built in 1989 and completed in 1994 based on the complete portfolio of drawings

FIGURE 9–2 J. Herbert MacNair designed this table-cabinet in 1901 ignoring the whiplash curves of the currently popular Art Nouveau style and emphasizing instead straight lines and geometric arcs and semicircles.
© Judith Miller/Dorling Kindersley/Lyon and Turnbull Ltd.

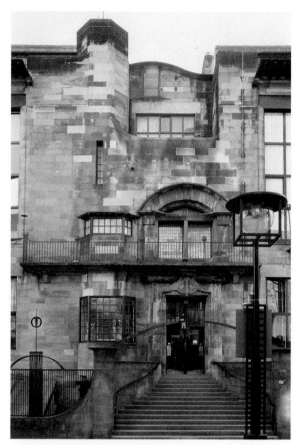

FIGURE 9–3 This view of the expansion for the Glasgow School of Art, designed by Charles Rennie Mackintosh, reveals modern features incorporating geometrical arrangement of architectural elements and subtle Art Nouveau motifs.
Stephen Whitehorn © Dorling Kindersley

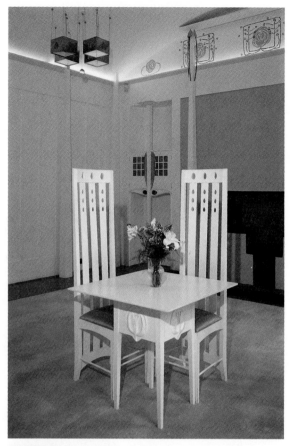

FIGURE 9–4 Two high-backed chairs arranged in front of a square table are set against the stark interior setting of the House for an Art Lover designed by Charles Rennie Mackintosh and Margaret MacDonald. The built-in cupboards, pendant light fixtures, and wall stencil designs characterize the couple's penchant for subtle Art Nouveau details amongst bare, minimalist interiors.
Stephen Whitehorn © Dorling Kidersley

from 1901. It stands as a testament to the truly timeless modernistic style envisioned over a century ago and features the collaborative work of husband and wife.

For the exterior of the house, Mackintosh drew on traditional Scottish architecture. The house features a gabled roof and cubic forms arranged with projecting rooms and balconies. Window muntins are arranged in a tight grid pattern, and the same motif is carried through on the interior furnishings. Striking contrasts between light and dark surfaces and furniture designed with stark minimalism were an extreme departure from Victorian fashions of the past century. Margaret's artistic hand appears in the interior design as well; her stencil patterns adorn walls, art glass panels feature delicate Art Nouveau–inspired botanicals, and grid-patterned textiles complement the austerity of the architecture (Figure 9–5).

Commissions for a series of tearooms owned by Kate Cranston in Glasgow brought the Mackintoshes' design into the public eye. The couple worked on designs for the Ingram Street Tea Room and the Willow Tea Room in 1900 and 1904, respectively, creating modern interiors that featured white walls, Art Nouveau–style murals, and straight-lined furniture (Figure 9–6). Tablecloths, silverware and tea services, light fixtures, and hat racks were designed in accordance with the interior architectural setting (Figure 9–7).

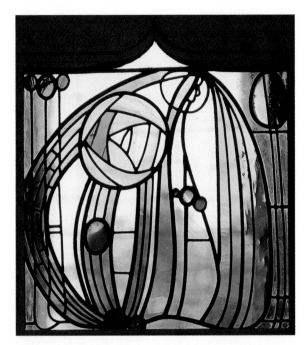

FIGURE 9–5 This stained glass panel inside the House for an Art Lover, designed by Charles Rennie Mackintosh and Margaret MacDonald, breaks down conventional Art Nouveau whiplash curves, bringing more control to both the rose and vine designs. *Stephen Whitehorn © Dorling Kindersley*

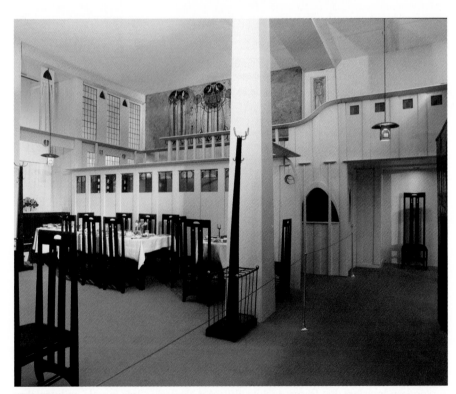

FIGURE 9–6 The interior of the Ingram Street Tea Room in Glasgow features white walls and paneling contrasted against dark-stained oak furniture, breaking from the Victorian tradition of darkened interiors. *Photolibrary, Glasgow Museums, Glasgow, Scotland*

FIGURE 9–7 A pendant light fixture designed for the House for an Art Lover, reproduced from Charles Rennie Mackintosh's original designs from 1900, features small amethyst-colored stained glass insets.
© *Judith Miller/Dorling Kindersley/Lyon and Turnbull Ltd.*

FIGURE 9–8 A pair of Glasgow School brass wall sconces, dated from 1900 attributed to Agnes Bankier Harvey (1873–1947); each is embossed with profiles of Art Nouveau maidens flanked by tendrils and poppy seedpods.
© *Judith Miller/Dorling Kindersley/Lyon and Turnbull Ltd.*

There is no doubt that the current fashion of whiplash curves and botanical imagery of Art Nouveau styling is apparent in some of the decorations completed by The Glasgow Four. Their work mixes Art Nouveau and Celtic motifs, although to place The Four in the category of Arts and Crafts or Art Nouveau designers would be misleading; their work embodied freshness by creating light and bright interiors that pushed design into the modern age. Other artisans in the Scottish School evoked a similar mood by mixing Art Nouveau styling with Celtic motifs (Figures 9–8 through 9–10).

FIGURE 9–9 This Scottish School brass mirror features repoussé work with a band of poppy seed heads with whiplash stems.
© *Judith Miller/Dorling Kindersley/Lyon and Turnbull Ltd.*

FIGURE 9–10 This Scottish School repoussé clock features Celtic knot work on a hammered brass ground.
© *Judith Miller/Dorling Kindersley/Lyon and Turnbull Ltd.*

Wiener Werkstätte

The Viennese designer Josef Hoffmann (1870–1956) came under the influence of Charles Rennie Mackintosh after the two met in 1903. Hoffmann broke from the Art Nouveau tradition under the auspices of the Viennese Secession to explore a rectangular style employing severe geometrical shapes. His work embodied the progressive attitudes of the twentieth century and anticipated the strict geometry of modern art (Figure 9–11).

Hoffmann's interest in uniting architecture and design resulted in the formation of the Wiener Werkstätte in 1903. Along with Koloman Moser (1868–1918), Hoffmann organized a workshop of artisans who would work together to produce goods in the more progressive modern spirit (Figure 9–12, 9–13). In the factory, workers handcrafted items that were popular among only wealthy patrons. Hoffmann designed the Austrian pavilion at the 1925 Exposition Internationale des Arts Décoratifs et Industriels Modernes held in Paris, which brought recognition to the group. By 1932, a dwindling supply of patrons forced the workshop to close, as workers could no longer compete against increasingly available mechanized goods.

Frank Lloyd Wright

In America, Frank Lloyd Wright (1867–1959) helped to introduce a new style of design comparable in theory to the honest purity of The Glasgow Four—one that broke with an adherence to traditional design full of historical references. Wright studied engineering from 1885 to 1887 at the University of Wisconsin before apprenticing in the offices of Adler and Sullivan in Chicago. In 1896, Wright opened his own architectural

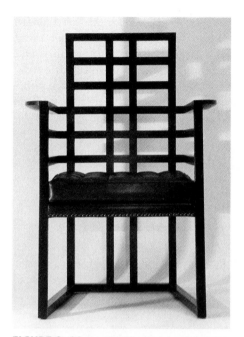

FIGURE 9–11 Josef Hoffmann designed this chair made from black-stained ash in 1908. Modern in design, the simple geometry features an apparent grid pattern on the back. A black leather cushion replaces traditional upholstery.
ICF Group

FIGURE 9–12 This silver flower vase (the glass liner is missing) by Josef Hoffmann from 1904–1906 was produced during his time at the Wiener Werkstätte. The basket and handle feature Hoffmann's strong grid motif.
© Judith Miller/Dorling Kindersley/Lyon and Turnbull Ltd.

practice and began designing residences in the fashionable Oak Park, Illinois, neighborhood where he lived. Wright's residences emphasized the horizontal plane expressed as geometric solids.

Wright broke away from the restricting bulk of the Victorian style and chose to articulate the contradiction of form and materials. Mass opposed void spaces, smooth poured concrete contrasted with the harsher textural qualities of brick and mortar, and light values visually advanced from darkened backgrounds. Wright's architecture leaped into three-dimensional space through these manipulations of mass and void, textural contrasts, and value changes. The Meyer May House built in Michigan in 1908 and fully restored in 1987 captures Wright's fresh architectural style and attention to interior details, which were deeply rooted in the Arts and Crafts movement (Figures 9–14, 9–15).

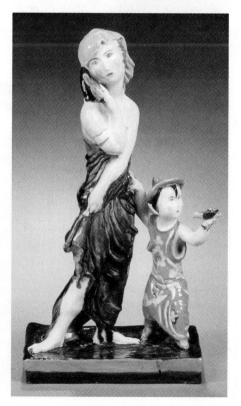

FIGURE 9–13 A terra-cotta figurine made at the Weiner Werkstätte with polychrome glaze; it features a mother and child both wearing exotic costumes.
© Judith Miller/Dorling Kindersley/Lyon and Turnbull Ltd.

In 1909, Wright completed designs on a house in Chicago for the Robie family. The house epitomized Wright's interest in the horizontal plane and the dichotomy of mass and void through its cantilevered flat roof offering shade to balconies and recessed windows. The design of the Robie House launched Wright's Prairie style, setting the stylistic direction for future projects and shattering the verticality of seemingly old-fashioned Victorian Queen Anne houses. Severely contemporary for its time, the Robie House demanded interior furnishings equally modern in design.

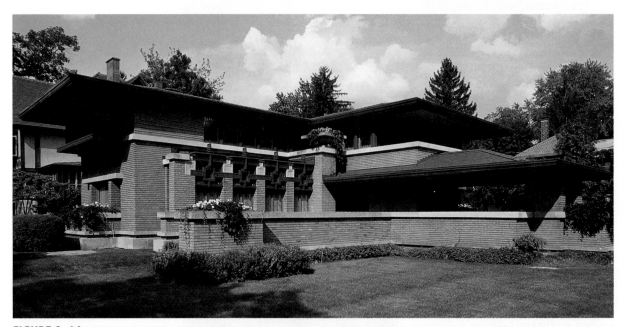

FIGURE 9–14 The Meyer May House in Grand Rapids, Michigan, designed by Frank Lloyd Wright and completed in 1909, features characteristic Prairie-style architecture with its low profile, deep-shaded eaves, and horizontal emphasis.
Jon Spaull © Dorling Kindersley

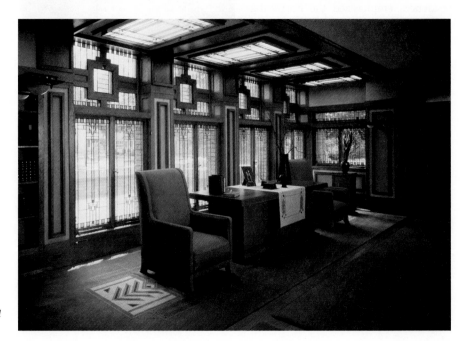

FIGURE 9–15 George Niedecken worked on the Meyer May House in Grand Rapids, Michigan, completing furniture, rugs, and mural designs for Frank Lloyd Wright.
Photo courtesy of Steelcase Inc., Grand Rapids, MI

Wright complied by assembling a team of artisans who followed his designs to produce furniture, textiles, carpets, lighting fixtures, and stained glass windows (Figure 9–16).

The unique open-plan interior of the Robie House enabled Wright to use a system of built-ins and carefully placed chairs and tables that ingeniously separated space with minimal walls or room dividers. Tall-backed chairs created a visual screen around the dining tables and separated the eating area from adjoining spaces (Figure 9–17). Wright's designs for furniture and textiles were explicitly connected to the structures he built. The Arts and Crafts movement and the American Mission style influenced his handmade oak furniture, although it was often criticized for being too heavy and cumbersome. George Niedecken (1878–1945) worked on several significant

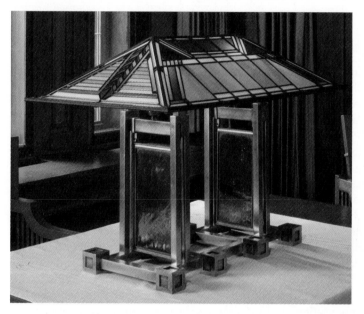

FIGURE 9–16 A table lamp for Frank Lloyd Wright's Susan Lawrence Dana House, built in 1903, was made from bronze and has leaded and stained glass panels.
Frank Lloyd Wright, Table lamp, Susan Lawrence Dana House, 1903. Bronze, leaded glass. Photograph © Doug Carr. Courtesy, The Dana-Thomas House, The Illinois Historic Preservation Agency. © 2008 Frank Lloyd Wright Foundation, Scottsdale, AZ

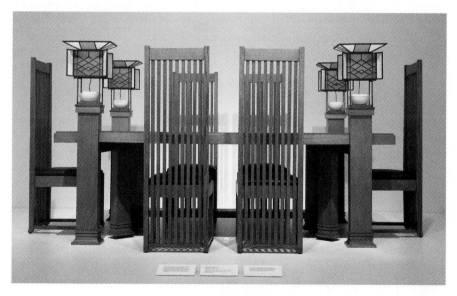

FIGURE 9–17 This dining room set designed by Frank Lloyd Wright and George Niedecken for the Robie House emulates Arts and Crafts styling with its straight lines and unornamented oak. The straight-backed chairs emphasize the strict formality of dining for the period, forcing erect posture while eating. Side lanterns of stained glass at each corner of the table create subdued lighting.
Andrew Leyerle © Dorling Kindersley. Courtesy of Frank Lloyd Wright Home and Studio Foundation

Wright-designed homes including the Robie, Meyer May, Avery Coonley, and Susan Lawrence Dana houses. He worked for Wright in his Oak Park studio completing designs for furniture, murals, and rugs from 1909 to 1913. Niedecken maintained his own practice designing and producing furniture and completing interior design projects throughout his lifetime, working once more with Wright in 1916.

Although several other architects worked in the Prairie style and its closely related Craftsman style of architecture, Wright's work stands out as innovative for breaking down the barriers of tightly planned and enclosed interior spaces. He went on to design many more residential and commercial buildings, each carefully orchestrated from the inside out to create a sense of harmony and balance between indoors and outdoor settings. For the most part, Wright's legacy is the introduction of modernism into the American vernacular of residential design.

International Style

By 1917, European architects had succeeded in removing architecture from traditionally based revivalist designs. Instead, they initiated a purely geometric approach to design and adopted structural innovations that relied on steel and reinforced concrete and non-load-bearing walls. Dubbed the International style by American architect Philip Johnson (1906–2005), the style is identified by its ability to escape the regional vernacular by adhering to geometrical form and avoiding applied ornamentation. Instead of relying on historical references, architects introduced a rational approach to design emphasizing international unity that crossed cultural boundaries. The end of World War I was the first in a series of events that began to globalize the world. For the first time in history, newsreels crossed cultural boundaries to bring news and information to the public through powerful visual images.

Capturing the zeitgeist, the modern architectural movement continued to dominate European design throughout the 1920s and 1930s. Coupled with Cubist, Fauvist, and Futurist artists of the avant-garde, industrial designers delighted a rising social class of aesthete elitists eager to commission works for the sole purpose of proclaiming an appreciation of ultra-modern art and design. The Cubist-inspired works of Swiss architect Charles Edouard Jeanneret (1887–1965), who changed his name to LeCorbusier, when he moved to France, were massive three-dimensional sculptures of geometric form. His International style exteriors and interiors lacked decoration, emphasizing instead sleek modernism in the use of concrete, glass, and steel (Figure 9–18).

De Stijl

Dutch artist and architect Theo van Doesburg (1833–1931) founded the De Stijl movement after collaborating with painter Piet Mondrian (1872–1944) and architect Gerrit Rietveld (1888–1964). The group adopted specific design characteristics that embodied the De Stijl movement including the extensive use of geometric form; the primary colors of red, blue, and yellow; and asymmetrical spatial relationships. The group designed without historical expressiveness and created imaginative structures that required equally inventive interior furnishings.

The Schröder House designed by Gerrit Rietveld in 1924 in Utrecht, the Netherlands, exemplifies the purest expression of De Stijl architecture (Figure 9–19). The recently restored house was designed for interior designer Truus Schröder-Schräder (unknown–1985) and features projecting cantilevers, balconies, and flat

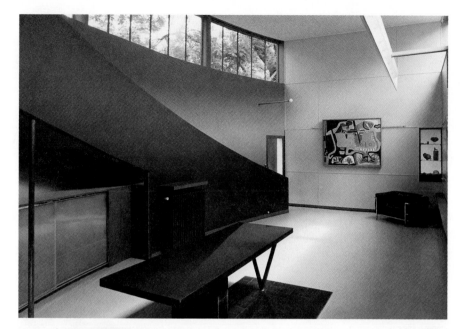

FIGURE 9–18 Villa La Roche, designed in 1924 by LeCorbusier, features stark, minimalist interiors with modern furniture and art of his own design.
© 2005 Artists Rights Society (ARS), New York/ADAGP, Paris/FLC

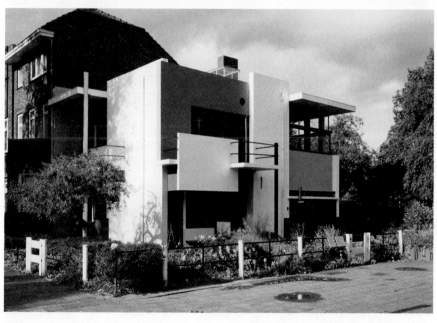

FIGURE 9–19 The Schröder House in Utrecht, the Netherlands, designed by Gerrit Rietveld in 1924, still holds it modern appeal and is considered the purest expression of De Stijl architecture.
Florian Monheim/Artur Architekturbilder Agentur GmbH, Cologne, Germany

rectangular planes that create interesting areas of mass and void. The color palette was restricted to the white surface treatment of the concrete accented by red, blue, and yellow with black on columns, windows, and door frames.

An open plan interior features sliding panels that close and separate spaces. The furniture is designed with geometric austerity (Figure 9–20). The house made Rietveld's 1918 design for the Rood Blau (Red Blue) Chair famous; his chair expresses the three-dimensional sculptural aspects of a Mondrian De Stijl painting with an emphasis on geometry and the integration of primary colors. Rietveld continued to design after the completion of the Schröder House, adapting his designs to children's toys and furniture.

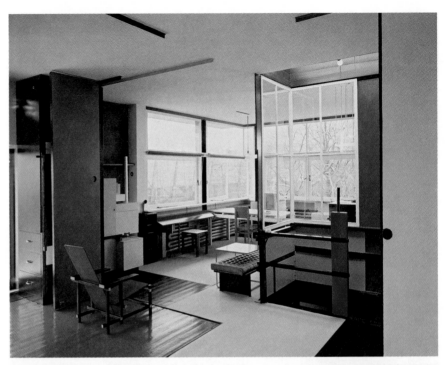

FIGURE 9–20 The main floor of the Schröder House shows a combined living and dining space, expansive glass windows, ceiling tracks accommodating movable wall panels, and the Rood Blau (Red Blue) Chair, designed in 1918. This is a restored interior of Gerrit Rietveld's architectural masterpiece.

Gerrit Rietveld (1888–1964). First floor 1987, view of the stairwell/landing and the living-dining area. In the foreground is the Red and Blue chair. Rietveld Schroderhlis, 1924, Utrecht, The Netherlands. c/o Stichting Beeldrecht, Anstelveen. Collection

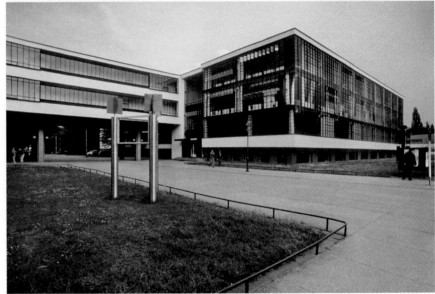

FIGURE 9–21 Walter Gropius designed the buildings at the Bauhaus in Dessau, Germany, in 1925. Following the tenets of modern architecture, the building lacks historical references or applied ornamentation focusing instead on the materials of construction such as concrete, glass, and steel.

Art Resource, NY

Bauhaus

In Germany, under the direction of Walter Gropius (1883–1969), a school called the Bauhaus ("build-house") opened its doors in 1919. The Bauhaus became the first school to recognize the importance of training artisans to design products for mass production. The design of the buildings at the school exemplified the intent of the school; they were radically modern by current architectural standards. Designed by Gropius in 1925, the Bauhaus school buildings were rectangular structures with flat roofs and glass and concrete walls, without ornamentation or references to the historical past (Figure 9–21).

Steel columns supported the structures allowing for large expanses of glass curtain walls.

Students at the Bauhaus were considered apprentices under the guidance of their instructors. They were encouraged to experiment with the materials of construction before working through the problems of design. Gropius and his colleagues believed it was important for students to understand how the materials of construction functioned relative to the design process. This clearly expressed the working philosophy of Gropius, and "form follows function" became the motto of the Bauhaus. Some of the most important names in twentieth-century art and architecture were connected with the Bauhaus. Students included Marcel Breuer (1902–1981), who later became director of the furniture shop at the Bauhaus; Marianne Brandt (1893–1983), who replaced László Moholy-Nagy as director of the metal shop; and Anni Fleischmann Albers (1889–1994), who studied weaving and met her future husband, Josef Albers (1888–1976), who taught painting classes. Other instructors included painters Piet Mondrian, Wassily Kandinsky (1866–1944), Paul Klee (1879–1940), and architect Ludwig Mies van der Rohe (1886–1969), who directed the architectural department from 1930 to 1933.

The Bauhaus led the way for an avant-garde style of teaching that emphasized cooperation between artist and machine. At first students were trained in the arts of painting and sculpture. Eventually, industrial arts and home product design—textiles, tableware, wallcoverings, lighting, and furniture—were introduced into the curriculum (Figures 9–22 through 9–24).

One of the most influential products to come out of the Bauhaus was a chromium-plated tubular steel chair designed by Breuer in 1928 (Figure 9–25). The Cesca Chair (named after his daughter Francesca) was made from bent tubular steel and had a cantilevered frame fitted with a cane back and seat instead of traditional cloth upholstery. The chair was too expensive to produce until proper tube-bending equipment could be developed. By 1930, the chair identified as the B 32 appeared in the Thonet catalog. Breuer's furniture designs and those of his Bauhaus colleagues, Mies van der Rohe and Mart Stam (1899–1986), revolutionized the concepts of furniture manufacturing, inspiring designers throughout the twentieth century. Members of the school dispersed throughout Europe and America when the National Socialist Party shut down the Bauhaus in 1933.

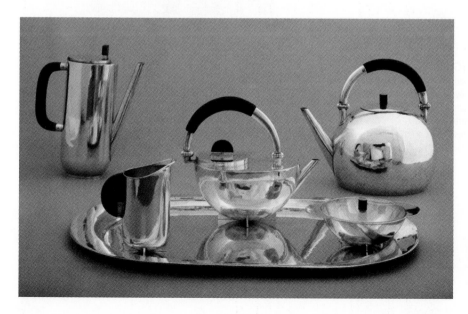

FIGURE 9–22 A silver and ebony coffee and tea service designed by Marianne Brandt in 1924 during her tenure at the Bauhaus. Her metalwork designs emphasize geometric form rather than decoration.

FIGURE 9–23 Marianne Brandt designed this clear glass teapot for the Schott & Gen of Jena, Germany, glass company. Inventive for its time, the teapot was made of a new heat-resistant glass.
© Judith Miller/Dorling Kindersley/Graham Cooley

FIGURE 9–24 This wall hanging made by Anni Albers in 1927 was woven from cotton and silk and features prominent geometric patterning.
Digital Image © The Museum of Modern Art

Cranbrook Academy

Finnish architect and designer Eliel Saarinen (1873–1950) is credited with bringing the International style to America when he was commissioned to design a building to house a new experimental school near Detroit in Bloomfield Hills, Michigan. Consequently, the Cranbrook Academy of Art opened its doors in 1932 offering an apprentice-style education in art and design fashioned after the Bauhaus. The Saarinen home on the Cranbrook campus was the result of the joint efforts of Eliel and his wife, Loja

FIGURE 9–25 These modern reproductions of Cesca Chairs based on Marcel Breuer's original 1928 designs feature chromium steel frames with cane and ebonized wood seats and backs.
Thonet Industries

FIGURE 9–26 Eliel Saarinen's house at the Cranbrook Academy of Art in Bloomfield Hills, Michigan, completed in 1930, shows the popular Art Deco influences of the time.
Hedrich Blessing

(1879–1968), who was a textile designer and sculptor (Figure 9–26). In addition to the Saarinens' modern architectural style, the couple's home featured rich veneers and marquetry-patterned furniture, geometric rugs and upholstery fabrics, and leaded glass windows—an interior characteristic of the prevailing Art Deco style. Saarinen remained president of the school until 1948.

Art Deco and Art Moderne

Often referred to as the Jazz Age, the 1920s was an era in which people embraced change like no other decade in history. Music, dance, clothing, and hairstyles resonated with the modernization exemplified in Erté's (1892–1990) graphic illustrations for *Harper's Bazaar* magazine. The 1925 Paris Exposition des Arts Décoratifs et Industriels expressed the new style of Art Deco, which evolved from an appreciation of machine aesthetics coupled with lavish ornamentation and rich color, to whimsical interpretations of space and form (Figures 9–27, 9–28). Evidence of this new direction in art and design appeared shortly after the end of World War I. Although this exposition introduced the world to Art Deco, the term was not widely used until 1966.

The Art Deco furniture styles of the 1920s emphasized exotic woods and high-quality artisanship that included inlays of equally exotic materials such as shagreen, ivory, tortoiseshell, and eggshell. Like the Art Nouveau movement beforehand, Art Deco led to elitism because only a select few could actually afford these lavishly designed objects. At the Paris Exposition, a special pavilion was devoted to the exotic furnishings of Jacques-Èmile Ruhlmann* (1879–1933), who revived the opulence of cabinetwork unequaled since the French Baroque period in the seventeenth century (Figure 9–29). Ruhlmann himself expressed the attitude of Art Deco even before the Paris Exposition took place:

> A clientele of artists, intellectuals and connoisseurs of modest means is very congenial, but they are not in a position to pay for all the research, the experimentation, the testing that is needed to develop a new design. Only the very rich can pay for what is new and they alone can make it fashionable.

FIGURE 9–27 A color rendering of a project designed for the library of the French Embassy in 1925 was exhibited at the Paris Exposition des Arts Décoratifs.
Picture Desk Inc./Kobal Collection

*There are contradictions in monographs as to the sequence of Ruhlmann's first and middle names; Èmile-Jacques also appears in print.

FIGURE 9–28 A French Art Deco–style low stool from 1928 has an upholstered cushion set in a rosewood frame with zebrawood banding. The textile is a woven design of stylized machine parts such as wheels and axles in typical Art Deco geometry.
© *Judith Miller/Dorling Kindersley/Jazzy Art Deco*

Fashions don't start among the common people. Along with satisfying a desire for change, fashion's real purpose is to display wealth.[*]

Modern skyscrapers were becoming a reality as New York City led the world in building high-rises with steel frames, modern elevators, and preliminary air-conditioning systems. The discovery of the tomb of King Tutankhamun in Egypt by the archaeologist Howard Carter in 1922 influenced modern styles from architecture and interior design to clothing and hairstyles. The discovery spurred a throwback to applied ornamentation of a historical nature as artifacts taken from the tomb were revealed to the world. Buildings such as the Chrysler Building, Empire State Building, and Rockefeller Center in New York City incorporated Aztec, Gothic, and Egyptian motifs along with images of classical gods and goddesses and primitive African designs (Figures 9–30, 9–31).

The Metropolitan Museum of Art in New York City made significant contributions to modern design. The museum's American Industrial Art Exhibition, held annually from 1917 to 1940, introduced the sleek styling of a streamlined age of industrial glamour. The name Art Moderne exemplified the marriage of art and industry in aesthetically designed objects that lacked the harsh angularity of early modern designs. Also, the harder edges of ziggurats were softened by incorporating a series of circles and arcs into glossy interiors accentuated with sleek and glossy furnishings (Figure 9–32). The streamlined designs of such notable industrial designers as Norman Bel Geddes (1893–1958) and

FIGURE 9–29 Jacques-Èmile Ruhlmann's brown velvet armchair features burr amboyna wood with ebony details and gilt metal footings.
© *Judith Miller/Dorling Kindersley/DeLorenzo Gallery*

[*]Kellar, Harold. "Twentieth Century Design: Jacque-Emile Ruhlmann." *Picture Framing Magazine,* July 1998.

FIGURE 9–30 Rockefeller Center in New York City comprises of a central plaza surrounded by fourteen skyscrapers designed by Raymond Hood in the Art Deco style. Begun in 1931, the buildings feature ziggurat profiles and applied decoration inspired by ancient civilizations. This sculpture of the Greek god Prometheus is located in the central plaza.
Stock Connection

FIGURE 9–31 The elevator doors inside the Chrysler Building in New York City feature papyrus blossoms in metal and wood inlay.
Dave King © Dorling Kindersley

Raymond Loewy (1893–1986) helped create a shift from looking at the past in awe (spurred by the discovery of King Tutankhamun's tomb) to looking toward the future.

The 1939 World's Fair held in New York City focused on the future, averting attention from the economic hard times of the Great Depression (Figure 9–33). The theme "Building the World of Tomorrow" introduced fair-goers to the latest technologies including Loewy's design for the fastest train on record for the time and New York City's first television broadcast showing off RCA TV sets. Bel Geddes designed Futurama for General Motors, an exhibit that gave attendees a glimpse into the future—what the country would look like in 1960 with modern highways and skyscrapers. Other futuristic-looking buildings designed for the fair emphasized smooth and rounded corners in the Art Moderne style. The fair's main exhibit, a diorama revealing industrial designer Henry Dreyfuss's (1904–1972) vision for a utopian future, was housed inside Perisphere (Figure 9–34). The motif of a Perisphere was repeated in future World's Fairs of the twentieth century. The fair ended in 1940, when optimism about the future was overshadowed by the escalation of World War II in Europe.

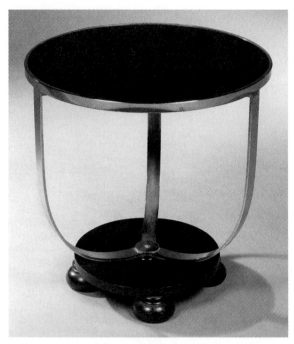

FIGURE 9–32 This Art Deco side table features a black glass circular top with chromium-plated supports on an ebonized base.
© *Judith Miller/Dorling Kindersley/Lyon and Turnbull Ltd.*

FIGURE 9–33 Postcards issued during the 1939 World's Fair in New York City feature some of the Art Moderne buildings designed for the theme "The World of Tomorrow."
© *Judith Miller/Dorling Kindersley/Tony Moran*

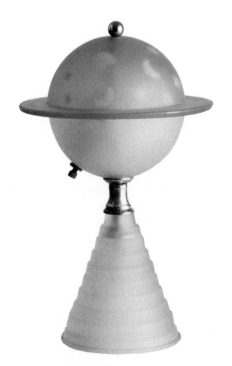

FIGURE 9–34 This frosted green and uncolored Saturn lamp with internally painted stars and planets was made to commemorate the 1939 World's Fair in New York City.
© *Judith Miller/Dorling Kindersley/Deco Etc*

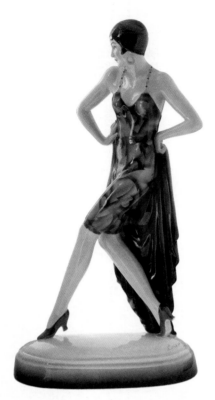

FIGURE 9–35 This Art Deco figure of a 1920s-style dancer produced by the Austrian firm of Goldscheider captures the fashions of young, independent women of the time.
© *Judith Miller/Dorling Kindersley/John Jesse*

FIGURE 9–36 This Clarice Cliff inverted ziggurat vase features a brightly colored tree in the fashion of the Fauvist painters.
© *Judith Miller/Dorling Kindersley/Woolley and Wallis*

Pottery

Art Deco and Art Moderne ceramics included a wide range of designs for decorative and functional purposes alike. Figurative ceramics featured popular subjects ranging from the modern woman to mythological goddesses. Figurines of women wearing the current fashion in poses of lively dance were widely available (Figure 9–35). The flapper of the 1920s epitomized the carefree and independent woman; she had short bobbed hair and wore newly marketed cosmetics influenced by Hollywood movie stars and short skirts revealing rolled-down stockings. It is clear that the figurines were produced in great quantities to adorn interiors, since many originals currently come up for auction or are available through dealers. Although high-quality porcelains were made by recognized factories such as Royal Worcester, Royal Doulton, and Goldscheider, mass-produced and painted plaster cast figurines found their way into the consumer market offering cheap substitutes.

One of the most innovative ceramicists of the Art Deco period was Clarice Cliff (1899–1972), who began working in a pottery factory in England as a young teenager. As an adult, she attended art classes at night while continuing to work as a pottery painter in the factory. After World War I, Cliff was given the chance to create some of her own designs and began to learn more about the shaping of pottery. Her unusual shapes and painted designs, which reflected the current interest in Cubism, Fauvism, and Futurism, were popular among consumers (Figure 9–36). Cliff

produced some of her most interesting pieces, called Bizarre ware by critics and the public alike, during the Art Deco period.

Plastics

Despite William Morris's denouncement of "shoddy machine made goods," mass production took hold of design culture in the early part of the twentieth century. New methods, processes, and materials were explored to create a wide range of products for middle-class consumers. A synthetic plastic first created by Dr. Leo Baekeland in 1909 led the way for the production of molded goods using a phenolic resin. The plastic known as Bakelite could be molded into virtually any shape and size, making products such as radios, telephones, and decorative objects more affordable (Figure 9–37). The hardness and durability of Bakelite, along with its heat-resistant qualities, made it the perfect material for table- and kitchenware (Figure 9–38). The material also found its way into the manufacture of jewelry, office equipment, and household appliances. By the 1930s, competitors developed other plastics, such as Catalin and Melamine, which could be colored any hue. Soon, all plastics from this era through the 1950s were referred to by the catchall trade name Bakelite.

FIGURE 9–37 This commemorative wall plaque of Sir Winston Churchill made from Bakelite dates from 1940–1942.
© *Judith Miller/Dorling Kindersley/Hope and Glory*

FIGURE 9–38 A 1930s French silver-plated box with a stepped lid in ziggurat fashion featuring Bakelite handles.
© *Judith Miller/Dorling Kindersley/The Silver Fund*

Glass

As William Morris feared, the machine eventually muddled the lines between the fine art of craft and inexpensive substitutions of inferior quality. The dichotomy between quality-made goods and cheap ones continued throughout the twentieth century. Glass-making was no exception as a wide range of press-molded glassware flooded the market. As Fenton had proven with his carnival glass, these machine-made, pressed-glass candy dishes, pitchers, vases, and compotes were attractive to middle-class consumers, who could buy them at next-to-nothing prices (Figure 9–39). Depression glass, as we call it today, was a press-molded glass made by machine (Figure 9–40). Advertisers used cheap glassware as free giveaways to entice consumers into their supermarkets, gas stations, and banks during the Great Depression.

Meanwhile, French artist René Lalique (1860–1945), who began his career as a jewelry designer, was equally known for his fine-quality glass and crystal designs. Some of his first works in glass took the form of perfume bottles he designed for Coty. These exquisite Lalique designs brought elitism to the perfume industry. His work on

FIGURE 9–39 This 1930s carnival glass compote features a grape and sycamore pattern in orange iridescent glass.
© Judith Miller/Dorling Kindersley/Mary Ann's Collectibles

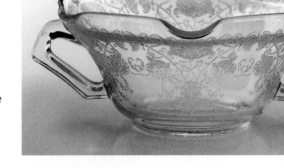

FIGURE 9–40 This pink Depression glass candy dish with foliate and scroll motifs created by the patterns of the mold lacks the fine quality of etched glass.
© Judith Miller/Dorling Kindersley/Take-A-Boo Emporium

the glass pavilion at the 1925 Paris Exposition des Arts Décoratifs et Industriels brought Lalique's work to the forefront of Art Deco design. His designs were created by hand pressing soft glass and crystal into shaped molds. After cooling, the pieces were then hand polished or acid etched to create beautiful patterns. The finished glass was often given a wash of color to enhance the relief designs (Figure 9–41). Although there were many hand processes involved in Lalique's glass, the molds allowed mass production of the same designs.

In addition to Lalique, well-established companies such as Baccarat captured the feeling of the Art Deco style by producing high-quality glass to be sold in high-end department stores (Figure 9–42). Designs included the stark geometric patterns

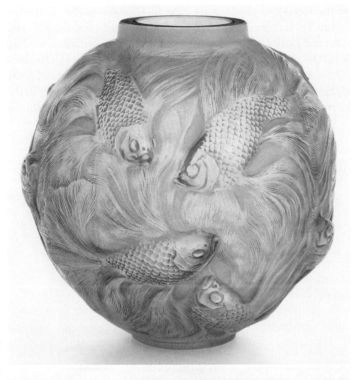

FIGURE 9–41 This Art Deco–style vase by René Lalique from 1924 features press-molded fish enhanced by a blue wash of color.
© *Judith Miller/Dorling Kindersley/David Rago Auctions*

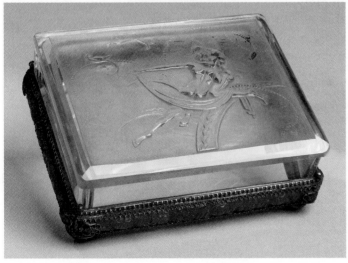

FIGURE 9–42 This Art Deco–style Baccarat glass box with metal filigree and jade insets features a press-molded lid of figures in a landscape.
© *Judith Miller/Dorling Kindersley/Lyon and Turnbull Ltd.*

inspired by Cubist paintings as well as nature motifs and young maidens. In competition with Lalique, Daum, a manufacturer of fine glassware located in Nancy, France, had its beginnings in the third quarter of the nineteenth century. Without formal training in glass manufacturing, the family-run business became a leading producer of glass in the Art Nouveau style in the early twentieth century. Daum began creating designs influenced by the Cubist painters under the influence of the work shown at the 1925 Paris Exposition des Arts Décoratifs et Industriels (Figure 9–43).

Although the production of glass near Orrefors in Sweden had first begun in the eighteenth century, it would take the 1925 Paris Exposition des Arts Décoratifs et Industriels to bring the region and its most prominent designer notoriety. Simon Gate (1883–1945), an artist hired to work at Orrefors in 1916, started the tradition of using fine artists at the factory to produce art glass in addition to the company's household glass (Figure 9–44). Edward Hald (1883–1980) joined Gate in 1917, and Orrefors employed several glassblowers and engravers when they exhibited work in the Swedish Pavilion at the 1925 Paris Exposition, which earned them the Grand Prix award. Along with Orrefors, Swedish glassmakers in the surrounding regions of Kosta and Emmaboda led the way in modern designed art glass, achieving popularity in the post–World War II era. Glass artist Vicke Lindstrand (1904–1983), who began his

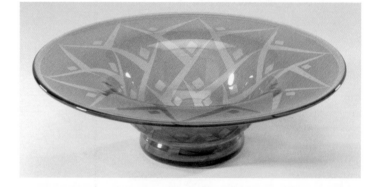

FIGURE 9–43 This Art Deco blown and cut bowl features lively geometric designs and bears the engraving Daum Nancy France.
© *Judith Miller/Dorling Kindersley/Freeman's*

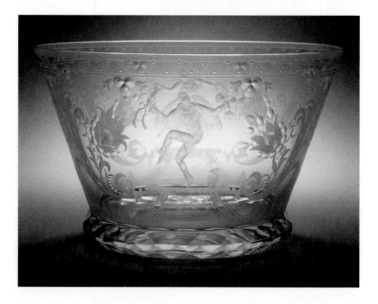

FIGURE 9–44 This Scandinavian etched glass bowl attributed to Simon Gate for Orrefors has a finely etched frieze of flowers and a dancing girl.
© *Judith Miller/Dorling Kindersley/Lyon and Turnbull Ltd.*

career at Orrefors in 1928, is well known for his designs for Kosta in the 1950s (later known as Kosta Boda).

Mirrors

With a boom in the cosmetics industry spurred by Hollywood, wearing makeup became an accepted part of modern culture for the new independent woman of the 1920s. In addition to wall-hung mirrors, many small dressing table mirrors and pocketbook-sized compact mirrors were produced (Figure 9–45). Also, the more streamlined furniture of the Art Moderne style prominently featured mirrored surfaces and inset panels in their designs (Figure 9–46).

Lighting

Electricity had revolutionized how interiors were lit, and in the twentieth century, many Art Deco and Art Moderne designers included lighting design in their vast repertoires (Figure 9–47). Jacques-Emile Ruhlmann designed lamps for his

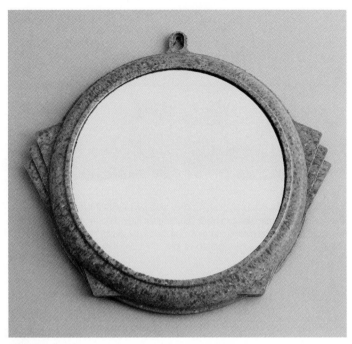

FIGURE 9–45 This 1930s wall mirror with a blue Bakelite frame features a pyramid design.
© *Judith Miller/Dorling Kindersley/Mark Hill Collection*

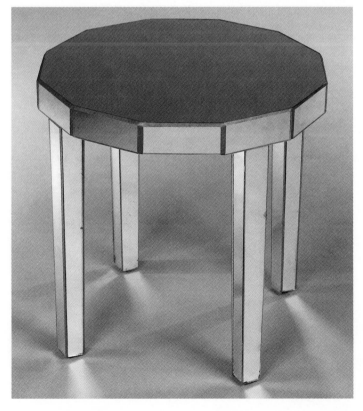

FIGURE 9–46 This small occasional table from the 1930s in the Art Moderne style is veneered on all sides, the top, and the legs with cut mirror glass.
© *Judith Miller/Dorling Kindersley/Lyon and Turnbull Ltd.*

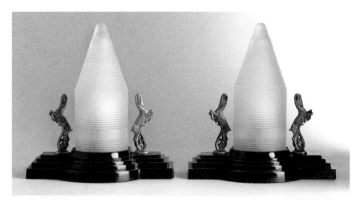

FIGURE 9–47 A pair of 1930s Art Deco table lamps with frosted stepped shades flanked by chrome gazelles on a black Vitrolite glass base. Vitrolite was a brand name for a type of structural glass produced during the 1920s and 1930s.
© *Judith Miller/Dorling Kindersley/Deco Etc*

clients, and Jean-Michel Frank (1895–1941) commissioned the sculptor Alberto Giacometti (1901–1966) to sculpt lamp bases for his interior design projects. René Lalique provided the glass designs for the luxury cruise ship the *S. S. Normandie (Normandy)* including lit skylights and fifteen-foot illuminated columns. Marius Sabino (1878–1961) founded a glassmaking company whose designs were similar to those of Lalique. His designs were evocative of the Art Deco period, and like Lalique, he produced light fixtures for the *S. S. Normandie*. For the more mainstream clientele, low-end manufacturers copied the beauty of Lalique's and Sabino's inspired designs and produced pressed-glass lamp shades as less expensive substitutes (Figures 9–48, 9–49).

Metalworking

The Danish silversmith and sculptor Georg Jensen (1866–1935) began creating small works of art and jewelry until he forged a working relationship with Johan Rohde (1856–1935) to produce flatware in 1905. The success of their company was apparent, and Jensen soon expanded his business. Harald Nielsen began apprenticing with Jensen in 1909 and later began designing his own pieces under the Jensen name (Figure 9–50). Jensen's company of silversmiths took the Grand Prix prize at the 1925 Paris Exposition des Arts Décoratifs et Industriels for their designs, and

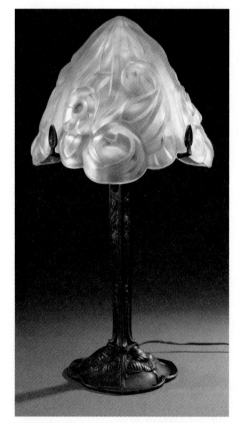

FIGURE 9–48 This French Art Deco frosted glass and metal table lamp from 1925 features the signature of Lalique on the press-molded shade.
© *Judith Miller/Dorling Kindersley/Sloans & Kenyon*

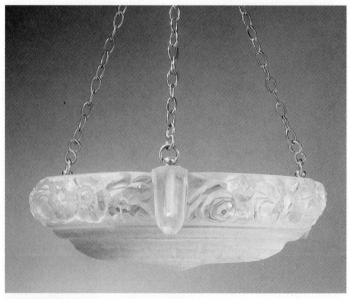

FIGURE 9–49 This 1930s French Sabino Art Deco glass chandelier with molded frosted glass shade features a floral design.
© *Judith Miller/Dorling Kindersley/Freeman's*

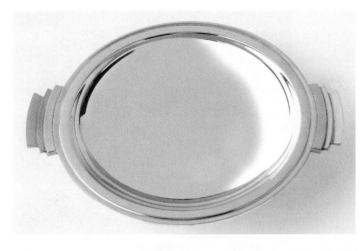

FIGURE 9–50 A Georg Jensen Art Deco Pyramid pattern silver tray designed by Harald Nielsen from the 1920s.
© *Judith Miller/Dorling Kindersley/The Silver Fund*

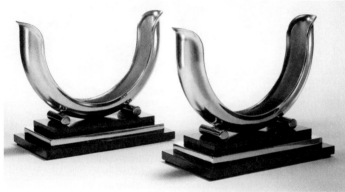

FIGURE 9–51 This unusual U-shaped chrome-plated aluminum candlestick on a ziggurat Bakelite base made by the Dole Vale Company of Chicago was exhibited at the 1939 World's Fair in New York City.
© *Judith Miller/Dorling Kindersley/High Style Deco*

their reputation for making fine silver and hollowware led to their winning numerous other awards.

To meet the demands of the middle-class market, American companies such as Chase Brass & Copper, the Dole Vale Company of Chicago, and Alcoa Aluminum hired freelance industrial designers to develop products their companies could easily mass-produce (Figure 9–51). Chase Brass & Copper got its start by making buttons in the nineteenth century, then realized the potential of using their resources and machinery to produce household products. Industrial designer Ruth Gerth and her architect-husband William were contracted by Chase to design collections of tableware made from copper and chromium that would appeal to the middle-class market (Figure 9–52). Industrial designer Russell Wright (1904–1976) also got his start by designing domestic metalwares. In 1934, Alcoa introduced a line of kitchenware made from aluminum. These aluminum wares were affordable silver for the depressed economic times (Figure 9–53). Aluminum manufacturing was diverted toward the war effort during World War II; when aluminum products reemerged in the 1950s, they appeared in brightly anodized colors that found their way into fashionable middle-class homes.

Clocks

Advancements in clockworks in the early part of the twentieth century included the introduction of battery-operated and electric clocks. The ever-popular mantel clock

FIGURE 9–52 This Chase Brass & Copper Company copper bud vase designed by Ruth and William Gerth has four asymmetrical tubes bound by a Bakelite collar and mounted on a stemmed circular base. The copper napkin holder also features a Bakelite handle. Both are from the 1930s.
© *Judith Miller/Dorling Kindersley/Freeman's*

FIGURE 9–53 An Art Deco chrome appetizer stand in the shape of a swan with a head made from red Bakelite.
© *Judith Miller/Dorling Kindersley/Freeman's*

FIGURE 9–54 This 1930s walnut-veneered Art Deco–style mantel clock features a streamlined design.
© *Judith Miller/Dorling Kindersley/Dickins Auctioneers*

was offered in a wide range of designs in the Art Deco style (Figure 9–54). Streamlined shapes made from wood offered high style to middle-class consumers. Industrial designers designed clocks from Bakelite (Figure 9–55). More elaborate models catered to a higher-end market; Lalique offered exquisite glass clock cases with the clock movements made in Switzerland (Figure 9–56). In 1926, the Howard Miller Clock Company of Zeeland, Michigan, began manufacturing mantel clocks in more traditional styles that appealed to more mainstream consumers.

FIGURE 9–55 This whimsical electric clock features a Bakelite base in the form of a modern airplane with wood and chrome accents.
© *Judith Miller/Dorling Kindersley/Deco Etc*

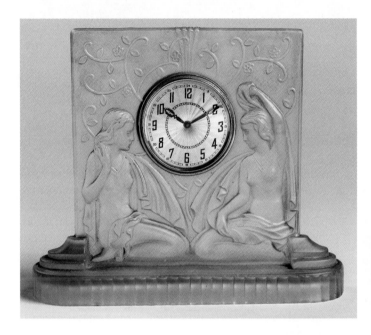

FIGURE 9–56 This Art Deco frosted blue glass mantel clock fashioned after the designs of Lalique features partially nude maidens surrounded by flowering vines.
© *Judith Miller/Dorling Kindersley/Lyon and Turnbull Ltd.*

Textiles and Wallpaper

Textiles and wallpapers reflected the jazziness of Art Deco and Art Moderne designs with Cubist-like geometry; bold Fauve colors; and the primitive forms of Egyptian, Aztec, and African design (Figures 9–57, 9–58). Gunta Stölzl (1893–1983) began her career as a textile weaver at the Bauhaus, first as a student, then as director of the weaving shop. After the school's closing in 1933, she established her own workshop in Zurich where she produced curtains, wall hangings, and fabrics for commissioned clients through the 1960s. Throughout Stölzl's career, her designs never wavered from the lively patterns and bold colors of the Cubist and Fauve artistic movements (Figure 9–59).

FIGURE 9–57 This close-up detail of an Art Deco machine-woven carpet shows the influence of Egyptian motifs following the discovery of King Tutankhamun's tomb.
© *Judith Miller/Dorling Kindersley/Lyon and Turnbull Ltd.*

FIGURE 9–58 This wallpaper design from the men's room at Radio City Music Hall in Rockefeller Center features jazzy motifs from the 1930s.
Angelo Hornak Photograph Library

FIGURE 9–59 Gunta Stölzl's 1926 Gobelin wall hanging made from brightly colored fabrics.
Bauhaus Archive Berlin, Germany/The Bridgeman Art Library

Scandinavian Design

While architects and designers in Europe and America in the 1920s and 1930s became increasingly accepting of industrialization and synthetic materials, designers from the Scandinavian countries looked to their own natural resources for inspiration. Combining mechanized production methods with hand-finished detailing, furniture designers from this region used teak, birch, and maple instead of the chromium tubular steel introduced by the Bauhaus. The warmth of natural fiber textiles used on seat cushions and in upholstery complemented the softer contours of Scandinavian furniture design.

Scandinavian designers from Finland, Alvar Aalto (1898–1976) and Aino Marsio (1894–1949), were both architects who began working on projects together when they married in 1924. The Aaltos formed Artek, a company that fabricated their unique furniture, glassware, and lighting fixtures (Figure 9–60). Using laminated beechwood, Alvar Aalto's design for a stacking stool was exhibited at the New York World's Fair in 1939, launching the popularity of Scandinavian design in America. The natural lightness of beech, birch, and ash along with the soft contours of their furniture designs helped set the tone for the Contemporary style throughout the postwar decade (Figure 9–61).

Contemporary Culture and World War II

America's economic recovery from the Great Depression in the 1930s was slow. Government intervention through the Works Progress Administration and the New Deal introduced by President Franklin Roosevelt (term, 1933–1945) boosted manufacturing and gave Americans the necessary

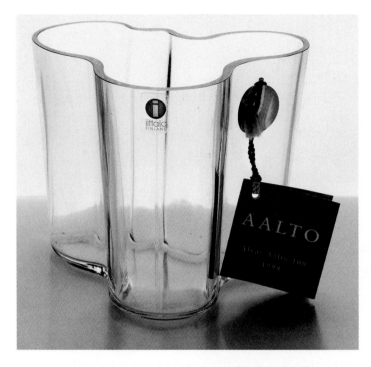

FIGURE 9–60 The Savoy Vase originally designed by the Aaltos in 1936 celebrates biomorphic form.
© *Judith Miller/Dorling Kindersley/Mum Had That*

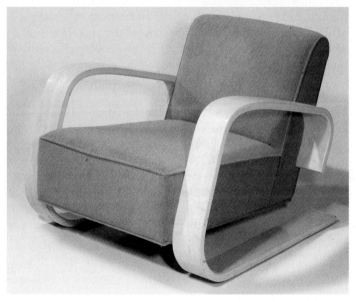

FIGURE 9–61 Lounge Chair 37, designed by Alvar Aalto in 1935 and produced by Artek, features a cantilevered bentwood frame made from birch.
© *Judith Miller/Dorling Kindersley/Freeman's*

means to support economic recovery. While Americans dealt with the Great Depression, independent European countries cautiously watched the activities of the National Socialist Party in Germany. Adolf Hitler's leadership as chancellor of Germany in 1933 led to the stronghold of Nazi power, which infiltrated Austria and Czechoslovakia. In 1939, Hitler ordered the invasion of Poland, which launched World War II. The war accelerated over the next two years, engulfing most of Europe, Great Britain, parts of Russia, Greece, North Africa, and the Pacific Islands.

At the onset of the war, the European governments involved restricted manufacturing to shift all efforts toward the production of wartime equipment. The United States

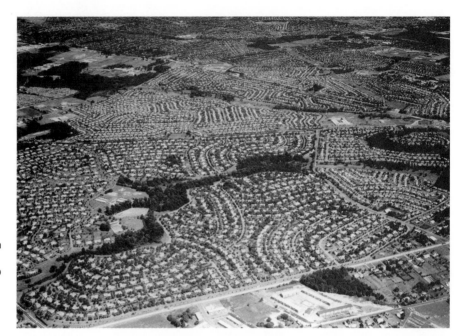

FIGURE 9–62 This 1949 photo shows the Levittown suburb in Pennsylvania built by developer William J. Levitt. Houses were primarily small capes and were mass-produced to keep them affordable to the returning G.I.s from World War II.
Pennsylvania Dutch Convention and Visitors Bureau

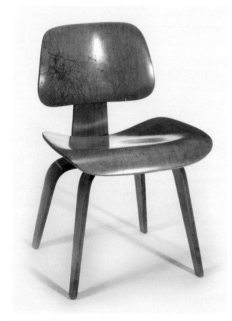

FIGURE 9–63 This Charles and Ray Eames plywood chair made by Herman Miller in 1946 features the award-winning design of the 1940 Organic Design in Home Furnishings competition sponsored by the Museum of Modern Art in New York.
© *Judith Miller/Dorling Kindersley/Freeman's*

entered the war in 1941 and was faced with similar restrictions, although the increase in manufacturing wartime equipment helped bring the country out of the Depression. Wartime restrictions and a shortage of raw materials led to the development of new materials including plywood, galvanized rubber, fiberglass, synthetic fibers, and PVC plastics. Turning to these resources, inspired designers created interior furnishings in new Contemporary styles, which were put to good use when the war ended.

Following the war, Europe was faced with rebuilding its bombed-out cities. In Britain, rationing remained in effect well into the 1950s. The United States faced a housing shortage as thousands of veterans returned eager to begin family life. In 1947, the American landscape was changed forever as suburban developments offered inexpensive, mass-produced housing (Figure 9–62). Designed and built with a sense of economy using prefabricated materials, these houses featured informal living spaces that created a casual atmosphere. The interior furnishings were equally casual and inexpensive for the time.

Organic Design in Home Furnishings

In 1940, the Museum of Modern Art (MOMA) in New York sponsored a competition with the central theme "Organic Design in Home Furnishings." Furniture, textile, and lighting designers were encouraged to send in entries, and the winners were promised manufacturing contracts to have their works produced. The results launched the Contemporary style of design in America and introduced casual and affordable interior furnishings designed with style and taste (Figure 9–63). However, when the United States entered the war in 1941, the production of the furnishings was interrupted as war rationing and government restrictions halted the production of unnecessary domestic objects.

Instructors and students associated with the Cranbrook Academy of Art before the United States entered World War II in 1941—including Charles Eames (1907–1978), Ray-Bernice Kaiser Eames (1912–1988), Eero Saarinen (1910–1961), Florence Schust Knoll (b. 1917), and Harry Bertoia (1915–1978)—brought America into the forefront of world design, setting the tone for the Contemporary style of design in the decades that followed. Eames and Saarinen won the competition at MOMA, and after the war their designs were manufactured by the Herman Miller Company in Michigan (operated by the father of Howard Miller, who produced clocks).

American Contemporary styles were organic in form, yet featured some of the latest synthetic materials (Figure 9–64). Press-formed plastic, molded plywood and fiberglass, along with foam rubber, aluminum, and plastic laminate were popular materials used in the manufacturing of home furnishings in the postwar period. Additionally, designs were inspired by the post-atomic age; the bombs dropped on Hiroshima and Nagasaki to end the war created an interest in science and technology (Figure 9–65). The home furnishings industry eagerly adopted motifs

FIGURE 9–64 A fiberglass chair supported on thin metal legs designed by Charles and Ray Eames introduced consumers of the postwar era to ultralight, casual home furnishings.
© *Judith Miller/Dorling Kindersley/Chiswick Auctions*

FIGURE 9–65 An unusual building in Brussels built in the 1950s in the shape of the molecular structure of an atom.
Demetrio Carrasco © Dorling Kindersley

FIGURE 9–66 The Ball Clock by George Nelson, originally designed for Howard Miller in 1947, features a radial display of orange balls emulating the molecular structure of an atom.
© *Judith Miller/Dorling Kindersley/Freeman's*

FIGURE 9–67 The Atomic Lamp by Frederick Ramon Lighting features alternating bentwood, and green and blue Lucite bands.
© *Judith Miller/Dorling Kindersley/Freeman's*

resembling exploding atoms, amoeba-like biomorphic shapes, and molecular structures influenced by the discovery of the double helix of DNA in 1953 (Figures 9–66 through 9–68).

The influence of the Organic Design in Home Furnishings launched by the MOMA exhibition in 1940 crossed into almost all of the decorative arts by the mid-1950s, appearing in everything from ceramics to lamps. In operation since the late 1800s, Poole Pottery in Great Britain introduced a "free-form" collection that was hand thrown on the potter's wheel and hand painted (Figure 9–69). Glass designs followed the trends of the times (Figure 9–70). By the end of the decade,

FIGURE 9–68 This free-form vase from Poole Pottery designed between 1955 and 1959 features a double helix design. The first scientifically correct drawing of the double helix of DNA was released in 1953.
© *Judith Miller/Dorling Kindersley/Art Deco Etc*

FIGURE 9–69 This Poole Pottery vase in the free-form style dates from around 1955 and emphasizes the period's adherence to organic form.
© *Judith Miller/Dorling Kindersley/Art Deco Etc*

the hard-edge geometry of the Bauhaus and De Stijl movements was quickly becoming passé.

Popular Culture of the 1960s

In 1957, scientific research and development propelled human beings toward space with the Russian launch of *Sputnik,* the world's first satellite. Landmark events in space exploration that occurred during the 1960s and 1970s influenced the current

FIGURE 9–70 This opalescent Orrefors glass vase features a biomorphic rim design.
© *Judith Miller/Dorling Kindersley/The Glass Merchant*

FIGURE 9–71 Italian architect Pier Liugi Nervi (1891–1979) designed the Olympic stadium in 1960 in a futuristic, space-age style emulating a "flying saucer."
© *David Lees/CORBIS*

generation of designers, and soon, space-age designs took over (Figure 9–71). The organic designs of the 1950s emulated spacecraft and space stations, and circular and futuristic interior furnishings followed (Figure 9–72). Home accessories were designed with a feeling of lightness, as if mass were suspended in space (Figures 9–73, 9–74). Finally, boomerang and biomorphic shapes replaced the rectangular styles of the Early Modern movement.

What was science fiction and a dream for the future in the 1950s became a reality in the 1960s. American president John F. Kennedy felt that the future lay in space and joined the Russians in a race to the moon. The World's Fair in 1964 held in New York City perpetuated the notion of space exploration. Attended by over fifty million people, the fair's theme, "Peace through Understanding," focused on the global community symbolized by a 140-foot steel sculpture of Earth. The *Unisphere* globe was placed at the end of the entrance promenade, giving viewers a peek at how the earth—tilted on its axis—would look from six thousand miles out in space (Figure 9–75). Eero Aarnio's (b. 1932) Ball Chair, designed in 1963, reflected the growing interest in planetary exploration (Figure 9–76).

FIGURE 9–72 Eero Saarinen designed the Tulip Chair in 1957 using molded fiberglass and plastic, aluminum, and foam upholstery. His designs for table and chairs feature a delicate pedestal support that gives the furniture the effect of weightlessness.
Courtesy of Knoll, Inc.

FIGURE 9–73 This vase from Orrefors was created using a two-step process of glassblowing that gives the colored area the appearance of floating above its translucent base.
© *Judith Miller/Dorling Kindersley/Nigel Benson*

FIGURE 9–74 This table lamp features a saucer-shaped base on spindly metal supports and has a pleated plastic shade.
© *Judith Miller/Dorling Kindersley/Manic Attic*

FIGURE 9–75 The massive globe sculpture *Unisphere*, from the 1964 World's Fair in New York City, shows the earth with rings tracking the orbits of the astronauts of the time.
Dave King © Dorling Kindersley

FIGURE 9–76 The orange Ball Chair designed in 1965 by Eero Aarnio creates the whimsical feeling of sitting inside a sphere. The upholstery fabric is Dacron polyester, the latest in synthetic fibers.
© Judith Miller/Dorling Kindersley/Lyon and Turnbull Ltd.

FIGURE 9–77 The *Habitat* housing project by Moshe Safdie for the Montreal Expo in 1967 features prefabricated "pods" assembled on-site.
Pearson Education/PH College

Furthermore, Expo '67 in Montreal, Canada; director Stanley Kubrick's (1928–1999) landmark movie *2001: A Space Odyssey,* released in 1968; and the U.S. moon landing in 1969 kept space-age designs in the forefront of popular culture through the early 1970s. Architect Moshe Safdie (b. 1938) designed *Habitat* for Expo '67, a futuristic housing project made from prefabricated building materials (Figure 9–77). Each room was a self-contained "pod" made in a factory, which was then shipped to the site and connected to other pods. The concept enabled the housing units to be expanded by adding more pods—a precursor to the concept behind the International Space Station of today. Space-age gimmicks were prevalent throughout the 1960s and 1970s in the design of household furnishings (Figure 9–78). Other industries responded by producing goods that suggested the future of space (Figure 9–79).

During the 1960s, the explosion of youth culture from the baby boomers—children of postwar veterans—led to yet another shift in design. Inspired by the pop art movement, designers evoked whimsy, fantasy, and gimmick, along with the notion of someday living in outer space, in their work. Pop art first appeared in London and New York with British artist

FIGURE 9–78 These mirrors show the influence of space; one has a bubble border design and the other features the rings of Saturn.
© *Judith Miller/Dorling Kindersley/Freeman's*

Richard Hamilton (b. 1922) leading the way with his iconographic collage from 1956, *Just What Is It That Makes Today's Homes So Different, So Appealing?* (Figure 9–80).

Hamilton's collage summarized popular culture and its unusual curiosities. The scene is set with the image of a glowing moon hovering above a living room outfitted with the latest in modern conveniences. A woman wearing a dress and high heels cleans a staircase with a new space-age vacuum cleaner, the Hoover Constellation, which actually hovered above the floor by the force of its exhaust. A bodybuilder holds a giant Tootsie Pop next to a coffee table that bears a canned picnic ham. The appearance of a film marquee, comic book page, and a television set along with a reel-to-reel tape recorder subliminally reminds viewers how often they are bombarded with images and sound. Completing the scene, a nude woman sits on a modern designed sofa wearing a spoof of the lamp shade hat made popular by Parisian couture.

The pop art movement captured the interest in consumerism provoked by television, magazine, and billboard advertisements integrated into popular culture. Artist Andy Warhol (1927–1987) turned ordinary consumer objects such as the Campbell Soup can and Coca Cola bottles into art through oversized and colorful silk screens. By the 1960s, it

FIGURE 9–79 Lava lamps contain two liquids that will not blend together; when subjected to the heat of the lamp, the colored liquids float as if defying gravity.
Steve Shott © Dorling Kindersley

FIGURE 9–80 *Just What Is It That Makes Today's Homes So Different, So Appealing?* by Richard Hamilton launched the pop art movement in London in 1956.
Kunsthalle, Tubingen, Germany/ The Bridgeman Art Library

appeared that the more gimmicky the idea, the more of a reaction it received from the public (Figure 9–81). Pop art capitalized on this and influenced a new generation of designers. Aptly titled, Robert Hughes's (b. 1938) book *The Shock of the New,* published in 1981, chronicled the changes in modern art and its impact on society in the twentieth century.

Pottery

Home furnishings matched wits with pop art by providing high-style ceramics and glassware with designs that followed the characteristics of modern art. Influenced by the work of Warhol and artist Peter Max (b. 1937), designers created abstracted city scenes in bright transfer-printed colors, and stylized flowers (Figure 9–82). The Midwinter pottery factory in Great Britain produced a collection of dinnerware for the hip new lifestyle of young homeowners (Figure 9–83). High-end collections were hand painted, and Midwinter retained artists to meet the demands of a burgeoning market. Madoura Pottery, located in France, was fortunate enough to pique the interest of world-renowned modern artist Pablo Picasso (1881–1973). Their exclusive pottery collections painted by Picasso appealed to the high-end collector and were produced from 1947 to 1971 (Figure 9–84).

Glass

Brightly colored tableware, vases, and knickknacks with stylized or abstracted designs were also produced in glass. Artist Peter Max captured the bright, psychedelic colors and bold patterns of the era in his silk-screen paintings, which were turned into inexpensive and easily purchased posters and transferred onto household accessories (Figure 9–85). Although the Chance glass factory in Great Britain had been around since the early nineteenth century and supplied the glass for the Crystal Palace in London, their collection of designs from the 1950s, 1960s, and 1970s set new directions for hip style and innovative manufacturing processes. Chance began applying the transfer process, which had been used for two centuries by potters, to print intricate designs onto glass (Figure 9–86). This process brought the cost within financial reach of young consumers.

The slogan "Flower Power," first coined in 1965, captured the carefree attitudes of a young generation that fought against government establishments and the accelerating crisis of the Vietnam War. Warhol created a series of silk screens of larger-than-life poppies, the flower symbolizing the remembrance of war veterans since World War I (Figure 9–87). To the young

FIGURE 9–81 The Joe Sofa, named for American Baseball legend Joe DiMaggio in 1971, captures pop culture's interest in designs with a gimmick. *Courtesy Palazzetti*

FIGURE 9–82 This storage jar from Staffordshire Potteries features stylized shocking pink and orange flowers and dates from the 1960s. *© Judith Miller/Dorling Kindersley/Wallis and Wallis*

FIGURE 9–83 This coffee set by designer Nigel Wylde features an abstracted cherry tree design in transfer print.
© *Judith Miller/Dorling Kindersley/Festival*

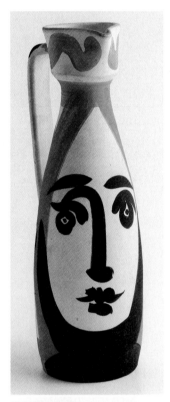

FIGURE 9–84 This pottery jug painted in bright yellow and black by artist Pablo Picasso features an abstracted face.
© *Judith Miller/Dorling Kindersley/Woolley and Wallis*

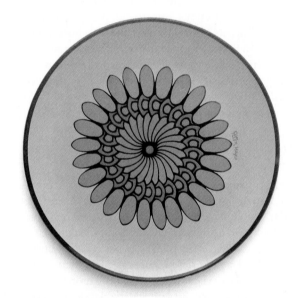

FIGURE 9–85 This glass dish features a screen-printed decoration designed by Peter Max.
© *Judith Miller/Dorling Kindersley/Wallis and Wallis*

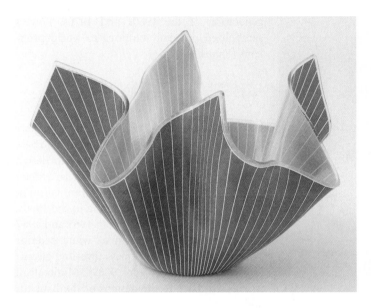

FIGURE 9–86 This vase dates from the 1960s and was made by the Chance glass factory. The vase shape was dubbed "handkerchief," and many companies copied the original design. Handkerchief vases came in a variety of colors and designs, which were transfer printed onto the surface of the glass. *© Judith Miller/Dorling Kindersley/Mum Had That*

FIGURE 9–87 American pop artist Andy Warhol stands in front of his silk screen of flowers. *Getty Images Inc. - Hulton Archive Photos*

FIGURE 9–88 This patterned fabric features the bright colors of abstracted poppies.
© Judith Miller/Dorling Kindersley/Luna

generation of the 1960s and 1970s, flowers symbolized peaceful solutions to world problems (Figure 9–88).

Minimalism

The set designs from the movie *2001: A Space Odyssey* featuring futuristic, stark white, and bare interiors made popular a new trend in design aptly called minimalism. Architect Richard Meier (b. 1934) captured the essence of minimalism in the residences he began designing in the 1960s. The Smith House, built between 1965 and 1967 in Connecticut, features an all-white exterior punctuated by expansive glass revealing gleaming white interiors (Figure 9–89). Minimalism was a throwback to the designs of the Bauhaus and De Stijl movements, bringing back a sense of geometrical massing and clean lines. White walls, stair rails, columns, and furniture juxtaposed against the richness of natural hardwood floors inside the Smith House emphasized Meier's geometrical organization of shape and mass.

Minimalism quickly became the latest new fashion in design. Interior spaces left white and uncluttered were accented by brilliantly colored accessories featuring the

FIGURE 9–89 Richard Meier's designs for the Smith House in Connecticut feature a minimalist interior with understated, built-in furnishings, gleaming white walls, and hardwood floors.
© Ezra Stoller/Esto.

form of the object rather than its decoration (Figure 9–90). The bright, psychedelic colors of the 1960s were replaced with earthy undertones such as burnt orange, avocado green, sienna brown, and creamy white (Figure 9–91). The organic shapes of the postwar era were fashioned into furniture and decorative accessories proving the malleability of plastics (Figure 9–92). Moreover, as plastics took over as the new wonder material, high design was available to a younger generation with limited funds. Through synthetic materials and sophisticated manufacturing processes, more and more goods were now available at lower prices.

Italian designer Joe Colombo (1930–1971) and Danish designer Verner Panton (1926–1998) began designing furniture and household accessories to be manufactured out of plastic. With Colombo's vision for the "habitat of the future" and Panton's idea of the "total environment," both designers focused on using plastics to create all-in-one, completely coordinated interiors (Figures 9–93, 9–94). Each came up with designs for stackable chairs made from one piece of molded plastic. Colombo's Universale Chair, introduced in 1965, was finally mass-produced in 1967; simultaneously, Panton worked on designs for his version, and the Panton Chair went into production in 1968 (Figure 9–95).

FIGURE 9–90 Mold-blown vases from the 1970s feature simple concentric circular forms shaped from colored glass.
© *Judith Miller/Dorling Kindersley/Mum Had That*

FIGURE 9–91 This textile design with its interlocking squares of color on a brown background indicates the popularity of bright orange in the 1970s.
© *Judith Miller/Dorling Kindersley/Luna*

FIGURE 9–92 The simple, straight line shaft of the Megaron floor lamp designed by Gianfranco Frattini (b. 1925) is made from thermoplastic resin.
© *Judith Miller/Dorling Kindersley/Freeman's*

FIGURE 9–93 This Joe Colombo chair made from three pieces of lacquered laminated wood was a precursor to his Universale Chair made from one piece of molded plastic.
© *Judith Miller/Dorling Kindersley/Sloan's*

FIGURE 9–94 This lamp designed by Joe Colombo for Kartell has a molded plastic shade and base.
© *Judith Miller/Dorling Kindersley/Lyon and Turnbull Ltd.*

Postmodernism

By the mid-1970s, whimsical pop art and space-age designs were considered kitsch. The contemporary designs of the postwar era had relinquished their hold over popular culture. Architect Robert Venturi (b. 1925), in his groundbreaking book *Complexity and Contradiction in Architecture*, published in 1966, proposed a vernacular approach to design, incorporating the local character of "place" rather than the nondescript rationalism associated with the Early Modern and International styles. His book put the wheels in motion for the Postmodern movement of the 1980s.

Launching what would become the Postmodern movement in design, Charles Jencks's book *The Language of Postmodern Architecture*, published in 1977, raised an awareness of the importance of designing architecture that could be understood by the broad spectrum of society. Jencks felt that design needed to "communicate with the public" and pushed for a responsible approach to urbanism that he felt was lacking in current "glass box" architecture. In the end, Postmodern designers often turned toward a romantic, sometimes sentimental interpretation of the past.

Michael Graves (b. 1934) was one of the first architects to explore Postmodernism in his design for the city of Portland, Oregon (Figure 9–96). The building, shocking when first completed in 1980, appeared as a pop art interpretation of Neoclassicism—overscaled pilasters; flattened festoons; and a sympathetic treatment of classical massing of structure that emphasized distinct base, middle, and top sections all appearing in bright colors. Graves designed other projects in a similar style for Disney, and critics began calling his work "Disneyesque."

FIGURE 9–95 A pair of stacking chairs by Verner Panton in bright orange sits in front of a minimalist chrome floor lamp with plastic shade. © *Judith Miller/Dorling Kindersley/Lyon and Turnbull Ltd.*

As the decade of the 1980s began, designers working in a Postmodern approach began to interpret historicism in unique ways. Venturi designed a collection of chairs for Knoll based on styles of the past including Chippendale, Hepplewhite, and Art Deco, among others. Unlike the designs from the Rococo and Neoclassic periods, his were made from laminated bentwood and featured bright colors with bold patterns; some critics described them as "cartoon-like" fashion (Figure 9–97). French furniture designer turned architect Philippe Starck (b. 1949) gained world renown with the completion of the Paramount Hotel in New York City in the 1990s. Reminiscent of old Hollywood, the lobby space features a retro Art Deco look. Starck relieved the banality of small, cramped rooms and dull architecture with imaginative furniture and accessories on the cutting edge of design and clever, oversized reproductions of Baroque period paintings (Figure 9–98). Like Venturi and Graves, Starck reinvented styles of the past into a fresh new aesthetic without resorting to Victorian revivalist conceptions.

Little did William Morris know that the "shoddy machine-made goods" of the late nineteenth and early twentieth centuries would find their places among the most elaborate handmade items in the history of the decorative arts. Yet, designers working at the fin de siecle of the twentieth century, like those working at the end of the nineteenth century, still debated the issue between craft and quality. Both Graves and Starck designed

FIGURE 9–96 The Portland Building, designed by Michael Graves in 1980, indicates an emerging Postmodern style.

Bruce Forster © Dorling Kindersley

high-end domestic products for the Italian company Alessi. Their designs captured an enthusiasm for freshness, and both went on to design for other high-end companies—Graves for Steuben and Lenox, and Starck for Vitra and O. W. O. (Figures 9–99, 9–100).

When Target department stores launched a new campaign, "Design for All," in 1990, both Graves and Starck embarked on designing affordable goods for Target's middle-class consumer market. The concept of achieving high style in affordable domestic products was first introduced by Charles and Ray Eames in the 1940s and industrial designers such as Norman Bel Geddes and Henry Dreyfuss. By the end of the century, retail stores such as Target and IKEA became leaders in providing well-designed household furniture and accessories within the financial reach of the average consumer (Figure 9–101).

The Twenty-First Century

At the turn of the twenty-first century, the urban landscape was dazzled by the daring architecture of Canadian architect Frank Gehry (b. 1929). His highly charged designs first appeared in the house he designed for himself in Santa Monica, California, in 1978, in which he experimented with wildly projecting walls clad with corrugated metal and chain link. His fascination with the sculptural massing of a building with

FIGURE 9–97 A collection of chairs designed by Robert Venturi and Denise Scott-Brown (b. 1931) in 1984 reinterprets traditional English designs of the eighteenth century with a Postmodern flavor.

FIGURE 9–98 The view into this guest room at the Paramount Hotel in New York City reveals an interesting juxtaposition of modern and traditional design. Designed by Philippe Starck in 1990, the hotel was one in a series of "boutique" hotels for Ian Schrager.
Esto Photographics, Inc.

FIGURE 9–99 Michael Graves's iconic tea kettle designed for Alessi in 1985 features a whimsical bird-shaped cap that whistles when the water boils.
Clive Streeter © Dorling Kindersley

FIGURE 9–100 Philippe Starck's Miss Sissi Lamp, designed for Flos in 1991, is made of plastic.
Steve Gorton © Dorling Kindersley

FIGURE 9–101 Chairs of sculpted steel tubing covered in mesh surround a metal folding table in this minimalist interior.
Jake Fitzjones © Dorling Kindersley

shiny, metal-clad surfaces was revealed in several projects in the late 1990s, including the Experience Music Project in Seattle, Washington; the Guggenheim Museum in Bilbao, Spain; and his recently completed Walt Disney Concert Hall in Los Angeles, California (Figure 9–102).

FIGURE 9–102 The exterior of the Walt Disney Concert Hall with its billowing stainless steel walls of sculptural intensity was designed by Frank Gehry and opened in 2003.
Scott Pitts © Dorling Kindersley

FIGURE 9–103 The cafeteria for the headquarters of Conde Nast Publications by Frank Gehry is a three-dimensional sculptural experience of form, color, and rhythm.
Michael Moran Photography, Inc.

Gehry's exploration of architecture as sculpture paved the way for ultimate freedom in design and creativity for the next century. His brilliant architecture encouraged designers to be as creative as possible and realize that anything is achievable in the realm of style and taste (Figure 9–103). The new global culture of the twenty-first century welcomes change, diversity, and individualism without restrictions or boundaries; ultimately, being part of a trend is no longer trendy.

Adamesque In the style of Robert Adam.

alabaster A natural calcite or gypsum material of translucent, creamy white coloring suitable for carving; was used in windows before glass panes.

amphora An egg-shaped Greek vase designed with a long neck and side handles; used to store and pour liquids.

amulet An Egyptian talisman or charm used to bring good luck or ward off evil.

Anaglypta The brand name for an embossed wallpaper with patterns in low relief.

aniline dyes Dyes made from a synthetic material derived from coal tar.

arabesque A free-flowing motif using flora, vines, or foliate patterns.

arcuated architecture A form of architecture that uses arches to carry the load of a building or structure.

Aubusson A flatly woven carpet, rug, or tapestry usually in soft pastel colors featuring floral and foliate designs.

Bakelite A plastic-like substance made from phenolic resins.

baluster A stile in the shape of an elongated vase, or bulbous in its design.

banding A narrow border of a contrasting material that follows the perimeter of an object to emphasize its surface.

biscuit ware Ceramic fired without glaze; the ceramic is left in its natural finish. Also called *bisque.*

bobbin lace Handmade lace made using wooden bobbins for managing the threads while weaving the lace.

bone china Porcelain with bone ash added to strengthen the clay and keep it from chipping once fired.

brass An alloy of copper and zinc.

bric-a-brac Small decorative objects collected for their sentimental or aesthetic value.

brocade A textile (originally silk) having fluid foliate and arabesque patterns woven into the fabric in contrasting values or colors.

bronze An alloy of copper and tin.

bulbous form Swelling form.

burnishing Polishing a metal surface to make it shine or bring out the patina.

calcite A mineral of calcium carbonate.

cameo glass Glass made by cutting away layered or laminated glass to expose the colors underneath.

candelabra A candleholder with multiple cups or branching arms.

cartoon A preliminary drawing or sketch used as a pattern for paintings, tapestries, or carpet designs.

carving The process of cutting into the surface material either wholly or in part to create pattern or relief.

case good/case piece Any furniture item used for storage including bookcases, bureaus, chests, china cabinets, and armoires.

casket A small chest or a large box.

cellulosic fibers Fibers obtained from plants or grasses.

ceramics Objects created from natural materials, usually clay. The objects are formed, then hardened by exposing them to heat. This firing process makes the material hard and impervious.

certosina The Italian term used to describe light-colored wood, bone, or ivory inlaid against a dark background.

chasing The process of cutting, embossing, or incising metal to create a design or pattern.

cheval A freestanding floor mirror.

chinoiserie A French term describing design motifs possessing distinctive Chinese styling.

chintz A textile of woven cotton having a printed pattern or design and a shiny finish.

cloisonné A type of enameling in which the design is created by fusing copper bands onto a surface. These cells maintain color separation through the firing process. The object is cooled and then polished to give the copper the appearance of gold.

concrete A building material made from cement and aggregate materials.

creamware Fine white earthenware developed after 1750.

cristallo The Italian word for crystal.

crockets Ornamental finials resembling the shape of the hilt on medieval swords.

crystal Colorless glass of high quality.

damask A textile with flatly woven monochromatic floral designs.

Delftware A style of earthenware with origins in Delft, the Netherlands.

earthenware Pottery fired at low temperatures, often making it coarser and more porous than other ceramics.

embossed A raised design created by stamping, molding, or carving.

embroidery The process of creating a design or pattern on cloth using thread and a needle.

enamel A surface treatment used to create a shiny or glossy finish.

etching The process of scratching into the surface of a material to create pattern or texture.

façade In architecture, the face of a building; usually the main entrance or side bearing architectural significance.

faience A glassy paste usually applied over earthenware or pottery to give the object the appearance of glass once fired.

finial An upright decorative object formed in a variety of shapes.

firing Subjecting an object to heat, as in pottery or cloisonné work.

flatware Completed metalwork having a thin surface as in plates, platters, forks, knives, and spoons.

flax The plant from which linen is made.

fluting Concave cut parallel grooves used as a decorative surface treatment. The process of fluting originates from Greek architecture; column shafts were decorated in this manner.

fresco A wall painting done on wet plaster.

fruitwood Wood from apple, cherry, or pear trees.

gable A triangular roofline.

gilding The process of applying gold leaf to a prepared surface such as wood or plaster.

glaze In ceramics, a coating applied to the surface of clay to give color or gloss. The glaze is activated by firing.

gold leaf Thin sheets of flattened gold used to decorate surfaces.

goldsmith A metal smith trained to work with gold.

great hall The largest room in a medieval castle.

grillwork Any design fashioned from open metalwork.

gros point Lacework featuring large-scale designs; needlework created with large stitches.

guilloche A decorative motif of interlocking circles with or without further embellishments.

hallmark strike The insignia of the maker; seen on metalware and pottery.

hard-paste porcelain Porcelain made from a ceramic material with good plasticity that holds its shape through firing, offering maximum sculptural capabilities.

hieroglyphics An ancient Egyptian form of writing using pictures or symbols to represent words or ideas.

hollowware Metalwork in modeled shapes, such as a teapot, bowl, or pitcher; the opposite of flatware, which refers to forks, spoons, knives, and so on.

incising Digging into the surface of an object with a sharp tool.

inlay The process of imbedding a variety of materials—including contrasting woods, bone, ivory, metal, and semi-precious stones—into a surface to create a decorative effect.

intarsia The Italian term for inlay of different colored woods.

iridescent Containing the bright luster of color on a surface.

ivory The teeth or tusks of an animal.

Jacquard A mechanized loom that uses a punch card system for creating an even and consistent pattern.

japanning A painting and varnishing process that imitates Oriental lacquerwork.

jasperware A hard biscuit ware pottery popularized by Wedgwood in the eighteenth century; essentially, unglazed porcelain.

klismos A Greek side chair having a concave back and saber legs.

knickknacks Small decorative objects collected for their aesthetic value.

krater A two-handled piece of Greek pottery used as a mixing bowl.

kylix A footed Greek drinking cup, with or without handles.

lace A type of needlework that leaves open areas as part of the design.

lacquer A glossy finish made from a natural or synthetic substance.

lead crystal Crystal with lead added for strength.

Lincrusta The brand name for an embossed wallpaper with patterns in low relief.

longcase clock A type of clock large enough to stand on the floor.

loom A weaving apparatus with a framework for attaching warp and weft yarns.

majolica, maiolica Tin-glazed earthenware (Italian).

mallorca Tin-glazed earthenware (Spanish).

marquetry A decorative treatment whereby colored wood, ivory, mother-of-pearl, metal, or tortoiseshell is inlaid into a veneered surface.

melamine A plastic made from resin.

millefleur Translated as "thousand flowers," the term refers to the appearance of a field of flowers in a design; often seen in tapestries.

millwork Woodworking including moldings, trim, stairs, window sashes, and doors.

moquette Carpeting made by sewing sections of woven carpet together to cover a room from wall to wall (eighteenth and nineteenth centuries).

mosaic A decorative wall or floor covering created by placing small pieces of colored stone, glass, or tile in a mortar or cement ground.

mother-of-pearl The iridescent layer inside certain seashells.

motif A recurring design.

Mudéjar A style of ornament based on a combination of Spanish, Christian, and Moorish influences.

mural A wall painting.

Murano glass A type of high-quality glass produced in the Italian municipality of Murano.

needlepoint Embroidery using threads to create a design or pattern on a canvas or open weave cloth.

objet d'art Literally translated from the French, "art object" refers to any small art object.

obsidian A natural siliceous (glass) substance formed from volcanic eruptions.

ormolu Brass or bronze mounts applied to furniture and other decorative accessories.

Palladian In the style of Andrea Palladio.

parcel gilt Partial gilding.

pargework A decorative treatment using molded or carved plaster; usually used on ceilings.

pâte-sur-pâte A decorative treatment on porcelain used to achieve the look of cut-glass cameo.

petit point Lacework featuring small-scale designs; needlework created with small stitches.

pewter A metal alloy of tin and lead.

pierced tracery Tracery with open cut work designs.

pietra dura Literally translated from the Italian, "hard stone" refers to colored marble mosaic.

pilaster A squared column with one side attached to a background.

pillow lace Handmade lace made by pinning the work to a pillow while weaving.

piqué An inlay design using metal and combinations of ivory, tortoiseshell, and stone.

plaster A mixture of lime, sand, and water.

plinth A small block placed at the base of a column, pilaster, or pedestal, or anything resembling this feature.

polychrome Having many colors.

porcelain A durable type of pottery with a fine texture and white, translucent color.

post and lintel construction A construction method for buildings and structures relying on posts or columns and lintels or beams to support the load.

pottery Objects made from clay and hardened by exposure to heat.

pottery shards Pottery fragments taken from excavated sites.

PVC Polyvinyl chloride; used to make plastics.

quatrefoil A design motif with four lobes or foils dating from the medieval period.

reed A grasslike stalk of cellulosic material.

refectory A room used for dining.

relief A raised design created by carving, molding, or repoussé work.

repoussé Metalwork designs created by hammering one side of an object to create a relief effect on the opposite side.

Sandwich glass A type of press-molded glass originating from a factory in Sandwich, Massachusetts, or anything resembling these patterns.

Savonnerie A high-quality knotted pile carpet or rug originally made in France.

scrimshaw Objects made from whale bone or ivory.

shagreen Sharkskin used as a veneer on surfaces of Art Deco furniture and accessories.

silver plate Items made from an application of silver over copper.

silversmith A metal smith trained to work with silver.

singerie The French term describing design motifs depicting frolicking monkeys.

slip Clay mixed with water to create a creamlike consistency. Slip acts as a bonding agent to join two pieces of clay before firing, or as a decorative treatment if colored.

soft-paste porcelain Porcelain made from a ceramic material with low plasticity, which limits its sculptural capabilities.

spindle (furniture) A shaped rod usually made from wood and turned on a lathe.

spindle (weaving) A shaped rod used to carry the weft yarns through a loom.

stained glass Glass created by applying color with pigment.

steel An alloy of iron and carbon.

sterling silver An alloy of 92.5 percent silver and 7.5 percent other metals.

stoneware Pottery fired at high temperatures to give it strength.

stucco A mixture of lime, sand, cement, and water.

taffeta A lightweight woven fabric with a crisp hand and high sheen.

tapestry A woven textile with the decorative pattern or design worked into the looming process.

taracea The Spanish term for inlay; usually bone, ivory, mother-of-pearl, and colored woods.

terra-cotta Coarse clay that maintains its reddish coloring after firing.

tesserae Small pieces of colored stone, glass, or tile used in mosaics.

textiles Woven fabrics, carpet, upholstery, or tapestry.

toile de Jouy A printed cotton textile made in Jouy en Josas, France, and popularized during the eighteenth and nineteenth centuries.

tole Enameled or painted metalwares.

torchère A lamp large enough to stand on the floor.

tortoiseshell Hawksbill turtle shell with a reddish brown and yellow mottled appearance.

trabeated Post and lintel construction.

tracery In architecture, decorative stone mullions used in windows such as those that hold the stained glass in a Gothic cathedral. A decorative carving that imitates this cut stonework.

treenware Small household objects made by carving or hollowing out wood.

trefoil A design motif with three lobes or foils dating from the medieval period.

trompe l'oeil French for "fool the eye"; refers to a type of illusionist painting giving the appearance of three dimensions.

unguents Perfumed ointments, lotions, or salves used by the ancient Egyptians.

velvet A woven textile with a cut pile.

warp The vertical yarns on a loom or in a weaving.

weaving The process of interlacing fibers or yarns using an over-under method or similar variation or process.

weft The horizontal yarns on a loom or in a weaving.

Wilton carpet A type of looped pile carpeting woven on a loom.

wrought iron Iron with a low carbon content making it easy to shape.

Further Readings

This bibliography offers a selection of the most current publications on the decorative arts. The list avoids collector-type books, focusing instead on publications representing scholarly research. For monographs on individual designers, it is best to consult Internet bookstores. This list is a testament to the fact that more scholarly research and publication in the field of the decorative arts is needed. Furthermore, several scholarly publications on the decorative arts are out of print and are excluded from this compilation of titles.

General Studies

Aav, Marianne, and Nina Stritzler-Levine, eds. *Finnish Modern Design: Utopian Ideals and Everyday Realities, 1930–97.* New Haven: Yale University Press, 2000.

Arwas, Victor. *Art Nouveau: The French Aesthetic.* London: Andreas Papadakis Publishers, 2002.

Blonston, Gary, and William Morris. *William Morris: Artifacts/Glass.* 1st ed. New York: Abbeville Press, 1996.

Campbell, Gordon. *The Grove Encyclopedia of Decorative Arts.* Oxford: Oxford University Press, 2006.

Cherry, Deborah, and Katie Scott, eds. *Between Luxury and the Everyday: French Decorative Arts in the Eighteenth Century.* Oxford: Blackwell Publishing Limited, 2006.

Eversmann, Pauline. *The Winterthur Guide to Recognizing Styles: American Decorative Arts from the 17th through the 19th Centuries.* 1st ed. Winterthur, DE: Winterthur, 2001.

Greenhalgh, Paul. *Art Nouveau, 1890–1914.* New York: Harry N. Abrams, 2000.

Gruber, Alain, ed. *The History of Decorative Arts: Renaissance and Mannerism in Europe.* New York: Abbeville Press, 1994.

J. Paul Getty Museum. *Summary Catalogue of Decorative Arts in the J. Paul Getty Museum.* Los Angeles: Getty Trust Publications, 2002.

Krill, Rosemary Troy. *Early American Decorative Arts, 1620–1860: A Handbook for Interpreters.* Rev. ed. Lanham, MD: AltaMira Press, 2000.

Luchs, Alison. *Western Decorative Arts: The Collections of the National Gallery of Art Systematic Catalogue.* Cambridge: Cambridge University Press, 1994.

Ostergard, Derek E., ed. *The Sevres Porcelain Manufactory: Alexandre Brongniart and the Triumph of Art and Industry, 1800–1847.* New Haven: Yale University Press, 1997.

Pons, Bruno, Johan R. Ter Molen, Ursula Reinhardt, Robert Fohr, and Alain Gruber, eds. *Classicism and the Baroque in Europe: History of Decorative Arts.* New York: Abbeville Press, 1996.

Riley, Noel, and Patricia Bayer, eds. *The Elements of Design: A Practical Encyclopedia of the Decorative Arts from the Renaissance to the Present.* New York: Free Press, 2003.

Snodin, Michael, and John Styles. *Design and the Decorative Arts.* London: V & A Publications, 2001.

Snodin, Michael, and John Styles, eds. *Design and the Decorative Arts: Georgian Britain 1714–1837.* London: Victoria & Albert Museum, 2004.

Tise, Suzanne, and Yvonne Branhammer. *Decorative Arts of France 1900–1942.* New York: Rizzoli, 1990.

Troy, Nancy J. *Modernism and the Decorative Arts in France: Art Nouveau to Le Corbusier.* New Haven: Yale University Press, 1991.

Wood, Ghislaine. *Essential Art Deco.* 1st North American edition. Boston: Bulfinch, 2003.

Woodham, Jonathan M. *Twentieth-Century Design.* Oxford: Oxford University Press, 1997.

Clocks

Cipolla, Carlo, and Anthony Grafton. *Clocks and Culture: 1300–1700.* New York: W. W. Norton & Company, 2003.

Dohrn-van Rossum, Gerhard, and Thomas Dunlap, trans. *History of the Hour: Clocks and Modern Temporal Orders.* Chicago: University of Chicago Press, 1998.

Glass

Arwas, Victor, and Susan Newell. *The Art of Glass: Art Nouveau to Art Deco.* New York: Rizzoli International Publications, 1997.

Brown, Sarah, and David O'Connor. *The Glass-Painters (Medieval Craftsmen).* Toronto: University of Toronto Press, 1991.

Curtis, Jean-Louis, Jacques Boulay, and Jean-Michel Tardy. *Baccarat*. New York: Harry N. Abrams, 1992.

Fleming, Stuart James. *Roman Glass: Reflections of Everyday Life*. Philadelphia: University Museum Publications, 1997.

Gable, Carl I. *Murano Magic: Complete Guide to Venetian Glass, Its History and Artists*. Atglen, PA: Schiffer Publishing, 2004.

Gudenrath, William, and Veronica Tatton-Brown. *Catalogue of Greek and Roman Glass in the British Museum: Non-Blown and Early Blown Glass*. London: British Museum Press, 2006.

Hatch, Carolyn. *Deco Lalique: Creator to Consumer*. Toronto: Royal Ontario Museum, 2007.

Macfarlane, Alan, and Gerry Martin. *Glass: A World History*. Chicago: University of Chicago Press, 2002.

Mentasti, Rosa Barovier. *Venetian Glass*. 1st ed. Venice: Arsenale Editrice, 2007.

Netzer, Nancy, and Hanns Swarzenski. *Medieval Objects in the Museum of Fine Arts Boston: Medieval Enamels and Glass*. Boston: Museum of Fine Arts Boston, 1986.

Nicholson, Paul T. *Egyptian Faience and Glass*. Buckinghamshire, England: Shire Publications, 1999.

Orrefors Glasbruk, Kerstin Wickman, and Dag Widman, eds. *Orrefors: A Century of Swedish Glassmaking*. Stockholm: Byggforlaget, 1999.

Ricke, Helmut, Jan Mergl, and Johann Lötz Witwe. *Lötz: Bohemian Glass 1880–1940*. Ostfildern, Germany: Hatje Cantz Publishers, 2003.

Ricke, Helmut, and Eva Schmitt, eds. *Art Nouveau Glass: The Gerda Koepff Collection*. Munich: Prestel Publishing, 2004.

Saliba, George, Linda Komaroff, and Catherine Hess, eds. *The Arts of Fire: Islamic Influences on Glass and Ceramics of the Italian Renaissance*. Los Angeles: Getty Trust Publications: J. Paul Getty Museum, 2004.

Stern, Marianne, Sylvia Funfschilling, and Johan Grimonprez. *Roman, Byzantine and Early Medieval Glass: Ernesto Wolf Collection*. Ostfildern, Germany: Hatje Cantz Publishers, 2001.

Tait, Hugh, ed. *Five Thousand Years of Glass*. Rev. ed. Philadelphia: University of Pennsylvania Press, 2004.

Turander, Ralf, Claes Britton, and Tom Rafstedt. *Gunnel Sahlin & Kosta Boda*. Corte Madera, CA: Gingko Press, 2000.

Warmus, William. *The Essential Rene Lalique*. New York: Harry N. Abrams, 2003.

Lighting

Dilaura, David L. *History of Light and Lighting*. New York: Illuminating Engineering, 2006.

Eidelberg, Martin, Alice Cooney Frelinghuysen, Nancy McClelland, and Lars Rachen. *The Lamps of Louis Comfort Tiffany*. New York: Vendome Press, 2005.

Metalworking

Bigelow, Francis Hill. *Historic Silver of the Colonies and Its Makers*. Whitefish, MT: Kessinger Publishing, 2005.

Hayes, John W. *Greek, Roman, and Related Metalware in the Royal Ontario Museum*. Toronto: Royal Ontario Museum, 1984.

Hornsby, Peter. *Pewter of the Western World, 1600–1850*. Atglen, PA: Schiffer Publishing, 1983.

Kauffman, Henry J. *Early American Copper, Tin & Brass: Handcrafted Metalware from Colonial Times*. Mendham, NJ: Astragal Press, 1995.

Pina, Leslie, and Donald-Brian Johnson. *The Chase Era: 1933 & 1942 Catalogs of the Chase Brass & Copper Co.* Atglen, PA: Schiffer Publishing, 2000.

Rainwater, Dorothy T., and Donna Felger. *American Silverplate*. 3rd ed. Atglen, PA: Schiffer Publishing, 2000.

Schroderti, Timothy. *English Domestic Silver: National Trust Book of English Domestic Silver and Metalware 1500–1900*. Reprint ed. London: Penguin, 1990.

Scott, Jack L. *Pewter Wares from Sheffield*. Baltimore: Antiquary Press, 1980.

Young, W. A. *The Silver and Sheffield Plate Collector*. London: Hesperides Press, 2006.

Pottery

Adams, Elizabeth. *Chelsea Porcelain*. Rev. ed. London: British Museum Press, 2002.

Birch, Samuel. *History of Ancient Pottery: Egyptian, Assyrian and Greek V1*. Whitefish, MT: Kessinger Publishing, 2006.

Bradshaw, Peter. *Derby Porcelain Figures, 1750–1848*. London: Faber & Faber, 1990.

Cook, R. M. *Greek Painted Pottery*. 3rd ed. Oxford: Routledge, 1997.

Cooper, Emmanuel. *Ten Thousand Years of Pottery*. 4th ed. Philadelphia: University of Pennsylvania Press, 2000.

Coutts, Howard. *The Art of Ceramics: European Ceramic Design 1500–1830*. New Haven: Yale University Press, 2001.

Elliott, Charles Wyllys. *Pottery and Porcelain*. Whitefish, MT: Kessinger Publishing, 2003.

Garner, Phillipe. *Emile Galle*. Rev. ed. New York: Rizzoli, 1990.

Greer, Georgeanna H. *American Stonewares: The Art and Craft of Utilitarian Potters*. 4th ed. Atglen, PA: Schiffer Publishing, 2005.

Hildyard, Robin. *European Ceramics*. Philadelphia: University of Pennsylvania Press, 1999.

Karmason, Marilyn G., and Joan B. Stacke. *Majolica: A Complete History and Illustrated Survey*. Rev. ed. New York: Harry N. Abrams, 2002.

Menzhausen, Ingelore. *Early Meissen Porcelain in Dresden*. New York: Thames & Hudson, 1990.

Peña, J. Theodore. *Roman Pottery in the Archaeological Record.* Cambridge: Cambridge University Press, 2007.

Poole, Julia E. *English Pottery.* Cambridge: Cambridge University Press, 1995.

Snyder, Jeffrey B. *Rookwood Pottery.* Atglen, PA: Schiffer Publishing, 2005.

Stevenson, Greg. *Art Deco Ceramics.* Buckinghamshire, England: Shire Publications, 1999.

van Dam, Jan Daniel. *Dutch Delftware 1620–1859.* Zwolle, The Netherlands: Waanders Uitgevers, 2007.

Wardell, Sasha. *Porcelain and Bone China.* Wiltshire, England: Crowood Press, 2005.

Whittle, Alasdair. *Europe in the Neolithic.* Rev. ed. Cambridge: Cambridge University Press, 2003.

Textiles

Brédif, Josette. *Toiles de Jouy: Classic Printed Textiles from France, 1760–1843.* London: Thames & Hudson, 1989.

Bremer-David, Charissa. *French Tapestries & Textiles in the J. Paul Getty Museum.* Los Angeles: Getty Trust Publications, 1997.

Broudy, Eric. *The Book of Looms: A History of the Handloom from Ancient Times to the Present.* New York: Van Nostrand Reinhold, 1979.

Cavallo, Adolfo Salvatore. *The Unicorn Tapestries in the Metropolitan Museum of Art.* New York: Metropolitan Museum of Art Publications, 2005.

Day, Susan. *Art Deco and Modernist Carpets.* San Francisco: Chronicle Books, 2002.

Delmarcel, Guy. *Flemish Tapestry.* New York: Harry N. Abrams, 2000.

Faraday, Cornelia Bateman. *European and American Carpets and Rugs: A History of the Hand-Woven Decorative Floor Coverings of Spain, France, Great Britain, Scandinavia, Belgium.* 2nd ed. Suffolk, England: Antique Collectors' Club, 1990.

Hackenbroch, Yvonne. *English and Other Needlework: Tapestries and Textiles in the Irwin Untermyer Collection.* Cambridge, MA: Harvard University Press, 1960.

Harris, Jennifer, ed. *Textiles, 5,000 Years: An International History and Illustrated Survey.* New York: Harry N. Abrams, 1993.

Jenkins, David, ed. *The Cambridge History of Western Textiles.* 2 vols. New York: Cambridge University Press, 2003.

Levey, Santina M. *Lace: A History.* London: Victoria and Albert Museum, 1983.

Parry, Linda. *Textiles of the Arts and Crafts Movement.* New York: Thames & Hudson, 1988.

Schoeser, Mary, and Kathleen Dejardin. *French Textiles: From 1760 to the Present.* London: L. King, 1991.

Schoeser, Mary, and Celia Rufey. *English and American Textiles: From 1790 to the Present.* New York: Thames & Hudson, 1989.

Sherrill, Sarah B. *Carpets and Rugs of Europe and America.* New York: Abbeville Press, 1996.

Synge, Lanto. *Art of Embroidery: History of Style and Technique.* Woodbridge, England: Antique Collectors' Club, 2001.

Wallace, Ann. *Arts & Crafts Textiles: The Movement in America.* Layton, UT: Gibbs Smith Publishers, 1999.

Wallpapers

Hoskins, Lesley. *The Papered Wall: The History, Patterns and Techniques of Wallpaper.* 2nd ed. London: Thames & Hudson, 2005.

Lynn, Catherine. *Wallpaper in America: From the Seventeenth Century to World War I.* New York: W. W. Norton & Company, 1980.

Oman, Charles, and Jean Hamilton. *Wallpapers: A History and Illustrated Catalogue of the Collection of the Victoria and Albert Museum.* London: Philip Wilson Publishers, 1982.

Warner, Joanne K. *Landscape Wallcoverings.* London: Scala Publishers, 2006.

Aalto, Alvar, 248, 249
Aarnio, Eero, 254, 256
Abbey Church of St. Foy, 54
Acanthus leaves motif
 Baroque, 106, 116
 Greek, 33, 42, 46
 Neoclassic, 153, 156, 158, 161
 Renaissance, 86–87, 91, 92, 98
 Rococo, 129, 137
 Rococo Revival, 212
 Victorian, 202
Acorn motif, 58, 60
Acropolis, 32
Adam, Robert, 151, 152
Adler and Sullivan, 224
Aegean cultures. *See* Ancient Aegean cultures
Aesthetic movement, 186, 187
Akrotiri, 25
Alabaster, 20
Albers, Anni Fleischmann, 231, 232
Alcoa Aluminum, 245
Alessi, 266, 267
Alexander the Great, 32
American Colonial style, 104–105, 110, 132
American Federal style, 151, 160
American Industrial Art Exhibition, 235
American Late Colonial style, 128
Amphoras, 37
Anaglypta wallpaper, 213
Ancient Aegean cultures
 architectural settings, 23–25
 design motifs, 25–27
 historical context, 21–22
 interior furnishings, 27
 metalworking, 29
 vessels and containers, 27–28
 weaving and textiles, 29
Ancient Egypt
 architectural settings, 10–11
 design motifs, 12–18, 235, 247
 historical context, 10
 interior furnishings, 18–19
 metalworking, 20–21
 vessels and containers, 19–20
 weaving and textiles, 21
Ancient Greece
 architectural settings, 32–33
 design motifs, 33–36
 historical context, 32
 metalworking, 38, 49–50
 vessels and containers, 37–38, 39–40
 weaving and textiles, 50
Ancient Rome
 architectural settings, 41–43
 design motifs, 43–45

 historical context, 41
 interior furnishings, 45, 47
 vessels and containers, 47–48
Animal design motifs, 15–16, 27, 35, 46
Ankh symbol, 17
Antefix, 35
Anthemion design motif, 35, 45
Antoinette, Marie, 150
Arabesque motif
 Baroque, 106, 107, 108, 155
 Middle Ages, 60, 63
 Neoclassic, 152, 155
 Renaissance, 77, 86, 87, 91, 92
 Rococo, 139, 143
 Roman, 43–44, 45
Architecture
 ancient Aegean cultures, 23–25
 ancient Egypt, 10–11
 ancient Greece, 32–33
 ancient Rome, 41–43
 Art Deco and Art Moderne, 235–236
 Art Nouveau, 180–187
 Arts and Crafts, 180–187
 Baroque, 100–106
 Contemporary, 250
 Early Modernism, 219, 220–221, 224–228
 Futuristic, 254, 257
 International Style, 228–233
 Middle Ages, 54–55
 Minimalism, 262
 Neoclassic period, 149–153
 Neolithic period, 4–5
 Postmodernism, 265–266
 Renaissance, 76–84
 Rococo, 124–128
 21st century, 266, 268–269
 Victorian, 180–187
The Architecture of Country Houses
 (Downing), 184
Argand, Aimé, 168
Argand lamps, 168, 169, 203, 204
Art Deco and Art Moderne
 clocks, 245–247
 glass, 240–243
 interior furnishings, 234
 lighting, 243–244
 metalworking, 244–245
 mirrors, 243
 overview, 234–237
 plastics, 239
 textiles and wallpaper, 247–248
Artek, 248, 249
Art Furnishers Alliance, 207
Art Moderne. *See* Art Deco and Art Moderne
Art Nouveau

architectural settings, 180–187
decorative accessories
 clocks, 209–210
 glass, 197–200
 lighting, 203–205
 metalworking, 98, 205–208
 mirrors, 145, 201–203
 pottery, 193–197
 textiles, 210–213
 wallpaper, 213–214
interior furnishings, 187–192
timeline and historical context, 179–180
The Art of Decorative Design (Dresser), 206–207
Arts and Crafts
architectural settings, 180–187
decorative accessories
 clocks, 209–210
 glass, 197–200
 lighting, 203–205
 metalworking, 205–208
 mirrors, 201–203
 pottery, 193–197
 textiles, 210–213
 wallpaper, 213–214
interior furnishings, 121, 187–192
lighting, 203–205
timeline and historical context, 179–180
Arts and Crafts Society Exhibition of 1896, 220
Atomic Lamp, 252
Aubusson textiles, 95, 211, 212

Baccarat lead crystal, 114, 135, 200, 241
Baekeland, Leo, 239
Bakelite, 239, 243, 245, 246
Ball Chair, 254, 256
Ball Clock, 252
Baroque
architectural settings, 100–106
decorative accessories
 clocks, 115
 glass, 112–113
 lighting, 114
 metalworking, 114–115
 mirrors, 113–114
 pottery, 111–112
 textiles, 116–118
 wallpapers, 118–119
design motifs, 106–108
historical context and timeline, 99–100
interior furnishings, 108–111
Barry, Sir Charles, 181, 183
Baskets. *See* Vessels and containers
Bauhaus, 230–232
Bayeux Tapestry, 69
B 32 Chair, 231
Beds. *See* Interior furnishings
Bel Geddes, Norman, 235, 236, 266
Belleek porcelain, 194, 196
Bellflowers with ribbons motif, 155, 156, 159
Belter, John Henry, 191, 192
Bernini, Gian Lorenzo, 100
Bertoia, Harry, 251
Bilston enamel, 140
Bing, Samuel, 208
Bizarre ware, 239

Blue cobalt designs, 197
Blue glass, 167, 168
Bobbin lace, 97, 143, 144
Bodleian Chair, 178
Boffrand, Germain, 124
Bohemian lead crystal, 112, 114, 135
Bolsover, Thomas, 170
Book of Architecture (Gibbs), 126
Botanicals motif, 106, 116, 184, 185, 199, 221
Boulle, André-Charles, 108, 110, 120
Boxes, 138, 140, 165–166, 170. *See also* Vessels and containers
Brandt, Marianne, 231
Brass. *See* Metalworking
Breuer, Marcel, 231
Bristol, 197
Brocades, 116, 118, 141, 157
Bronze. *See* Metalworking
Brown, Ford Madox, 191
Bullfinch, Charles, 151
Bungalow-style homes, 187, 189
Burlington, Lord, 127
Burne-Jones, Sir Edward, 70–71, 191

The Cabinet Maker and Upholsterer's Drawing Book (Sheraton), 159, 162
The Cabinet Maker and Upholsterer's Guide (Hepplewhite), 159
Cabriole legs, 130
Cameo glass, 47–48
Candelabra, 102, 114, 131, 134, 170, 171
Candles and candleholders. *See also* Candelabra; Chandeliers
 Art Deco, 246
 Art Nouveau, 197, 204
 Arts and Crafts, 203
 Baroque, 114
 Egyptian, 20
 Medieval Europe, 65–66, 67, 68
 Modern, 245
 Neoclassic, 164, 169
 Renaissance, 94
 Rococo, 136, 137, 138, 139
Canopic jars, 23
Carnival glass, 199, 240
Carpenter Gothic, 184, 186
Carpets, 95, 116, 173, 175, 211, 213
Carter, Howard, 18
Carter, John, 139
Carver armchair, 111
Caryatids, 38, 155
Cassone, 91
Castles, medieval, 55
Catal Huyak, 8, 45
Catalin, 239
Cathedral of Seville, 59
Catherine, Queen of France, 79
Cellerets, 166
Celtic design motifs, 223, 224
Ceramic Art Company, 194
Ceramics. *See* Pottery; Vessels and containers
Cesca Chair, 231, 233
Chairs. *See* Interior furnishings
Chalices, 20, 94
Chambord, 79, 81
Champion, William, 136–137
Chance glass factory, 259, 261

Chandeliers
 American Colonial, 134
 Art Deco, 244
 Arts and Crafts, 205
 Baroque, 102, 103, 108, 109, 114, 117
 Medieval Europe, 65, 66
 Neoclassic, 157
 Renaissance, 80, 84, 94
 Rococo, 125, 131, 137
 Rococo Revival, 186
 19th century Oriental, 181
Charles II, King of England, 102
Chase Brass & Copper, 245, 246
Chasing technique, 114–115, 137
Château de Malmaison, 150, 151, 158–159, 171
Chateau du Chambord, 79, 81
Checkerboard design motif, 18
Chelsea porcelain, 135, 162, 164
Chests. *See* Interior furnishings
Chevals, 201, 202
Chevron design motif, 16, 17, 18
Chinese Chippendale, 131, 132, 181
Chinese fret motif, 128, 129, 182
Chinese lacquerwork, 130, 131
Chinese porcelain, 111, 112
Chinoiserie motifs, 108, 128, 136
Chippendale, Thomas, 131, 159
Chippendale style, 133
Chiswick House, 127, 151
Christian iconography, 56
Chrysler Building, 235, 236
Claydon House, 126
Cliff, Clarice, 238–239
Clocks
 Art Deco and Art Moderne, 216,
 245–247
 Art Nouveau, 209–210, 216
 Arts and Crafts, 209–210
 Baroque, 115
 Contemporary, 252
 Glasgow School, 224
 Neoclassic, 151, 171
 Regency, 172
 Renaissance, 94–95
 Rococo, 140–141
 Victorian, 209–210
Cloisonné, 65
Colbert, Jean-Baptiste, 113, 116
Colombo, Joe, 263, 264
Colston, Richard, 115
Comparative designs
 chairs, English Regency and Late 20th
 century, 177–178
 clocks, 19th century, Art Nouveau, and Art
 Deco, 215–216
 eggs, Mycenaean and Faberge, 30
 horse figurines, Neolithic and 19th century, 9
 jars, Egyptian canopic and Wedgwood
 jasperware, 23
 marquetry, 17th century and 19th century,
 120–121
 mirrors, Rococo and Art Nouveau,
 144–145
 tapestries, 16th and 19th century, 70–71
 teapots, Bronze Age and 18th century, 8
 vases, ancient Roman press molded glass
 and 1930s milk glass, 51

 vases, 5th-century, and contemporary silver
 trophy cup, 40–41
 wall plaques, 17th and 20th century, 98

Complexity and Contradiction in Architecture
 (Venturi), 265
Composite order, 42
Concrete, 41–42
Conde Nast Publications, 269
Conner, Jerome, 207
Constantine the Great, 54
Containers. *See* Vessels and containers
Copper. *See* Metalworking
Core forming glass-making technique, 19
Corinthian order, 32, 33, 149
Cornucopia motif, 155, 156
Cortland House, 128
Couches. *See* Interior furnishings
The Craftsman (Stickley), 187
Cranberry glass, 198
Cranbrook Academy, 232–233, 251
Cranston, Kate, 221
Creamware, 164–165
Cristallo glass, 63, 93
Crocket motif, 57–58, 59
Crowninshield Bentley House, 127
Crystal, 63, 114, 135, 167, 200, 241
Crystal Palace, 181, 182, 184, 190, 199
Cupids design motif, 45, 85, 106

Dacron polyester, 256
Damask, 116, 118, 141, 157, 158
Daum, 242
Davidson, Archibald, 174
da Vinci, Leonardo, 79
Decorative accessories. *See* Clocks; Glass;
 Lighting; Metalworking; Mirrors;
 Pottery; Wallpaper; Weaving and Textiles
Deities as design motifs, 15, 44–45
Delamair, Pierre-Alexis, 124
Delftware, 111, 112, 113, 134
de Pompadour, Madame, 133
Depression glass, 240
Derby porcelain, 135, 136, 162–163, 164
Design motifs. *See also* specific motifs
 ancient Aegean cultures, 25–27
 ancient Egypt, 12–18
 ancient Greece, 33–36
 ancient Rome, 43–45
 Baroque, 106–108
 Celtic, 223, 224
 Glasgow School, 223, 224
 Middle Ages, 55–60
 Neoclassic period, 153–156
 Renaissance, 84–89
 Rococo, 128
De Stijl, 228–230
Doesburg, Theo van, 228
Dole Vale Company, 245
Doric order, 32, 33, 149
Downing, Andrew Jackson, 184
Dresser, Christopher, 203, 206, 207
Dreyfuss, Henry, 236, 266
Driscoll, Clara, 205
Dubac, Jean Baptiste, 171
Ducal Palace (Italy), 78
Duncan Phyfe style, 162

Eames, Charles, 250, 251, 266
Eames, Ray, 250, 251, 266
Early Modernism, 219
Edison, Thomas, 205
Eggs, decorative, 30
Egypt. *See* Ancient Egypt
Eiffel Tower, 182, 185
El Escorial, 78, 80
Elizabethan Revival style, 144, 151, 180, 191
Embroideries, 69, 97, 107, 116
Empire State Building, 235
Empire style, 151, 157, 160, 162, 167
Enameling, 64–65, 110
Encoignures, 201
English Regency, 177
Evans, Sir Arthur, 23–24
Experience Music Project, 267
Expo '67, 257

Faberge eggs, 30
Faience, 19, 38
Favrile glass, 200
Federal style, 151, 160, 173
Fenton, Frank Leslie, 199, 240
Festoons, 104, 128, 158, 215, 265
Flax, 29, 50
Fleur de lis, 56–58, 67, 68, 87, 88, 125, 157
Floor coverings, 7. *See also* Carpets
Floral patterns, 106–107
Flos, 268
Foliate designs
 Baroque, 108, 115, 116
 Modern, 240
 Neoclassic, 153–154, 156, 158–159, 171, 172
 Renaissance, 86
 Rococo, 128, 129, 130, 137
 19th century, 194, 213
Fontaine, Pierre François Léonard, 150
Fontainebleau, 79–80, 82, 109
Four Books of Architecture (Palladio), 126
Frank, Jean-Michel, 244
Frederick Ramon Lighting, 252
French Empire, 167
Fret design motif, 15, 17, 18, 25, 33, 34
Furniture. *See* Interior furnishings
Futuristic design, 254–257

Gabriel, Ange-Jacques, 125, 150
Gabriele, 157
Galle, Emile, 200
Garland motifs, 85–86, 106, 216
Gaslighting, 203, 205
Gate, Simon, 242
Gehry, Frank, 266, 268–269
The Gentleman and Cabinet Maker's Director
 (Chippendale), 131, 159, 181
Geometric design motifs, 16–17, 38, 43, 44,
 87–89
George III style, 162, 170, 171
George IV, King of England, 180–181
Georgian style, 127–128, 132
Gerth, Ruth, 245
Gerth, William, 245
Giacometti, Alberto, 244
Gibbons, Grinling, 129
Gibbs, James, 126
Gibson House, 213

Gilding, 18, 20
Gilt, 158
Giza, 10–11
Glasgow Four, 220, 222
Glasgow School, 220–224
Glass. *See also* Crystal; Stained glass
 ancient Egypt, 19
 ancient Greece, 37
 ancient Rome, 47–48, 49
 Art Deco and Art Moderne, 240–243
 Art Nouveau, 197–200
 Arts and Crafts, 197–200
 Baroque, 112–113
 Bauhaus, 232
 Contemporary style, 252, 254
 futuristic, 255
 Middle Ages, 63–64
 Minimalism, 263
 Neoclassic period, 166–167
 popular culture of the 1960s, 259–261
 Renaissance, 93
 Rococo, 135
 Victorian, 197–200
Gobelins, Jean, 116
Gold, 20, 29, 49, 93
Goldscheider, 238
Gothic Revival style, 144, 151, 180, 184, 191, 211
Gothic style, 54
Grapes as a design motif, 45, 49, 56
Graves, Michael, 265–266, 267
Great Exhibition of 1851, 181, 185, 190, 194, 210
Greco-Roman style, 32
Greece. *See* Ancient Greece
Greek key designs, 15
Greek Revival style, 144, 151, 160, 180
Griffins as design motifs, 16, 17, 35–36, 85,
 106, 161
Gropius, Walter, 230–231
Grueby pottery, 195
Guggenheim Museum, 267
Guilds, 66
Guilloche motif, 14, 26, 86, 87, 153, 175
Guimard, Hector, 184

Habitat housing project, 257
Hald, Edward, 242
Hall, John, 84
Hall of Mirrors (Palace of Versailles), 102,
 113, 114
Ham House, 119
Hamilton, Richard, 257–258
Hampton Court, 80–81, 82, 104
Hanks, Benjamin, 171
Hardouin-Mansart, Jules, 101, 102
Hard-paste porcelain, 133
Harvey, Agnes Bankier, 223
Henry II, King of France, 79
Hepplewhite, George, 159
Herculaneum, 149, 151, 180
Herman Miller Company, 251
Herrera, Juan de, 78, 80
Historical context. *See also* Timelines
 ancient Aegean cultures, 21–22
 ancient Egypt, 10
 ancient Greece, 32
 ancient Rome, 41
 Art Deco and Art Moderne, 218–219

Baroque, 100
Contemporary culture and WWII, 248–250
futuristic design, 254–257
Middle Ages, 54
Modern and Postmodern, 218–219
Neoclassic period, 147–149
Neolithic period, 4
Renaissance, 76
Rococo, 123–124
Victorian, Arts and Crafts, Art Nouveau, 180
Hoffmann, Josef, 224, 225
Homer, 32–33
Honeyman and Keppie, 220
Hood, Raymond, 236
Hope, Thomas, 160
Hopkins, Stephen, 105
Horta, Victor, 185
Hôtel de Soubise, 124
Hôtel de Varengeville, 131
Hôtels, 124, 125, 128
House for an Art Lover, 220–223
Household Furniture and Interior Decoration
 (Hope), 160
Houses of Parliament, 181, 183
Howard Miller Clock Company, 246
Howzer, Wolfgang, 115
Hubbard, Elbert, 207
Hughes, Robert, 259
Hukin and Heath, 207
Hunter, Dard, 207
Hutchinson, John, 220
Huygens, Christiaan, 115
Hydrias, 37

Ikea, 266
Incandescent lightbulb, 205
Incised designs, 6
Industrialization, 180, 191
Ingram Street Tea Room, 221, 222
Interior furnishings
 ancient Aegean cultures, 27
 ancient Egypt, 18–19
 ancient Rome, 45, 47
 Art Deco and Art Moderne, 234–235,
 237, 243
 Art Nouveau, 187–192
 Arts and Crafts, 187–192
 Contemporary, 250–253
 Early Modernism, 219–225, 227
 International Style, 230–233
 Middle Ages, 61–62
 Minimalism, 264
 Neoclassic period, 156–161
 Neolithic period, 4–5
 Renaissance, 90–91
 Rococo, 128–133
 Scandinavian design, 248
 Victorian, 187–192
International style
 Bauhaus school, 230–231
 Cranbrook Academy, 232–233
 De Stijl movement, 228–229
 Frank Lloyd Wright, 224–228
 Glasgow School, 220–224
 Wiener Werkstätte, 224
Ionic order, 32, 33, 149
Irish Belleek porcelain, 194, 196

Ironstone, 164–165, 194
Islamic design, 77
Italianate Revival style, 151, 180, 184
Italian Mannerist style, 79–80
Italian Renaissance style, 76–79, 149
Ivory, 165, 166, 167

Jacob-Desmalter, François Honore Georges, 158
Jacquard, Joseph Marie, 173
Jacquard loom, 210
Jacquard weave, 173, 174
Japanning, 131
Jeanneret, Charles Edouard, 228
Jefferson, Thomas, 151, 160, 171, 180
Jencks, Charles, 265
Jensen, Georg, 244
Joe Sofa, 259
Johnson, Philip, 228
Jones, Inigo, 83, 87, 102, 127
Josephine, Empress of France, 150, 158
Jugendstil, 208
*Just What Is It That Makes Today's Homes So
 Different, So Appealing?* (collage,
 Hamilton), 257–258

Kaiser, Ray-Bernice, 251
Kandinsky, Wassily, 231
Kaolin, 161
Kartell, 264
Kent, William, 127
Kerosene lamps, 169, 203
Klee, Paul, 231
Klismos chair, 37, 40, 160
Knoll, 265
Knoll, Florence Schust, 251
Knossos, 22–23, 24, 27, 29
Knox, Archibald, 207
Kosta (Kosta Boda), 243
Kraters, 37
Kylix, 37

Lace, 97, 116, 117, 119, 143
LaFarge, John, 200, 201
Lalique, René, 240, 241, 244, 246
Lamps. *See* Lighting; Oil lamps; Vessels and
 containers
The Language of Post-modern Architecture
 (Jencks), 265
Lannuier, Charles-Honore, 176
Laurel leaves design motif, 87, 155
Lava lamps, 258
Lead crystal, 114, 167
LeBrun, Charles, 101, 102
LeCorbusier, 228, 229
Lectus, 46
Leeds pottery, 164
Lekythos, 37
Le Nôtre, André, 101
Lenox, 266
Lenox, Walter Scot, 194
Le Vau, Louis, 102
Levittown, 250
Liberty & Company, 202, 207
Lighting. *See also* Candles
 Art Deco and Art Moderne, 243–244
 Art Nouveau, 203–205
 Baroque, 114

Lighting. *See also* Candles (*Continued*)
 Contemporary, 252
 Early Modernism, 227
 futuristic, 255
 Minimalism, 263, 264
 Neoclassic period, 168–170
 pop art, 258
 Renaissance, 94
 Rococo, 136
 Victorian, 203–205
Limoges, 161
Lincrusta wallpaper, 213
Lindstrand, Vicke, 242
Linenfold motif, 58, 59
Linoleum, 213
Lion design motif, 35
Loetz, 200
Loewy, Raymond, 235
Loos, Adolf, 219
Lotus design motif, 12, 13
Louis XIV, King of France, 95, 108, 109–110,
 116, 124
Louis XV, King of France, 124–125, 130–131,
 133, 137
Louis XVI, King of France, 148, 150, 157, 158
Lounge Chair 37, 249
Lozenge motif, 87
Lusterware, 194, 195
Luxor, 11
Lyre motif, 155, 157

MacDonald, Frances, 220
MacDonald, Margaret, 220, 222
Mackintosh, Charles Rennie, 220, 221, 222, 223
MacNair, J. Herbert, 220
Madoura Pottery, 259
Mail order catalogs, 187
Majolica earthenware, 92, 194, 195
Majorelle, Louis, 193
Malmaison. *See* Château de Malmaison
Mantegna, Andrea, 77
Manufacture des Gobelins, 101, 116
Marquetry
 Art Nouveau, 193
 Arts and Crafts, 121
 Baroque, 106, 108, 110–111, 115, 120
 International Style, 233
 Neoclassic, 165
 Renaissance, 92
 Rococo, 128, 130
Mason family pottery, 193
Max, Peter, 259, 260
McIntire, Samuel, 151
Medallion designs, 153, 158
Megaron floor lamp, 265
Meier, Richard, 262
Meissen porcelain, 135
Melamine, 239
Metalworking
 ancient Aegean cultures, 29
 ancient Egypt, 20–21
 ancient Greece, 38, 49–50
 Art Deco and Art Moderne, 244–245, 246
 Art Nouveau, 205–208, 209
 Arts and Crafts, 205–208, 210
 Baroque, 110, 114–115, 120
 Bauhaus, 231
 Glasgow School, 210
 Medieval Europe, 64–68, 208, 209
 Neoclassic, 159, 172
 Neoclassic period, 170–171
 Renaissance, 93–94
 Rococo, 136–139, 137, 138, 139, 140
 Victorian, 205–208
Metropolitan Museum of Art, 235
Meyer May House, 225, 226
Middle Ages
 architectural settings, 54–55
 decorative accessories
 glass, 63–64
 metalworking, 64–67
 pottery, 62–63
 textiles, 68–71
 design motifs, 55–60
 historical context, 54
 interior furnishings, 61–62
Midwinter pottery factory, 259
Mies van der Rohe, Ludwig, 231
Millefiori patterns, 93
Millefleurs, 69–71, 96
Miller, Herman, 250
Minimalism, 262–264
Minton, Herbert, 194, 196, 197, 207
Mirrors
 ancient Rome, 20–21
 Art Deco and Art Moderne, 243
 Art Nouveau, 144–145, 201–203
 Arts and Crafts, 201–203
 Baroque, 113–115
 futuristic design, 257
 Glasgow School, 224
 Neoclassic period, 167–168
 Renaissance, 93
 Rococo, 135, 144–145
 Victorian, 201–203
Mission style, 191, 193, 205
Miss Sissi lamp, 267
Modern and Postmodern. *See also* Art Deco and
 Art Moderne; International style;
 Popular culture of the 1960s
 organic design in home furnishings,
 250–253
 Postmodernism, 265–266
 pottery, 259
 Scandinavian design, 248
 21st century, 266–269
 timeline and historical context, 217–219
Moholy-Nagy, László, 231
Mondrian, Piet, 231
Monticello, 151, 152, 153
Montreal Expo '67, 257
Moorish influence, 77
Moquette carpeting, 173
Morris, William, 70, 186–189, 191, 211, 213, 214
Morris & Company, 191, 192, 212, 213, 214
Mosaic glass, 19, 43, 48, 93
Moulton silversmiths, 205
Mudéjar style, 78, 79, 88–89
Murdock, William, 203
Museum of Modern Art in New York
 (MOMA), 250

Napoleon, 150
Nash, John, 180

Needle lace, 97
Needlework, 141, 143, 173, 175. *See also* Embroideries; Lace
Nelson, George, 252
Neoclassic period
 architectural settings, 149–153
 decorative accessories
 boxes, 165–166
 clocks, 171
 glass, 166–167
 lighting, 168–170
 metalworking, 170–171
 mirrors, 167–168
 pottery, 161–165
 textiles, 171–175
 wallpaper, 175–176
 design motifs, 153–156
 interior furnishings, 156–161
 timeline and historical context, 147–149
Neolithic period, 4–8
Nervi, Pier Liugi, 254
Nestor, 25
Newcomb pottery, 195
New York World's Fair of 1939, 236, 237, 248
New York World's Fair of 1964, 254, 256
Nichol, Maria Longworth, 195
Niedecken, George, 226, 227–228
Nielsen, Harald, 244

O. W. O., 266
Oakleaf motif, 58, 60
Oberkampf, Christophe-Philippe, 175, 176
Oil lamps, 94
Olympic stadium, 1960, 254
Organic Design in Home Furnishings, 249–250
Orrefors, 242, 255
Osterley Park, 151, 152
Ostrich egg vases, 30

Palace of Knossos, 22–23, 24, 27, 29
Palace of Nestor, 25
Palace of Versailles, 101, 102, 103, 113, 114, 117
Palazzo Davanzati, 96
Palazzo Poli, 101
Palladianism, 76, 104, 126, 149
Palladio, Andrea, 76, 126
Palmer, Thomas, 213
Palmettes design motif, 14, 35, 151, 153, 161
Panton, Verner, 263
Panton Chair, 263, 265
Papillon, Jean Michel, 119
Papyrus design motif, 12–13
Paramount Hotel, 265, 267
Parian ceramics, 194, 196
Parian clock, 215
Paris Exhibition of 1889–1890, 182, 208
Paris Exposition Internationale des Arts Décoratifs et Industriels Modernes of 1925, 224, 234, 241, 242, 244
Paris International Exposition, 205
Paris Metro stations, 184
Parthenon, 33
Paterae motif, 151, 153, 154, 155
Pâte-sur-pâte, 194, 196
Paxton, Sir Joseph, 182
Percier, Charles, 150
Pericles, 32

Periwig chair, 110
Perkin, W. H., 210
Petit Trianon, 150
Pewter, 66, 67, 137–138, 139, 208
Philip II, King of Spain, 78
Phyfe, Duncan, 160, 176
Picasso, Pablo, 259, 260
Pilasters, 106
Plastics, 239, 250, 263–264
Plimoth Plantation, 105
Pompeii, 149, 180
Poole Pottery, 251, 253
Pop art, 257–261
Popular culture of the 1960s
 glass, 259–262
 Minimalism, 262–264
 overview, 253–258
 pottery, 238–239
Porcelain, 110, 111, 133
Portland Building, 266
Postmodern. *See* Modern and Postmodern
Pottery. *See also* Vessels and containers
 Art Deco and Art Moderne, 238–239
 Art Nouveau, 193–197
 Arts and Crafts, 193–197
 Baroque, 111–112
 Contemporary style, 252, 253
 Middle Ages, 62–63
 Neoclassic period, 161–165
 popular culture of the 1960s, 238–239, 259
 Renaissance, 92
 Rococo, 133, 135
 Victorian, 193–197
Prairie style, 226, 228
Pre-Raphaelite Brotherhood, 70, 191
Prince of Wales plume, 155, 159
Pugin, Augustus Welby, 181, 183
Putti figures, 85, 106, 128, 129, 155
Pyramids of Giza, 10–11

Quatrefoil patterns, 57
Queen Anne style, 130–131, 132, 184–185
Queen Hatshepsut's funerary temple, 11, 16
Quimper pottery, 193

Radio City Music Hall, 248
Ravenscroft, George, 114
Red House, 187
Regency style, 157, 160, 161, 166, 170, 172, 182
Relief designs, 6–7
Religious deities as design motifs, 15, 44–45
Renaissance
 architectural settings, 76–84
 decorative accessories
 clocks, 94–95
 glass, 93
 lighting, 94
 metalworking, 93–94
 mirrors, 93
 pottery, 92
 textiles, 95, 97
 design motifs, 84–89
 historical context and timeline, 75–76
 interior furnishings, 90–91
 Italian room setting, 96
Renaissance Revival, 191, 210, 211
Repoussé work, 114, 137, 206, 224

Revere, Paul, 170
Revere Copper Products, 170
Rietveld, Gerrit, 228, 229, 230
Rinceau design motif, 43–44, 45, 107
Robie House, 226, 227
Rocaille shell design, 128, 129
Rochester Keep, 55
Rockefeller Center, 235, 236
Rococo
 architectural settings, 124–128
 decorative accessories
 clocks, 140
 glass, 135
 lighting, 136
 metalworking, 136–139
 mirrors, 135
 pottery, 133, 135
 textiles, 140–145
 treenware, 140
 wallpaper, 144
 design motifs, 128
 interior furnishings, 128–133
 timeline and historical context, 123–124
Rococo Revival style, 144, 186, 191, 212
Rohde, Johan, 244
Romanesque style, 54, 180
Rome. See Ancient Rome
Rood Blau (Red Blue) Chair, 229, 230
Rookwood Pottery, 195, 197
Room settings
 American Victorian, 186
 Art Nouveau, 185
 Arts and Crafts bungalow, 189
 English Early Neoclassic, 152
 French Baroque, 109
 Italian Renaissance, 96
 Late Colonial, 134
 medieval, 66
 Rococo, 125
Roses/rosettes design motif
 ancient Aegean cultures, 25, 26, 29
 ancient Greece, 33, 35
 Art Nouveau, 222
 Arts and Crafts, 121
 Egyptian, 12, 14, 15, 18
 Medieval Europe, 56–57, 60, 68
 Neoclassic, 152, 153–155, 158, 169, 175
 Renaissance, 87–89, 91, 93
 Rococo, 141
Rosetta process, 93
Roseville Pottery Company, 195, 197
Rossetti, Dante Gabriel, 191
Rousseau, Jean Simeon, 157
Royal Doulton, 238
Royal Pavilion, 180–181, 182
Royal Worcester, 238
Roycroft, 207, 208
Roycroft Campus, 191
Ruhlmann, Jacques-Èmile, 234, 235, 243–244
Ruins of the Palace of the Emperor Diocletian
 (Adam), 151
Ruskin, John, 191, 196

Saarinen, Eero, 251, 255
Saarinen, Eliel, 232–233
Saarinen, Loja, 232–233
Sabino, Marius, 244

Safdie, Moshe, 257
Salon de l'art Nouveau, 208
Salon of Apollo, 117
Salvi, Nicola, 101
Samplers, 173, 174
Savonnerie carpets, 116, 211
Savoy Vase, 249
Sax, Sarah, 197
Scandinavian design, 248
Schott & Gen, 232
Schröder House, 228, 229, 230
Schröder-Schräder, Truus, 228
Scott-Brown, Denise, 267
Scrimshaw, 166, 167
Sears and Roebuck mail order, 186, 188
Secession, 208
Second Empire, 151, 184
Sèvres porcelain, 133, 134, 159, 161–162, 194, 195
Shell motif, 44, 106, 125, 129, 131, 136, 156
Sheraton, Thomas, 159
Sheraton style writing table, 160
Shingle-style homes, 186, 187
The Shock of the New (Hughes), 259
Siegfried, 208
Silk, 50, 157
Sillón de frailero, 79, 90
Silver, 49, 93, 137, 139, 170, 245
Silver plate, 170
Singerie, 128, 135
Skyscrapers, 235
Smith House, 262
Soft-paste porcelain, 133
Sons of Liberty Bowl, 171
Space age design. See Futuristic design
Sphinx design motif, 16, 35–36, 155
Spiral wave design motif
 ancient Aegean cultures, 25, 26, 28, 33
 ancient Greece, 33, 34, 44
 Egyptian, 14, 15, 17
 Medieval Europe, 63
St. Paul's Cathedral, 102, 103, 126
Staffordshire pottery, 133, 135, 164, 194, 259
Stained glass, 63–64, 200–201, 222
Stam, Mart, 231
Starck, Philippe, 265–266, 267
Steiner House, 219
Stern, Robert A.M., 178
Steuben, 266
Stickley, Gustav, 187, 189, 191, 193, 205, 208
Stile Floreale, 208
Stölzl, Gunta, 247
Stoneware pottery, 193–194
Stools. See Interior furnishings
Strawberry Hill, 181, 182, 183
Sun King emblem, 106, 108
Susan Lawrence Dana House, 227

Tables. See Interior furnishings
Tapestries, 68–69, 95, 96
Target, 266
Temple of Apollo, 149
Terry, Eli, 209
Tesserae, 43
Textiles. See Weaving and textiles
Thomas, Seth, 209
Thonet Brothers, 191
Tiffany, Charles Lewis, 200, 205

Tiffany, Louis Comfort, 200
Tiffany & Company, 206
Tiffany Studios, 201, 205, 206
Timelines
 ancient Greece and Rome, 31
 ancient world, 3
 Art Deco and Art Moderne, 217
 Baroque, 99
 Medieval Europe, 53
 Modern and Postmodern, 217
 Neoclassic period, 147–149
 Renaissance, 75
 Rococo, 123–124
 Victorian, Arts and Crafts, Art Nouveau, 179
Toile de Jouy, 171–173, 175
Tole, 138, 139, 165
Toledo, Juan Bautista de, 78, 80
Tombs, 14, 17, 18, 20, 21, 27, 29. *See also*
 Tutankhamun, King of Egypt
Tortoiseshell, 165, 166
Towle, 205
Transferware, 165, 172, 259
Treenware, 136–139
Trefoil patterns, 57
Trestle tables, 61
Trevi Fountain, 101
Triton design motif, 35–36
Trompe l'oeil, 86, 155
Tudor style, 83, 84
Tulip Chair, 255
Tuscan order, 42
Tutankhamun, King of Egypt, 20, 21, 29, 235,
 236, 247

Unisphere, 254, 256
Universale Chair, 263, 264
Upholstery
 American Renaissance Revival, 192
 Baroque, 116, 118
 International Style, 231, 233, 248
 Mission, 193
 Modern, 225, 255, 256
 Neoclassic, 157, 173, 177
 Renaissance, 79, 95
 Rococo, 130, 141–142
 Victorian, 189, 190, 192
Urns and swags motif, 151, 152, 215

Vanderbilt, Cornelius, 180
van der Vinne, Leonard, 120
Vargueño, 92
Vaseline glass, 198, 199
Vases. *See* Pottery; Vessels and containers
Veneer, 130
Venetian glass, 63, 93, 112, 113
Venturi, Robert, 265, 267
Versailles, 101–103, 113, 114, 117, 125, 157, 158
Vessels and containers. *See also* Pottery
 ancient Aegean cultures, 27–28
 ancient Egypt, 19–20
 ancient Greece, 34, 37–38, 39–40
 ancient Rome, 47–48
 Neolithic period, 5–7
Victorian
 architectural settings, 180–187
 decorative accessories
 clocks, 209–210

glass, 197–200
lighting, 203–205
metalworking, 205–208
mirrors, 201–203
pottery, 193–197
textiles, 210–213
wallpaper, 213–214
 interior furnishings, 187–192
 room setting, 186
 timeline and historical context, 144, 151,
 179–180
Victorian Cottage Residences (Downing), 184
Viennese Secession, 224
Villa La Roche, 229
Villa of the Mysteries, 43
Villa Rotunda, 76–77, 127, 151
Vines motif, 44–46, 60, 98, 145, 185, 213,
 216, 247
Vitra, 266
Vitruvian scrolls design, 153
Vitruvius, 76
Volutes, 87
Voysey, Charles F.A., 213

Wainscot chair, 91
Wallpaper
 Art Deco and Art Moderne, 247–248
 Art Nouveau, 185, 213–214
 Arts and Crafts, 211, 213–214
 Baroque, 118–119
 Gothic, 183
 Neoclassic period, 175–176
 Renaissance, 97
 Rococo, 145
 Victorian, 181, 213–214
Wall plaques, 98
Walpole, Horace, 181
Walt Disney Concert Hall, 268, 269
Walton, Frederick, 213
Warhol, Andy, 258, 259, 261
Warwick Castle, 131
Waterford lead crystal, 114, 135
Weaving and textiles. *See also* Damask;
 Embroideries; Lace; Tapestries;
 Upholstery
 ancient Aegean cultures, 29
 ancient Egypt, 21
 ancient Greece, 38, 50
 Art Deco and Art Moderne, 247–248
 Art Nouveau, 210–213
 Arts and Crafts, 210–213
 Baroque, 116–118
 Bauhaus, 232
 Middle Ages, 68–71
 Minimalism, 263
 Neoclassic period, 171–175
 Neolithic period, 7–8
 Renaissance, 95
 Rococo, 140–145
 Victorian, 210–213
Webb, Philip, 187, 191
Wedgwood, Josiah, 162
Wedgwood pottery, 23, 162, 163, 194, 207
Wheat motif, 157
Whiplash curves motif, 185, 197, 223, 224
Wiener Werkstätte, 224, 225
William and Mary style, 104, 108, 111

Willow Tea Room, 221
Wilton carpets, 116, 213
Wilton House, 127
Wimpole Hall, 126
Winterthur Museum, 134
Worcester porcelain, 135, 136, 194, 238
Work, Henry Clay, 209
World's Fair of 1939, 236, 237, 248
World's Fair of 1964, 254
Wren, Sir Christopher, 82, 102, 103, 126
Wright, Frank Lloyd, 224–228

Wright, Russell, 245
Wrought iron, 65, 169
Wylde, Nigel, 260

X-form folding stool, 46

Young, John B., 205

Zinc, 137